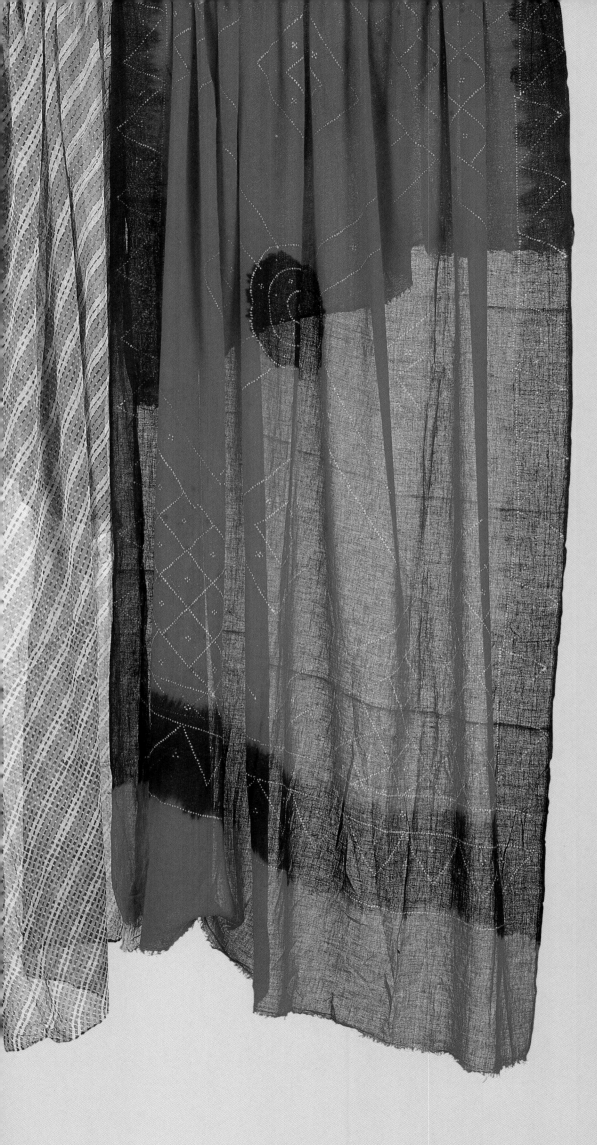

Costume, Textiles
and Jewellery of

INDIA

Traditions in Rajasthan

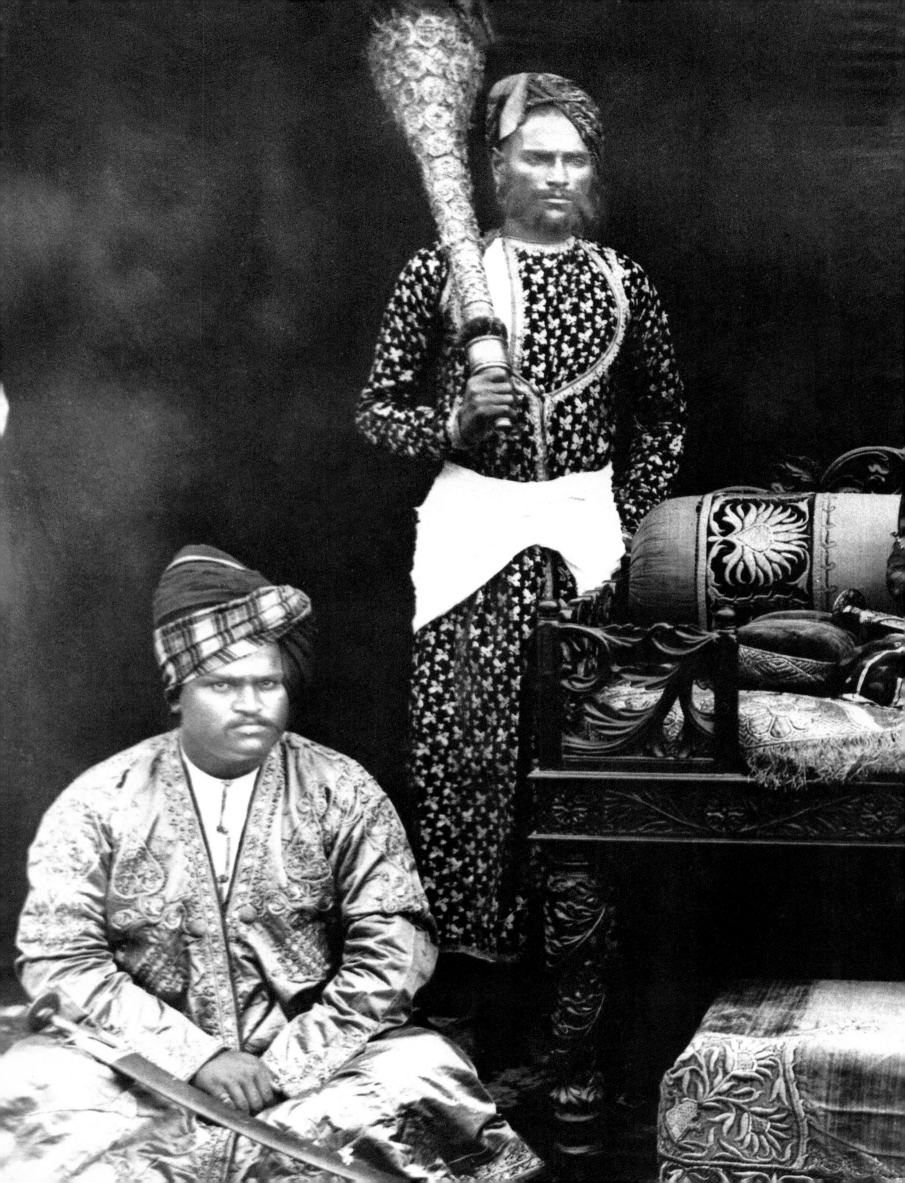

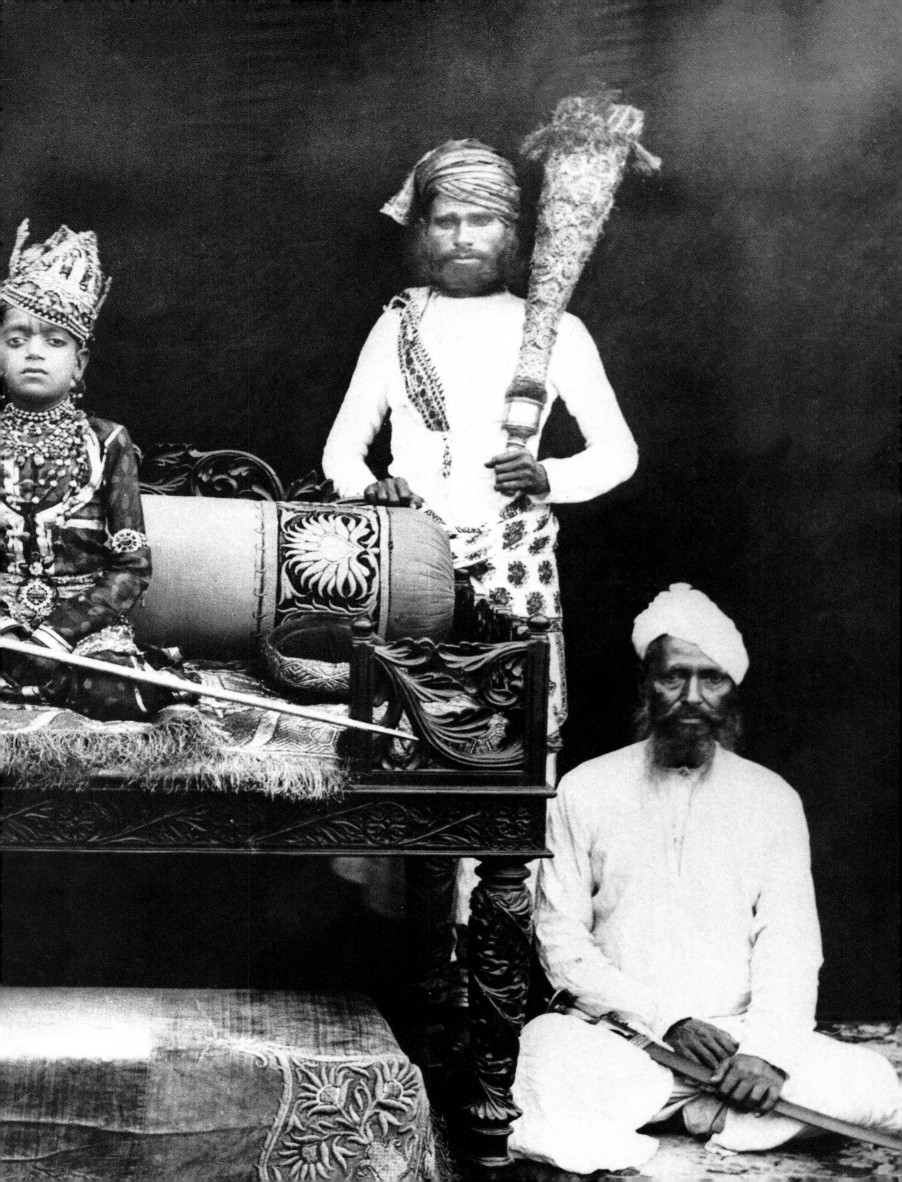

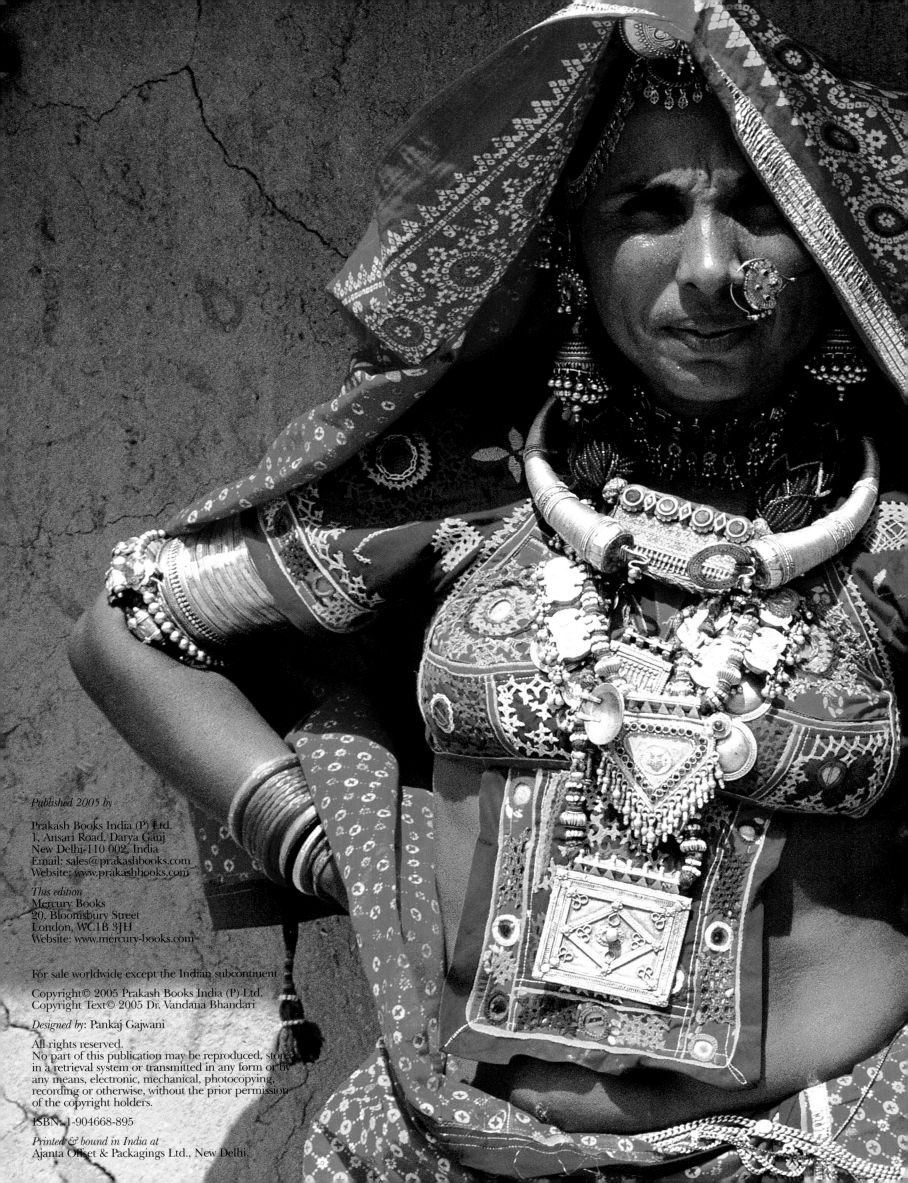

Published 2005 by

Prakash Books India (P) Ltd.
1, Ansari Road, Darya Ganj
New Delhi-110 002, India
Email: sales@prakashbooks.com
Website: www.prakashbooks.com

This edition
Mercury Books
20, Bloomsbury Street
London, WC1B 3JH
Website: www.mercury-books.com

For sale worldwide except the Indian subcontinent

Designed by: Pankaj Gajwani

ISBN: 1-904668-895

Printed & bound in India at
Ajanta Offset & Packagings Ltd., New Delhi.

Costume, Textiles and Jewellery of INDIA

Traditions in Rajasthan

Vandana Bhandari

MERCURY BOOKS
LONDON

Contents

Preface

Vandana Bhandari has conducted prolonged fieldwork in Rajasthan over the years and the material gathered by her on these trips forms the basic strength of this volume.

The study that began more than a decade ago had at its core, the objective of documenting women's garments in Rajasthan. For various social and cultural reasons every community in India sought to express its identity in terms of women's clothing. This orthodoxy of women's dressing had led to prolonged periods of vogue of certain materials and dressing styles, leading to the establishment of tradition. From what is available in the living practices today, one could form some idea about the general aesthetic and social considerations that might have played a role in fashioning women's garments among different social groups.

When we talk of 'tradition' in this context, we do not mean a rigid changeless monolith, but a broad social, cultural and aesthetic genre within which, historically, changes have always occurred. What started as a study of rural women's clothing in Rajasthan, eventually developed into a wider project, to include costumes, textiles and jewellery of the people of Rajasthan.

Starting with various forms of woven and patterned cloth - their materials, techniques and motifs - the book goes on to discuss some of the popular forms of jewellery of Rajasthan, the motifs of which, share, to some extent, an aesthetic milieu with the textiles of the region. Once the basic materials and motifs of the textiles of the region are dealt with, Vandana Bhandari proceeds to deal with the clothing of different communities.

One important contribution of this book is the section devoted to the patterns of typologically selected garments discussed in the book. The inclusion of this section not only enhances the book's documentary value, but provides the reader with an opportunity to be able to revive and use some of these traditional garments in the present times. The patterns will also serve as valuable archives and reference material for students of fashion technology.

Jyotindra Jain,
New Delhi, April 2004

Author's Note

India has a diverse culture, which has remained rooted in history and heritage. Underneath this diversity lies the continuity of the Indian system of values and thought, which are reflected in its social structure from the earliest time till today. There are two reasons for this coexistence. The first is India's vast geographic spread. The second is a history of interaction with the outside world, which periodically refreshed the time-honoured ways with new ideas and influences. This is true of most of the country's border states especially, but nowhere do all these influences come together more splendidly than in Rajasthan, 'the abode of princes'.

For centuries, Rajasthan, the region on India's north-western borders has stood firm against marauders, witnessed invaders and caravans that plied the ancient trade routes across its vast sandy deserts but has also absorbed some of their traditions, culture, costume and style. These, in turn, sustained and enriched the area, endowing it with a colourful and romantic heritage. This is reflected in the magnificent architecture of its palaces and forts, in the legendary exploits of its heroes, in the powerful rhythms of its music and dance and in the vitality of its craft traditions.

No element of a culture can exist in isolation. Each artistic expression is part of a composite whole. The aesthetics of architecture, craft, music and dance flow into each other and are echoed in the dress of the people of that culture. A study of costume then provides an index to the social, cultural, political, historical and economic aspects that shape people and its ethos. Every community and tribe in Rajasthan has its own distinctive costume. The models, which have been fashioned over time, have an integral logic, influenced by geography, climate and socio-cultural factors.

Today, as change sweeps over the face of the Subcontinent, no section of Indian society has remained unaffected and traditional costume is in a state of transition. A documentation of the dressing habits of the many social and ethnic groups was therefore thought to be of importance - as also a record of the changes that have been taking place over a period of time. Such a study makes accessible not only the skills and techniques developed over generations but also the meaning and symbolism of the garments, their colour and form. It also reveals the changes that have affected society over a period of time.

The content of this book is based primarily on the data collected during field studies for my doctoral work on textiles and costume in various parts of Rajasthan and supplemented by additional research conducted over the past decade and a half. This is not aimed as a historical record of costume in Rajasthan. Eminent scholars, like Motichandra, B.N. Goswamy, Chandramani Singh, G.S. Ghurye, and Roshan Alkazi, have extensively and comprehensively detailed the development of attire over the last five thousand years. This work, in contrast, looks at the living traditions of costume and accessories as seen through contemporary eyes. In its compilation, information culled through interviews with weavers, dyers, printers, tailors and, of course, the end-users, has been analysed against changes that have occurred in their historical context.

This book also records the present-day costume in Rajasthan and by tracing its evolution, links it to its roots. It thus chronicles a living history, preserved through the attire of the people. Linking the threads of culture and tradition, modernity and history, utility and mythology this book is an attempt to bring together the story of the evolution, significance and usage of everyday attire and ornamentation of the people of Rajasthan. The multi-dimensional nature of the subject makes it difficult to account for every regional variant. However, it is my hope that the examples presented here will shed some light on aspects that reveal a rich and exceedingly diverse culture through its textiles, costume and jewellery.

Vandana Bhandari

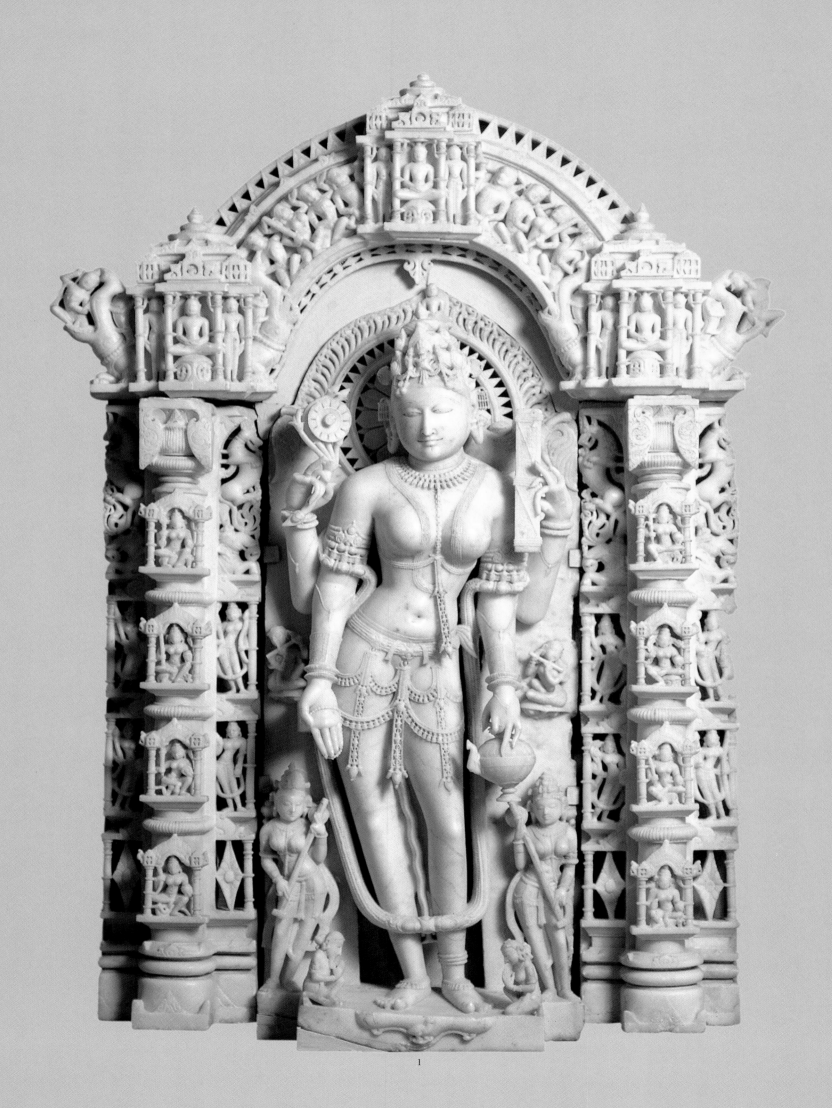

1

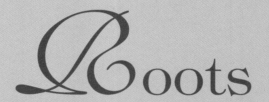

Roots

"No single source of evidence can, at a glance, tell the historian so much about his society [as the way in which its members are dressed]: its comparative prosperity, the distance between rich and poor, the grading of the social hierarchy, its occupational, religious, military or ceremonial inclinations, its frivolous or serious cast of mind, its attitudes towards women, children, servants or the poor, something even of its moral standards and its ideal type of man or woman..."

-- H.J.Perkins

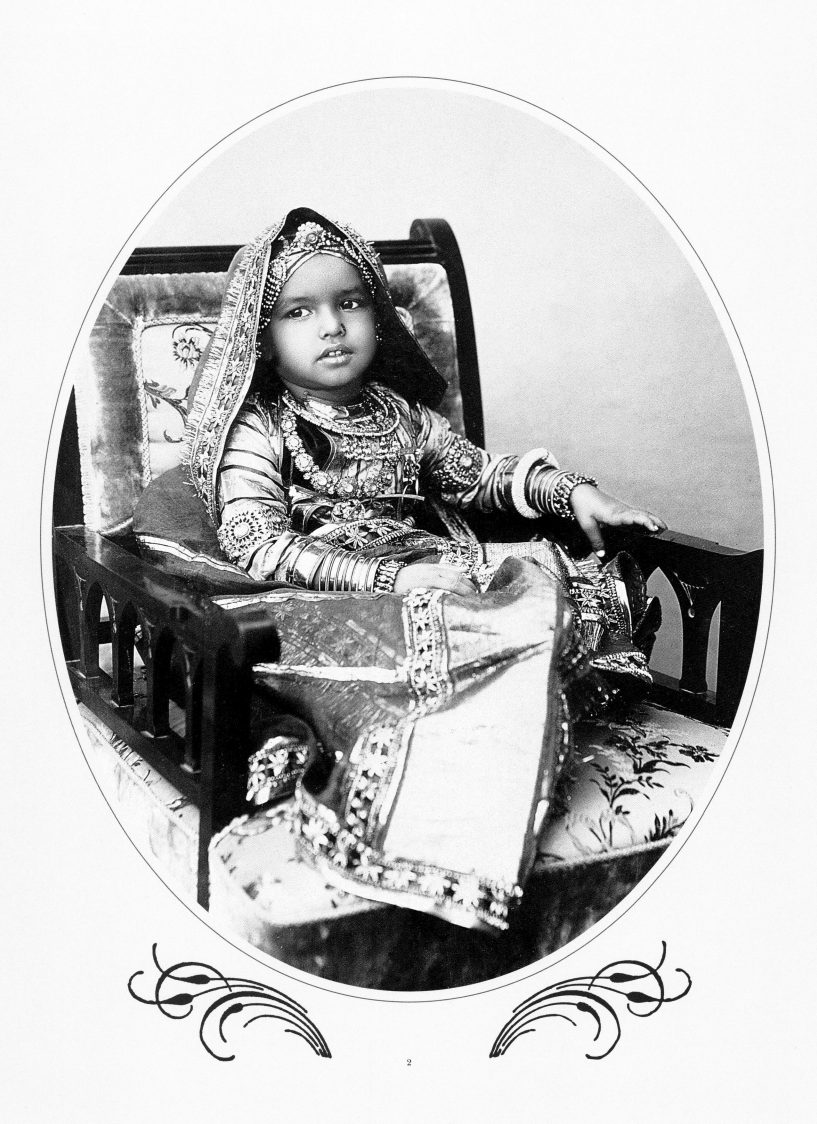

ndia and its people provide some of the most striking and colourful sights. Attire, adornment and decoration play a vital part in both material and spiritual aspects of life. Here, dress and ornament do more than simply protect and enhance the body - they nourish the soul. Commonplace tasks of ablution and worship take on an air of ritual - not only in the offering of prayers, so the day goes well, but also in the decoration of the sacred altar, the home and the workplace. This veneration of the visual experience forms the very matrix of Indian culture, from where arises such splendid diversity of region, faith and community.

The value of ornamentation is not principally aesthetic, although this, too, is important. Its primary purpose is to link function, spirit and form in a well-balanced, holistic context for daily life. In the words of Ananda K. Coomaraswamy:

"The beauty of anything unadorned is not increased by ornament, but made more effective by it... a thing is ritually transformed and made to function spiritually as well as physically."

In the last few decades many traditional societies have been witness to rapid change and westernisation. Though this has led to an adaptation of lifestyles, these communities have still managed to retain their cultural continuity. Much in India has also been transformed by these influences. However, it is in India's half million villages, where about 80 per cent of the population lives, that many of the old customs are preserved and valued. Rajasthan is probably the finest example of this continuity.

Rajasthan is an ancient land; the cradle of what may, perhaps, be one of the earliest human civilizations. The discovery of sites, such as Kalibangan, are evidence of an organized social order dating as far back as the fourth millennium. Excavations in the region have yielded ceramics, paintings and a host of textiles, firmly establishing the presence of a sophisticated and skilled people who had an appreciation and understanding of both the fabrication and use of handicrafts. Rajasthan has long been a feudal society, which encouraged the development of indigenous crafts. The modern state of Rajasthan came into being in the aftermath of the Indian Independence. It was created by the merging of over twenty-two princely states in a region still referred to by some as Rajputana, land of the *Rajputs* or 'sons of kings'. Even though court circles and governance have been dominated by the Rajputs and Brahmins, Rajasthan is largely inhabited by nomadic and semi-nomadic communities who have kept alive their culture and traditions.

Rajasthan is a timeless amalgamation of the old and the new. Contemporary attire in Rajasthan has changed little from the costume worn centuries ago, though, with the passage of time, new fabrics and styles have been introduced. However, distinctions based on ethnic groups are apparent even today, in clothes, jewellery, accessories and the manner in which garments are worn. The vivid colours, the array of prints and varied styles in the construction of garments are seen across diverse communities. Cotton is the most abundantly available fabric here and traditional techniques of ornamentation

3

1. (previous page): **Saraswati.** *Pallu, Bikaner. (12th century).* Hindu goddess of music, learning and intelligence. White marble with fine detailing of ornaments.

2. **Princess Chand Kanwar.** *Bikaner (1907).* The daughter of Maharaja Ganga Singh, she is dressed in an elaborate brocade ***ghaghra*** and ***zardozi*** blouse with a gossamer ***odhna***. She wears a ***bor*** and ***mathapatti*** on her forehead. Around her neck are a ***hansli*** with bells and ***kundan*** necklace. A ***bajuband*** is fastened on her upper arm. Her lower arms, from elbow to wrist, are covered in a variety of bangles and bracelets.

3. **Bronze Figurine.** *Mohenjodaro (2200-1800 B.C.).* A dancing girl wears a necklace and bangles on the upper and lower arms.

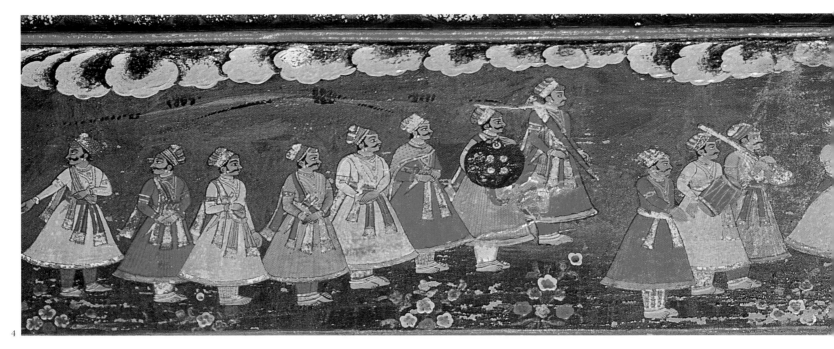

4

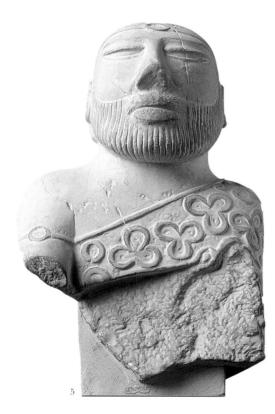

5

ments are worn. The vivid colours, the array of prints and varied styles in the construction of garments are seen across diverse communities. Cotton is the most abundantly available fabric here and traditional techniques of ornamentation like block printing, tie-dye and embroidery are still used extensively on both stitched and unstitched clothing.

According to Gerald Heard, an early twentieth century writer on the sociology of dress, costume may be classified into two main categories: *gravitational*, which depends on the natural fall of the materials made into clothing; and *anatomic*, which, irrespective of the natural fall, is based on cutting and shaping the garment according to the lines of the body. In India, everyday attire is usually a combination of both these forms. This is apparent in the dress of various communities all over India as it is in Rajasthan.

Ancient civilizations always used draped clothing in warm climates. Literature and art, over the ages, show that unstitched clothing was the preferred mode of dressing in India. Watson, in the nineteenth century, referred to these unstitched garments as "*...garments which leave the loom, ready for wear*". More recently, B.N. Goswamy, a noted art-historian, has defined them as the "*timeless*" Indian dress. The widespread use of draped clothing, however, does not mean that stitched costume or sewing skills were unknown. Historically, due to the scarcity of cloth, cutting and stitching was considered a waste of material, to which Indian thinking was opposed. The reason for the extensive use of unstitched clothing was its great adaptability and flexibility of application, making it quite comfortable for the Indian climate. Unstitched clothing was worn stylistically - whether it adorned the head, lower body or the torso. The flexibility of unstitched clothing made it possible to easily alter the structure, change form and widen the scope of its usage.

In India, draped clothing has been associated with the highest and most respected members of society, like the Brahmin priests whose attire is minimal and unornamented. Watson says: "*...strict Hindus still do not wear cut or stitched cloth as, for them, a garment made of several pieces of cloth sewn together represents defilement and abomination*". Unstitched attire is a mark of high status and sophistication. This is evidenced among Marvari men who wear the *dhoti*, an unstitched length of fabric, and gracefully carry one end of it in their hands.

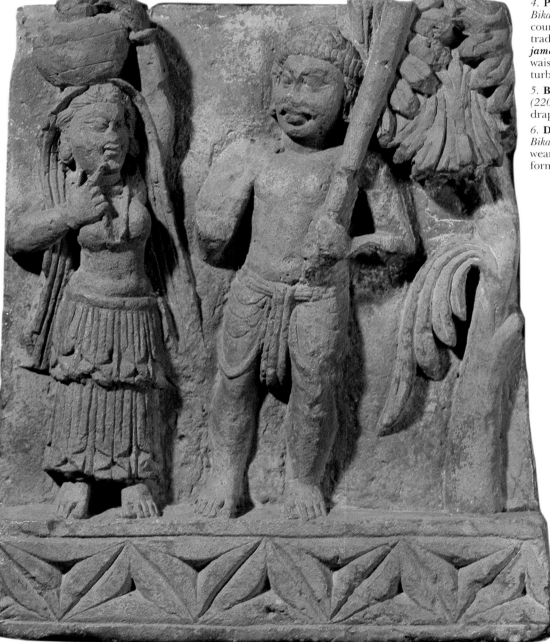

4. **Painted wall panel.** *Junagarh Fort, Bikaner (1587 AD).* The King and his courtiers are depicted wearing the traditional upper garment known as the **jama**, with **churidar** trousers and waistband or **cummerbund.** They wear turbans for headgear.

5. **Bearded King-priest.** *Mohenjodaro (2200-1800B.C.).* The statue displays a draped shawl with a trefoil pattern.

6. **Dan-Lila** plaque, terracotta. *Rangmahal, Bikaner (c. 320 A.D.).* The female figure wears a **ghaghra** and **odhna** and the male form is in a short dhoti and headdress.

6

The unstitched dress is rooted in the customs of the people, in the understanding of its versatility and in its convenience. Even today unstitched clothing is a part of everyday wear in both rural and urban areas. It continues to be used by people especially during festivals and rituals.

The long and complex history of India and the dearth of written records make it difficult to trace the origins of traditional attire. From the evidence of an impression of woven fabric and cottonseeds found at the Indus Valley site of Mehrgarh, cotton is believed to have been cultivated in northern India for more than 5,000 years. Spindles of wool and coarse cotton along with copper needles have been unearthed at Mohenjodaro and Harappa, cities of the Indus Valley civilization and in parts of what today is Rajasthan. The seals and figurines found here depict men and women wearing both draped unstitched garments and a variety of stitched tunics, cloaks, skirts and trousers in conjunction with jewellery. A statuette of a naked dancing girl shows her with hair drawn back, displaying heavily bejewelled arms and neck. Another figure of a bearded man, thought to be a priest, has him wearing a shawl with a trefoil pattern.

At Mohenjodaro's sister-city of Kalibangan in modern Rajasthan, cotton and linen cloth have been found together with precious metals and stones like turquoise, lapis lazuli and jade as well as effigies of men and women wearing elaborate headdresses. These indicate not only an evolved society but a prosperous one at that, carrying on a flourishing trans-national trade with its neighbours.

Costume finds expression in the writings of poets, philosophers, travellers and novelists. In India, the earliest evidence of such records dates back to about 1200 B.C. This is the time when the Aryans from Central Asia were migrating to the sub-continent. They were semi-nomadic and, so far, no traces of their arts and crafts have been found.

The *Vedas*, the first literary source from that period, provide a record of some of the earliest costumes worn in India. The Rg Veda mentions four

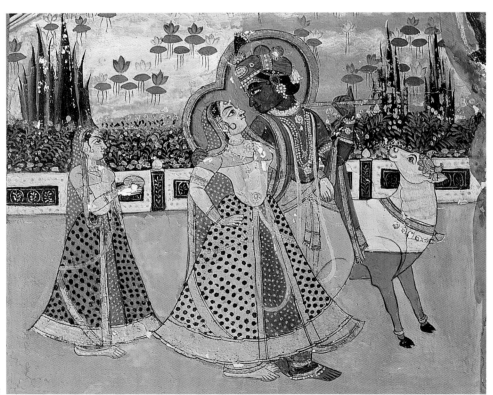

also wore an unstitched garment elegantly draped around the shoulders and thrown across the chest, much like the *angavastra* that is worn today. The turban was already becoming the most important item of a man's costume.

A community, which finds mention in the *Puranas*, the oldest Hindu text, dated between the third and the seventh century B.C., is race of the Rajputs, who lived, and still continues to live, mainly in Rajasthan. Believed to be directly descended from the Kshatriyas, the warrior and political ruler class of the Vedic India, they were first mentioned as the descendants of Rama, the hero of the epic Ramayana, and Krishna, the protagonists of the Mahabharata.

Over the centuries -- from the Mauryas through to the Gupta era and the dynasties that followed -- socio-religious systems were developed and a sophisticated culture evolved, that is relevant even today. The institution of caste became firmly established and the Hindu philosophy and laws were codified. Costume depicted in the paintings and sculptures of this period is a combination of both stitched and unstitched dress. Kings and queens and other members of the aristocracy, normally wore unstitched draped clothing, whereas their servants and attendants were shown wearing tunics, coats, trousers and waistbands. This denotes the high status that was accorded to the unstitched clothing in this period.

The figures found in the Gandhara region of the upper Indus Valley, the hub of the Kushana Empire in the reign of King Kanishka (AD 78-100), show marked Greco-Roman and Central Asian influences. An effigy of King Kanishka depicts him wearing a thick quilted tunic and trousers tucked into padded boots. It seems that though the draped clothing of earlier periods continued to be used, new concepts of dress had gradually started to fuse with the 'timeless' Indian wear.

Evidence from the Gupta period, which flourished during the fourth and fifth centuries, also demonstrates the continuity of these influences. Coins minted at that time represent that the Gupta kings dressed in tunics, trousers

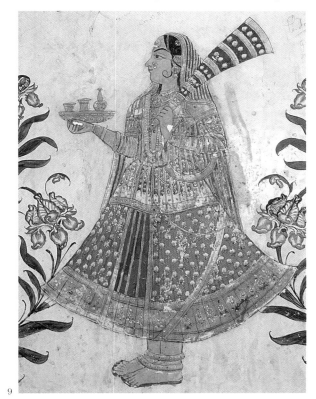

7. ***Radha-Krishna*** wall painting. *Jaisalmer Palace (late 12th century).* Radha is depicted in a traditional **kanchli,** block-printed **ghaghra** and **odhna**. In keeping with her stature, Radha's ornaments and costume are more ornate than those of her attendant. Krishna wears a **dhoti**, a **dupatta** around the neck and a richly ornamented turban. Elaborate jewellery adorns his neck, ear and hands.

8. **Statue of a girl in dancing pose.** *Jaisalmer (late 19th century).* Jewellery adorns her head, neck, arms, waist and legs.

9. **Fly whisk bearer**, *wall painting. Jaisalmer (12th century A.D.).* She is dressed in elaborate traditional ensemble.

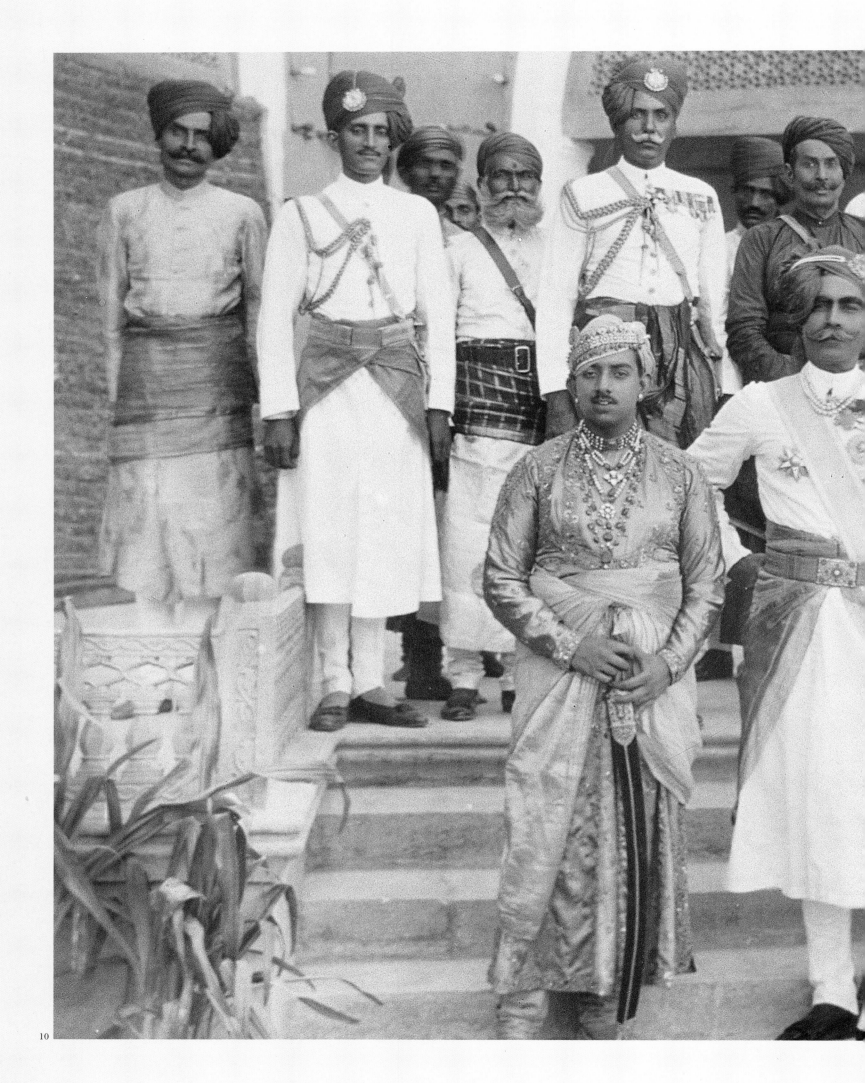

10

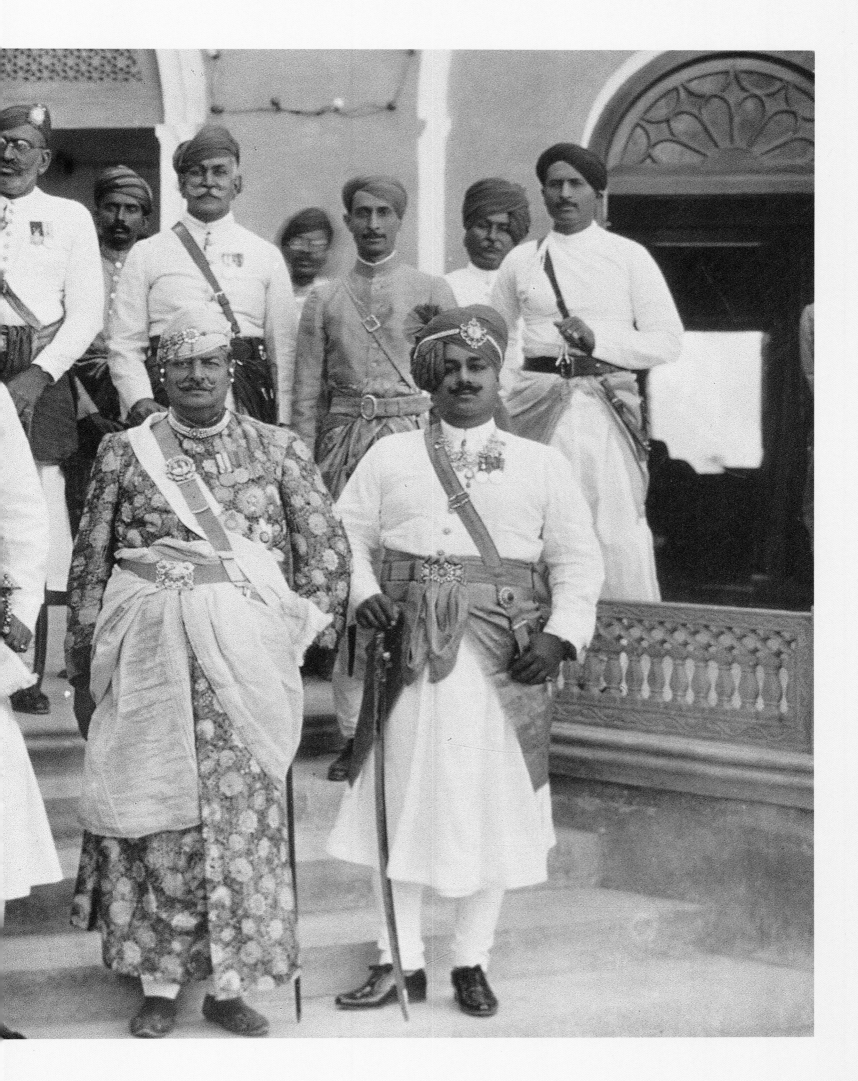

and high boots and the queens wore the antariya and the uttariya. A terracotta plaque from the early Gupta period found in the Rangmahal apartments at the Bikaner Palace portrays the Hindu goddess, Parvati, in a *lehanga*. Another showed Lord Krishna, wearing a dhoti. A number of fifth and sixth century statues attest to the widespread use of the *odhni* as an upper garment over the head. These draped garments are commonly worn in Rajasthan even today. Other artefacts found at Bikaner show evidence of bead and bangle making and other crafts. An eighth century sculpture from Bansi in Rajasthan depicts Kuber, the Hindu god of wealth, adorned with a silver necklace or *hansli*, an ornament still popular among the people there.

The end of the Gupta Empire, in the sixth century, left India's northern regions divided into small kingdoms. The Chinese pilgrim, Hiuen-Tsang, documented the costumes of north India in the seventh century. His writings describe stitched and unstitched clothing, including close-fitting jackets, quilted with ginned cotton and tied at the side, cloaks, pleated skirts, blouses and a *chandataka* (a type of petticoat). Al-Biruni (973-1048 AD) also recounts the use of turbans as trousers, probably describing dhotis.

The tradition of cave and temple paintings, another important source of historical information, illustrates the many different ways in which clothing developed in the various regions. Distinctions in the clothing of the Hindu and Muslim courts can also be gathered from illuminated manuscripts, which appeared in the fifteenth century. Though their themes were mostly religious, some, which dealt with secular subjects, furnish us with details of the daily life of that period and help recreate a picture of everyday clothing. The men in these manuscripts wear the antariya. Headdresses include turbans and jewelled tiaras, and the hair is long, usually knotted at the nape of the neck. Most male figures sport a beard and the royal prince is resplendent in a profusion of jewellery. The women are dressed in the antariya and uttariya, the latter, worn like a veil, is made of very fine material and also referred to as the odhni. Their hair is either worn loose, or tied in a bun, or braided, often adorned with flowers. They also wear jewellery on their neck, arms, ankles, and in their ears, with a *bindi* on the forehead.

The meeting of cultures always makes for an interesting synthesis, from which emerges new traditions. Where Muslims and Hindus were near neighbours, each influenced the other, particularly in the increased use of stitched clothing for men. The clothing of Hindu women, however, changed little and unstitched clothing remained more common among them. The practice of women in *parda*, previously unknown in India, spread quickly from the Muslims to the Hindus.

Indian textiles, the fine muslins, in particular, found great favour with the courts of the Delhi Sultanate. There are countless descriptions of royal workshops specializing in the fabrication of robes of honour for the courts. Since Islam prohibits the representation of living beings, the designs fashioned for the Muslim courts were primarily floral and geometric. Gold embroidery, sometimes encrusted with jewels, was also used in ceremonial dresses.

Although the Muslim influence on court and ceremonial dress was con-

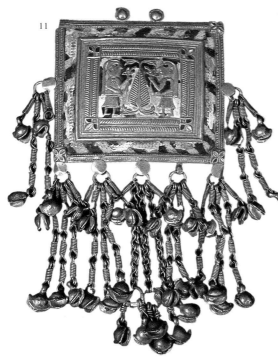

10. (Previous page): **Wedding party**. *Kota (1930).* Men in traditional finery at royal wedding of Prince Bheem Singh of Kota and Princess Shiv Kumari, daughter of Maharaja Ganga Singh of Bikaner.

11. **Silver pendant.** *Ajmer (c. 1920).* The medallion is worn on the neck.

12. **Rajput Princess.** *Bikaner (early 20th century)* Bai Saheb Sushila Kanwar of Bikaner wears a blouse over a **ghaghra** worked in heavy **zardozi** embroidery and an **odhna.** On her forehead is a **bor** and **mathapatti.** There is a **galapatti** around her neck. A **kundan** work **bajuband** with a suspended **talia** is tied on her upper arm and she wears a **gajra** on her wrist.

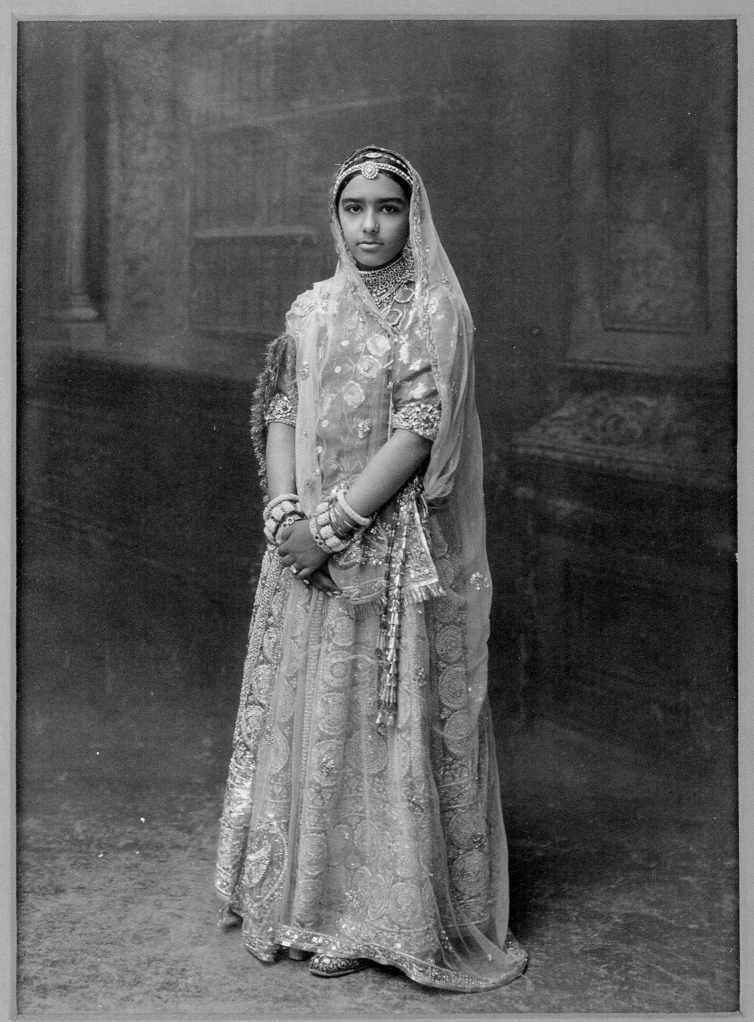

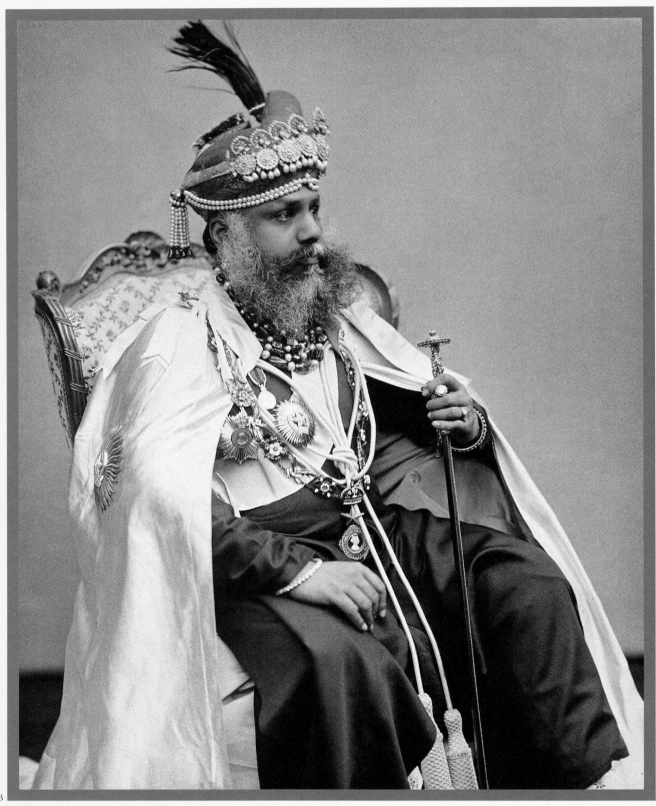

13

siderable, the Hindu, Buddhist and Jain paintings and carvings from the medieval period show that regular attire for the majority of the population was still, by and large, draped garments. The evolution of costume involved changes, mainly in the textile crafts and techniques, as they developed and became more diverse and sophisticated.

The rise of the Mughal Empire led to a degree of fusion of the Persian and Indian cultures in the regions where the Empire held sway. The Mughal rulers appreciated India's rich heritage, especially the sophisticated grasp of textiles and weaving, dyeing, printing and embroidery techniques. A priceless legacy of miniature paintings and chronicles from the Mughal court give us an insight into the dress codes of the ruling class. Several such accounts state that the Mughal Emperor Humayun, who ruled during the mid-sixteenth century, chose the colour of his robes in accordance with the movements of the planets and reserved a special treasure house in his palace to accommodate the royal textiles and garments. However, his clothes were significantly still not of Indian in origin.

His son and successor Akbar (reign: 1556-1605), who married a Rajput princess, desired greater integration with local Hindu rulers and promoted the wearing of local textiles and costumes, which were, in any case, better suited to the Indian climate.

Akbar's son, Jahangir, was a great patron of the arts and gifted ceremonial robes of honour, *khilat*, to visiting dignitaries. A few surviving garments of this period, such as the brightly-coloured silk brocade, Bikaner coat, probably woven in Persia and a white satin the early seventeenth century riding coat with chain-stitch embroidery, possibly from Gujarat, demonstrate the exquisite workmanship of the time. However, none of the elaborate jewelled clothes, worn by Jahangirs' son, Shah Jahan and his family, have survived. Francois Bernier, a French doctor visiting the court of Aurangzeb, son of Shah Jahan, in 1663, describes the emperor's turban of gold cloth, bedecked with diamonds and a huge topaz, his immensely liked pearl necklace and white satin jacket, embroidered with gold.

However, an eighteenth-century painting of the Hindu court of Bundi in Rajasthan, shows a strong regional identity, with no trace of Central Asian influence. The king, dressed in a white muslin *angarkha*, is on a terrace and with his wife, looks on, as other ladies of the court frolic in the gardens. The ladies are all dressed in traditional *ghaghra*, *choli* and odhni. Indeed, in the majority of the Hindu courts of Rajasthan, women preferred their own traditional patterns and draped, unstitched clothing. This preference continued during the Mughal era and throughout the British rule in India.

As Mughal glory began to fade, the British and European influences made their entry. A weak and divided land soon yielded to the British might and they came to rule India as the new masters. The vast majority of the Rajputana's princely rulers remained loyal to the British through the

14

13. **H.H.Maharaja Madho Singh II of Jaipur** *(late 19th Century).* This photograph was taken to mark his investure of the title, Grand Commander Star of India, Grand Commander Indian Empire. Royalty under British rule proudly wore costume decorated with British insignia. The Maharaja wears the cape of the Most Exalted Order of the Star of India.

14. **Sarpech.** *Udaipur. (19th century).* Turban ornament, silver with emeralds.

great uprisings over the partition of Bengal and during the First World War. Later, the people of the Rajput states, however, started to agitate not only for freedom from the British rule but also against the feudal orders of their princes.

Although the British brought some westernisation of dress, particularly to the princely courts and the workspace of the middle classes, most Indians resisted any change in their regular attire, which was, and is, closely related to the identity and culture. The independence movement came to be identified with a reversion to the traditional clothing and to the indigenous Indian textiles, thus making *khaadi* the symbol of the struggle for freedom from British imperialism and economic exploitation.

Independence bestowed on India a new national identity and political structure. However, religious and social structures were comparatively slow to change. Consequently attire, which in India, and particularly so in Rajasthan, is closely linked to these institutions remained, more or less, unaltered. Over the last few decades, however, sweeping transformations in social and economic structures and the introduction of new professions have added impetus to a change in the dress codes.

This changing attire reflects the demands of time, society and dominant paradigms of aesthetics. Today, the traditional costume of the Rajasthani women is in a state of transition. The women are opting for new fabrics, designs and accessories. This transition becomes more apparent among the affluent, the educated and those who, through their work or otherwise, have had exposure to a range of other influences. Similarly, men's costume has also seen a significant change. The Rajasthani man is often seen clad in the urban garb of trousers and a shirt, or, sometimes, in an interesting combination of both urban and traditional garments, teamed together, providing comfort and utility, while, simultaneously, preserving the cultural identity.

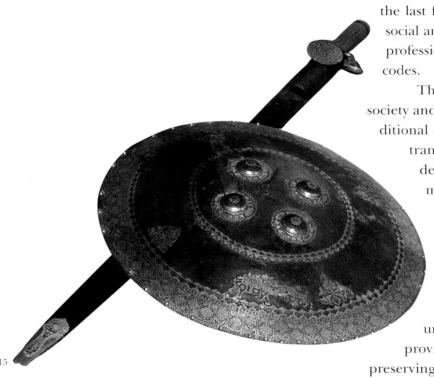

15

15. **Ceremonial sword and shield.** *Jaisalmer (19th century).*

16. **Maharawal Brij Raj Singh of Jaislmer.** The Maharawal is dressed in a silk brocade ***shervani***, ***pyjama*** and ***leheriya*** turban. His turban is ornamented with a ***sarpech***. Around his neck is a ***baleora***, an enamel and pearl necklace with seven clasp units decorated with gemstones. The necklace is attached to a central unit called ***dhukdhuki*** or ***jugni***.

Synthetic fabrics, which are easily available, durable and need little maintenance, have been slowly replacing cotton as the favoured choice of the consumer. Also mechanisation in the manufacture of textiles, jewellery, dyes and sewing techniques have accelerated this metamorphosis.

Education has played a key role in persuading people to discard aspects of dress that have lost their relevance and also to accept the newer, more pragmatic aspects of urban attire. The spread of education has also transformed traditional occupations, making work-specific costume redundant. This change is also dependent on the size of the region or village and its proximity to urban or industrial centres.

Popular culture is another important influence, which produces significant alterations in dress. A major source of inspiration is television and cinema. For Indians in remote villages, these are often their only exposure to glamour, fashion and trends. Similarly, magazines and newspapers are instrumental in changing mindsets and the way people dress. There is also a rising aspiration to an upward social mobility. Migration and urbanization are the other forces at play, which contribute to the modifications in traditional costume. However,

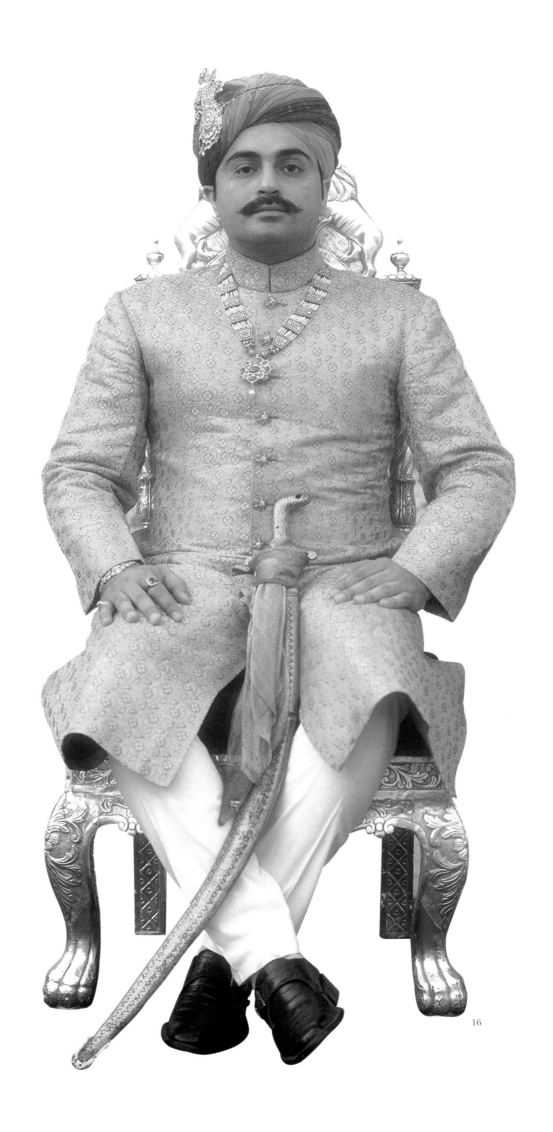

16

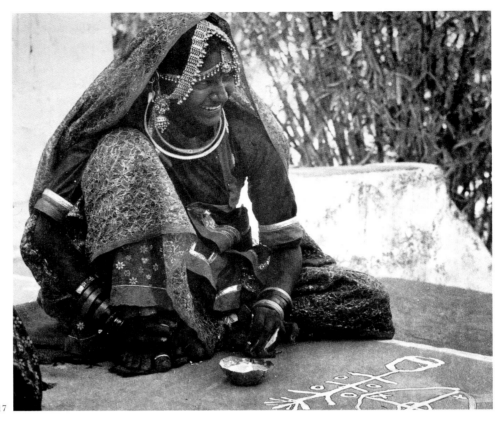

change has merged harmoniously with tradition, maintaining the spirit of Rajasthani dress.

Even though modern influences and contemporary needs are affecting dressing habits in some manner or other - traditional garments are still extensively worn in Rajasthan today. A historical record of costume, techniques of construction and significance of a particular dress code is of immense importance. It highlights the social and cultural changes that have impacted a people over the span of several decades. It is symbolic of changing lifestyles and social norms, of myriad influences that coalesce in the essence of contemporary India.

17. **Village woman ornamenting the mud floor with** *mandana Udaipur.* The woman in traditional ensemble of ***kanchli, ghaghra*** and ***odhna*** and silver jewellery practices the ritual decorative art which is symbolic of festivity and welcome.

18. **Sarpech.** *Bikaner (c.1890).* Turban ornament with ***kundan*** settings.

19. **Bangles.** Plastic, embellished with gold strips and small bells. These bangles are worn exclusively by married women.

20. **Woman in a pila odhna.** *Kishangarh.* The red and yellow draped garment, appliquéd with silver ***gota*** and edged with small bells indicates that she is the mother of a male child. The ***kurti-kanchli*** is worked with rickrack and ***gota.*** The gold nose-ring symbolizes her marital status as it does for all social groups.

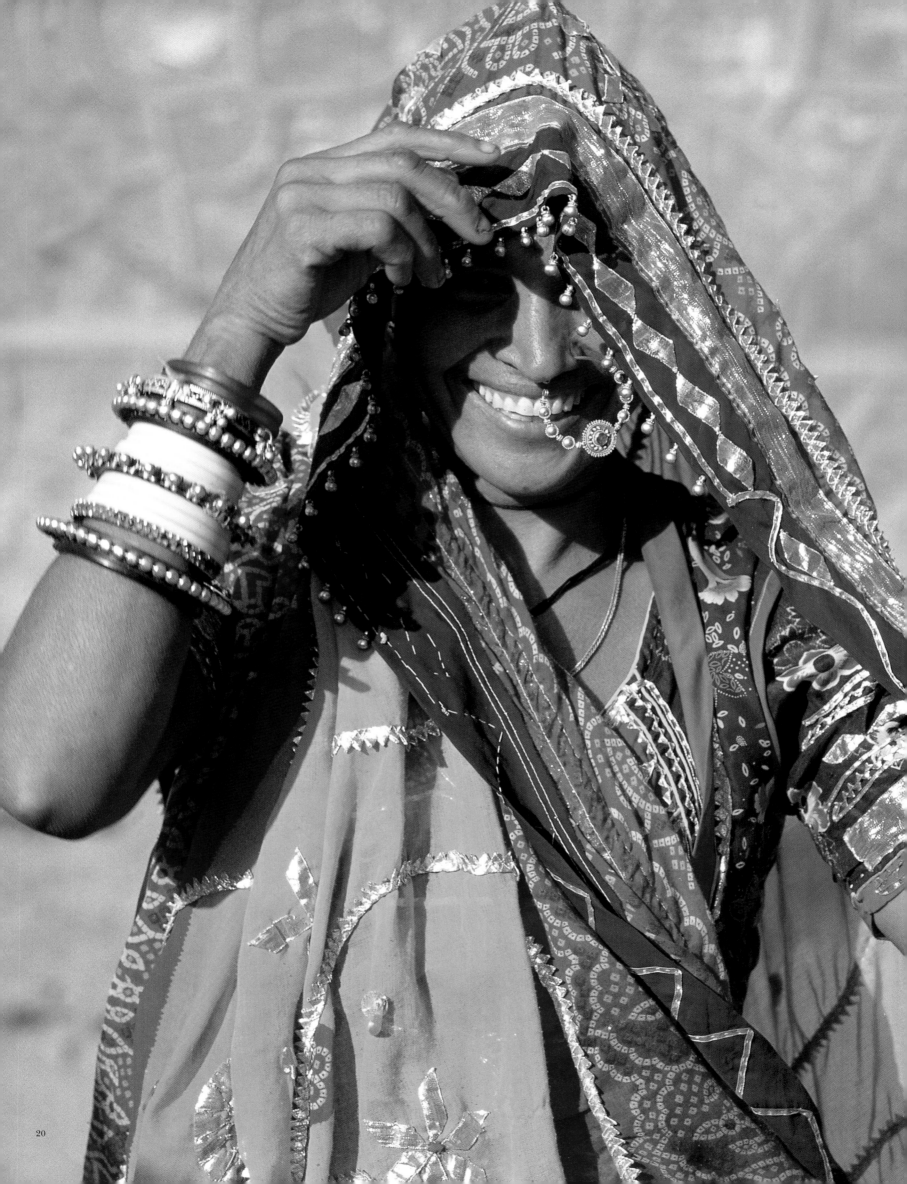

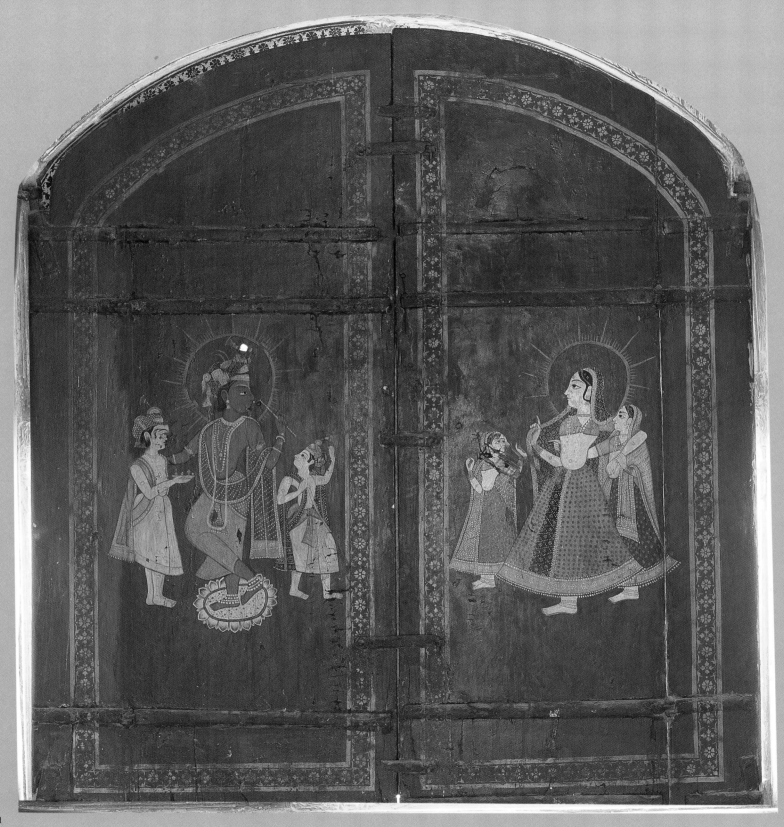

21

Timeless Textiles

"The cosmos, the ordered universe is one continuous fabric with its warp and woof making a grid pattern."

-- Rg Veda v

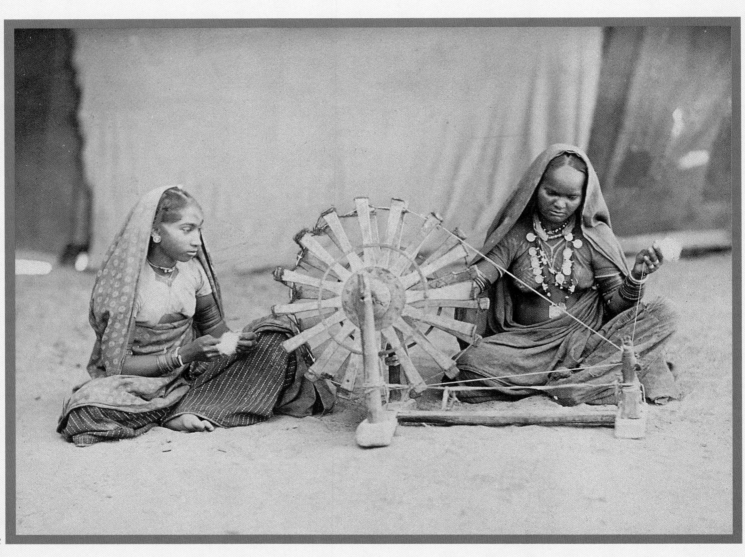

22

The ancient art of textiles uses fibres like cotton, silk and wool to create beautiful designs and textures. In Rajasthan, as in other parts of India, royal patronage encouraged master-craftsmen to create the finest fabrics. The remarkable diversity of traditional textiles, both in technique and style, has survived to the present day. It forms the basis for further innovation in pattern and design, defining the aesthetics of the region and representing the evolving social and cultural values of its people. This section explores handmade textiles, used primarily for apparel.

WEAVING

The art of interlacing yarns—the warp and the weft—has been practised for centuries and hand-weaving is probably as old as civilisation itself. Ancient terracotta spindles and fabric, excavated from the Indus Valley, attest to the familiarity of the crafts of spinning and weaving. The importance of weaving is highlighted in a verse from the Atharva Veda, where the rhythm of light and darkness spread over the earth by day and night is likened to the weaver throwing a shuttle on the loom. Weaving in India is predominately a cottage industry. In Rajasthan, the village weaver has been the community's sole source of fabric. The loom has held a vital position in the social, economic and cultural lives of the people.

With modernisation and industrialisation of the Indian textile sector, mill-made fabrics have made severe incursions into the village weavers' traditional stronghold. The unique beauty of the khaadi, *reza* and fine Mathania *mulmul* from Rajasthan, is becoming harder to find. Powerlooms are fast replacing handlooms. However, hereditary weaving-skills live on in many families and economically viable products like *Kota doria, pattus, durries, jajams* and pile carpets, in traditional and contemporary designs are still woven in the region.

Knowledge of the principles of weaving is found even amongst the most primitive people. The process itself is simple and consists of four basic steps, irrespective of the kind of loom, level of technology or the pattern to be woven. These basic steps are shedding, picking, beating and taking up and letting off.

Shedding is the process of raising or lowering the warp yarn by means of harness and heddles to form a shed. The weft is passed through this shed in a process known as picking. This is followed by beating, in which the weft or filling yarn is evenly packed (made compact) with a comb-like structure, called the reed. Once the primary motion is complete, newly formed fabric is rolled on to the cloth beam and fresh warp is released from the warp beam. This taking up and letting off is the secondary motion in the weaving process.

The village weaver in Rajasthan traditionally produces two types of cotton cloth, the *khaadi* and the reza. These are woven either as yardage or a finished garment, like an *odhna* or a dhoti. Using locally available cotton yarn, he plies his craft on the khaddi or pit-loom. Khaadi is made from hand spun yarn in a plain weave, while a basket weave is employed for the thicker reza fabric. These fabrics are then dyed and patterned, as required.

Pattu weaving

Western Rajasthan is famous for a special shawl or blanket, the pattu, a term derived from the word *patti*, meaning a narrow strip. This traditional wear is

21. (Previous page): **Radha-Krishna with attendants.** *Jaisalmer (c. 1880).* Pigment painting on wooden door.

22. **Village women spinning yarn on a charkha.** *Bikaner (c. 1910).* The women are in traditional costume and their hairstyles are typical of the desert region.

23. **Pattu, woven shawl.** *Phaloudi.*

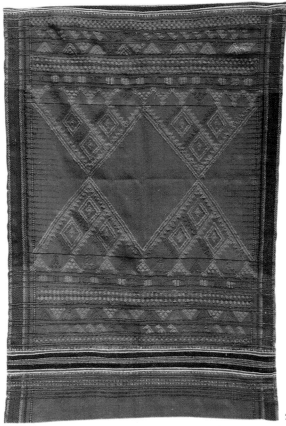

23

Textiles of Rajasthan

Hand block prints

Places for hand-block printing in Rajasthan are jaipur, Sanganer, Bagru, Kaladera, Jahota, Basi, Jayrampura; Jodhpur, Pipad and Pali; Balotra, Barmer; Jaisalmer; Udaipur and Akola in Chittorgarh District. Also at Nathdwara, Bhilwara, Chittor, Kota, SawaiMadhopur, Ajmer, Alwar, Sikar and Tonk.

Embroidery

Fine needlework by women is native to many areas in Rajasthan. The desert in the west are known for embroidery inlaid with mirror pieces and also pattu embroidery. Leather embroidery : District- Ajmer, Jodhpur, Pali, Sirohi, barmer, Jaisalmer.

Tie and dye

Tie and dye work, known as bandhej or bandhni is popular all over Rajasthan in the form of colorful odhnis and saffas.
Places for bandhejwork are-

Jaipur : Jaipur city, Bagru, Sanganer, kaladera
Churu : Churu city, Navalgarh
Kota : Kota city
Sawai Madhopur : Sawai Madhopur
Sikar : Sikar, Fatehpur, Rangarh, Lakshmangarh
Alwar : Alwar
Bharatpur : Bharatpur
Jhunjunu : Jhunjunu
Tonk : Tonk
Jodhpur : Jodhpur
Udaipur : Udaipur
Nagaur : degana
Pali : Pali, Padarali
Jaisalmer : Jaisalmer
Chittorgarh : Chittorgarh

Weaves

Weaving is a very basic

Chautan),
Pali (Pali.Nayagaon, Gundoj), Bikaner (Kolayat block and Bikaner block).
Pattu embroidery : Jaisalmer (Gomat, Chacha, Sam), Nagaur (Ren and Gojara).
Wool embroidery : Bikaner
Gota Kinari : Jaipur
Jat embroidery : Tonk
Hand embroidery : Hanumangarh
Patchwork : Barmer, Udaipur, Tilonia, Sawai

Wooden blocks

Used in hand-block printing are primary to the craft. Jaipur, Sanganer and Bagru- are the places to look for these skilled block makers. Purani Basti, Bagru Walo Ka Raasta and Jiyalal Munshi Ka Raasta in Jaipur. Nathdwara has the distinction of using sandalwood blocks, lending a fragrance to the printed fabric.

shawls and woollen lengths. Reza or radha - A basic cotton cloth is woven all over Rajasthan. Fine Kotadoria is at the other end of the cotton range.

Khadi

Khadi Gramudyog Bhandars: existing at town, village, tehsil and block level are an outlet of reliable and reasonable utility items. Institution was set up by Mahatma Gandhi during India's freedom movement. Blankets, woollens shawls, suit cloth, jerseys, sweaters, readymade garments and namdas(rugs from wool waste), cotton khadi material and readymade garments, towels, khadisilk and kotadoria saris, durries, jajams floor coverings, bedspreads, quilts and now polykhadi material (lighter and more lasting with a synthetic mix) and readymades. Also handmade paper, cotton, poly-cotton and woollen khadi is woven all over Rajasthan.

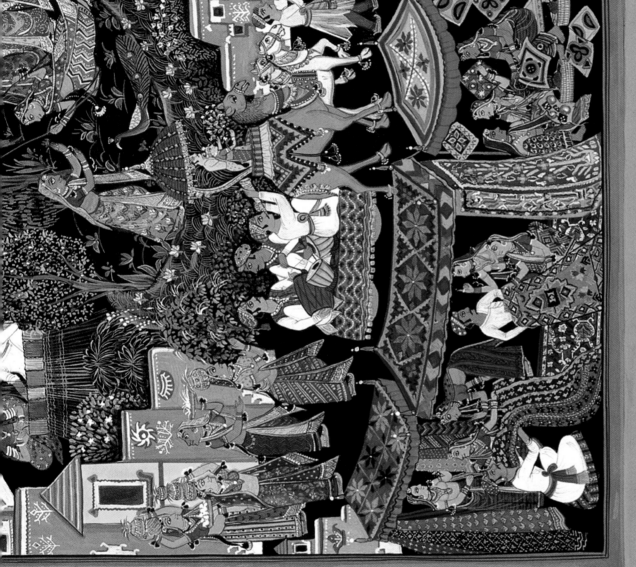

Fairs and festivals

Rajasthan abounds in fairs the year round. These are the main outlets for crafts in the particular area- be it terracotta, shoes, durries, woodwork, stone carving, cotton and woollen fabric and silver jewellery.

Pushkar Fair- Woollen shawls, cotton fabric, durries and leather items; Baneshwar Fair- tribal jewellery and silver jewellery; Ramdeoji Fair- Silver jewellry and horse made out of rags for offerings; Khatu Shyamji Fair fabric; Nakki Lake Fair- silver, textiles and stone carving; Jannashthami Fair at Nathdwara- Silver and pichwais; Barmer and Jaisalmer Fairs- woollen fabric, jadpattis, terracotta; Gogamedi Fair- Fabic; Kamimata Fair at Deshnok- wood carving, bandhej and woollen fabric.

Fairs in Bikaner, Shekhawati and Chittorgarh area offer woodwork.

Teej and Gangaur, celebrated and all over Rajasthan, are special at Jaipur. Main crafts at the melas are tie and dye, lac bangles and terracotta. Shoes sold all over are specially good at Bhimmal in jalore District, Jobner in Jaipur District, Jaitaran and Ninaz in Pali District.

Map courtesy Dastkari Haat Samiti with modified text.

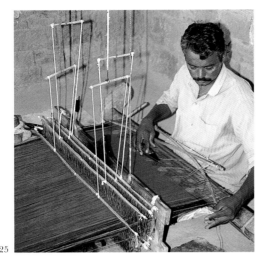

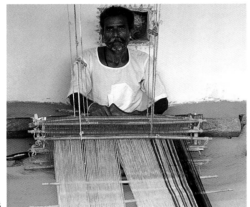

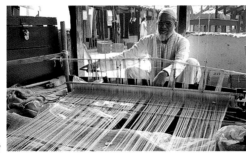

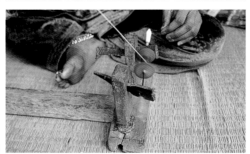

mostly seen in Jaisalmer, Barmer and surrounding villages. Camel and sheep wool, available in natural colours of cream, brown and black are used to weave the pattu. Of late, however, the introduction of synthetic dyes and cotton fibre has added colours like bright red, saffron, blue, green, pink and orange to this time-honoured palette.

The fabric is worked in a twill weave on a pit loom and myriad patterns are created through the techniques of interlocking and extra weft-figuring. In the warping, vertical warp bands in contrasting colours are placed on the sides of the loom and the interlocking technique is used to get a pure colour on these bands. A bobbin, which carries a weft in the same colour as the contrasting band, is used to weave the limited sections of the bands.

Extra weft-figuring creates an embroidery-like effect on the loom. The extra weft is wound on a small stick that is passed between a minimum of two and a maximum of twelve picks. The weaver lifts the warp yarns by hand to insert the extra weft yarn.

The local Meghval community specialises in creating a variety of beautiful pattus like the *baladi* check, *hiravali* pattu and *kashida* pattu. The two other famous designs from this region are the *bhojsari* and *malani*. Weavers, elsewhere, employ the same process to make a woollen dhabla and a cotton *saadi*, which is the lower garment of the Gujar and Kumhar women.

The motifs have a geometric orientation and are inspired from household articles and the wall and floor paintings, called *mandana*. A combination of triangles, diamonds, squares and other geometric forms in stark contrast to the plain background give the pattu a visually striking effect.

Each pattu has a characteristic join in the centre. This is because the piece that is actually woven on the loom is of narrow width. Two strips are joined to make a pattu, which is worn by both men and women. The bright, colourful pattu is warm and long enough to wrap around the body. Farmers, shepherds and others use it extensively in the rural areas.

Masuriya or Kota Doria

Typical weaving villages in Rajasthan, like Khaitoon, Siswali, Sarnsan and Mangrol have at least one loom in each household. These may be simple pit looms, handlooms or powerlooms and are generally set up by the weavers themselves. The village Khaitoon is famous for the production of one of the most exquisite Indian textiles, *masuriya* or Kota doria. Khaitoon lies fifteen kilometres from Kota,

24. (*Previous page):* **Textile map of Rajasthan.**

25. **Pattu weaving on a pit treadle loom.** *Phaloudi.* Multi-coloured yarns are used as extra weft to create geometric motifs.

26. Bands of solid colour on the borders are achieved by using an interlocking technique with multiple shuttles.

27. **Pit treadle loom.** The gossamer light **Kota doria** fabric is woven on this loom.

28. **Reeling silk-cotton yarn on a bobbin winder.**

29. **Kota sari.** Traditional colours for these fine saris are off-white and gold. Fine quality yarn is used to weave a textured cloth, ornamented with gold **zari**.

from which it gets its modern name, Kota doria. All communities in Rajasthan wear odhni, *pagadi* and dhoti made of masuriya. Light and translucent, it was favoured by royalty for its elegance. The masuriya fabric has evolved from pagadi to odhni to sari, and while the masuriya odhni and pagadi are still worn, it is the Kota sari that is most popular and, hence, more commercially viable.

Reeling, dyeing, sizing, warping and finally weaving, using a *jaala* attachment are the processes that go into the creation of this beautiful fabric. The first four steps are for the preparation of the silk yarn, which is of two kinds. The thicker variety is made up of 80 counts whereas the finer yarn is of 120 counts. A hand-turned spindle is used for reeling. In earlier times, dyers living in Khaitoon dyed the yarn, but today easily available mill-dyed yarn is mostly used. The yarn is refined and strengthened by the process of sizing. It is treated with a solution made from boiled wild onions, which also adds lustre. In the warping stage the yarn is arranged on the loom in a specific length and width and pure gold and silver thread are worked into the design.

The simple pit treadle loom utilized by the weavers of Khaitoon, is fitted with a crossbeam, attached with wooden pegs. These pegs raise selected warps so that extra weft can be inserted to create the exquisite designs that are characteristic of this material.

In fact, the masuriya has some distinguishing features that set it apart from other weaves. The first is the use of very fine quality yarn. The second is its distinctive square *chaukaris* locally known as *khat*, which are produced by weaving. The outer check is constructed from the thicker yarn and the finer yarn provides the inner texture. This makes the cloth, with its little protrusions, uneven and the artisan boasts that it is this quality that gives the cloth a better—if not perfect—drape. Pure *zari* is woven into the borders and end piece for ornamentation.

Earlier, white and beige were preferred, but now the craftsmen have added variety to colour, motif and design, in keeping with changing sartorial tastes. The motifs on Kota saris seem to have been adapted or borrowed from the other textiles like the Banarasi sari. *Ambi, gamla, bel, svastika*, and *pan* are commonly used, as well as animal shapes, like the peacock and the elephant.

The plain check is woven in single colour or with a multicoloured warp and weft. This may be further embellished with zari work all over the sari in consonance with the self-check of the fabric in a mesh effect. The extra weft may be of silk yarn or zari. Sometimes, tie and dye and other printed designs may also be incorporated.

Previously the masuriya fabric was woven from cotton fibre but in the last few decades, silk yarn has been introduced into the weave. This new cotton-silk blend is also known as masuriya. Today, pure silk masuriya saris are produced and are extremely popular for their gossamer quality.

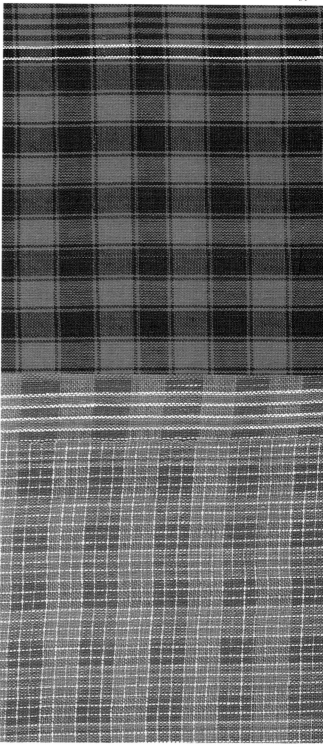

30. **Silk *odhna*.** This diaphanous wrap is part of the Rajput bride's ensemble and is worn over a satin **kurti-kanchli** and **ghaghra** in the same colour.

31 & 32. **Woven cotton *Saadi* design.** *Ajmer.* Jat and Gujar women wear checked fabrics like these as their lower garment.

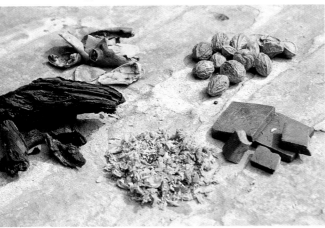

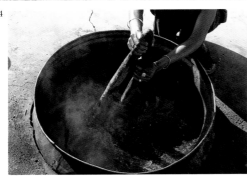

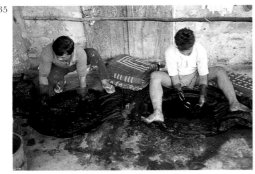

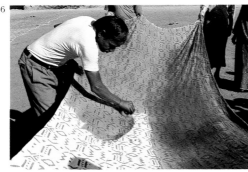

33. Raw materials from which natural dyes are extracted. The colours dyed using these have subtle tones. The dyes can be *substantive*, which are applied on their own or *adjective*, applied using a mordant. Shown here (clockwise) are: *pomegranate rind, harda, katha, daabri-ka-phul, bark of the neem tree* and *bark of the ratanjyot tree.*

34. Copper vessel with alizarin dye. Bagru. Alizarin is dissolved in hot water and fabric treated with mordants is immersed in it. Colour develops in the treated sections - red, in the areas covered with Alum and black where iron is applied.

35. Indigo dyeing in underground vats. Bagru. The Indigo is fermented and deoxidised in underground pits. Fabric is dipped in the solution, which on exposure to air, oxidizes, to impart a rich blue shade.

DYEING

"The village textile tradition, rooted in customs and ritual, was based on a deep comprehension of the nature of mass and volume in which depth of colour was a vital dimension."

-- Pupul Jayakar

Throughout history, colour has held an important place in Indian culture. People have used it to mark a change of mood or season. It has deep significance in religious ceremonies and festivals. This vast spectrum of colour on clothing and materials is accomplished through the process known as dyeing.

Dyeing is the technique of colouring fabric and yarn by immersing it in a solution of colouring substance obtained from vegetable, animal or mineral sources. As a consequence of the vital status of dyeing in the Indian tradition, almost unrivalled skills were developed, especially in the art of fixing colour on fabric. Pupul Jayakar says of the craftsman's understanding of colour:

"A superlative knowledge of colour chemistry and of the rich resources of madder dyeing gave to India's coloured cloths a quality of growth and maturing, in which the colours ripened in the sun. The sun was a catalytic agent which constantly acted and reacted upon the minerals, vegetables and water, so that colour came to life in response to the sun's rays; the fading too was like flowers that age in the sun, giving back their colour to the energy that gave it birth"

The knowledge of mordants was well-known to the dyers of the Indus Valley Civilization. Mordants are chemical agents which react with a fugitive dye and assist in fixing it to the fabric. In Rajasthan, through the centuries, communities specialized in the production of specific crafts. This has led the dyers of the region, *rangrez* or *neelgar* as they are called, to establish a special place in the social order. Many villages or their surrounding areas are famous for their local textiles and textile designs.

Rajasthan also has a wealth of dye-yielding plants and the waters of its rivers seem to have special properties that bring out the vivacity of the colours in which the materials are dyed. Each region in Rajasthan has its distinct hues, which are rich and unique because of the quality of water and processes used. Traditionally, dyeing and printing centres were located near a river or some other source of water. The final outcome in shades of colour depends on various factors, like exposure to the sun, hardness of water, and whether it was still or running water.

The fabric that is used for dyeing is greige cloth (unprocessed material, straight from the loom) and in the traditional dyeing practice, is usually first treated with a *telkhar* emulsion. This emulsion is prepared with oil, *khar* or river residue and sheep or goat dung. It is applied to desize, bleach and make the fabric soft and absorbent for further treatments.

Harda powder or myrobalan tannin, a chemical agent that also acts as a mordant, is mixed with water to prepare the *pila karna* solution. This is used to treat cotton fabric, which has an inherently low affinity for natural dyes. The harda treatment improves the cloth's affinity to the dye and improves dye-fastness. The fabric is soaked in pits containing this solution and beaten for even penetration. This imparts a pale yellow colour to the fabric.

Although chemical dyes are generally employed in large-scale textile production, many artisans still retain traditional methods and materials. Natural

materials commonly used for dyeing are alizarin, myrobalan, iron filings, jaggery, turmeric, alum, *kesula* flowers, indigo and pomegranate rind. Of these, the most popular are alizarin, indigo and pomegranate rind.

Alizarin is a red dye, most extensively seen on textiles. One of its natural sources is the root of the madder plant, *rubia tinctorum*. The alizarin extracted from this root combines with alum to produce a rich red colour. Both natural and synthetic alizarin is used on fabric, which is dyed in a *tamda* (copper vessel). The required amount of alizarin is dissolved in water to obtain the desired shade of red. The fabric is then immersed in a heated dye bath. As the temperature is raised, a red colour develops in the areas printed with *begar* paste (alum mixed in gum, which acts as the mordant). Subsequently, the fabric is washed and dried before the next treatment.

Neel or Indigo, the blue dye, is also frequently used in the region. It is extracted from the leaves of the indigo bush, *indigofera tinctorum*, although synthetic indigo is now readily available in the market. As both natural and synthetic indigo are insoluble in water, the dye is first made soluble by reducing it through treatment with an alkaline solution. The fabric to be dyed is dipped in the cold solution and on exposure to air oxidizes to a blue colour. Extended and repeated treatment in the dye bath produces a fast, dark blue. A rich yellow colour comes from the dye known as *nashphal*. This is obtained by boiling dry green rinds of the pomegranate fruit. Another yellow dye is the pomegranate solution produced by boiling pomegranate rind, turmeric and oil in water. The technique of application is called 'potna' which literally means 'to smear'. The solution colours the fabric to a rich yellow.

The colour, black, comes from a dye produced by fermenting scraps of iron with jaggery. This, when thickened with a gum solution, attains a suitable viscosity for printing and the paste is called *syahi*.

Each of these dyes combined with the many different dyeing and printing techniques creates the variety of designs and colours admired in the everyday life of the people of Rajasthan.

Bandhani or Resist-Dyeing

Bandhani or tie-dyeing is one of the simplest techniques of resist-dyeing used to pattern fabric and is prevalent throughout the Subcontinent. It ornaments a varied range of textiles in Rajasthan. This simple method of binding individual sections of cloth to shield them from the dye has been raised to the level of an art form by the skilled artisans of Rajasthan and is popularly known in

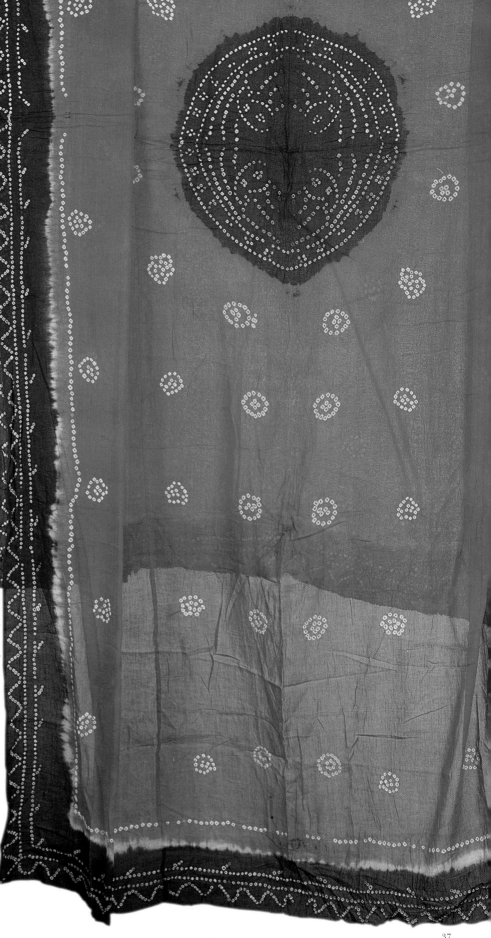

37

36. **Daubing fabric with a pomegranate rind solution.** The fabric is first printed with mud resist. Dye solution is applied with a sponge to produce a bright yellow colour on the unresisted areas.

37. **Bandhani chunri.** *Sikar.* Employing the *bandhani* technique the fabric is repeatedly resisted and dyed to produce several colours - white, yellow, red and brown. The red veil, known as a ***chunri***, symbolizes the essence of womanhood and is worn by married women.

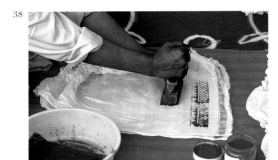

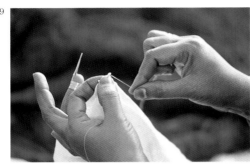

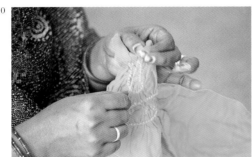

The *bandhani* process. *Jaipur.* Designs are created by selectively tying and then dyeing the fabric. Resisted areas retain the base colour and the unresisted portions absorb the dye.
top to bottom:

38. **Chapai:** In the first stage, a wooden block dipped in ***neel***, a fugitive dye, is used to print the pattern to be resisted.

39. **Bandhana:** A woman uses untwisted cotton thread to resist the outlines of the design. She uses a brass implement called a ***nua*** to lift the fabric.

40. The fabric has been immersed in yellow dye and is now tied again to resist the yellow areas. The process is repeated until the desired number of colours is obtained.

41. **Gujar woman.** *Kishangarh.* The traditional red and yellow ***pila odhna*** proclaims her status as a mother of a male child.

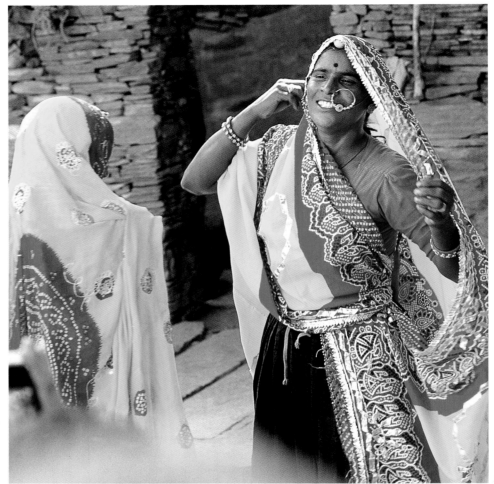

India as bandhani or *bandhej*; derived from the verb *bandha*, to tie. Hence, this process is also called 'tie and dye'. The design is achieved by applying a mechanical substance that acts as a resist, to prevent the dye from colouring selected portions of the fabric.

Although it is difficult to pinpoint a definite period of its origin, the earliest references to bandhani are obtained from the frescoes of the Ajanta caves, dating back to the 6th-7th century A.D. where the paintings show women wearing bodices and skirts with resist-dyed designs. Literary references to bandhani also appear in the poems of Banabhatt, the court-poet of King Harshavardhana in the 7th Century A.D. The poet describes the king's sister Rajyashri's odhni as being dyed with the bandhani process.

The bandhani carries, perhaps, the deepest cultural resonance for the people of Rajasthan, especially its women. Much celebrated in folksongs throughout the region the tie-dyed *chunri* or odhni, the veil worn over the head and shoulders, symbolizes the various states of womanhood and marriage.

Bandhani, on fine muslins, georgette and chiffons, in exclusive colour schemes flatters the sartorial tastes of the wealthy urban community. The village woman in Rajasthan preserves the traditional choice of colours and patterns, which, untouched by fashion, are derived from a time-honoured community-based aesthetic.

Different types of tie-dyed fabrics are worn to mark annual seasons and festivals. The special status accorded to bandhani textiles is also reflected in their customary use as offerings at shrines of various deities in Rajasthan.

Design variations are seen in different regions. The villages around Barmer and Jaisalmer produce some of the simpler bandhani designs,

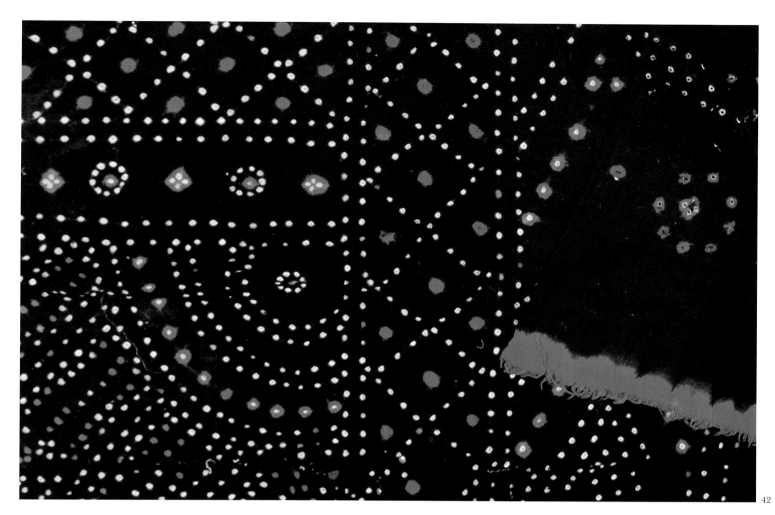

whereas urban centres such as Jaipur, Jodhpur, Sikar, Kota, Ajmer and Alwar create complex and sophisticated patterns. Although there are several band-hani centres throughout Rajasthan, Jaipur has, to date, retained its reputation as a leading bandhani centre, both for the chunri and the *leheriya*.

In essence, this design process involves tying the fabric and then dyeing it. The areas that have been resisted retain the base colour of the fabric and the unresisted areas absorb the colour of the dye. The process is repeated until all the desired colours are obtained on the fabric.

The fabrics employed range from fine voile, coarse cotton, silk, georgette and chiffon. The cloth is first washed to remove any starch or impurities and to improve its softness and absorbency. After this, it is bleached and the patterns are created.

Traditionally, the artisan drew all the patterns by hand and there was no limit to his imagination. These days, however, wooden blocks, dipped in fugitive dyes like neel or *geru*, are employed to print the design on the fabric. The dyer performs this process known as *chapai* or *likhai*.

The next step in the process is the tying of those areas in the design, that are to be resisted from the dye. Women, known as *bandhanari*, perform this task, using untwisted cotton thread for the tying. The thread is sometimes further coated with wax, which helps to prevent dye penetration in the tied areas. To facilitate tying and achieve symmetry in the pattern the fabric is often folded in two or four layers. The folded material is raised with the nail of the little finger, which is grown especially long and pointed, or with a brass nail called *nua* or *nolia* worn over the finger. The thread is then wrapped tightly around the raised fabric. This creates a simple fine dot (*bundi* or *bindi*) that

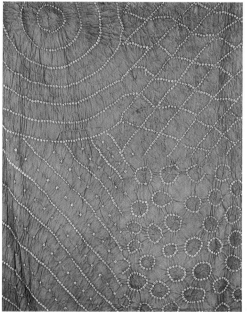

43

42. **Odhna.** Woman's veil. Tie-dyed cotton. The palest colour is resisted first and the shades grow progressively darker with each successive tying and dyeing, producing this multi-coloured effect.

43. **Odhna.** Woman's veil. Tie-dyed cotton. Placement of the **bindi** or dot, the basic motif in **bandhani**, creates the design.

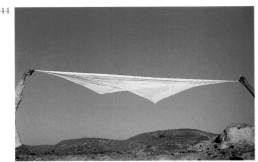

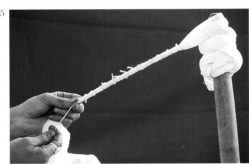

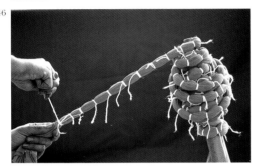

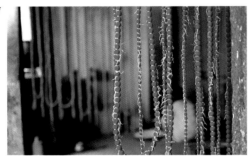

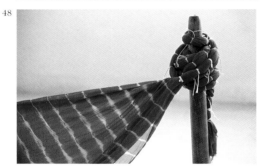

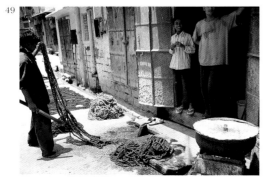

forms the basic motif of this design. Several variations in the method of tying produce different designs. For instance, if the tip of the bunched cloth is not resisted, the circle acquires a coloured centre. Another technique is *tritik* or stitch-resist tying whereby the design is outlined in running stitch and gathered by drawing the thread taut, thus obtaining the resist effect.

After the tying is completed, the dyer may dab certain delineated areas with colours. This process is called *tipai* and before further dyeing takes place, these areas are once again resisted. The process of dyeing begins after the first tying. Dyeing is begun with the lightest shade and with each additional tying a darker colour is applied. The number of times the tie and dye process is repeated depends on the final effect desired. Typically the number of colours employed could be anywhere between two (used for a red chunri) and seven (for a *samudralehar* or ocean wave pattern).

Leheriya

Leheriya is another popular variation produced using the basic technique of tie and dye. The term is derived from the Hindi word *lehar*, meaning 'wave'. The dyer creates wave-like patterns by producing diagonal stripes on the fabric. This process is practised in Jodhpur, Jaipur and Udaipur. The leheriya was patronised in the nineteenth and early twentieth centuries by the Marvari merchant class of Rajasthan, who wore turbans of brightly coloured leheriya fabric.

In order to create diagonal stripes, the craftsman uses a special method of resist-dyeing, wherein the material—generally a turban or sari length—is rolled up diagonally across opposite corners and tied tightly at intervals before the actual dyeing process begins. Delicate, light fabrics such as thin cotton voile, fine silk and chiffon are preferred, as they allow the colour to penetrate through the rolled cloth. The fabric is wrapped around a wooden pole, usually while it is still wet, though it may also be in a semi-dry or dry state. The thread that ties up the cloth acts as a resist, yielding a pattern of diagonal stripes after dyeing. The thickness of the thread and the distance between the ties may be varied to obtain stripes of different widths.

The dyer's extraordinary skill allows him to create multi-coloured stripes after the first dyeing by opening up some sections of the rolled fabric, leaving other sections still bound, and tying up fresh sections, then dyeing the whole or part of the fabric in a different colour. A checkered pattern, is called *mothra* and is produced by the intersecting of diagonal stripes. To achieve this, the fabric is unrolled and then rolled up from the opposite corner. The

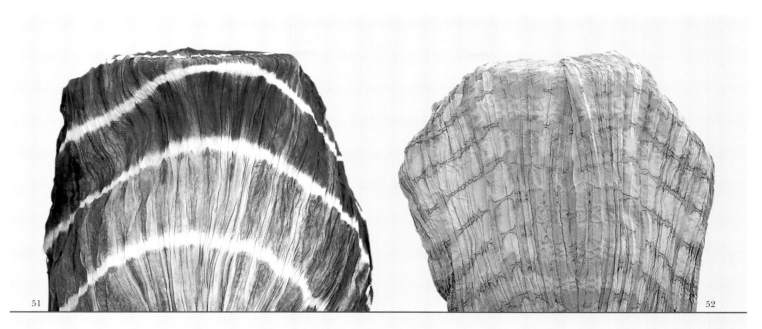

51 52

53 54

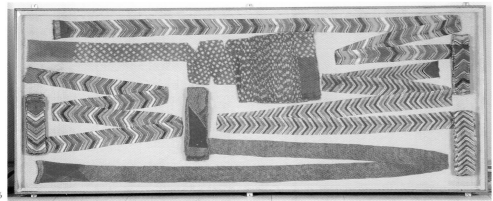

55

process of tying and dyeing the cloth is then repeated.

An astounding variety of leheriya is produced using this simple process. A *panchranga* (five-coloured) design is considered the most auspicious, since the number five has a special position in Hindu mythology. Another beautiful pattern, *satranga*, flaunts the seven colours of the rainbow. Stripes that follow in one direction and colour are known as leheriya, while, when diagonal stripes intersect at right angles to form checks, the pattern is known as a mothra. *Gandadar, pratapshahi, rajashahi, samudralehar* and *salaidar* are all variations of stripes created by this technique.

The *leheriya* process. *Top to bottom:* The fabric is resist-tied diagonally and dyed to produce wave-like patterns.

44. The fabric is stretched and rolled diagonally.

45. Cotton thread is used to resist the rolled fabric wrapped around a wooden stick.

46. After immersion in pink dye the fabric is tied a second time. Repeating the tie and dye process produces a multi-coloured effect.

47. Tie-dyed fabric twisted into ropes, washed and hanging out to dry.

48. Opening up a single coloured *leheriya*.

49. A tied *leheriya* is dyed on street in Jaipur.

Leheriya designs. Patterns are produced by variations in the resist techniques and repeated dyeing with different colours.

50. *Odhna.* Wrap-resist dyed *leheriya*.

51. *Leheriya* fabric with single resist, dyed in natural indigo.

52. *Leheriya* with single resist. This is a scented fabric, dyed with the natural dye ***malyagiri***.

53. *Mothra.* Checkered pattern. A multi-coloured effect is produced by repeating the tying and dyeing. Three natural dyes, ***pomegranate, henna*** and ***turmeric*** have been used here.

54. *Leheriya* fabric dyed in Indigo and Rubia tinctoria.

55. Designs in the tie-dye technique.

COLOUR SYMBOLISM

The use of colour is widespread in every aspect of attire and ornamentation. This extensive usage has important cultural, religious, and climatic associations. Each colour embodies complex and significant connotations in that particular time, space and region. It is also derived from India's ancient dyeing history and techniques. India has rich resource of madder dyeing and it gave to its coloured textiles a maturity of colours that ripened in the Indian sun. Hence any attempt to understand the attire of the people of Rajasthan would be in complete without understanding what each colour denoted and the chemistry associated with it.

In India colours are filled with emotional content and rich association. They are an important means of conveying moods, seasons, religious values, customs and ceremonial occasions. Rituals and ceremonies are touched by varied hues, each representative of particular traditions. The dyeing tradition in Rajasthan is ancient and its is visible in the many hues and maturity of the colours that are found in the attire of its people.

Even today, colours in Rajasthan are used to identify communities and social status of its wearer. Apart from this of course colours have aesthetic, psychological and biological connotations.

The colours are divided into two categories depending on their end usage. *Kachcha* colours or temporary are used among unmarried women and married while the widows only use the *pakka* or permanent colours. Kachcha thus represents a temporary marital phase, with widowhood being the permanent phase of a woman's life. Thus the life of a woman changes from maidenhood to marriage and then to widowhood.

Red, yellow, parrot green, and saffron are some colours which are kachcha, while the pakka colours are grey, brown, dark green, dark blue and maroon.

Red is a popular colour and is considered auspicious, denoting well being and joy. Traditionally it is obtained from the root of the manjit plant and is synonymous with blood or the force of human life. Red is also a sign of a woman's marital status. The married woman used red *sindur*, on her forehead as embellishment and also wears a red chunri. It also has erotic connotations and is used at the time of marriage.

White on the other represents purity and is considered an embodiment of light. It is also a very male colour and is worn extensively by men. Married women never wear any garment, which is completely white. They often wear a combination of red and white which is representative of both the masculine and feminine. White as such is a negation of splendor and signifies simplicity. However men use pure white only at the times of death. Priests use white for religious ceremonies, and may sometimes even use it in conjunction with another colour.

Kesariya, the colour of saffron and other shades of yellow, are extensively used in the attire of both men and women and have since the earliest times been regarded as auspicious colours. These are obtained from the precious saffron leaves and in earlier times was an expensive and rare colour. The Rajput made much use of kesariya in their clothes. The colour was used in their wedding robes and was also associated with the brave warriors that died fighting on the battlefield. When defeat was imminent, the Rajput warriors would don saffron robes and ascend the battlefield. They termed this as *kesariya karna* or a brave deed. Marriage was also termed the same especially when it resulted in alliances to protect land and kingdoms. Yellow is a part

56. Red is an auspicious colour and is used for the ritual of marriage.

57. **Gangaur procession.** *Jaipur.*

58. **Red flags outside a temple.** Red is prominently displayed at temples of deities.

59. **Gangaur in all her finery.** Married women pray to Gangaur, consort of Lord Shiva who is worshipped for the longevity and preservation of conjugal harmony.

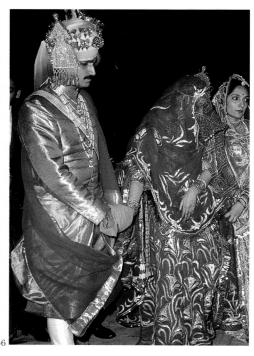

56

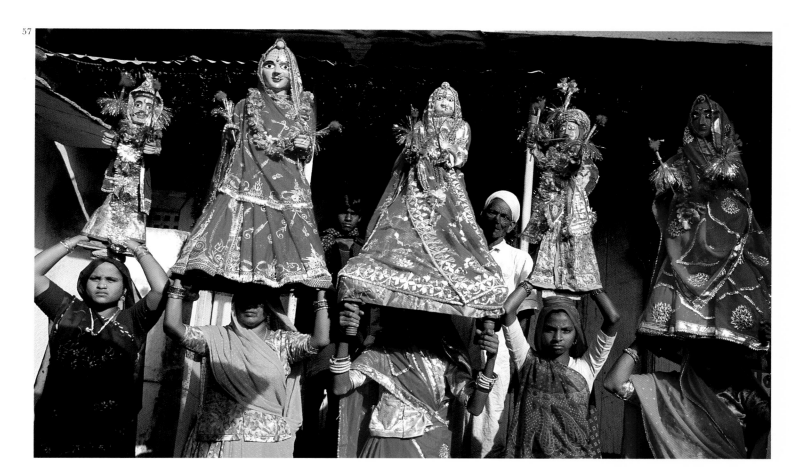

of all religious ceremonies and also represents the sun god.

The symbolism of these colours and their energies is apparent in the way they are integrated in the everyday attire of the people, especially women. Certain colours and designs are also favoured for certain months. Orange and golden are favoured for the New Year, or the month of *chaith*. In high summer colours of *kapasi* or light yellow, *javai* or light peach and *motia* or pearl pink is worn for their cooling affect.

Savan or the months of the rainy season are welcomed with green clothes, which depict prosperity and joy. A green *leheriya dupatta* is worn during this time. A *kasumal* or red odhna is worn at the time of *teej*, a festival celebrated by women to pray for the long survival of their husbands. The festival of Diwali is also brightened with colours of red and yellow. The Rajput women wear a deep purple odhni on Diwali. Thus each colour has its own specific significance, meaning and is also worn depending on customs, time of the year and occasion.

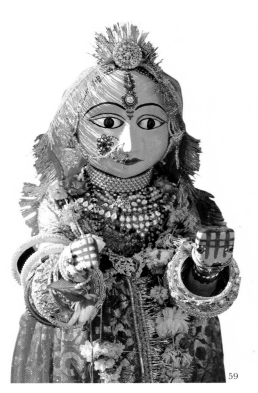

BLOCK PRINTING

Rajasthan has long enjoyed a formidable reputation for its fine handprinted cotton textiles. The craft has been perfected over many centuries and skills in block printing, *dabu* (resist-printing); *khadi* and *warak* printing are unparalleled. A continuity of tradition is apparent in the similar design styles of printing that are found even today, despite the availability of modern techniques like screen-printing. Since tradition decrees that craft skills be passed down the generations, from parent to child, the expertise remains within the family and people engaged in this trade form an identifiable group called the Chhipa community.

The craft is practised in virtually every village in Rajasthan. As it is heavily dependent on water, commercial printing centres sprang up, near water sources, the most famous being Sanganer and Bagru near Jaipur, Barmer, Jodhpur and Akola near Udaipur. Over time, each centre has developed its own unique design style and techniques—for example, sombre colours and delicate lines, creating finer designs like the poppy, rose and lotus, usually against a white background, are characteristic of fabric, printed at Sanganer. In contrast, motifs are traditionally big and bold in Bagru, where dabu (resist-printing) and the dyeing process produce a reddish black shade. Wild flowers, buds and foliage have provided inspiration to the printers of Bagru. In Jaisalmer, printers use wax resists and create a dramatic wedding odhna called *jajar bhat* in red and black.

The Rajasthani craftsperson usually creates a motif that is a combination of flower, bud and leaves or other forms such as *keri* (mango), *pan* (betel leaf), *katar* (dagger) or *jhumka* (ear-ring). A notable feature of the region's printing tradition is that animal motifs are not used on fabric meant for costume. Royal patronage in Jaipur and Jodhpur encouraged local printers to work exclusive designs on various garments. Motifs in this region have been influenced by Islamic culture and floral designs are often associated with other crafts like brass, silverware and marble.

Local art is also a strong inspiration, as in Udaipur where the art of *pichvai* painting is reflected in the printed textile. Another example is Nathdwara where dyers make their blocks from sandalwood and also add perfume to the colour mixture to produce scented fabrics.

It is important to understand that motifs also serve as a mark of group identity and, hence, have remained unchanged. For example, women of different communities use different motifs on their ghaghras. The Jat use the *teetri bhat* and *koyali bhat* motifs. Young, unmarried Jat girls, wear the *dhola-maru* motif, while older women of the Kumhar community use the *daabri bhat* motif. Even now, when polyester and mill-made warp-knitted fabrics have become the norm, people still strive to wear traditional designs on new fabrics.

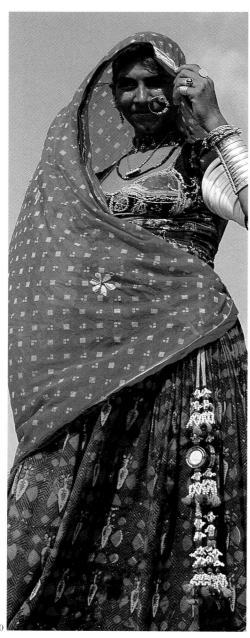

Block printing is one of the earliest known techniques of printing by hand. It is a popular, inexpensive technique, used, especially, for small yardages and single pattern designs on cloth pieces. The colours are derived from vegetables and metals depending on local availability.

Wooden blocks are the main printing tools and are prepared by the local carpenters. These blocks are hand-carved from locally available wood and may be rectangular, square or circular. The blocks have cylindrical holes drilled in the back to enable the release of air bubbles during the printing process. Registration notches are cut on the side of the blocks to ensure proper alignment for each subsequent colour. This ensures that each block registers accurately.

The *gad*, *rekh* and *datta* are three distinct types of blocks that are distinguishable by their different styles of carving. The gad is carved in intaglio and is employed to print large background figures, while rekh and datta are carved in relief. Rekh blocks also mark the outlines of the motif and are often used in conjunction with gad blocks, the rekh then forming the fine intricate lines within the imprint made by the gad block. Datta is carved in bold relief and complements the designs of both the gad and rekh blocks. Each of these blocks is used separately or together to produce endless design variations.

Some of the pastes used in printing are syahi, begar and dabu. Adding a gum solution to the paste thickens it and provides a viscosity suitable for printing. The begar paste prepared with *fitkari* or alum, gum and geru produces a red colour. Alum acts as a mordant and combines with the colouring substance alizarin to produce colours ranging from pink to deep red on cotton fabric.

The process of block printing begins with washing and desizing the fabric. The printing paste is poured into trays known as *saj*. A bamboo net, *chipri* is placed in the wooden tray and a coarse woollen cloth, *kambal ki gaddi*, is spread over it. This prevents excess colour from rising to the surface and ensures that the block picks up the dye evenly. Dried fabric is spread out on flat, softly padded wooden tables and printing is begun from one end. The block is lightly pressed on the printing tray and then pressed on the fabric, transferring its impression on to the material. The process is repeated, taking care to ensure the blocks' alignment with each other over the entire cloth. Each colour in the design requires repetition with individual blocks. The printed cloth is dried and washed again to remove the gum that was added while printing. Finally, as the last stage, the fabric is dried in the sun.

There are several other techniques of block printing. In the direct method the block is dipped in the paste and then pressed directly on the pre-treated fabric. This does not involve any resist and no dyeing procedures are necessary.

Dabu or resist-printing is another method of block printing. Here the actual sequencing of the process and different stages of dyeing and printing can vary depending on the desired final pattern. The fabric is printed with a mordant (alum) or a resist (dabu) or both. When a cloth printed with mordant is immersed, it reacts with the dye and colour develops only in those areas which have been treated with mordant. If the fabric is printed with resist, however, only the areas that are unresisted will accept the dye.

The fabric is initially washed and completely desized, then treated with harda solution. It is then printed with the syahi and

60. **Village woman.** *Ajmer.* She wears the traditional upper garments, ***kurti-kanchli,*** over a block printed ***ghaghra*** skirt and a red tie-dyed veil or chunri. An ornamental drawstring, its ends decorated with cowry shells, large mirrors and colourful pom-poms gathers the ***ghaghra*** at her waist, adding grace and movement to the dress. Arm ornaments ***chuda*** and silver ***chud*** are worn on her upper and lower arm. The gold nose ring represents her married status.

61. **Elephant and lotus borders.** *Gujarat, (10th century A.D.). Ashlomean Museum Oxford.* Cotton, block printed resist, indigo-dyed.

62. **Wooden printing blocks.** *Bagru*

62

64

63

65

Block printed cotton fabric for making *ghaghra*. *Jodhpur.*

63. ***Bel-me-makoda*** design.

64. ***Kap bhat*** design.

65. ***Bel bhat*** design.

66. ***Phuldi bhat*** design.

66

68

69

70

71

67. *Methi bhat* design.
68. *Chhint* design.
69. *Pili chhint* design.
70. *Chaukri* design.
71. *Ghand bhat* design.

67

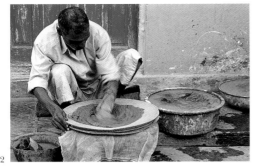

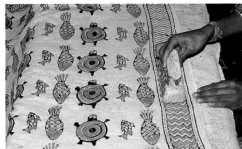

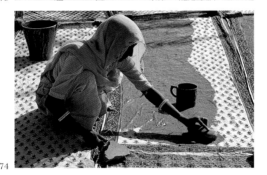

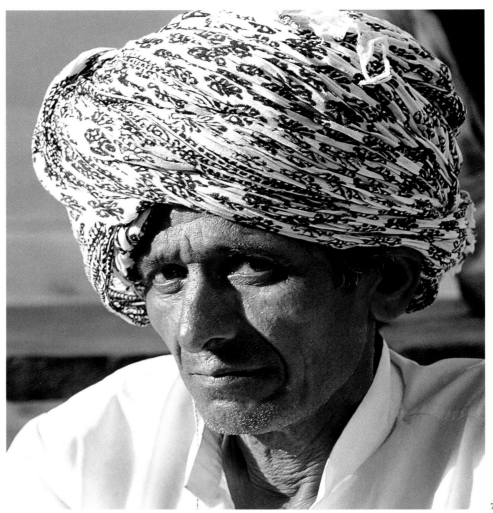

72. **Sieving the mud resist - *dabu*.** *Bagru.* A mixture of clay, lime and wheat flour is soaked overnight. The gelatinous paste produced is strained through a fine muslin cloth.

73. **Printing the mud resist with a *datta* block.** *Bagru.* The resist-printed areas will retain the ground colour after the fabric has been dyed.

74. **Modern method of resisting fabric with *dabu*.** Instead of printing the fabric with a block, the *dabu* is spread with a brush. A batik-like effect is produced when the dried resist cracks and fabric is dyed.

75. **Dyeing the *dabu* printed fabric.** The cloth is spread out in the sun after it has been immersed in Indigo.

76. **Man belonging to Gairi community.** *Udaipur.* He wears a block printed turban.

77. ***Rekh* block.** Wooden blocks carved in relief are used to mark the outlines of the motifs in block printing.

begar paste in two distinct steps. The dabu is applied to the cloth using a datta block. The areas resisted with dabu will not absorb colour on further dyeing. Following the application of dabu, sawdust is sprinkled over the surface to facilitate quick drying of the fabric. Dyeing with alizarin develops a rich red colour in areas printed with the begar paste. The fabric is then washed and dried and, if needed, printed again with resist before being immersed in indigo dye, which produces a deep blue colour. Sometimes, nasphal (yellow dye) is also used on the fabric. This can give it additional tones of yellow and green. In some regions, the material is dipped in the nasphal solution, whereas in others the solution is smeared on the surface.

Dabu is prepared with clay. This mud-resist is removed once the desired pattern has been achieved. Different types of dabu solutions are used—some of these are *kalidar* dabu, *dolidar* dabu and *gawarbali* dabu. The last is produced from roasted seeds and has the maximum adhesive qualities. The most commonly used, however, is the kalidar dabu. It is made with *kali mitti* (clay), *chuna* (lime), *bidhan* (wheat flour) and *gaund* (gum), a natural adhesive. The clay is soaked overnight and to this are added wheat flour (soaked in water) and lime solution. This is thoroughly mixed by the treading of feet and gum is periodically added to this mixture. The gelatinous paste thus produced is strained through a fine muslin cloth to remove any particles. The solution is then ready for use in resist-printing.

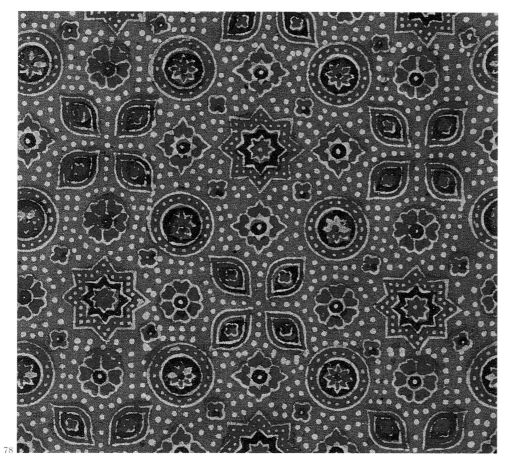

78-80. *Ajrak* **designs.** The predominant colours are deep blue and red. Patterning is geometric and motifs follow a grid-like system. Each quarter of the block creates an identical pattern. This fabric is used by men as a *lungi* around the waist and as a shoulder cloth and head covering. Women in some communities like the Meghval and Musalman wear *ajrak* printed *ghaghra*.

Ajrak Printing

The term *ajrak* may have evolved from the Sanskrit word *jharat*, from which a-jharat, (stable object) was coined. It could also be a derivation of *azrak*, meaning blue in Arabic—as traditionally, blue is one of the principal colours in ajrak printing.

This style of printing is restricted to certain areas of Western India—and Barmer and Akola in Rajasthan excel in the art. The ajrak technique is used to create various functional garments, like the head covering and the sarong-like *lungi*, both of which are popular with the men in this region. It is also used as a wrap, a carrying cloth or a floor sheet. Meghval and Sindhi Muslim women wear ajrak printed ghaghra and odhna. The process is in itself lengthy and highly specialized:

> "*To experience the raw fabric length come to life, pulled exhaustively through the river many times, scoured, beaten, steamed, mordanted, printed with resist mud-pastes from the banks of the river, covered with powdered camel dung and ground rice husks; dyed in deep, deep madder and indigo; the resultant—Ajrak, a precious jewel-like fabric*"

> —Noorjehan Bilgrami

Before the actual process of printing begins, the fabric is washed and treated with a harda solution. Thorough washing and desizing is necessary, as it improves the cloth's capacity to absorb colour.

Kariyanu is the first step in printing. A resist-paste of lime is stamped on to the fabric. This marks the white outlines of the design. The borders are

81. **Steps in *ajrak* printing:**
a. The fabric is resist printed on one side with a **rekh** block.
b. Its reverse is then resist printed with the **rekh** block.
c. Iron paste (for black) is used for printing with the **datta** block.
d. An alum mordant resist is applied, using a **datta** block.
e. The fabric is dyed in indigo.
f. Washing after indigo dyeing.
g. Fabric is immersed in alizarin solution.
h. A sample is dyed and boiled with the madder root.
i. Resist printing with alum and **dabu** using a **datta** block.
j. Indigo dyeing - double dyeing with indigo, known as **mina**.
k. Washed sample.
l. Boiling and dyeing with alizarin.

82. **After boiling with madder, an alternate result is obtained by following a different procedure:**
m. The fabric is boiled and dyed in alizarin
n. Resist printing on fabric
o. Dabbing the fabric with pomegranate rind solution
p. Dabbing with turmeric dye solution
q. End result after fabric is dyed in alum

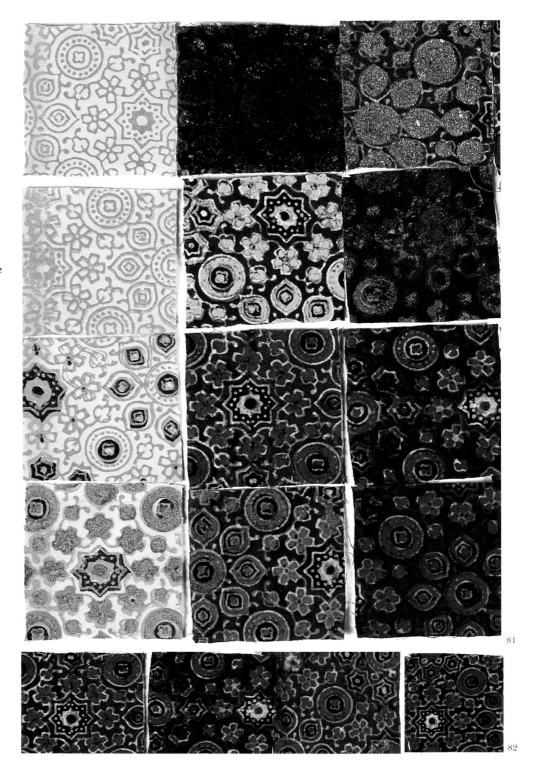

81

82

printed from left to right—always before the main body of the fabric. Ajrak printing can be single or double sided. When the reverse side is printed, the process is carried out while the material is still damp, as fabric tends to shrink when it dries.

Syahi paste, which turns black on contact with alizarin, is used in the second stage of printing. All areas to be resisted for indigo are printed with *gach*, an alum resist-mixed with mordant. Dried rice husk is sprinkled on the damp areas to fix the resist. The fabric is now immersed in an indigo vat, then washed and dried.

The next treatment is with alizarin. The cloth is washed and dried, once again. It is then printed with fresh resist on all areas of the ajrak, except those which have been coloured with indigo in the first immersion.

In a special process called *mina*, the fabric is dyed once again to enhance its colour. The deep, rich shade of blue so obtained is characteristic of ajrak printing. Subsequently, the cloth is put through a final washing and a special finishing gives the ajrak its distinctive lustre. In recent times, the inclusion of nasphal in the dyeing process has added yellow and green to the ajrak palette.

The ajrak is clearly distinguished from other block-printed textiles not only by its deep red and blue hues but also in its structuring of motifs. Here, each of the motif's quarters is produced by an identical impression of the block, the four parts coming together to form the whole motif.

The print is worked within a grid, the repetitive pattern creating a web-like design or the central *jaal*. Apart from this jaal, border designs are also employed. These borders are aligned both vertically and horizontally and frame the central field, distinguishing one ajrak from another. The lateral ends are printed using a wider, double margin in order to differentiate the lay-outs of borders.

Khadi or Chamki work (Tinsel printing)

Khadi, or chamki work as it is popularly called, adds a touch of glamour to even the plainest textile. In the past, this manner of decorating textiles was extensively applied to the costume of royalty and the articles they used. Though practised all over Rajasthan, Jaipur, Jodhpur, Barmer, Ajmer and Udaipur are famous for their elegant khadi prints. It is fascinating to watch the designer create exquisite patterns on wedding odhnis, saris and turbans with breathtaking dexterity and speed. Previously, artisans used gold or silver dust for printing. This was replaced by flakes of crushed mica, or cheaper metal powders, called *bodal*. Nowadays, granular and fine metallic powders, in different colours on a gold or silver base, are commonly used for printing.

Khadi is worked primarily on garments worn for ceremonial purposes. It is also done on garments like the ghaghra, *kanchli*, angarkha, jama, odhna and turban cloth.

A special bridal chunri called *phavri* or *phamri* is an essential part of the Rajasthani bride's trousseau and is worn on festivals like Gangaur and Teej. This wedding chunri is red in colour and has a special design called *khaja*, printed on its centre.

This ancient tradition of ornamenting cloth makes use of a special engraved brass block called a *sancha*, one end of which has a design or motif perforated on it. The sancha is paired with a matching carved wooden datta, which fits its contours, exactly. The two blocks are used together to stamp designs on to the cloth. The sancha comes in a variety of shapes, such as round, oblong, square and rectangular.

The sancha is filled with *rogan*, a thick viscous paste that the craftsman can either prepare himself or buy the readymade product locally. This mixture is heated briefly before it is poured into the sancha. The wooden datta is then inserted into the sancha and with a syringe like action is pressed out through its perforated end. The paste is then stamped on to the evenly spread cloth. The stamping action

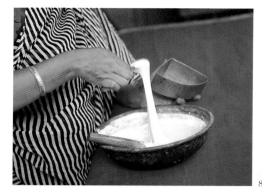

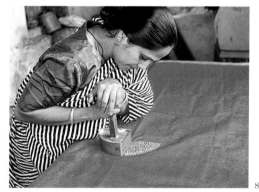
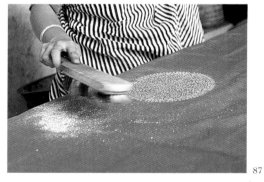

Tinsel Printing.

83. **Tools for tinsel printing.** *Sancha, datta* and wooden stick.

84. **The** *sancha,* **perforated brass printing block is filled with** *rogan* **or printing paste.**

85. Sancha **and** *datta.* The brass block has a perforated design. A wooden *datta* is fitted inside it.

86. **Printing adhesive paste on a** *phavri,* **wedding** *odhna.* This is a *khaja* design.

87. **Silver powder is sprinkled on the adhesive print while it is still wet.** The excess powder is gently brushed away.

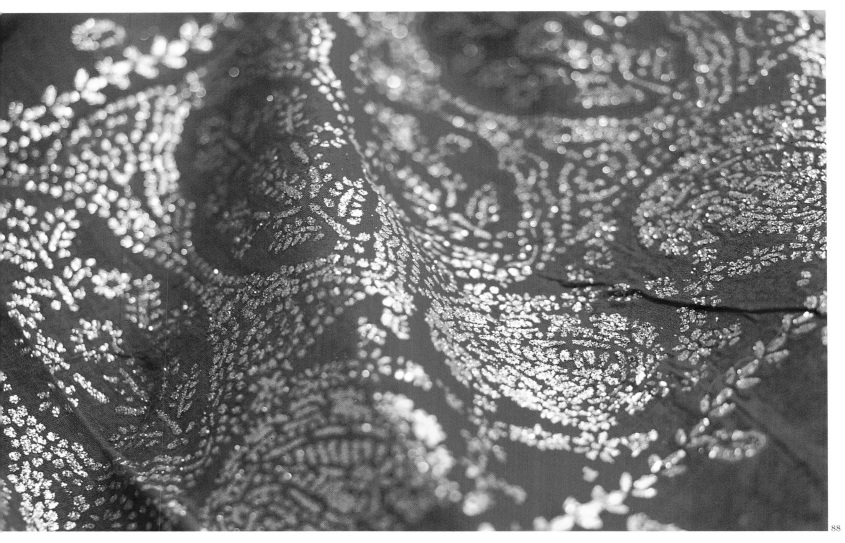

is rapid but firm to allow the paste to form an adhesive film on the fabric. Before it dries, gold or silver powder is sprinkled on the fabric, which settles on the printed design and is fairly permanent. Excess powder is collected and reused.

The procedure is repeated till the whole cloth is printed over and the fabric is then dried. The most common motifs, used in khadi printing, are the *phul, buti, chandani, mor, mogra, keri* and *khaja*. The ground fabric may be of any colour and does not have to be pre washed as in other printing techniques.

Warak or Gold Leaf Printing

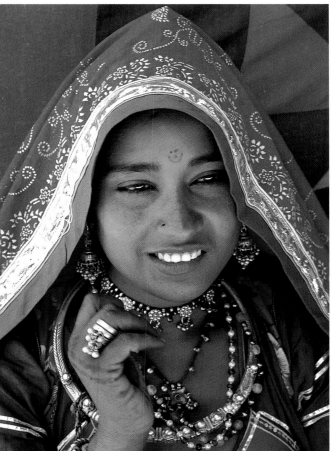

This is a very specialized form of printing and is characterized by the use of gold or silver leaf, called warak instead of the powder used in tinsel printing. The ornamentation of cloth by this method was—and continues to be—expensive. In the past the elite all over India used it extensively but it lost much of its patronage over the tumultuous years of colonial rule and at the advent of independence. However, recent times have seen a revival of interest in warak printing, although only a limited number of artisans still practise the technique.

The process of making warak is a skill in itself. Sheets of gold or silver are alternated with layers of parchment

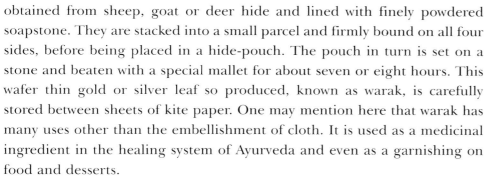

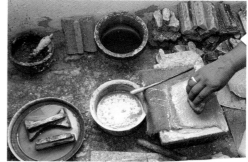

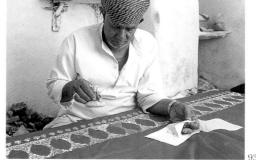

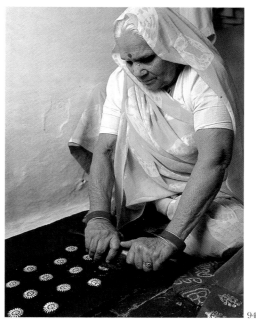

obtained from sheep, goat or deer hide and lined with finely powdered soapstone. They are stacked into a small parcel and firmly bound on all four sides, before being placed in a hide-pouch. The pouch in turn is set on a stone and beaten with a special mallet for about seven or eight hours. This wafer thin gold or silver leaf so produced, known as warak, is carefully stored between sheets of kite paper. One may mention here that warak has many uses other than the embellishment of cloth. It is used as a medicinal ingredient in the healing system of Ayurveda and even as a garnishing on food and desserts.

In warak printing, the cloth is first spread on a padded wooden printing table and motifs are then stamped on to it with the aid of blocks, which are generally made up of wood. Some of these blocks may actually comprise a simple piece of wood with iron nails embedded on its surface to form a design. These blocks, however, use less warak, so the wooden blocks are preferred as they impart a better lustre.

The process begins with the preparation of an adhesive paste, made of *safeda* (fine white powder) and a resin, *saresh*. Each is heated to its melting point and the two are then combined. This mixture is further strained in order to remove any impurities. Finally, an adhesive paste is obtained, which will be used for printing on the fabric. Readymade paste, which has a longer shelf-life, is also available in the market. Now, a wooden block is pressed gently on the paste which is spread on the printing pad and, then, stamped onto the fabric to create a design on its surface.

88. **Bridal *phavri* veil.** Gold tinsel print on cotton voile.

89. **Girl wearing a tinsel printed *odhna*.** It is edged with a *gota* border and *magazi*. *Waraq* printing.

90. Waraq **printing blocks.** Wooden and metal blocks are used for *waraq* printing.

91. **Floral *waraq* print on cotton voile.**

92. **Adhesive paste is spread on the printing pad and lifted, using a wooden block.**

93. Waraq **or gold leaf is applied on the adhesive print.** The craftsman squats on the floor as he works on the fabric, which is spread out on a low table.

94. **After drying the printed areas are burnished with a rolling pin to bring out the lustre of the *warak*.**

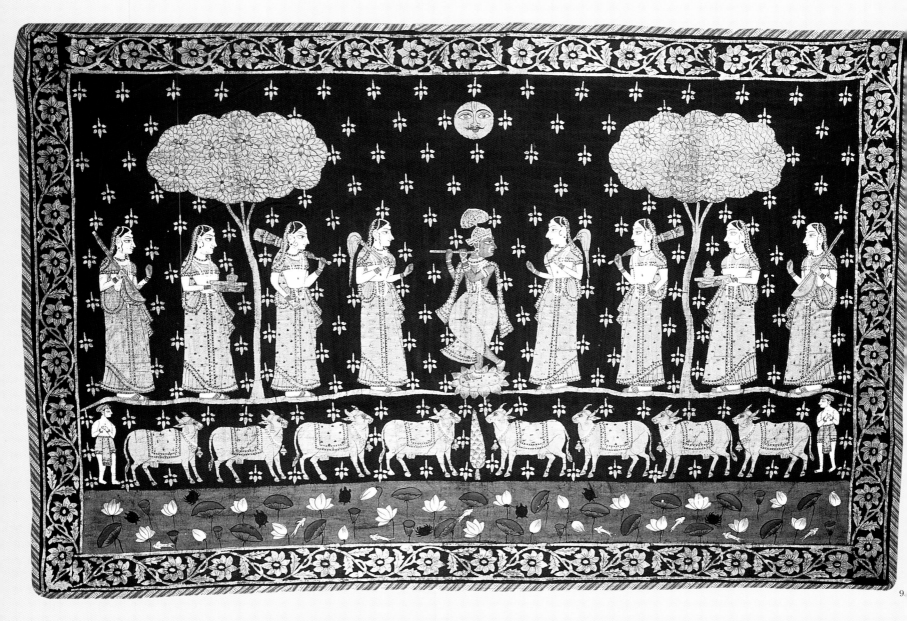

9

96

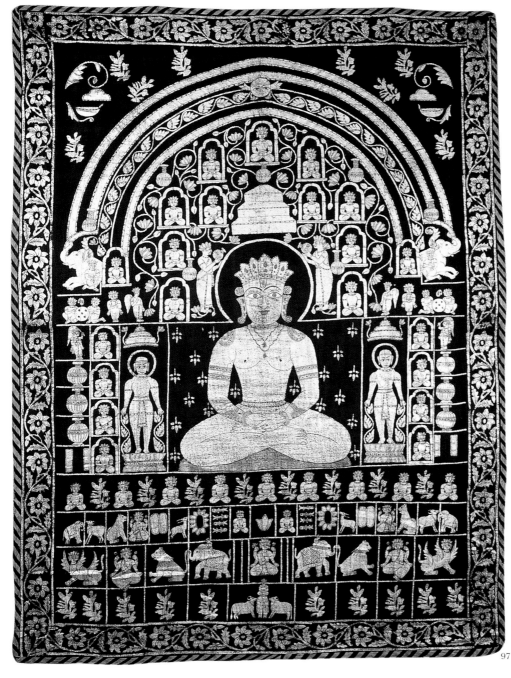

95. *Warak* **printed** *pichvai. Nathdwara.* Temple hanging of the Vaishnava religious group.
96. *Khaja* **design on** *odhna. National Museum (19th century)* Tinsel printing technique.
97. **Ceremonial hanging for a Jain temple.** Printed design in *waraq* depicting Lord Mahavira.

97

Once the design has been outlined on the fabric, warak is applied. A small pad in the shape of a little pouch filled with cotton wool is used for this. A hand brush is used to remove all residual warak. Finally, the cloth is burnished with a rolling pin attached with a stone or moro, which gives it a beautiful glossy sheen.

Warak printing is carried out on pichvais, dhotis, safas, saris and on ceremonial altar cloth offered at temples as, for example, at the temple of Nathdwara. The Kankroli temple also has an image of Lord Krishna wearing a dress with a special warak design.

Popular motifs for warak ornamentation are keri-ki-bel, mehraab, keri-buti, phul-ki-bel, jawar bhat, genda, chaukhana as well as deities like Radha and Krishna.

EMBROIDERIES OF RAJASTHAN

Embroidery brings new character and dimension to any article that it graces. This is an ancient craft, which has changed over time to reflect the prevailing social, material and sometimes even the political mood of the times.

The most meticulously ornamented fabrics and articles are often those for personal adornment. In Rajasthan, some form of embroidery invariably embellishes the three garments worn by women, the kanchli, ghaghra and odhna. Similarly men's garments like the angarkha, achkan and jama also display some elements of embroidery. It is also used to enhance household items, like bedspreads, wall hangings and animal trappings. Where embroidery is done for domestic use, it is by custom a feminine occupation. Men traditionally produced embroideries like *zardozi* and *danka*, which were patronized by the royal courts. They continue to do so even today.

As in many traditional societies, Rajasthani women lead somewhat restricted lives. With the exception of a few pastoral and tribal communities, their interactions are usually limited to the confines of their homes and villages. Embroidery, thus, becomes the expression of a woman's artistic temperament. In fact, activities focused within the household have led to development of a variety of arts and crafts. These are often leisure-time activities, after the daily chores are done, around the home, in the fields and any other area that falls within their domain. It is then that the needles come out and ply busily until sundown.

Thus embroidery becomes the idiom of expression for girls, who may never learn to read or write. These young artists begin their training at the early age of seven or eight, learning to create exquisite patterns on plain fabric. Initially working on simple designs, they gradually perfect their skills, acquiring the delicacy and refinement of accomplished needlewomen. They work as apprentices to their mothers and grandmothers, sisters and aunts, who pass on to them designs, patterns and a heritage that has evolved over the centuries.

A wide variety of techniques are used in the embroidery of costumes and textiles. Some of the popular styles are, among others, metal embroidery, *gota* work, and *suf bharat*.

Metal Embroidery

Metal Embroidery was patronized mainly by royalty and the wealthy merchant classes who wore elaborately ornamented clothing. They preferred garments profusely embroidered in gold and silver because embroidery was considered auspicious and also because it represented opulence, power and importance. The royalty were so fond of this style of ornamentation that they often employed it on a wide range of articles other than apparel, like footwear, belts, caps, cushions and even elephant caparisons and canopies. The embroidery on these garments is, sometimes, so extravagant that the surface of the ground fabric cannot be discerned.

Metal embroidery is largely of three kinds—zardozi, gota work and *danke-ka-kaam*. Gold and silver are drawn through a series of dies to obtain

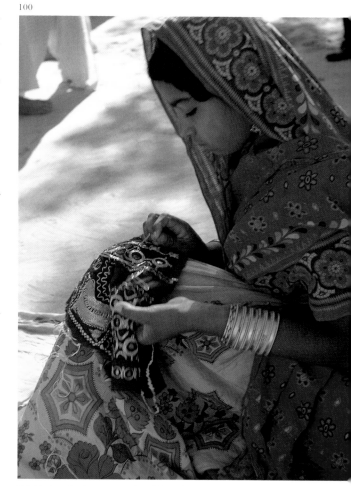

a fine thread. This can either be hammered flat or used as it is. It could also be wound around a silken or cotton filament core to make a thread. Nowadays, electroplating with other metals also achieves a similar effect.

Zardozi

Embroidery that uses pure gold and silver wire, zari, is known as zardozi and was, probably, derived from the Persian word *zar*, meaning gold. This style of embroidery was a result of the Mughal influence on Rajasthani courts and has survived well, over time. While zari is more often used in weaving, it is also used selectively for embroidery. Zardozi work is also known as *karchobi*, which is derived from *karchob* or framework. The embroiderer stretches the fabric tightly on a wooden frame, within which this style of embroidery comes to life.

Zardozi is worked in two distinct styles. The first, karchobi, is recognisable by the density of its stitches on a heavy base material such as velvet or satin. It is usually seen on items like coats, tent coverings, furnishing and canopies. The second is *kamdani*, the lighter, more delicate work, which is well-known in Rajasthan. Kamdani adorns elegant fabrics like silk and muslin. Although this kind of work is considered most suitable for scarves and veils, these days it is most visible on bridal wear.

The design is first traced on the fabric and assorted metallic wires and shapes are laid out on it. The embroiderers fashion their motifs from different shapes and sizes of gold and silver wire and discs. The *badla* is a flat wire with a thread base, the *salma* is curled and springy, while the *dabka* is a thin tightly coiled wire. A *sitara* is a tiny ring of metal resembling a star, *gijai* is a circular, thin stiff wire and the *tilla* is a flat metal wire. Sequins and coloured beetle wings are also often used. The most expensive and ostentatious examples of zardozi include semi-precious stones and pearls.

The metallic wires form the design and nee- dle and thread are employed merely to sew the elements on to the fabric. Laid-stitch, backstitch, couching, chain stitch, running stitch and satin stitch are also employed in these exquisite embroideries.

Zardozi usually places geometric shapes alongside floral designs. Circles and triangles, for instance, may be worked into the margins, framing a body of flowers. Borders often display triangular forms with finely wrought floral scrolls. The corners are adorned with mango motifs, a floral spray or peacocks. The

98. **Bokani.** *Barmer.* Embroidered cloth used as waistband and head cloth. ***Pakka*** embroidery on cotton fabric and cotton thread.

99. **Embroidered hand fan.** *Bikaner.* Accessory used to decorate religious statues of Lord Krishna. Sequins and ***zardozi*** embroidery on silk. The edges are fringed with ***kinari.***

100. **Young girl doing *mukka* work embroidery on a *kanchla.*** *Barmer.*

101. ***Zardozi*, metal embroidery.** The ***kalipatti*** silk ***ghaghra*** is a woman's lower garment.

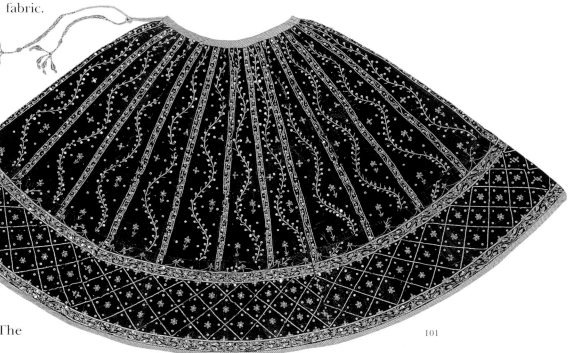

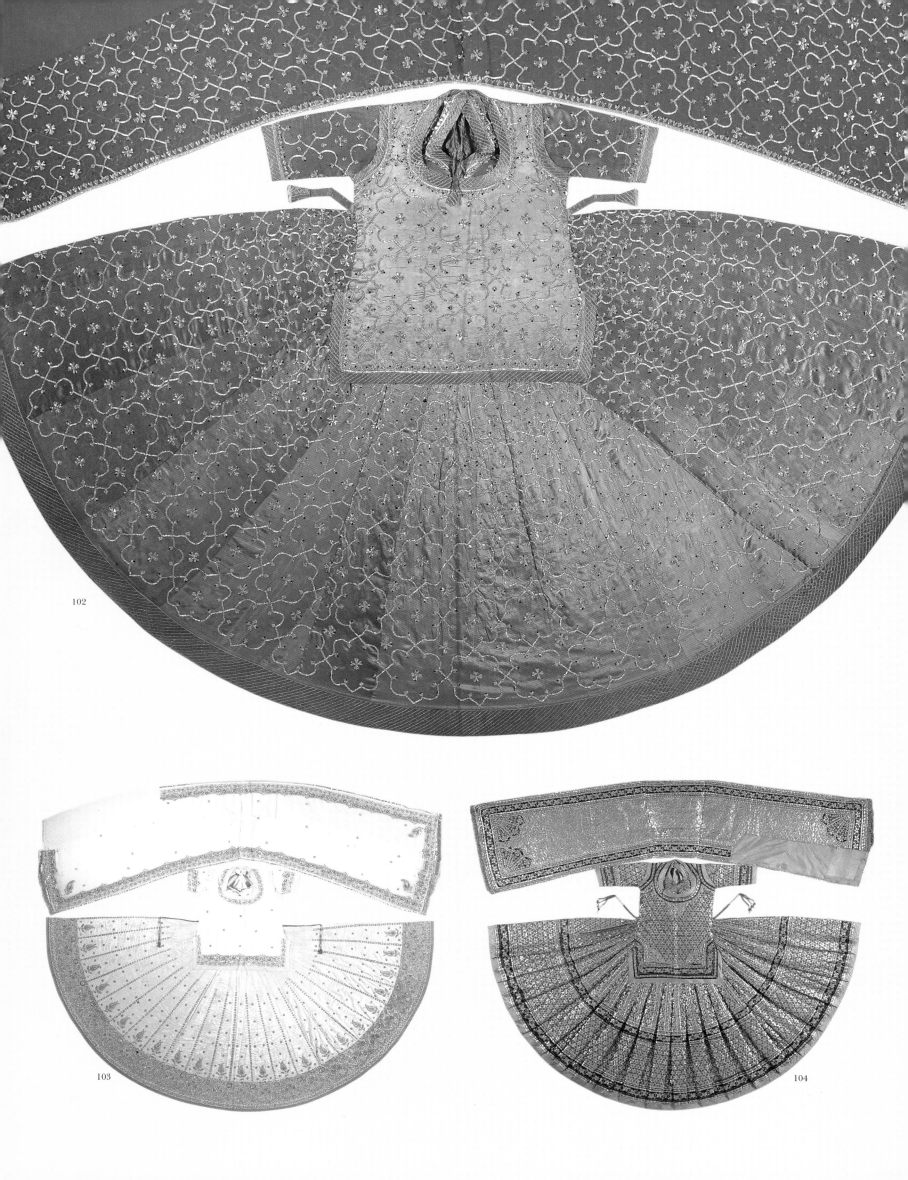

102

103

104

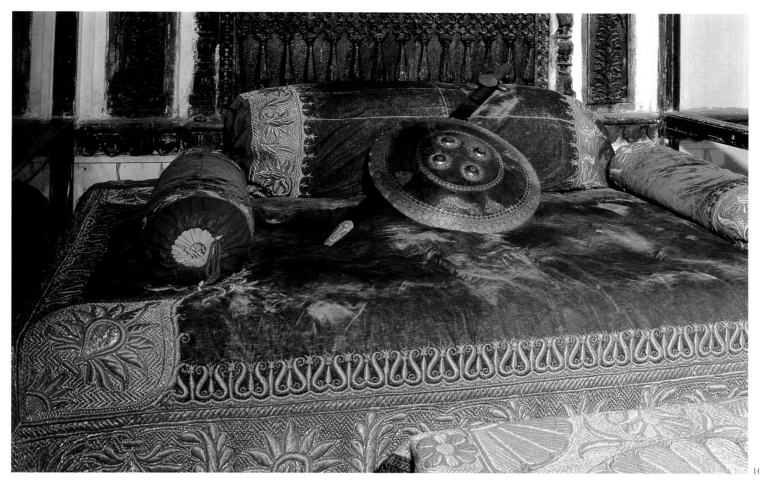

105

field is filled with sprays, flower buds and animal figures, especially in the karchobi style. Another elegant feature is the delicate *jaali* (net) on some portions of the fabric. Currently, zardozi is being extensively used on urban clothing. The assimilation of this age-old craft into urban life has ensured its longevity and popularity.

Gota Work or Lappe-ka-kaam

The embroiderers of Jaipur, Ajmer, Bikaner, Udaipur and Kota are renowned for their uniquely styled gota work. This form of fabric ornamentation, was, perhaps developed in Rajasthan. It is also known as *gota-kinari* work and *lappe-ka-kaam*. On religious, social and festive occasions, men, women and children dress in their finest clothes, ornamented with gota. Gota lacing is extremely popular and odhni and turban edges are often worked with it. Many printed or embroidered ghaghras are also trimmed with gota.

Depending on its width, gota can be found under different names, such as *chaumasiya* and *athmasiya*. Essentially, gota is a strip of gold or silver ribbon of varying width, woven in a satin weave. Badla, a metal yarn, made of beaten gold or silver, forms the weft and silk or cotton is used in the warp.

Gota is worked on fabric with the appliqué technique. With a bit of hemming or simple running stitch, elegant designs flow from the artisan's fingers on to the garment. Popular design elements like flowers, leaves, stylized mango motifs and heart shapes are usually worked on odhna and ghaghras. Checkerboard patterns are also quite a favourite. Animal figures, like the parrot, peacock and elephant are some of the more popular motifs. As a variation, floral designs are cut from gota and embroidered on to the cloth. Some sections of the pattern are filled with

Finely crafted women's apparel in silk, richly embellished with gold and silver.

102. ***Zardozi*** **embroidery and** ***gota*** **work on woman's ensemble.** Shown here are a ***kurti-kanchli***, ***ghaghra*** and ***odhna*** with an overall floral pattern on a silk base. The embroidery has been worked in pure gold.

103. **Women's ensemble.** ***Zardozi*** on silk.

104. **Woman's ensemble with** ***gota*** **appliqué.**

105. **King's throne.** *Jaisalmer. (c. 1910).* The velvet spread and bolsters are lavishly embellished with ***zardozi*** embroidery. The ceremonial royal sword and shield are symbols of state.

106. **Royal dupatta.** *Bikaner.* The shoulder cloth is in silk with ***gota*** appliqué.

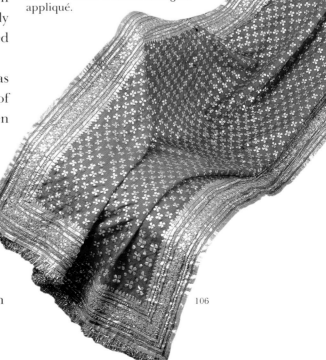

106

107. **Wooden frame for** *danka* **embroidery.** *Udaipur.* The fabric is stretched on the frame as the craftsman sews on the *danka,* a small metal square made from silver plated with gold.

108. ***Ghaghra*** **and** *odhna* **with** *danka* **embroidery.** *Udaipur.*

109. **Border designs executed in** *danka* **work.** *Udaipur.*

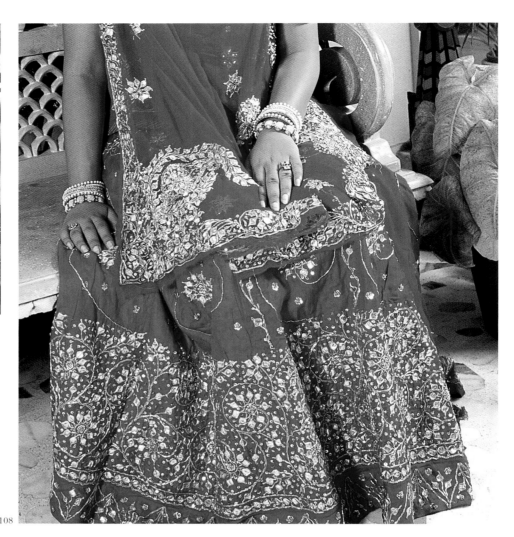

coloured satin, resulting in a rich design that resembles the enamelled jewellery of the area.

Men and women of all communities wear gota, as it is auspicious and indispensable during ceremonial occasions.

Danke-ka-Kaam

A specialty of Udaipur and neighbouring areas, this craft is distinguished by the use of a small, metallic square around which zardozi is worked. The danka is a small square plate, which varies in size but is not bigger than 1.5 cm. This technique was earlier also known as *korpatti-ka-kaam.* Although the danka was originally made of pure gold, silver plated with gold, is commonly used these days.

Previously, danka was also made with fine silver sheet, which was first warmed and then gold foil was applied to its surface and pressed. Of late, well-finished, polished thin silver sheets of 98 percent purity are electroplated with gold in strips of 30 cm. by 2.5 cm. These are then washed in plain water and polished once again with fine granular sand. The strip is then cut into 1.25 cm. squares. The cost of the danka is calculated according to its weight.

This decorative technique is usually worked on satin, chiffon or silk fabric. The fabric is stretched tightly on a wooden frame before it is embroidered and the craftsman sits on the floor. Danka pieces are laid out on the fabric as required by the design. The danka is pierced with a needle, drawing the thread through the fabric. About three to five strands of *kasab* (gold or silver wire) are placed over each danka and couched down along its edges. It is

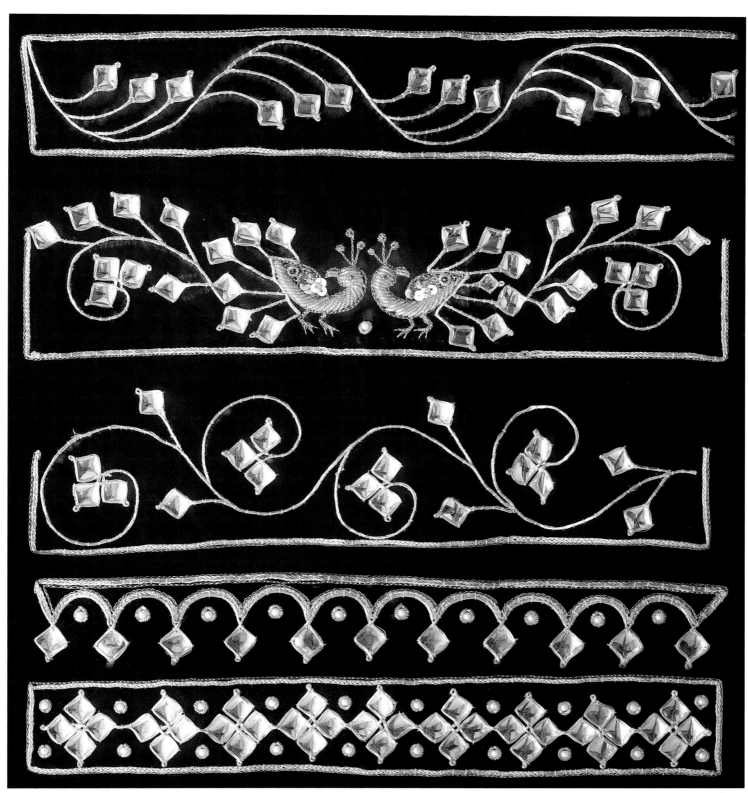

secured with eight stitches in the shape of a knot. Two stitches go into the back, two at each corner and two on the front. Round and flat metal braids about one quarter of a centimetre in width are used to highlight the design. Additional stitches employed include the chain stitch, satin stitch for the design filling, while stem and running stitches are for lighter work.

The most popular motifs used in danka work are inspired by nature—like the paisley, which takes a stylised form, as do the sun and the moon.

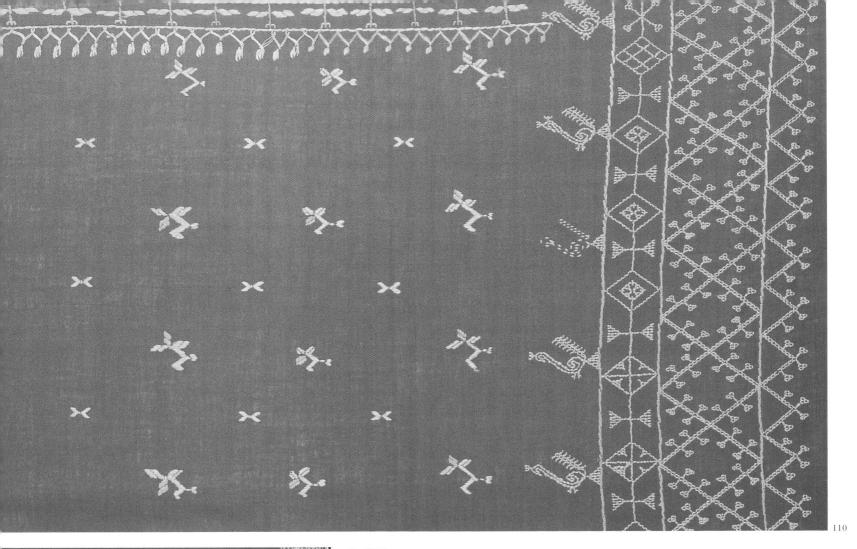

Suf Bharat

The suf bharat embroidery style closely resembles the *phulkari* of Punjab, Baluchi embroidery of Iran and the needlework of Swat and Hazara in Pakistan. It can thus be identified as a style of embroidery common to the wider region of Southwest Asia. In Rajasthan, Rabari women are well known for embellishing many household articles with suf. Among these are articles of daily use like the *reta*, a type of odhni, the *thalphosh*, which is a cover for a plate and the *bokani*, which is a long embroidered strip of fabric that can be tied at the waist or wrapped around the head. This embroidery is also popular with Jat, Meghval, Bishnoi, Rajput and Sindhi Musalman women.

The distinguishing feature of this style is that it is worked from the reverse side of the fabric in surface satin stitch, forming fine geometrical motifs. The style is also known as *tantik*, derived from the word *tantu* (thread), since the embroiderer works in the motifs by counting the warp and weft threads.

Suf is embroidered with plied cotton or in some cases with silk floss thread

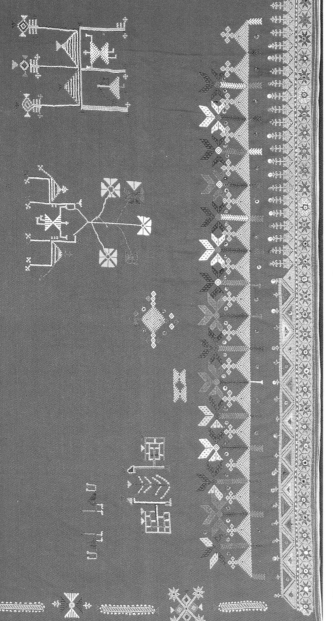

*110. **Damini, wedding shawl.*** Peacock motifs and floral borders are embroidered in surface satin stitch with untwisted silk floss on a cotton **khadder** base. In this style of embroidery known as **suf bharat**, the motifs are worked by counting threads.

*111. **Damini, wedding shawl.*** *Suf* work in *passam* or untwisted silk. Motifs include flowers and twin peacocks facing each other. The patterning is concentrated along the border, which frames the face and hence there is no wasteful ornamentation.

*112. **Bokani.*** *Barmer.* Embroidered rectangular cloth used as a narrow waistband and headscarf by grooms of the Meghval community. It is made of cotton fabric, with **suf** embroidery in cotton thread and is 1 ½m. long and 15cm. wide, joined along the width. The **bokani** is traditionally presented to the groom by the bride's mother. Embroidery has always had a ritual significance and been used to denote a change in status.

112

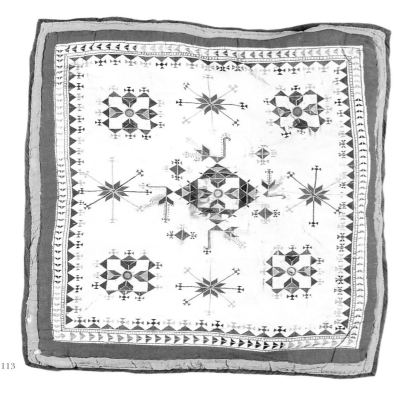

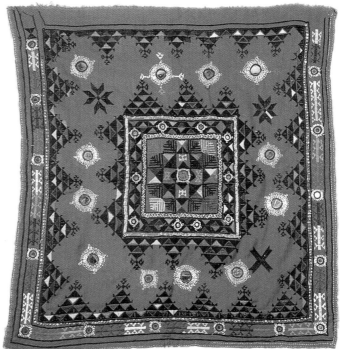

113

114

as well. Subtle nuances and shades are created with the use of *passam* (untwisted floss), producing dramatic effects with mirrors and other accessories. Radiating lines from the romanian stitch worked around the circumferences of the mirrors adds a distinctive accent, while the herringbone stitch is used to fill in the larger areas.

The predominant combinations of colours used in suf are yellow on red or red on white. However, a wider colour palette is available to artisans, including a profusion of reds, greens and yellows with a somewhat smaller amount of white, black and blue.

The basic motif of suf is the triangle—from which all other motifs are said to emanate—and to which the name suf refers. Suf embroidery is not always geometrical and sometimes takes the shape of figures such as camels, humans or peacocks. Suf motifs are neither sketched nor outlined with thread. Unlike those of *pakka* and *kharak* styles, they are worked by counting thread. There is also a marked similarity in the suf designs and the wall paintings of this region, especially the mandana. Some popular motifs are the *chulangar* or *chulna, bhugariyo, guntari, munjar, kungriyo, kugari, panri* and *sur.*

Mukke-ka-Kaam

The couching of gold and silver metal thread, known as *mukke-ka-kaam*, produces stunning embroideries that are used a great deal in this region. *Mukka* (plural, mukke) is the local name for metallic (gold or silver) thread wound around a core of cotton fibre. Both golden and silver mukka is used in this embroidery. It is done mostly in the Thar belt in Rajasthan, especially among the Sindhi Musalman and Meghval communities. The metal thread is doubled, laid on the fabric and couched down by stitching with another thread. The couching is skilfully executed so as to

*113. **Gaddi.** **Suf** embroidery incorporating mirrors. Untwisted silk floss on cotton base. The basic motif is a triangle worked in surface satin stitch. Combinations of these are used to create designs accented with mirrors.*

*114. **Rumal,** cushion cover. **Suf** embroidery in cotton thread on cotton fabric.*

115. **Sindhi Musalman woman.** *Barmer.* Her **kanchla** or blouse is embroidered with gold **mukka** work - couching technique. Gold metal thread, mirrors and woollen pom-poms are sewn onto the cotton fabric. Her arms are covered with **chuda** and she wears a **timania** as a neck ornament.

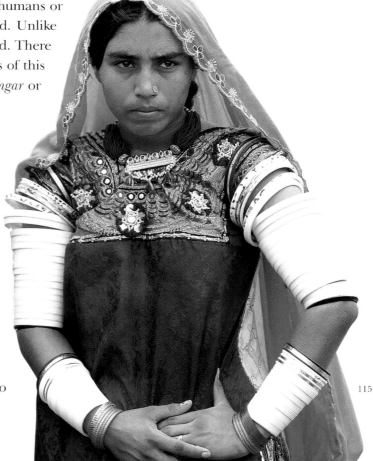

115

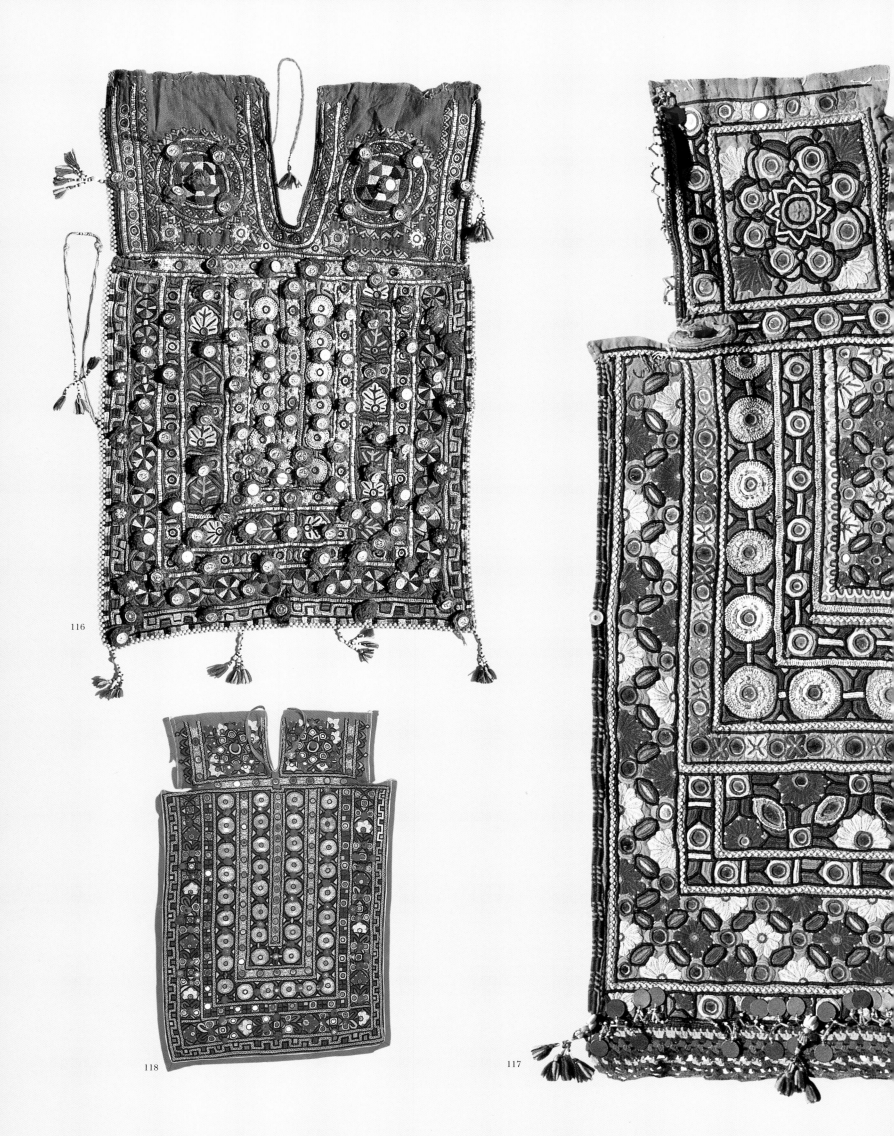

116

118 117

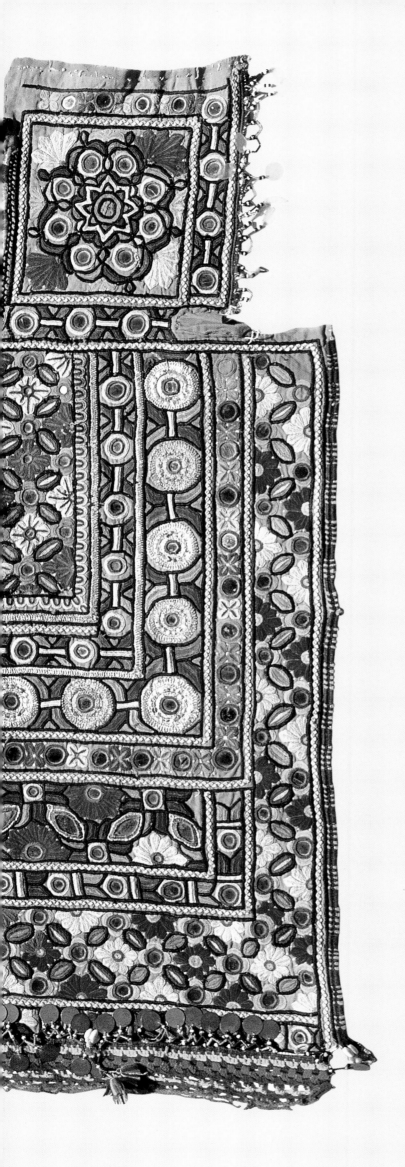

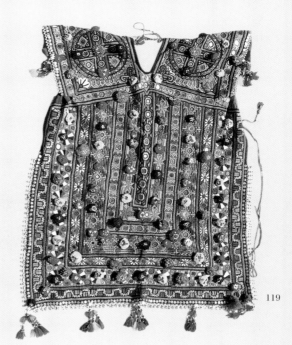

119

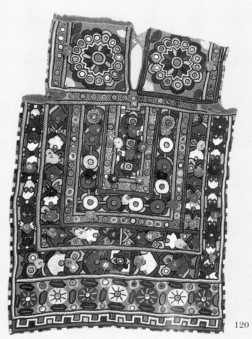

120

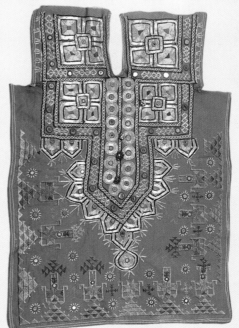

121

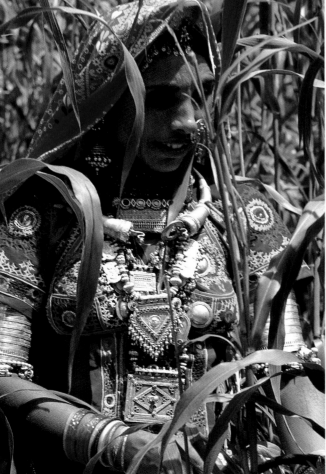

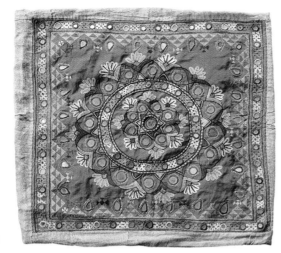

122

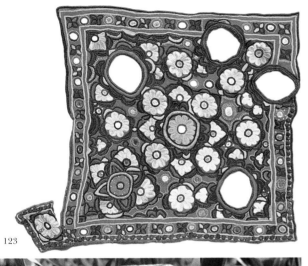

123

124

reveal the maximum surface area of the metallic yarn. In addition to couching, various other stitches like the buttonhole and outline stitches are also employed for filling in the designs.

The artisan sketches the design on the cloth and uses a black thread to fill in the outline. A mirror is attached in the centre of the motif, with the mukka couched around it. Mukka work is combined with other styles of embroidery, which are used to fill in the background cloth. The final outcome is a very rich and colourful piece of embroidery in geometric designs. Zigzag patterns stars, and triangles are especially popular designs. The local names for motifs and designs are derived from everyday objects, like funi, a sweet, *patasha*, a white sugar disc, *chaukri*, courtyard and *dabbo*, a box. It is most often seen on kanchlis, wall hangings and purses.

Pakko Bharat

Pakko bharat is a style of embroidery, so called for its sturdiness and longevity. Pakko is derived from 'pakka', which means, permanent. In this style, a tight square of chain and double buttonhole stitch, supplemented with the satin stitch and fly stitch are used to create a dense pattern on the cloth.

The motifs used in pakko bharat are both geometric and floral. These are first outlined with a chalk like substance and then worked predominantly in shades of red, dark green and gold or yellow—with a characteristic black, though sometimes yellow or white, outline. Mirrors, called *tika*, are used as the centres of the flowers and to form border designs. Though embroidery threads of silk may be employed, cotton is usually preferred. Trimmings like mirrors, beads, buttons and tassels enhance this style to produce richly ornamented odhnas, chadars and kanchlis.

There are several kinds of motifs in use. The border designs have a variety of expressive names, such as *dak mutarna, rana-ro-band*. Floral motifs like *kemai-ro-gul* or *kulhe-ro-guland* and peacock motif variations like *buto bharat* and *mor* are also commonly used.

116.(Previous page): **Kanchla. Mukka** work in gold and silver and *pakko bharat* in mainly floral designs. The edging is worked with beads, buttons and woollen pompoms.

117.(Previous page): **Kanchla.** This upper garment is embellished with gold and silver **mukka** work and *pakko bharat.* Two floral circle designs called **kemai-ro-gul** are embroidered on the front of the blouse. Its sides display a stylised peacock motif. Woollen pompoms have been added for protection against the evil eye. The blouse has a blue edging around the neck and sleeves. Edgings serve the dual purpose of magical and physical protection.

118.(Previous page): **Kanchla. Pakko bharat** with mirror work. The top is embroidered with two circular **kemai-ro-gul** patterns, while the bottom half is decorated with the **dak-mutarna** and **adhr-phul-ro-band** motifs. Circular metal plates, like sequins, add sparkle to the piece.

119.(Previous page): **Kanchla.** Woman's upper garment, heavily ornamented with a combination of techniques, including **suf, kharak** and mirror-work. Woollen pom-poms are strategically placed to protect vulnerable spots and tassels are added to attract attention and confound the evil eye. The garment is edged with small beads.

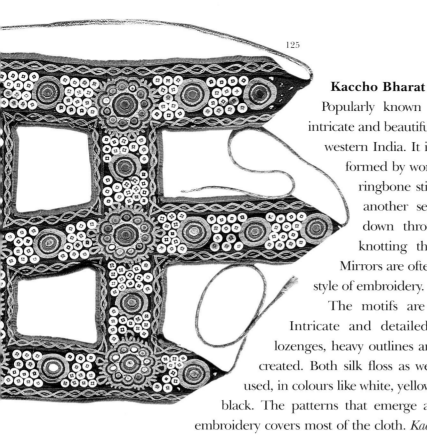

Kaccho Bharat

Popularly known as *Sindhi taropa*, this intricate and beautiful stitch is seen all over western India. It is an interlacing stitch, formed by working two rows of her-ringbone stitch and then weaving another set of threads up and down through those rows and knotting the points of overlap. Mirrors are often incorporated in this style of embroidery.

The motifs are mostly geometrical. Intricate and detailed hexagons, squares, lozenges, heavy outlines and stylized flowers are created. Both silk floss as well as cotton thread is used, in colours like white, yellow, green, blue, red and black. The patterns that emerge are so dense that the embroidery covers most of the cloth. *Kaccho bharat*, however, is rarely used as an independent style and is combined with other styles of embroidery.

Kharak

Kharak, another well-known style of embroidery in this region, derives its name from the fruit of the desert, the date, and locally called kharak. Its characteristic feature is its clusters of narrow bands or bars of satin stitch. The embroiderer deftly counts warp and weft threads on the ground cloth, producing the perfect geometric patterns in which the bars are arranged. As in pakka embroidery, the design is first outlined on the cloth. The needlewoman uses a black double running stitch as she counts. The outlines are later filled in with multicoloured thread. Unusual effects are produced using the satin stitch to form small rectangular designs.

Cotton threads in bright colours add vitality to the base fabric. The design is accentuated by green, white, pink and yellow within a stark black outline. Often, mirrors are worked into the pattern and set in a ring of blue, with embroidered white lines radiating from them, creating motifs that resemble the sun. Kharak bharat motifs are limited and sometimes human figures are rendered in chain stitch. Popular designs include *bewari kharak* and *ghinghro wali kharak*.

Khambhiri

Line and backstitch is used to form geometric designs in a light embroidery known as *khambhiri* in Rajasthan. Beautifully executed, this embroidery produces an identical effect on both surfaces of the fabric. Here, simple stitches in cotton thread create silhouettes in various shapes on fabric. Square, rectangular and floral motifs are created by enclosing their outlines on the ground cloth. These designs often have religious significance.

Moti bharat

Moti embroidery or beadwork is a remarkable feature of this region. It stands apart from other styles in that the beads are not sewn on to cloth, but fashioned directly into articles using the tri-bead method.

Vibrant coloured beads are strung together, three at a time, with needle and thread, the designs woven in such a manner as to form a solid base. White

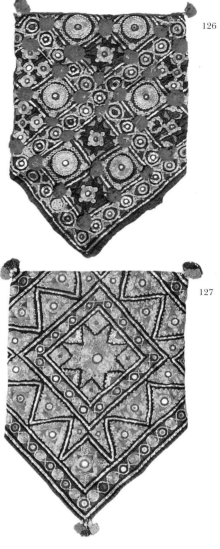

*120.(Previous page): **Kanchla. Pakko bharat** with mirror work. The lower edge has a **dak-mutarna** border, while the top is embroidered with the circular **kemai-ro-gul** and stylised peacock designs.*

*121.(Previous page):**Kanchla.** Red **tul** fabric embroidered with gold and silver **mukka** in the centre and **suf bharat** on the sides. The motifs used here are the 'peacock on a roof- top' locally called **kot, mor, pakhri** and **mugat**, worked in the **suf** style.*

*122. **Chakla** worked in **pakko bharat**. Barmer. This embroidered square piece is used as a wall hanging on special occasions. It also serves as a cover for ceremonial gifts.*

*123. **Animal trapping embellished with pakko bharat**. Barmer. The head covering for animals, with slits for the horns and eyes not only protects and decorates, but also serve to identify the owner and show off his wealth as well as the artistic talent of the women of the household.*

*124. **Jat woman.** Barmer. She wears a **petivali kanchli**, blouse, embroidered in the **kaccho bharat** style. Around her neck are the ornaments **kanthi, timania, phul, sanger, hamel** and **badla.** Her upper arms are covered by **madaliya** and **chud.** A **nath** adorns the side of her nose. In her ears are **totia** and **jhumka** and a **bor** hangs on her forehead.*

*125. **Mohra, decorated bridle for a camel.** Jaisalmer. Buttons have been cleverly worked into the embroidery to create a pattern.*

*126-127. **Bujaki.** Barmer. Small purse. Square piece embroidered in **mukka** technique with three corners folded towards the center. A tie-cord with pompom is attached to the fourth corner. The article is a gift for the groom.*

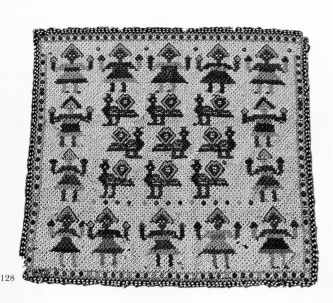

128

129

130

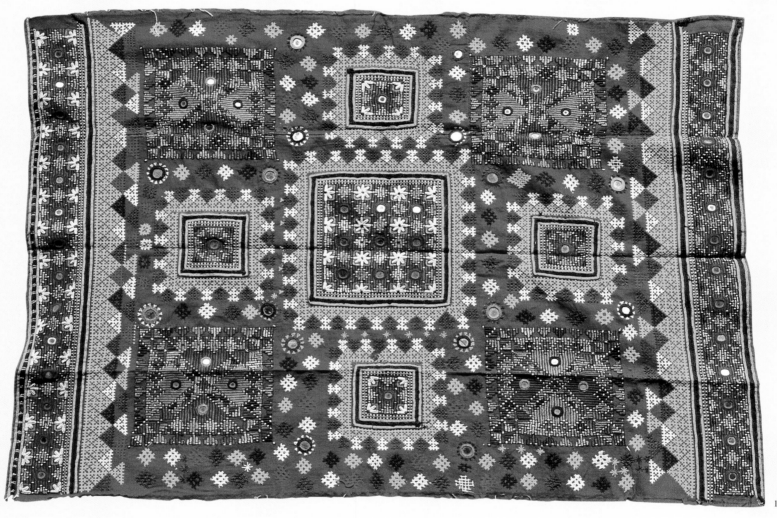

131

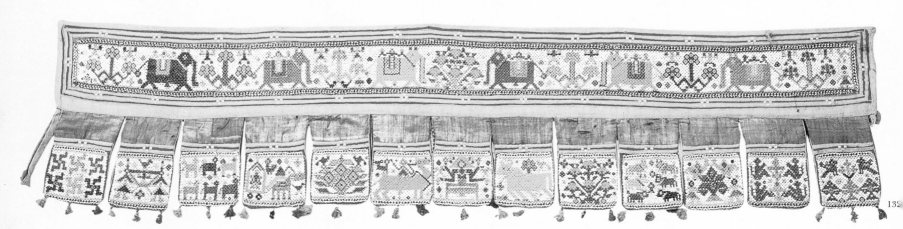

132

beads create the background, while multicoloured beads are added to highlight the motifs. These beads are elongated or compressed, leaving no gaps in the end-product. The beads are translucent or semi-translucent in a range of colours that include white, blue, green, red and black. Colourful and extraordinarily beautiful patterns thus emerge. Commonly used motifs include parrots, elephants, human and divine figures, floral designs and the svastika. Some beautiful pieces like the *toran*, i.e. threshhold hangings, fans, bags, pouches and mats are created in this embroidery.

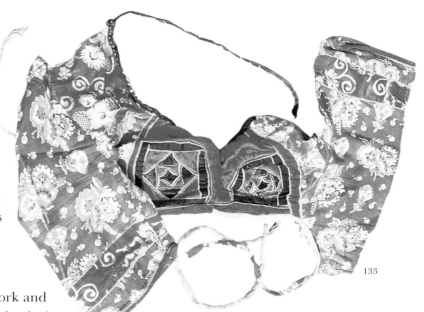

133

Patchwork and Quilting

Among Rajasthan's many unique textile crafts, its patchwork and quilting are renowned. These techniques are employed in the devising of a range of articles, from apparel to soft furnishings. Of all these items, the *ralli* or quilt, is best known. The ralli is constructed from white material, the top layer of which comprises new fabric. The lower folds that are not visible are made with material from old garments, an excellent example of the thrifty nature of the artisans. The ralli is appliquéd in decorative designs with coloured sections and cutout patterns. A cutout border is tacked along the margins and delicately worked tassels of cotton, silk and sequins are attached to the four corners. Vibrant colours are used for the ground fabric. The inspiration for this craft comes from the values of thrift and prudence, espoused by the people of Rajasthan. Here, every available bit of fabric is utilized and recycled to create objects that are, at the same time, appealing and functional.

134

This craft primarily uses two techniques. The first is patchwork—in which geometric pieces are joined together with a running stitch. A plain fabric then backs the patchwork and it is quilted in straight lines with a simple running stitch. Articles such as floor spreads and camel trappings are made with this method.

In the second technique, pieces of fabric—shaped in geometric, floral or animal forms—are cut, hemmed and appliquéd to large pieces of brightly coloured fabric. This technique is used in the fabrication of articles like the *chandani* or canopy.

Mochi Bharat

Mochi bharat or leather embroidery is a style common to most parts of this region. It was originally developed to ornament leather objects and is seen on shoes, animal saddles and trappings. In addition, gold and silver zari is employed on accessories like leather belts, bags and wallets.

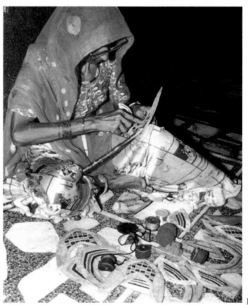

135

Usually, soft leather is used, as it is easy to work on. More recently, however, mochi embroidery has also found its way into the decoration of textiles like cotton, silk and velvet. Rajasthani women are often seen in a ghaghra and choli ornamented with this style of embroidery.

Mochi bharat is executed in fine chain stitch. Simple line patterns of leaves and flowers are created in zari thread. In the villages, bolder patterns are preferred, where the entire surface is covered with brilliant colours and the design is highlighted through contrasts. The design is often cut out on paper and then pasted on to the surface to guide the embroidery. In other cases, motifs are block-printed on the material with fugitive dyes, before it is embroidered.

128. **Chakla.** *Barmer.* Square wall hanging for special occasions. **Moti bharat**, with dancing girl and peacock motifs. The beads are strung together with a needle and thread, in the tribead technique.

129. **Thalphosh.** *Jaisalmer.* Cover for gifts. It is embroidered in the **khambhiri** style, using cotton thread on cotton fabric. The geometric designs are worked in line and back stitch.

130. **Bujaki.** *Barmer.* Small purse worked in the khambiri technique. Cotton thread on cotton fabric, incorporating pompoms.

131. **Wedding shawl.** Cotton thread on cotton fabric. The shawl is embroidered in **kaccho bharat**, incorporating mirrors and an interlacing stitch.

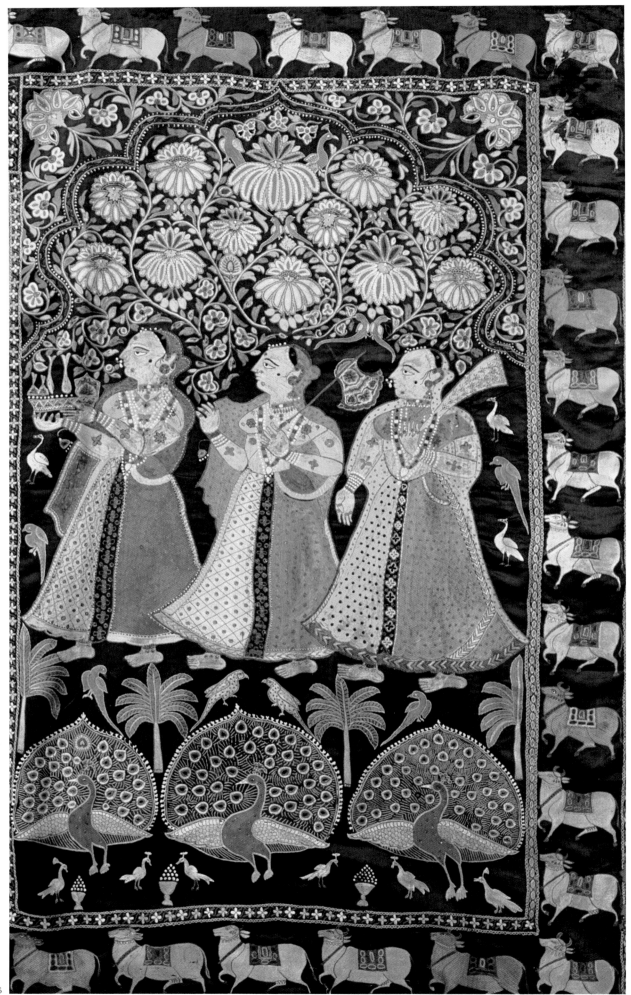

136

The artisan uses an implement called the *ari*, an adaptation of the cobbler's awl to execute the embroidery. The ari has a notch incised just above its point to form a hook resembling a crochet needle.

The hook pierces the material and a loop embroidery of thread is drawn up. Repeated hooking and pulling of the thread forms a chain stitch, which is used for outlines and a backstitch is seen on the reverse. The motifs are filled with satin and herringbone stitches. Couching is also used in some portions.

Sometimes, silk floss and cotton threads are employed for mochi embroidery. When done on a *juti*, the middle of the shoe upper is treated as a division for the pattern and a mirror image embroidered on either side. The adaptability of the chain stitch allows the artisan a free hand in the design. As a result exquisitely rendered examples of intricate motifs of birds like parrots and peacocks can be seen in this style of embroidery.

There are two types of religious embroideries, the pichvai and Jain embroidery, which are executed in mochi bharat.

Pichvais are pictorial, narrating a legend or an incident from the life of Lord Krishna. Richly coloured cotton, satin or velvet have been used for making these altar clothes. In keeping with the changing seasons, velvet and satin pichvai are used in winter, while cotton is hung in the summer months. Usually, silk or cotton threads in bright red, green, yellow and orange as well as darker shades are used for embroidering a red, purple, blue or white ground. The face of Srinathji, an incarnation of Lord Krishna, is always depicted in blue with a black outline. In patchwork pichvai, green, yellow, black and white threads are embroidered on a red background, the whole work being offset with an outline of white cord. The designs worked on pichvai select and depict events from the Rasmandala, Krishnaleela and Gokulvana, all epics on the life of Krishna.

The embroideries that are offered at Jain shrines reflect the ideology of Jainism. Satin fabrics in red, indigo, blue or violet are used as a base and are embroidered with silk threads in colours of red, yellow, white, green and blue. It is not uncommon to find Jain embroidery embellished with gold and silver metallic threads. The images in such embroidery depict themes based on Jain philosophy, such as the *mandala*. The mandala is a representation of Jain beliefs and concepts, depicting the Lord Mahavira as the centre of the Universe, surrounded by the gods and goddesses in the heavens. Pali, Jaipur and Churu continue to be the finest centres of Jain embroidery.

Our master weavers, dyers, printers and embroiderers are the custodians of a resilient yet fragile tradition. They have provided continuity in the history of textile design, creation and ornamentation. Modernization has made both beneficial and, at times, detrimental inroads into their craft. In order to sustain any craft and maintain its quality, it is important that the product be well marketed and economically viable for the craftsmen. Financial incentives are important if the quality of our traditional crafts is to be maintained. Above all, the craftsmen must be accorded their due recognition and respect for preserving these rare and precious crafts and keeping alive our rich and colourful heritage.

137

132. (Previous page): **Toran worked in *moti bharat.*** *Barmer.* Door hangings are considered festive and sacred. Three beads are interlinked in a tri-bead method to work out the design in rows. They incorporate auspicious motifs like the *svastika* which are used to welcome good fortune and ward off evil.

133. (Previous page): **Kanchli.** Upper garment in cotton, generally worn by married Bishnoi women. The ***tuki*** or breast-piece is worked in appliqué.

134. (Previous page): **Mochi pounding on leather to make *jutis.***

135. (Previous page): **Woman embroidering leather.** She uses a crewel and thread to create chain stitch patterns.

136. **Embroidered *pichvai.*** Altar cloth with *mochi bharat* embroidery.

137. **Ornamental doorway decoration.** Beautifully worked in *moti bharat* embroidery it is an auspicious symbol suspended on doorways. Motifs like parrots and peacocks signify prosperity and happiness.

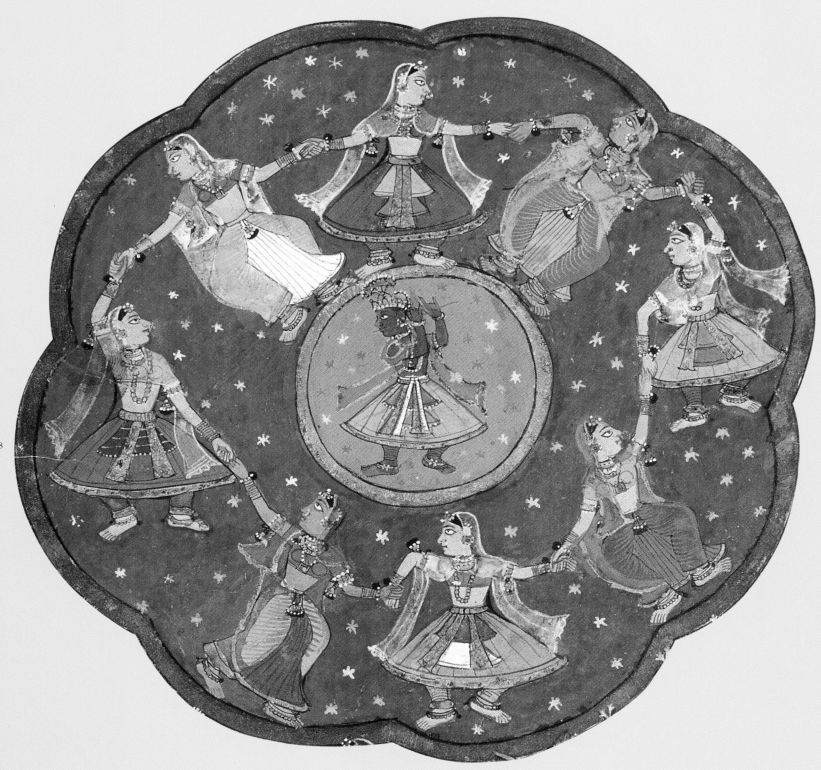

138

Stitched and Unstitched Cloth

"In some parts of Rajasthan, a single coloured odhni tells that the girl has not yet reached puberty, a large bandhni circle on one corner of the odhni, thereafter states that she is married; and a single large circle in the centre, in bright red, tells that she now is a mother-and suddenly, the colour deepens, the circles become shadowy; she is a widow. These concepts of form, colour and ornament are an integral part of the heartbeat of oral thought and tradition".

Martand Singh

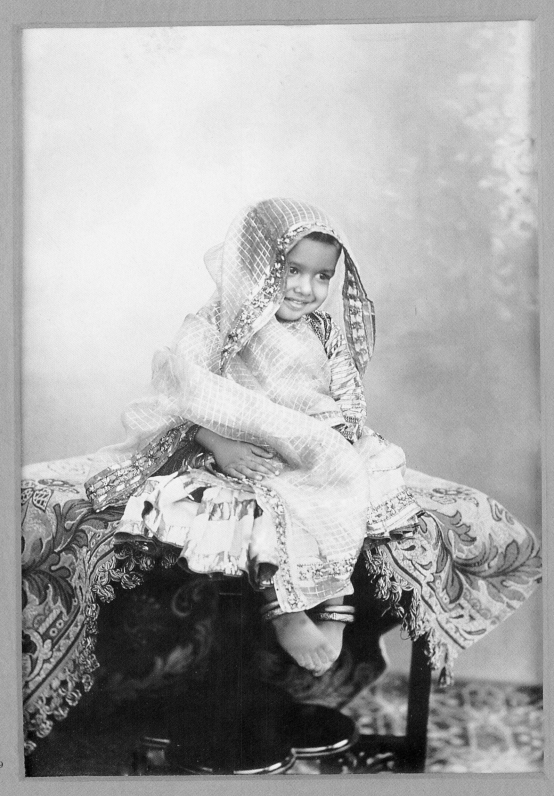

WOMEN'S COSTUME

The women of Rajasthan, much like the region itself, are surrounded with colour and tradition. This is reflected in the vitality of their dress and ornament. For centuries, the ensemble most commonly worn by the women in Rajasthan has been a combination of an upper garment (the *puthia*, or *kanchli* and *kurti*), a lower garment (the *ghaghra* or skirt) and the veil (*odhna*), draped to flow across the upper and lower parts of the body. There are numerous variations and additions to this ensemble across and within communities, depending on the wearer's social position. However, these three items of dress comprise the essential costume typically worn by women in Rajasthan even today.

The most important factor that determines variation in a woman's costume within a community is her marital status. Bright colours, heavy ornamentation and rich fabrics are associated with marriage, fertility and the prime of a woman's life. In sharp contrast, a widow's attire, though similar in style, is dull in colour and lacks embellishment, emphasizing abstinence. Numerous variations in style, cut, colour and embellishment are clearly visible in the various communities in Rajasthan.

Styling of dress is also an indicator of social disparity. For instance, the Rajput women, who belonged to the highest social order, traditionally followed the parda system where women's movements were, by-and-large, limited to the *zenana*. Their costume, in the privacy of the women's quarters, could be elaborately decorated and free of restriction. Their ghaghras were fairly short exposing beautiful leg ornaments, as portrayed in numerous paintings. However, as the parda became outdated, women's attire saw corresponding changes to ensure the preservation of feminine modesty in public places. Therefore, the length of the ghaghra was increased to avoid exposing any part of the leg and feet. The present day Rajput ghaghra now trails on the ground. In contrast, many women who work in the fields, wear ghaghras which end about 10 cm. above their ankles, as dictated by their occupation. They also wear leg and ankle bracelets, not just for adornment, but also as protection against brambles and bites as they walk through the fields.

Puthia

In Rajasthan, newborn babies, young unmarried girls, elderly women and widows wear the puthia as an upper garment. It indicates the nonfertile, sexually inactive phase of a woman's life. Therefore, the puthia is discarded only after the girl attains puberty, even though she may marry in the meantime. This is, especially so, in case of child marriages where the bride goes to her marital home only after the onset of puberty. It is worn among all Hindu communities with minor variations in style and construction that are indicative of the community to which the wearer belongs.

The puthia is akin to the angarkha, especially its shorter version, the *angarkhi* and is similar in construction. The antiquity and indigenous origin of these garments is evidenced from the roots of the term angarkha, derived from the Sanskrit: *anga*—body and *raksha*—protection. Usually unbleached, hand-woven khaadi cloth is used to construct this garment though some communities may also wear printed cotton, brocades and plain coloured fabrics.

The puthia is a double-breasted garment with the upper flap crossing over the right side and tied with a cord under the left armpit. The entire length of the garment is constructed from a single piece of fabric. So there are no joints

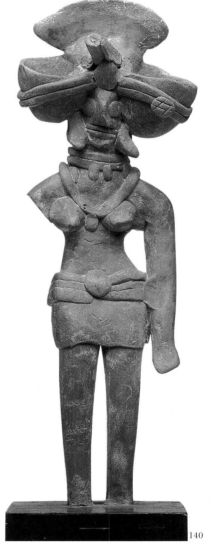

140

138. (Previous page): **Painting depicting** ***rasamandala.*** *National Museum (17th century).* Krishna dancing with Gopis.

139. **Rajput princess**. *Bikaner (c. 1905).* Bai Saheb Chand Kanwar of Bikaner, wears a **Kota doria odhna** worked with **zardozi** embroidery along its border, and a satin **ghaghra** with **gota** appliqué. Her heavy anklets are visible under the **ghaghra.**

140. **Terracotta mother goddess.** *Indus Valley civilization (2500 B.C.).* A short wrap on the waist is secured by three bands. It is fastened with a medallion in the front. The headdress is fan-shaped, and around the neck is a double necklace with four pendants.

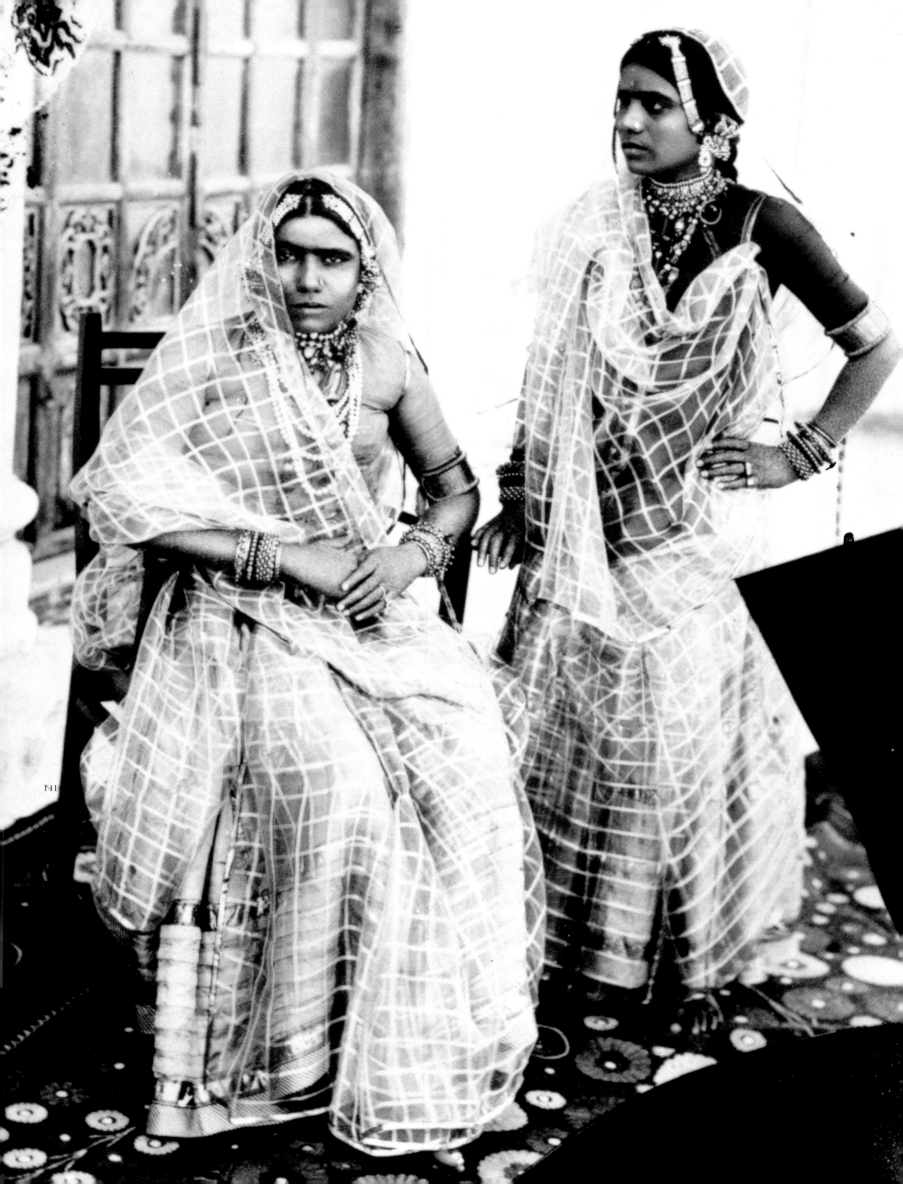

at the waist and the garment ends gracefully at the hips. The sleeve-length may vary from short, elbow, to full-length. Though the garment is usually white, contrasting piping or *magazi*, generally in red poplin, is sewn along the edges.

The harsh landscape and scarce resources of a desert environment has taught rural communities in Rajasthan to be prudent, a quality evident in their judicious use of cloth. For instance, the pieces of the puthia are cut in geometric shapes—squares, rectangles and triangles—to minimise wastage. These are the most economical shapes and the style is reminiscent of patterns from the earliest times. The puthia is constructed of two front panels, one front extension, one back piece, two sleeves, four side panels and two gussets. The opening is in the front (centre), with one to three buttons or ties. The neck is deep, shaped like a horseshoe, with its widest portion over the chest. An inner flap or parda covers the chest with a high round neck, and fastens on the inside of the right shoulder with a loop and cloth button. This flap is also held at the waist with cloth tie-cords and is further attached to the seam, which runs along the side.

The back is plain and cut straight, with hardly any shaping. Contours are added to the front and back by the addition of flared side-panels. These side-panels are left partly unstitched at the lower ends of the side seams, to form slits for ease of movement. The puthia sleeves fit into a square or slightly circular armhole and taper towards the hem. The shape of the sleeve at the armhole may be either slightly elliptical or straight. Fullness and shape under the armhole come from the use of triangular gussets known as *khankhi*.

The neck, centre-front, side-slits, hemline and sleeve edges are trimmed with bias binding, approximately 2.5 cm wide. This bias is attached on the double. The fabric is turned, with the fold on the outside and the two unfinished edges stitched into the garment. This type of facing is also used to demarcate the upper and lower portions of a woman's attire and is appliquéd by topstitching at the chest portion of the puthia. Most of the joints are closed and finished with clean seams leaving no raw edges on the inside, which makes this hand-stitched garment extremely comfortable.

The application of colour is also strongly indicative of the community and social order of the wearer. A newborn wears a red puthia with green piping but among most communities, after the child's first Holi, the festival of colour, the colour of the garment changes to white. An unmarried Bishnoi girl usually wears the traditional white *pichodi* with red piping, while Jat girls sometimes dress in printed red chhint with small floral designs. The unmarried Rajput girl wears a puthia of cotton, satin, brocade or velvet in yellow, pink and white and, sometimes, red fabric with small green motifs.

142

141. **Dancing girls.** *Jodhpur.* Dressed in traditional ensemble of **kurti-kanchli, kalipatti-ghaghra** and **odhna. Gota** is used to ornament the dress, and the women are adorned with jewellery.

142. **Puthia.** Silk with blue and yellow **magazi**. Young girls and older widows wear this double-breasted upper garment. Married women in some communities also use the **puthia.**

Kanchli, Choli, Angia

The kanchli is an upper garment worn by married women in most Rajasthani communities. Sculptural depictions of a stitched upper garment in India suggest that its usage began around the beginning of the Christian era. Until then, the upper part of the body was probably left bare or covered with a simple, unstitched length of fabric. Sculpture, paintings and early Sanskrit litera-

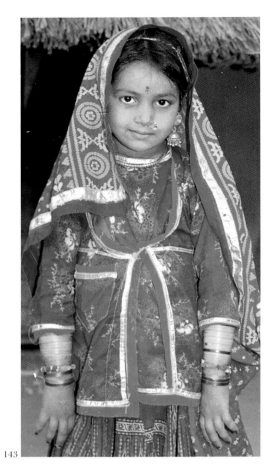

143

ture abound with references to a piece of cloth of varied description and width that was simply or artfully tied around the chest. In Hindu tradition, a stitched garment was considered impure and even today, especially in rural areas, the practice of draping unstitched cloth as an upper-body covering continues specially at marriage ceremonies and religious occasions. Among some tribals, the upper garment is a contemporary addition to their costume. Until recently, the brides of the Maheshvari community wore a very simple wedding dress, where the body was wrapped only in a white sari. It was called a *kavaljoliya*, like a kamal (lotus) flower, and no stitched garments were used for the marriage ritual.

It is likely that the Saka, Kushana or other tribes from the colder parts of Central Asia were responsible for the introduction of stitched bodices. Initially it would have retained its original character but as it was assimilated into daily wear, the garment was adapted to suit Indian climatic conditions and sartorial tastes.

The Gupta period saw the introduction of the kanchli, a small bodice with sleeves. In Sanskrit literature this garment is referred to as the *kancuka, kanculika, kurpasa, kurpasaka, choli and angia*. It was adopted by women in northern and western India and became a common feature of their attire, especially in the region that is now Punjab and Rajasthan. It continued to be worn through the medieval era and it is still the upper garment of a married woman in Rajasthan and neighbouring states.

Among most communities in Rajasthan, a girl changes her puthia for a kanchli only when she is married. This is done after completing the fourth *phera*, the fourth of the seven circles around the sacred fire in the traditional Hindu wedding ceremony. Although kanchlis are sometimes made in other fabrics like silk, satin and even velvet, cotton is the preferred fabric throughout India–and with its scorching summers, Rajasthan is no exception.

The fascinating choli or kanchli fits snugly on the curve of the breast. It is the finest example of the technical grasp of the moulding of a flat two-dimensional material, the fabric, to the contours of a three-dimensional form, the human body. Like the puthia, it is produced using geometric sections of cloth. The few scraps of fabric that are left over after the garment is cut are used as trimmings, demonstrating, once again, the thrifty nature of these people. Enclosed seams that have no raw edges on the inside give the kanchli additional strength and prevent abrasion of the tender skin at points of contact. The cutting and construction of the garment supports the breasts and gives the body a pleasing silhouette. The garment is designed to enhance–and thus draw attention to–what is generally considered to be one of the most beautiful and seductive parts of a woman's body.

The kanchli usually has a sweetheart neckline, with three or five points. A high round neckline with a V shape in the centre is also worn. Most kanchli, however, have deep revealing necklines. They are only slightly wider than the modern brassiere and

144

are functionally similar. The length of the sleeve varies depending on the ethnic group. Most communities wear a sleeve length, which covers the biceps on the upper arm and, occasionally, a kanchli can also have elbow or full-length sleeves. The selection of ornaments that accompanies such attire also determines the design of the garment. For example, a kanchli with short sleeves does not necessarily mean that the arms are left bare. In many communities, the entire arm is covered with the *chuda*, bracelets that cover the entire length of the exposed arm, proclaiming the wearer's marital status.

The cords attached to both sides at the back allow for minor changes in body proportions. Tying the strings loosely or tightly accommodates pregnancy, lactation or changes in weight. This makes these garments extremely practical. The tie cords, made of wool, cotton, coloured thread or strips of fabric, are very attractive. They can often be long, touching the hem of the ghaghra, with tassels at the ends. The tassels are decorative, worked with beads, shells, gold and silver threads and mirrors. The cords sway with the movement of the body, adding grace, beauty, motion and, sometimes, even music to the step.

As the kanchli is revealing, it is usually worn either with an odhna that drapes across the front and the exposed back or a kurti and odhna which covers the torso more completely. At times a small rectangular piece of fabric is stitched to the centre of the hem to cover the belly. This is known as a *peti* and such a garment is a *petivali* kanchli. The size of the peti is indicative of status. The longer the peti, the more rigid are the concepts of modesty and the higher is the status of that community. In the princely courts, a woman could not enter the women's quarters in the palace, the zenana, without a petivali kanchli.

The *tuki*, a triangular piece of cloth at the breast is especially ornamented. This is usually in a contrasting colour, with gold or silver bands, rickrack or other forms of embroidery. Trimmings on the upper and left parts of the kanchli are more elaborate, as these portions are visible, the right side being concealed by the odhna.

Red is the predominant colour of the prints used for kanchli. Other colours are introduced in the form of piping, which is attached as an edging and between the sections of the blouse to make the garment vivid and colourful. The width and colour of the bias varies a great deal, according to its symbolic implications for the community and reflect social status. For example, a fine saffron trim normally represents the marital status of a woman and is incorporated only in the kanchli of a married woman. The saffron fabric is stretched at the time of stitching, so it appears as a narrow roll. The piping protects the edges of the blouse from

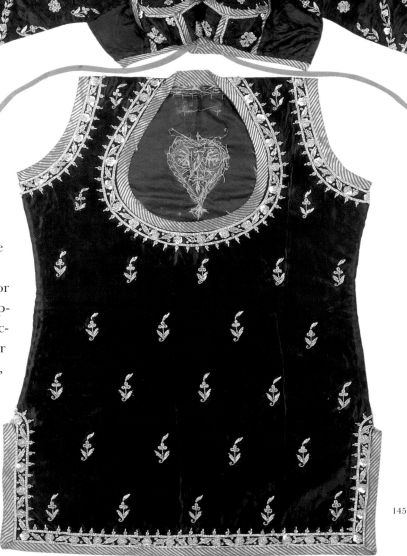

143. **Young Rabari girl.** *Barmer.* She wears a printed double-breasted ***chhint puthia***, a ***katari-bhat kalidar ghaghra*** and a printed red ***chunri***. All the garments, in cotton, are edged with ***magazi*** and ***gota***. She wears ***muthia*** on her arms and ***jhumka*** in the ears. Around her neck is a ***hansli***.

144. **Young girl.** *Balotra.* Her upper garment is the ***puthia***, worn with a red ***chhint printed chunri*** or veil. It is decorated with embroidery and edged with ***magazi***. A ***hansli*** adorns her neck and she wears a ***muthia*** on her arms.

145. **Kanchli and Kurti.** *Bikaner (c. 1920).* Upper garments for married women. Worn by a Rajput woman, the set, made of velvet is embroidered in ***zardozi*** and edged with a striped ***zari*** fabric.

145

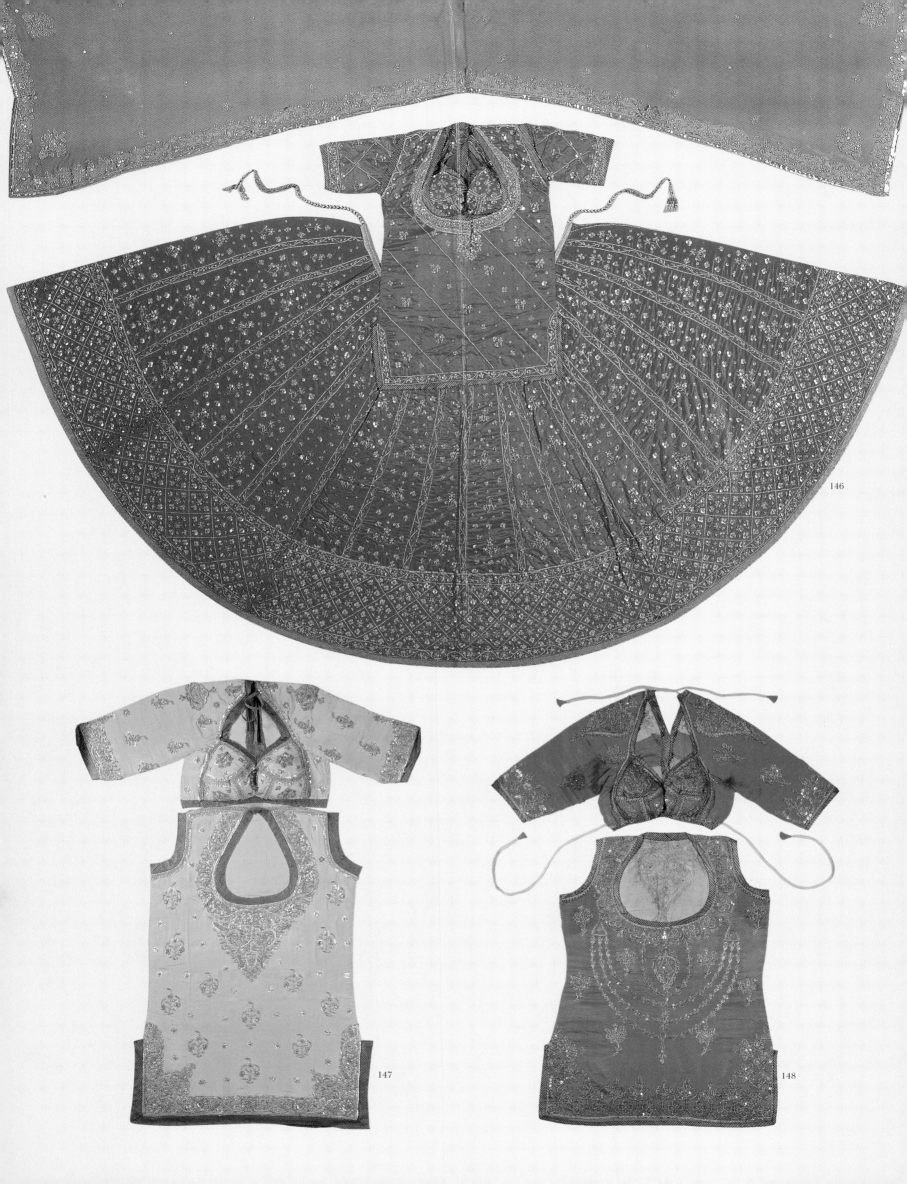

146

147

148

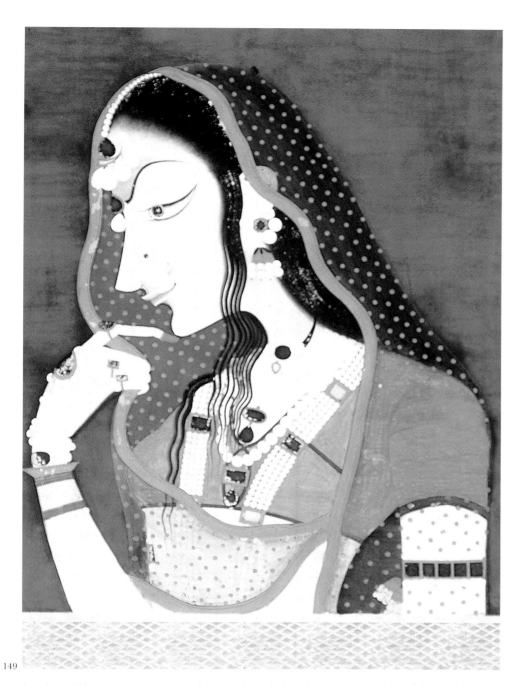

149

fraying. Often, a second much broader piping is set on the kanchli, which may be in red, green or blue.

Regional variations may be found in the dress of the same community. When people live together they tend to influence each other's lifestyles. This is most evident in their everyday attire. For instance, the Sindhi Musalman women wear a knee length kanchli, embroidered with mukka work, as their only upper garment. The Meghval, who are a Hindu community and have traditionally lived near the Sindhi Musalman, are influenced by their way of life. This is apparent by their embroidered kanchli or kanchla, which fall below the hipline.

Kurti

The kurti is an upper garment worn with a kanchli. However, it is not seen in early paintings or sculptures and seems to be a recent trend, perhaps, not more than 200 years old. In the earliest paintings, for example, of the *Banni-Thanni* of Kishangarh, only the kanchli is seen. It was possibly under the expanding power and influence of Mughal rulers that it came to be

146. **Rajput woman's ensemble.** *Bikaner (c. 1910). **Kurti, kanchli, odhna** and **ghaghra**, in silk with zardozi embroidery.*

147-148. **Rajput woman's upper garments.** *Bikaner (c. 1920). **Kanchli** and **Kurti. Zardozi** work on a silk base. The motif on the **kurti** simulates a necklace pattern.*

149. **Radha.** *Kishangarh. (c. 1735-57).* The Kishangarh Radha is believed to have been modelled on Banni-Thanni, a singing girl who was romantically involved with Samant Singh, the ruler of Kishangarh. Her **kanchli** is distinctive and a diaphanous veil, printed in gold tinsel, covers her head. Radha's jewellery shows a profusion of pearls. A **tika** hangs on her forehead, there are **jhumka** with chains in her ears, a pearl necklace and **chandanhaar** round the neck. She wears a nose ring, and on her arms are a **bajuband** and bracelets.

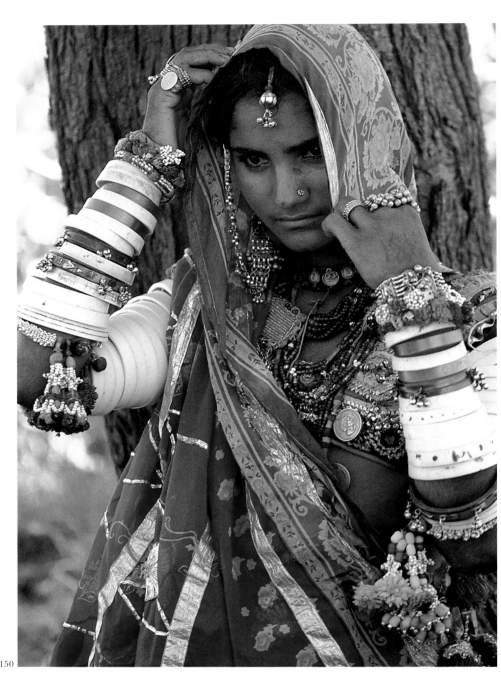

150

considered immodest to reveal so much of the upper body and women started wearing a kurti. However, in all walks of life the angia or kanchli is still preferred for daily use. In Rajasthan, only married women are required by tradition to wear a kurti. Amongst the Rajput, a widowed woman rarely wears the kurti.

The kurti is usually a sleeveless garment with a deep, horseshoe shaped neckline. Since the neck is large, most of the kanchli worn underneath is exposed. Bias binding is sewn around the armhole, neckline, side plackets and hem, enclosing the raw edges and adding colour. Variations in the construction of the kurti exist among different communities. For instance, the kurti worn by Bishnoi women has side slits and a deep neckline that reveals almost all of the kanchli. The Jat kurti is front open, much like a jacket, where the left side has an extension for an overlap over the right. Piping is added at the edges with a string holding the overlap at the side seam and the front is fastened with buttons and loops. On the other hand, the Rajput kurti has no centre-front opening and is slipped over the head.

Ghaghra

Early Indian literature, speaks of the *bhairnivasini*, a skirt like garment, which evolved from the antariya, a simple tube-shaped garment. This was stitched on one side, gathered and held at the waist by a girdle. Women wore it as a lower garment. It later evolved into a skirt with a drawstring called the *ghaghri*. The ghaghri was a narrow skirt, made from five and a half metres of fabric - the same length as the original antariya. Representations of a similar garment can be seen in Buddhist sculptures and paintings dating from the Kushana or early Gupta period. This was probably the prototype of the modern ghaghra.

The skirt in India is known by many different names, depending on the regional style, the most popular, by far, being the ghaghra. Other names in literature for the woman's lower garment are *ambara, amsuka, antariya* and *jaghanamsuka*. Another term used was the *lehanga*, a compound of the Sanskrit words–*lanka* (waist) and *anga* (body or limb). The lehanga is generally associated with a panelled skirt that is narrower than the ghaghra. However, there are no rigid definitions and the terms have found a more generic usage. This and other styles of the skirt are very popular in North India.

Changing fashions and foreign influences probably transformed this straight, simple garment into a full panelled skirt. Regional differences developed, with variations in length and the number and shape of panels, which were either rectangular or triangular. The most voluminous skirts could be made up of over 20 metres of cloth. It was the flare that made the ghaghra such a sumptuous garment–and one so captivating that it was celebrated both in poetry and art.

From the fifth to sixth century A.D., the ghaghra came into common use. It is now worn in all parts of the country, but the ghaghra's most prevalent and varied form is seen in Rajasthan and its neighbouring states. It is almost always worn with a kanchli and odhni. Sometimes a *patka* or *phetiya* is worn as a centrepiece over the ghaghra to control its volume and fabric. This prevents any random movement of the ghaghra that might expose the body. It is distinct in colour and decoration than the ghaghra and indicates a high social status. It is seen in early Rajput paintings and sculpture and was essential wear for women entering the royal *zenana*.

The ghaghra is really a long skirt, which has the construction of a simple gathered skirt or a flared gored skirt. It covers the legs fully or partially, depending on the norms of propriety among different ethnic groups, although a long ghaghra usually relates to a more puritanical modesty.

The flare of the ghaghra has inspired much romance and passion in the works of folk singers, poets and painters alike. *Gherdar, ghumerdar ghaghra, assikali ko ghaghro, kali kali ma gher* are lyrical expressions from folk songs, describing the beauty of the ghaghra worn by the female protagonists. The central figure in Rajasthani paintings is always shown wearing the most voluminous embellished ghaghra. Expensive fabric, exquisite embroidery and other ornamentation reflected the wearer's high social status. Also, the greater

151

150. **Village woman.** *Ajmer.* She wears a highly ornamented ***kanchli***, and a profusion of jewellery. The ***chuda*** on her arms with woollen tassels, her neck and hand ornaments, all indicate her married status.

151. **Rajput woman's *kurti*.** *Bikaner (c. 1930).* ***Zardozi*** embroidery on gossamer-fine silk.

the volume, the more fabric the woman had to contend with, so it was indicative of her physical strength and affluence. To accommodate the fullness of the figure and the flare of the skirt, a horizontal line was stitched along the hem. This was known as the *seva*, a tuck in the fabric, so that the skirt fell evenly to the ground. This also enabled its length to be altered as and when required, keeping the garment in use for long periods of time and possibly even allowing it to be passed down through successive generations.

The *kalidar* ghaghra is the most popular of these skirts. It is a long garment with numerous vertical pleats. It is like a gored skirt in construction, each gore being a triangular section, known as a *kali*. A large number of kali are sewn together to form a ghaghra, which flares at the hem. The size of each panel varies between communities but is most commonly 5 cm. wide at the apex and 20 cm. at the base. When extra fullness is required at the waist, the panel is cut 10 cm. wide at the top. The number of panels in a ghaghra may vary from 20 to 100. As much as two bales or 20 meters of fabric can be used in a single ghaghra. Among royalty and the affluent Rajputs, a *poshak*, a three-piece ensemble, was presented to the bride by her mother-in-law during the wedding. This poshak had to include a 100-panel *ghughravaat ghaghra*, which would have little gold bells sewn along its hem.

Each flared section is attached to the others on either side along its length. This cumulative voluminous flared piece is then gathered or pleated at the waist and a belt is sewn on. A belt in the same fabric as the ghaghra usually has narrow yellow piping where it is attached to the main skirt. The belt is approximately 4 cm. wide and the finished waist of the ghaghra is 1½ times the waist size of the wearer. A tape is drawn through the belt to tie it at the waist. A side opening on the left is finished with facing and is 7.5-10 cm. in length.

The lower edge of the kalidar ghaghra is finished with several bindings. A married woman's ghaghra has two bindings: a broad strip, varying in width from 2.5 to 10 cm. and finer 0.5 cm. piping. The broader piping is in different colours, red being the most popular. Sometimes, it matches the colour of the ghaghra. Saffron is used for the fine piping known as *guna*. Magazi was traditionally the prerogative of women in the upper echelons of society. As one went up the social ladder, the magazi grew broader while the less privileged used a narrow piping called got. A strip, cut 10 cm. wide on straight grain, is attached under the ghaghra all along the hem. Known as *phervaj*, this edging is made with red unbleached cotton. It serves to finish the two pipings and also adds weight and strength to the garment. The drape and fall of the ghaghra is thus enhanced. Traditionally, the kalidar ghaghra is handstitched with plain seams.

The *pat ghaghra* is made of several rectangular panels of fabric, which are sewn together. Gathers or knife pleats are sewn in at the waist to give the skirt fullness. The finishing of the skirt is the same as the kalidar ghaghra.

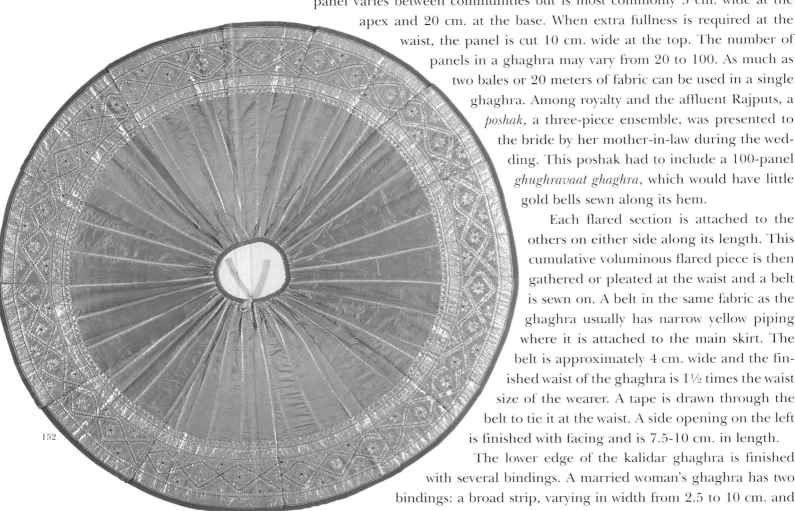

152

152. Kalidar ghaghra in satin silk. It is embellished with *gota* appliqué and a red bias edging.

153. Young Rajput girl. Bikaner (c. 1920). She wears a shirt over a *kalipat ghaghra* with a gossamer *odhna.* On her head can be seen a *mathapatti* and *bor.* Around her neck are a *gulband haar* and long necklace with a *kundan*-work pendant. Her wrists are covered in a variety of ornaments, including a *gajra.*

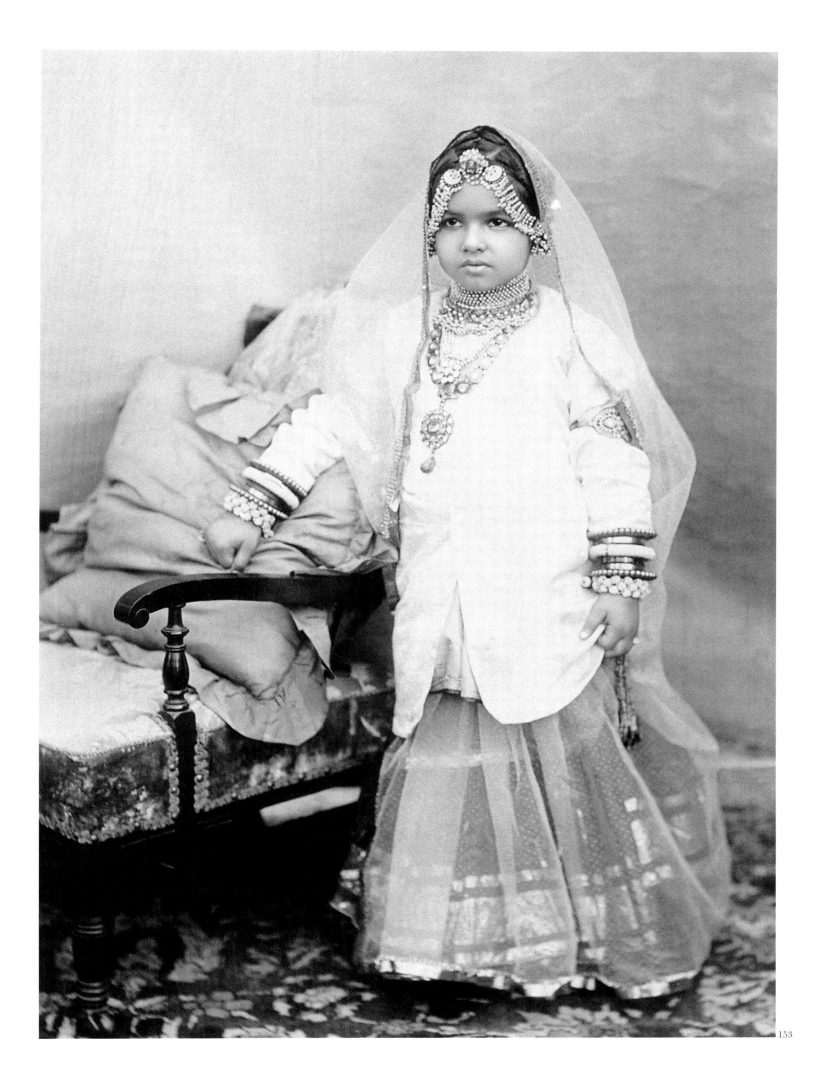

153

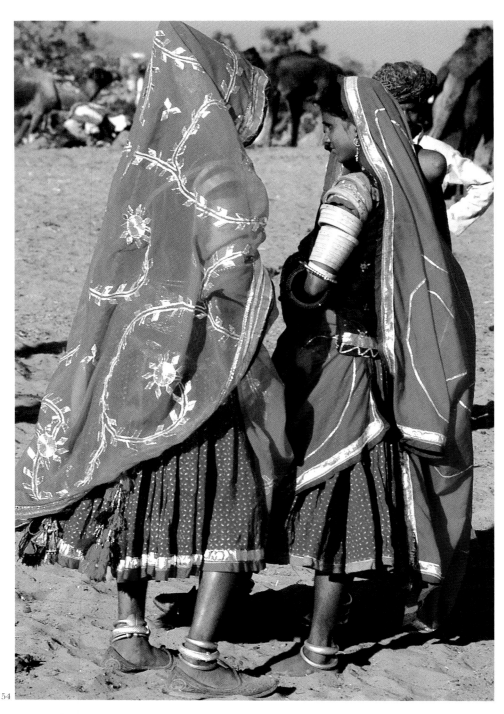

154

Generally, silk or satin is used for the pat ghaghra, which is heavily orna-
mented with metal embroidery. Satin and silks are fabrics that tend to fray eas-
ily but are still used to make pat ghaghra as the construction of this skirt
requires larger pieces of fabric.

Elderly women and widows wear the pat ghaghra. This may be due to the
fact that less fabric is required to make them and they are less ornamental.
Although among certain communities such as the Maheshvari, pat ghaghra is
the norm and used for festive, ceremonial and everyday wear.

The *kalipatti* ghaghra is a combination of the kalidar ghaghra and a
straight length of fabric. The top half of the ghaghra is made of panels,
whereas the lower portion is a straight piece. This facilitates movement and
makes it very comfortable to wear. The kalipatti is less unwieldy than a kalidar
ghaghra and also more affordable. It is commonly worn among Jat, Bishnoi
and Rajput women.

The *dhabla* is worn by women of the Jat, Bishnoi, Gujar and Kumhar com-

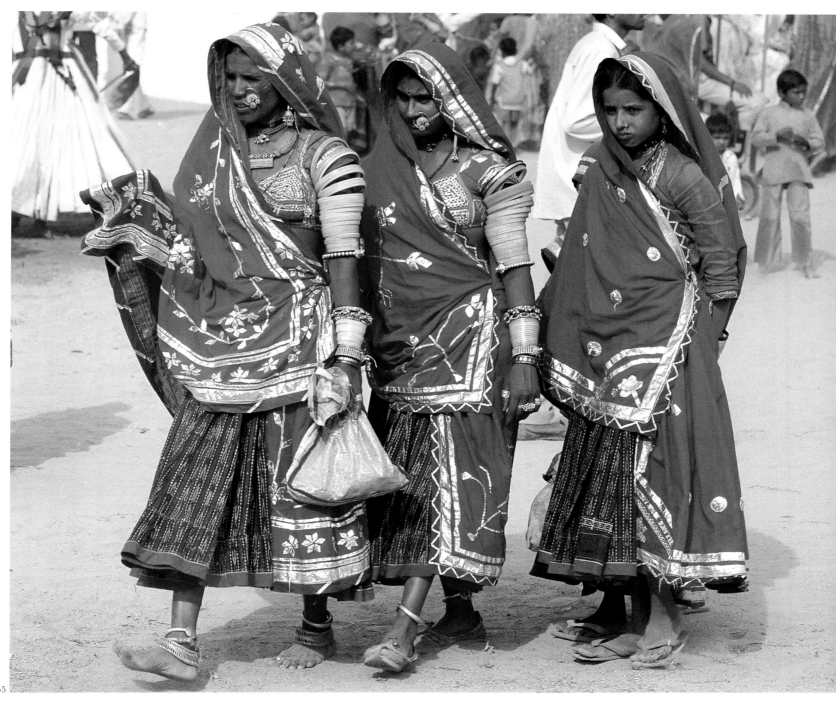

munities and is essentially an unstitched length of narrow width fabric. It is also known as a *saadi or ligra*. This fabric is woven in a technique similar to that of pattu weaving. Two narrow strips, which are woven on the pit loom, are joined along the length such that the selvedge is visible on the lower and upper borders. The length in between forms the height of the garment.

A single length of thread is used to create gathers at the waist by hand tacking. The thread is used to pull the skirt tight around the waist and a cord is wrapped around to secure it. This goes around several times and is long enough to hang down one side, touching the end of the ghaghra. This cord, commonly known as a *dori*, has a diameter of between 0.5–2.5 cm. and is made of plaited coarse dark brown wool. The ends are ornamented with beads, tassels, shells and bits of coloured wool.

154. **Rabari women.** *Pushkar.* They wear short printed **chhint ghaghra**, edged with red **magazi** and **gota**. Their muslin **odhna** are embellished with **gota** work. A long braid, ornamented with beads, pompons and wool, falls to the end of the **ghaghra**. A cylindrical object braided into the hair gives the head a raised conical appearance. The women's arms are covered in **chuda**. They wear numerous silver anklets and **juti** on their feet.

155. **Village women at the Ger festival.** *Kanana.* Their cotton garments include the **kanchli** and red **odhna**, appliquéd with **gota**. A **katari bhat** block printed **kalidar ghaghra** edged with yellow and red **magazi** is worn as the lower garment. The **chuda** and nose ring proclaim their marital status and are worn along with other ornaments.

Odhna

The odhna or odhni is a veil. It represents the continuation of an unbroken tradition of wearing unstitched lengths of fabric that was the preferred style of clothing of ancient India. A whole body of Vedic literature identifies the use of the stole as a universally worn over-garment called the uttariya–a length of fabric draping the top half of the body. Early Sanskrit literature has a wide vocabulary of terms for the veil or stole, such as *avagunthana, niringi, nirangika, mukhapata, sirovastra,* and *yavanika.*

The odhna, like other graceful attire, comes alive only when it is worn. It is a rectangular cloth, 3-4 meters in length and 1.25-2 meters wide. The odhna makes an impression, not just because of the beauty of its fabric and ornamentation, but also due to the elegance of its draping. The fabric used may vary from fine voile to coarse cotton cloth, although georgette, fine silk and chiffon are also used. Of late polyester has gained popularity because of its affordability, sturdiness and easy availability.

The odhna is embellished by many techniques of ornamentation. These designs are dictated by tradition. Nevertheless, each woman vies with the other to wear a more beautiful odhna. Some of the techniques used to bring these exquisite odhna to life include bandhani, block printing, weaving and embroidery. The bandhani technique produces all sorts of stunning and colourful odhna. Numerous leheriya styles abound, some of them being *pratapshahi, rajashahi, gandadar, samudralehar* and *bhopalshahi.* Block prints also decorate the *odhni–bhindi bhat, lalar, morya, karna* and *jaal bhat* are some common patterns. A striking odhna, known as phavri or phamri, is made of fine red voile, using a modified technique of block printing called tinsel printing. Gold or silver flowers are printed all over the fabric, standing out in relief. Brides wear a phavri as part of their wedding dress.

The most common form of surface ornamentation is the use of gota. Woven bands of gold and silver produce dazzling floral and geometrical patterns. These designs are distributed mostly around the head and the end pieces. All communities use this form of embroidery.

Other styles of embroidery such as mukke-ka-kaam, suf, kharak, pakko bharat, kaccho bharat and khambhiri are also used to embellish the odhna. Certain weaves create exquisite designs on the surface of the odhna. Among Rajput, Osval and some other communities, the brocade technique is used to weave odhna, with silk threads in gorgeous colours, like bright pink and violet.

The wonder of the odhna lies in the variety of its styles of draping. In one such style, Rajasthani women pleat and tuck one end of the odhni into the left side of the ghaghra. The other end is carried under and behind the left arm, over the head from the back, onto the right shoulder, and tucked back into the ghaghra on the front left, covering the chest.

Another way is to make two to three pleats at one end, which are tucked into the left side of the ghaghra. The odhna covers the head and one end goes over the right shoulder. The other end goes under

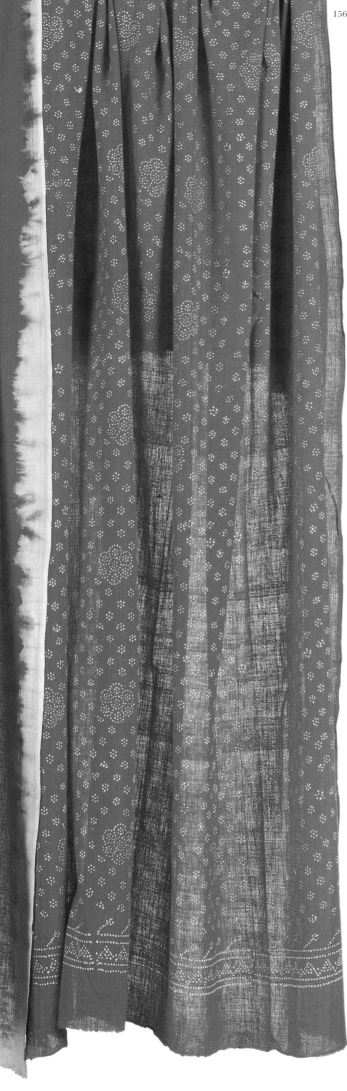

the arm, over the front of the body and tucks into the left side of the ghaghra's waistband. Rajput women draw the odhni over the head and down, towards the chin to veil their face. In some regions, they also drape a *thirma*, made of white fabric and large enough to cover the entire body.

Among the odhna, the chunri is the most commonly used. This is a tie-dyed odhni for the married woman and its loveliness is often extolled in folk songs and stories. It is usually red, with designs like birds, flowers and leaves that are set in white. Another kind of odhna is the *pila*. It has a yellow base, a red central motif and borders and is symbolic of the arrival of a newborn in the family. The lotus flower, a symbol of purity and fertility, lends its name to an odhna called the *pomcha*, which is made in bandhej and is a combination of red and yellow or red and pink. The borders and central flower are bright red on a ground of pink or yellow.

The odhna holds an important place in Rajasthani culture. Each element of the odhna changes to match corresponding changes in the age and status of a woman.

The fabric of the odhna is closely interwoven with the lives of the people. Specific colours and patterns symbolise various milestones, from childbirth, adulthood and marriage to death. Brides wear odhni of specified colours on their wedding day. Once married, the patterns and colours of a woman's odhni indicate her status. Different coloured odhni are worn on festive days such as Holi and Teej. For example, a *phaguniya* with its traditional white base, red borders and red central design is generally worn for Holi.

In Rajasthan, the odhna is the first visual manifestation of a woman's presence and, through it, she strives to express her personality and social identity. Married Bishnoi women wear the *kangrechi* and the *damini* odhna. Jat wives use a *hara palla* odhna, and those of the Meghval community wear an *angutha-chhap* odhna. On the other hand, Jat widows wear a *khopra bhat* odhna but those of most other communities wear *mankhi bhat*, *kali jaal bhat* and *morya bhat odhna*.

Thus the odhna becomes the symbol of a woman's community, her social and marital status as also her sense of modesty. Greatly

156. **Cotton *odhna*.** *Jodhpur.* Draped garment, worn mainly by married women. From left to right: block printed **angutha-chaap** used by married Meghval women; married Rajput women's **bandhani, pila-palla odhna;** block printed odhna for married women.

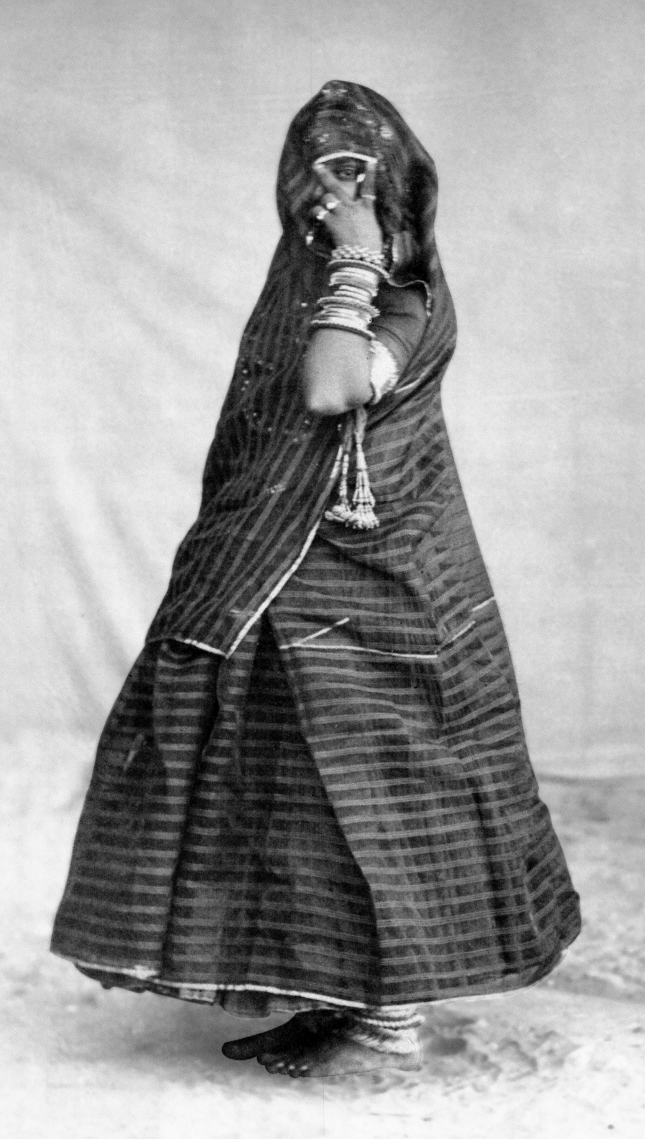

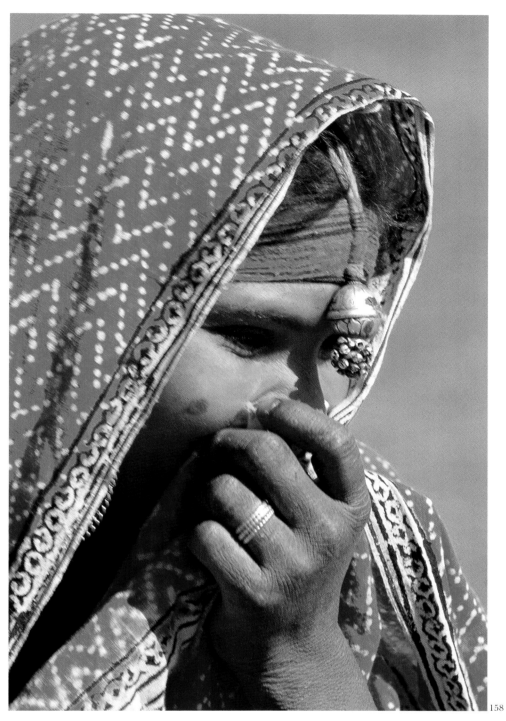

158

celebrated in literature, art and music, the odhna remains as popular as ever and finds place even in the expressions of popular culture of contemporary times.

157. **Marvari woman in a gossamer** *odhna. Bikaner (c. 1880).* Her arms display *bajuband* with hanging tassels, silver ornaments and ivory bangles. She wears rings on all her fingers. Silver anklets, **haathe** and **kadi** are visible on her ankles and she is wearing toe rings, indicating that she is married.

158. **Bhil woman.** *Banswara.* She wears a typical block printed *odhna* and a silver *bor* on her forehead.

159. **Block Printed** *odhna.*

159

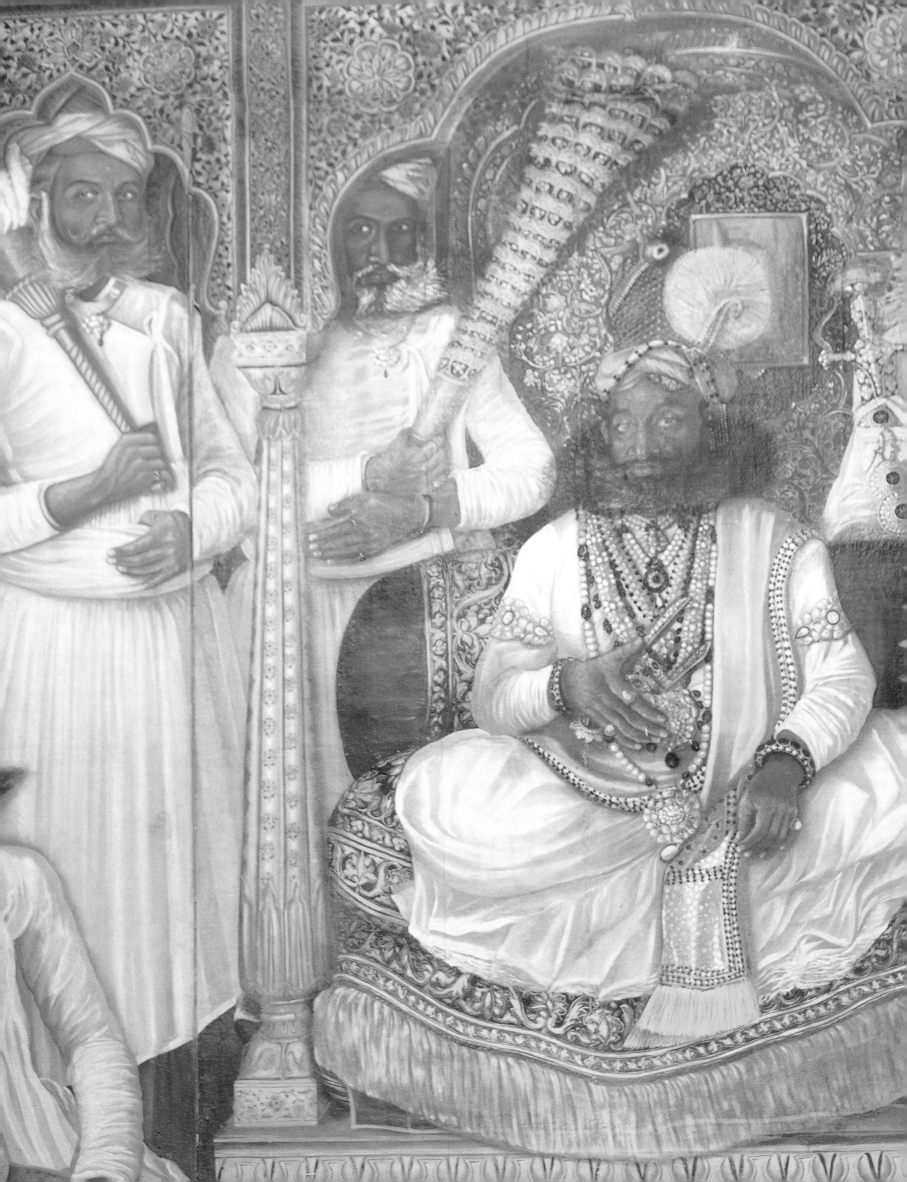

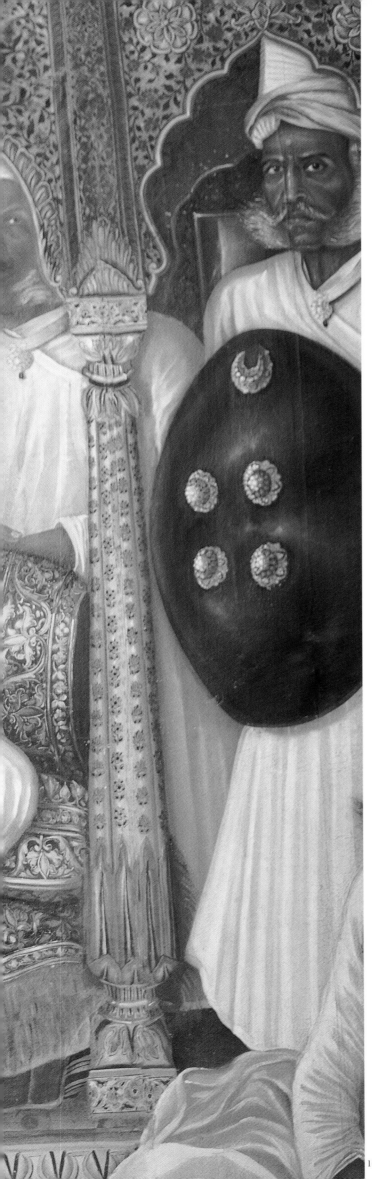

MEN'S COSTUME

Rajasthan is a frontier state, whose people have been exposed to sustained interaction with outsiders who entered India in successive migratory waves. Consequently the men's clothing is an assimilation of numerous historical and foreign influences and is now a combination of stitched as well as unstitched garments. While most items are of indigenous origin, elements of a definite foreign influence are also apparent. The Rajasthani man's dress, if somewhat more restrained than the women's clothes, is still very colourful and diverse in form and texture.

Traditionally the lower garment for men can be the unstitched dhoti, the truly native Indian costume, or a stitched garment such as the pyjama, which is a type of trouser. Some garments related to the pyjama are the *izar, suthan, shalvar* or *salvar, survala* or *sural* and *ghutanna*. The upper garment can include a *bandi* and a *kurta* or tunic that is commonly worn across the different communities. Formal occasions see men dressed in the angarkha and sometimes a garment called the *achkan* or *shervani*. The turban and a draped piece of fabric around the shoulders complete the ensemble. Shawls and blankets, usually made of camel and sheep wool, are seasonal additions, useful for warding off the biting cold of Rajasthan's desert winters.

Two other upper garments, the *jama* and the *choga*, were an important part of the male ensemble in the Mughal era. Although superbly tailored and ornamented, the jama and choga are now seen mostly in museums. However, it would be inaccurate to say that they have disappeared completely. Some of the elite and royal families still wear such garments, albeit on ceremonial occasions. As formal wear, made of relatively light material to suit the local climate, the jama may well have developed a cut and form of its own in the north Indian courts, especially in Rajasthan. The attire of the gentleman was incomplete without a long stole, which, depending on the section of society, could be either an *angocha* or a *dupatta*. The *atamsukh*, like a cloak, fell from the shoulder when the wearer was on the move and doubled as a shawl when he was in repose and possibly evolved from the stole.

Upper Garments

The two upper garments worn by men in Rajasthan are the bandi and the angarkhi, although today the kurta is considered traditional wear and takes precedence over all other garments. Among royalty and the aristocracy, garments like the jama, achkan, shervani and choga are also worn. Interestingly, the men have a wide variety of upper garments to satisfy their sartorial tastes. Two other such garments are the *chapkan* and the *chasuble*. In addition to these are a large number of jackets like *sadri, mirzai, farji,* and *fatu.*

Bandi

The bandi is a close fitting, sleeveless or, sometimes, short-sleeved inner garment that is functionally similar to the ubiquitous vest. It serves as a cool and comfortable garment, such that in the privacy of

his home, a man will often take off his kurta and relax in a bandi. While most communities in Rajasthan use it as an inner or under garment, men of the Kumhar or potter-community, choose to wear the bandi as their outer upper garment, though, occasionally, they too wear the angarkhi.

Comfort being its prime function, the bandi is tailored from unbleached white cotton khaadi, which is softer than the fabric used for outerwear. Fine cotton muslin is also used, as in the case of the bandi worn by Maheshvari men. The garment is cut on a true bias, i.e., diagonally across the warp of the fabric for maximum stretch. This makes the bandi especially comfortable, as it does not restrict the wearer's movement.

The bandi generally has a round neck in the front and the back. Different communities wear the bandi with variations in the neck openings. For example, a central placket with buttons could be incorporated or an opening on the shoulder with ties. On festive occasions the Kumhar bandi has five silver buttons linked by a chain. Often the garment has no opening and some fall just a fraction below the waist, while others may fully cover the hips.

A slit pocket on the left side, about 20 cm. wide, was useful for holding valuables and money before wallets became commonplace and which in rural areas still serves the same function.

Kurta

The development of the upper garment, known as the kurta, probably began in the nineteenth century and it is, at present, a popular garment among men of Rajasthan. The length and girth of the kurta may both vary from region to region and it can be tailored in a variety of styles.

The kalidar kurta is made up of several geometrical pieces. It has two rectangular central panels in the back and the front. The width of these panels is equal to the shoulder size and the length varies from above the thigh to below the knees. Four, flared-side panels called kali, are attached on either side of the central panels. Their shape is roughly triangular, narrow at the top and wider at the bottom to achieve the desired fullness. This ensures a snug fit around the chest which lends the lower part a loose-flared fall. Comfort is further emphasized by deep slits at the side seam. The sleeves, which are generally full-length, are also rectangular. They are cut square at the top and the armholes are set somewhat deep. Small triangular gussets are inserted under the arms and the sleeves taper very slightly towards the wrist. The neck of the kurta is usually round; although it may sometimes also have a Chinese collar and most garments have a side pocket. The centre front-opening has a placket with buttons and buttonholes as closures. Sometimes, buttonholes are made on both sides of the placket, into which are inserted silver or gold buttons, which are held together by ornamental chains.

Another variation on the original kurta has two central panels, back and front, which flare out at the bottom. The armholes are also shaped and the sleeves are fitted into them with a gusset.

A shorter variation of the kurta is the *jhulki*. Interestingly, both the men and women of the Garasia community wear it. The men's jhulki is essentially white. It is a half-sleeved garment that has three buttons on the front. It has a pocket stitched on the left side of the bodice. More recently, men have also adopted a garment, which is a cross between the classic men's shirt and the traditional kurta. It has a shirt collar, cuffed sleeves and a kurta placket. It is

161

162

160. *(Previous page)*. **The King with attendants.** *Junagadh Fort, Bikaner (19th century)*. Wall painting. The King wears a turban, ***angarkha***, ***dhoti*** and draped shawl with woven ***zari*** borders and a variety of ornaments around his neck. ***Bajuband*** are visible on his upper arms and a ***sarpech*** graces his turban. The royal attendants are dressed in comparatively less ornate clothes, including ***angarkha***, plain ***cummerbund***, ***pagri***, and ear and neck ornaments.

161. **Farmer.** *Dhorimina*. He is dressed in ***dhoti***, turban and ***bandi***, a men's cotton inner garment, which is cut on the bias.

162. **Kurta.** *Bikaner.* Men's upper garment in cotton muslin. The sleeves are treated with a washable glue to produce a crinkled effect. The saffron headdress is a ***khirkiya pag***.

163. **Angarkha.** *Bikaner(c. 1930)*. Men's upper garment in brocade with ***zardozi*** embroidery and pink ***magazi***.

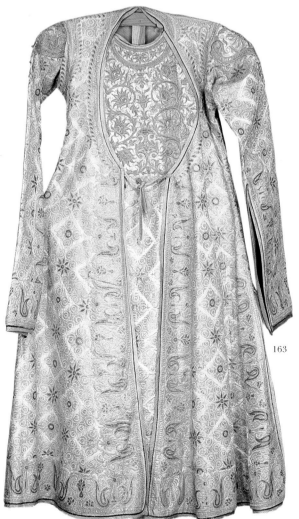

163

as long as a kurta and its cut is the same but the hem is shaped with short slits at the side seam.

Angarkha, Angarkhi and Puthia

The angarkha forms a part of the traditional male ensemble and is worn by almost all communities in Rajasthan. While the angarkha is the longer version, the shorter angarkhi is cut in a similar style.

The angarkha is, by and large, the formal wear of the affluent. Rajasthan's pastoral and tribal communities may also wear the angarkha on special occasions. However, for day-to-day activities, they normally wear its shorter cousin, the angarkhi, known as the puthia in the region. Styles and lengths vary from region to region but the basic cut of this garment remains the same.

The unique design element of an angarkha is the round-edged, sometimes, triangular opening at the front and the inner panel known as the parda, which covers the chest and is visible through the cut out portion of the yoke. Some angarkha are tailored like a panelled coat while others are constructed by joining the bodice and skirt at the waist–although traditionally there was no seam at the waist. The fullness of the skirt varies, as does the size and shape of the garment. To enhance mobility, slits are occasionally made at the sides and also at the wrists. The angarkha is usually fastened at the neck, underarm, chest and waist with fabric ties or cords. It is interesting to note that in the

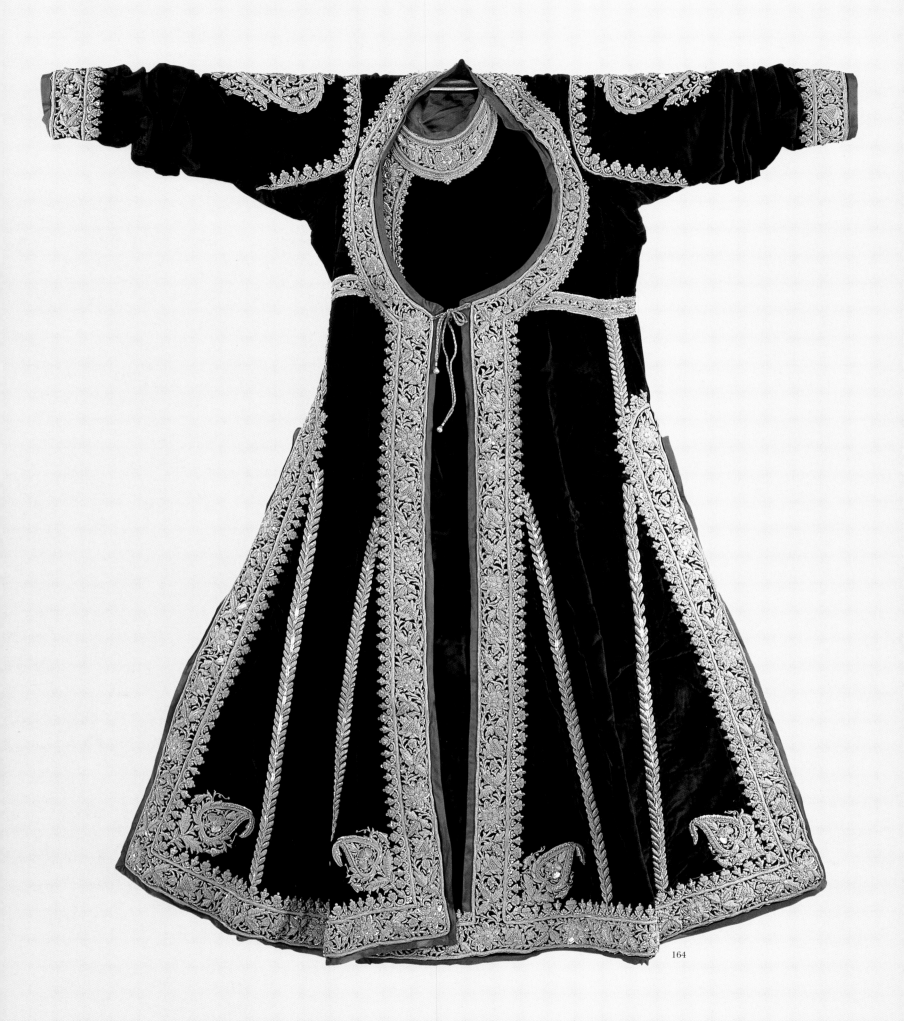

164

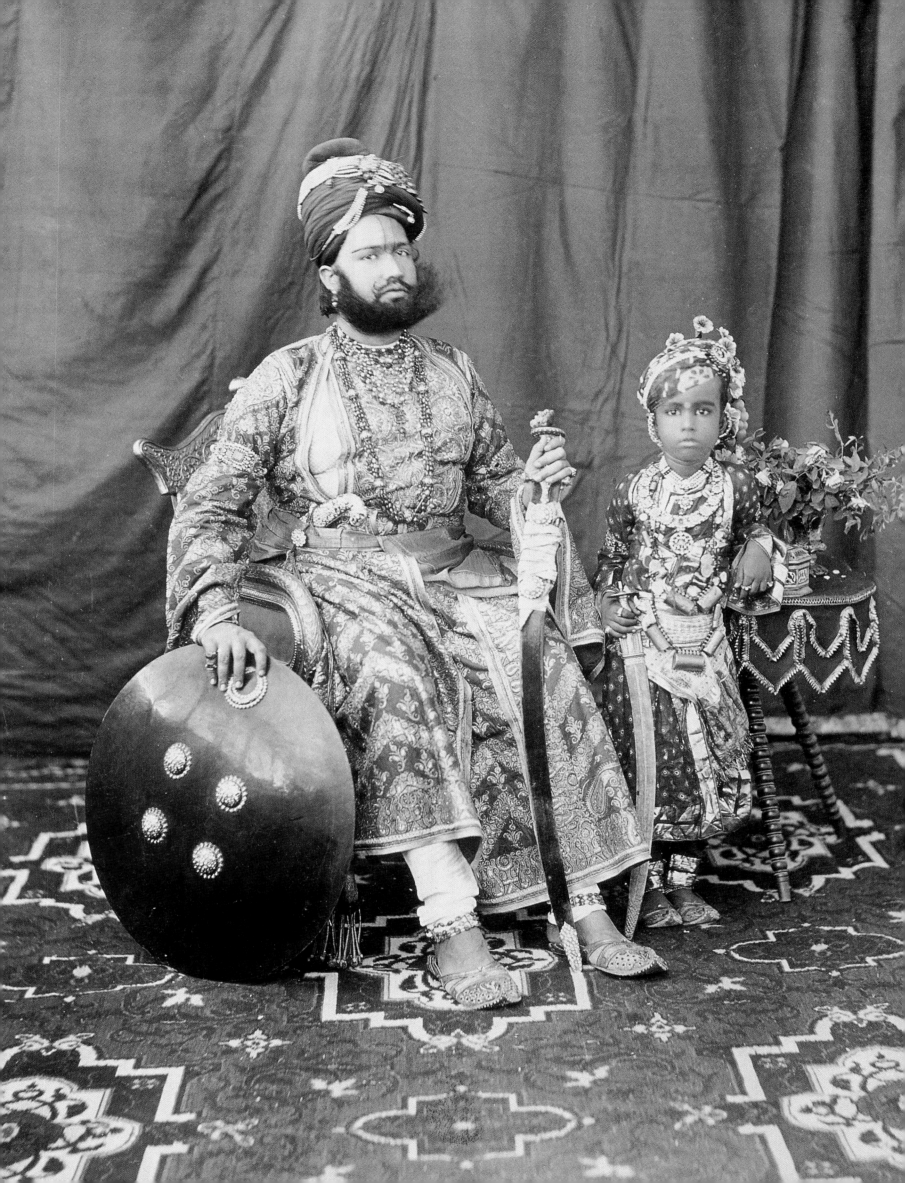

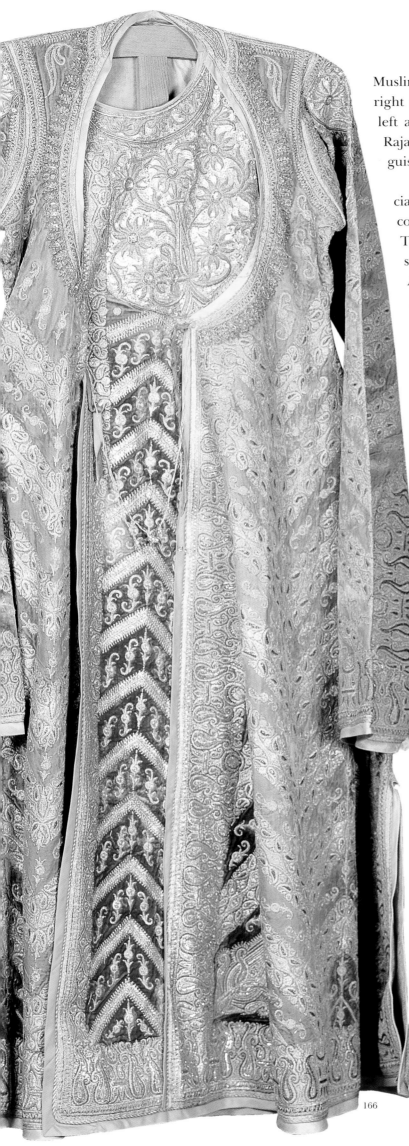

Muslim tradition, the visible outer tie cords are positioned under the right armpit, while the Hindu angarkha have the visible ties under the left armpit. The inner fastenings are on the opposite side. In fact in Rajasthan and other parts of the country this style of tying still distinguishes the two communities.

Traditionally, the angarkha is made of plain silk or brocade, especially for weddings. Fine cotton voile is also used and block printed cotton, with gold tinsel printing makes for a more dramatic angarkha. There are some splendid examples of elegantly tailored and handsomely embellished angarkha on display in Rajasthan museums. Angarkha made of thick and, sometimes, quilted material are worn in winter while fine cotton is naturally preferred for summer.

At many Rajasthani courts and in other parts of Northern India the popularity of the angarkha as a garment for formal wear continued into the nineteenth century. Its length and flare swayed to the dictates of fashion and varied over periods of time but its essential shape has survived unaltered.

The angarkhi or puthia has the same cut but is worn short, reaching just below the hips. It is made using white handspun cotton, reza and is occasionally coloured with vegetable dyes. In some communities the garment is made from red *tul*. The basic angarkhi worn among different communities has a cut and construction very similar to the puthia described in the section on women's costume. The front of the angarkhi consists of a right and left side with multiple panels, which overlap (angarkhis often have a front circular yoke that is highlighted by piping). It has two front panels–right and left. These panels are divided into three sections–the right panel has one central piece, one on the side and the third is attached at the front from below the waist. The front left has one central panel, one at the side panel and the third runs from top to bottom. Often, the back or the sleeves of the angarkhi are embroidered.

In Rajasthan, even commoners were said to wear a relatively light garment whenever they were expected to be formally dressed, for instance, when present at the courts. It was called a *kamari* or kamari angarkhi meaning-that which touches the waist.

As mentioned before, the basic cut of the angarkhi is common among all the communities of Rajasthan but differences are seen in the length and flare of the garment, the type of fabric and piping used as well as the usage or absence of colour.

The length can vary from 5-7.5 cm. below the waist down to the ankles. The Gaduliya Lohar's angarkhi is waist-length and its full sleeves have 5 cm. wristbands cut on the bias with no slits. The Gujar's angarkhi ends and reaches the hipbone. The Jat angarkhi falls just a little below his waist and the Meravat wears a long angarkhi.

Thus, the style of the garment seems to be mainly influenced by the wearer's social status, the type of work the community does and the occasion on which it is worn. The Rajputs, who were predominantly landowners and, therefore, wealthy enough to afford

166

quantities of fabric, preferred a flared, ankle-length garment. Similarly, the trading communities such as Maheshvari, Osval and Agarval, who were accorded a high status in the society, wore a knee-length angarkha made of soft cotton khaadi. Significantly, people who were traditionally involved in more sedentary work would wear a garment like this at all times. A farmer, on the other hand, would pragmatically wear a shorter, close fitting garment.

Jama and Baga

The antiquity of the Jama has been long debated though most scholars ascribe its origin to Central Asia. This garment had a definite Mughal influence and in its current form was introduced through the Mughal court, from where it spread to others. Jama is, perhaps, the more Mughal and generic North Indian name for the garment. The local name for a garment, less ostentatious, but of a similar cut and construction is the *baga*.

The jama has a tight fitting bodice, high-waist and a flared-skirt, which can vary from knee to ankle length. It is an open-fronted garment with one panel crossed over the other on the front, to be tied at the side just below the right or left armpit rather than the usual opening down the middle. It is kept in place by tie-cords which hold the inner panel on the inside at the waist or armpit. Similarly, there are tie cords on the outside but attached to the front cross panel. It is worth noting that strings or tie-cords known as *kasa* were the usual device for tying the jama or angarkha. The hidden tie-cords are simple and functional but the visible ones are heavily ornamented and attractive.

In Rajasthan, the jama was made of a variety of materials like fine cotton, silk, wool or brocade. Used by the aristocracy, lengths of fabric were specially woven, printed and embroidered to create the jama. Floral designs were often sprinkled profusely over the bodice. References to the jama abound, in paintings, photographs and museum collections.

The use of the jama remained limited to a section of society which may be additional proof that it was not indigenous. Surviving Mughal and Rajput paintings show that the jama was worn in a variety of styles. Perhaps, two of the most popular were the *chakdar jama* and the *gherdar jama*. The chakdar jama had hanging, tapering ends of the sort that one sees in many Mughal paintings, while the latter had an even, round hemline and tended to be full. Until the late sixteenth century, the *takauchiya jama* as the chakdar jama was also known, was a court-dress.

Although evidence of the chakdar jama with slits and flared panels is found prior to the Mughals, it is difficult to be absolutely certain of the difference between a jama and an angarkha or angarkhi, because no detailed information on the cut or use of these garments has survived. One has to rely on pictorial depictions and oral records in order to distinguish them. Some scholars are of the opinion that the two terms apply to the same garment and

167

164. (*Previous page*): **Angarkha.** *Jaisalmer (c. 1930)*. Velvet with *zardozi* embroidery, lined with blue satin silk, red *magazi* in silk.

165. (*Previous page*): **Maharaja Sri Dungar Singh with his younger brother, heir apparent Sri Ganga Singh.** *Bikaner. (1885)*. The Maharaja wears a brocade *angarkhi* worked with *zardozi* embroidery, Jodhpur breeches and *cummerbund* with an ornate belt buckle. His *safa*, headdress, is ornamented with a *pag-ki-ladi sarpatti* and he wears *kundal* in his ears. Around his neck are various necklaces, the *motimala*, made of pearls and an emerald *kanthabharan*. He wears *bajuband* on the upper arm. His anklets are set with precious stones and on his feet are embroidered *jutis*. His sword is decorated with a brooch and fabric. The Maharaja's heir apparent, Sri Ganga Singh wears a tie-dyed *angrakha* appliquéd with *gota*. His *pyjama* is also worked with *gota*. The ensemble is completed with a tie-dyed turban with a *chandrama sarpech*, a decorative *cummerbund*, and embroidered *jutis*. He carries a sword to show his royal status. His jewellery includes necklaces of pearls and emeralds with *dhukdhuki* and *baleora*, an amulet on a string and *bajuband* on his arms.

166. **Angarkhi.** *Bikaner (c. 1930)*. Brocade with *zardozi* embroidery and yellow *magazi* piping

167. **Jama.** *Jodhpur (c. 1920)*. Man's upper garment, block printed cotton fabric, with front opening and gathers at the waist.

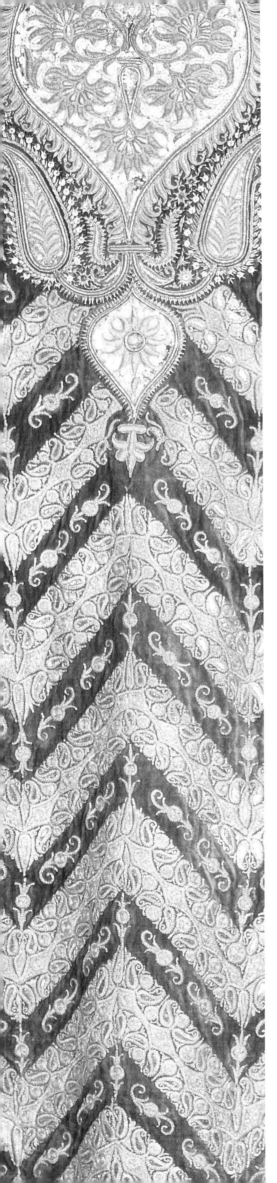

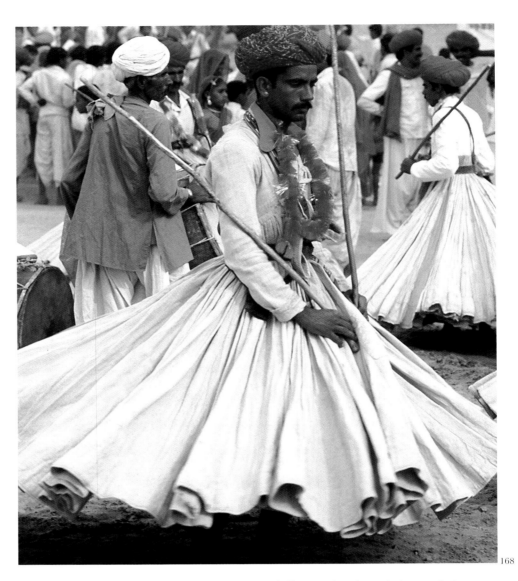

are used interchangeably: the first essentially Persian in origin, and the second, with its Indian roots. However, if the distinguishing features of these garments are highlighted–the term 'jama' may be used for those garments that are 'Mughal' in cut, being tied close to the armpit at the right or the left, while the word 'angarkha' may be reserved for garments that have a chest opening covered by an inner flap or parda and are tied at the waist. Both garments have a similar length and flare of the skirt.

The lengths of these frock coats varied from court to court. In Rajasthan, for example, a long jama that covered the feet and trailed the floor was very fashionable from the eighteenth century onwards and replaced the earlier knee-length style.

The dress used by Ger dancers and the Bhopa, wandering minstrels who worship Pabuji, is called a baga. The baga has a wide skirt with panels on the side and an overlapping bodice. The bodice is joined to the skirt by a seam at the waist. The *bagatri* and *bagalbandi* are also garments akin to the baga and jama in this region. The jama is still worn, though with some variation in some areas of Rajasthan, especially near Udaipur.

Choga

The choga is described as a long-sleeved robe that fits loosely around the bodice and does not have a noticeably tailored look. Traditionally, the choga has a deep oval or heart-shaped neckline. A pair of loops and cloth-cased but-

tons fastens the garment at the chest. It is worn as an outer-garment over a kurta or angarkha and is generally made of fine woven wool, though fine cotton is also used. Often, it was made of brocaded material or velvet embroidered with metal embroidery.

The word choga and perhaps the garment itself is of Turkish origin. The choga was worn as an outer garment in Central Asia. Ancient literature, Buddhist sculptures from Satavahana period and Gupta paintings indicate that the origin of the choga predates the Christian era. By the medieval period, this coat-like garment had a very definite presence in India and was the preferred garment of the nobility.

In the Indian context, the choga was a much more splendid and formal garment than one would gather from its general description. Numerous museum-exhibits, portraits and paintings of royalty show that the choga was made of ornate fashion like brocade and embellished with lavish embroidery. The intricate detailing in its design, as with the loop, tells the story of the elite's extensive use of the choga. Thus, the choga was an elegant, comfortable overcoat that enjoyed royal patronage. The choga made of muslin or woven in the *jamdani* (flowered muslin) style was worn in summer. It was lightly embroidered with silks, befitting the season. It usually had a narrow floral border on the edges and large floral sprays on its front, back and shoulder and on the lower edges. In winter, woollen and quilted choga were preferred, which were embroidered with silk and zardozi. Often, the embroidery was detailed and the choga was stitched with utmost care, sometimes, with a double-lining of cotton and silk. Though rarely worn now, the garment has reappeared, of late,

168. **Man doing *ger* dance.** *Kanana fair.* He wears a white ***baga*** and a red ***safa.*** The ***baga*** has a gathered skirt with an overlapping bodice, and is similar in construction to the ***jama.***

169. **Ornate loops and buttons on a *choga*, overgarment**. *Jaipur.*

170. **Choga.** *Bikaner (c. 1920).* Velvet overcoat with Chinese collar worked in ***zardozi*** embroidery. The gold buttons are fastened with exquisitely wrought loops.

171. **Choga.** *Bikaner (c. 1930).* Brocade with ***zardozi*** embroidery. Two buttons are fastened with gold loops.

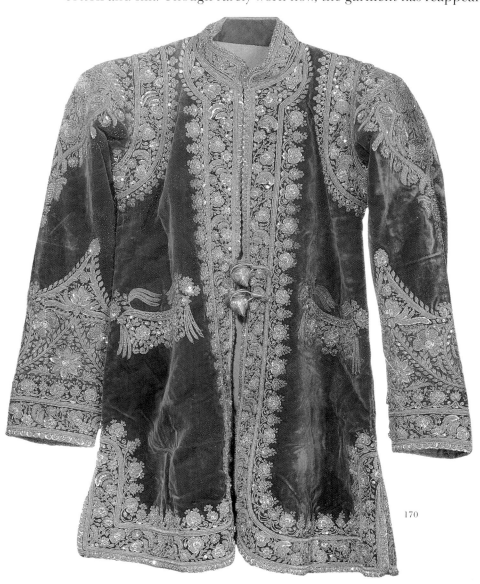

170

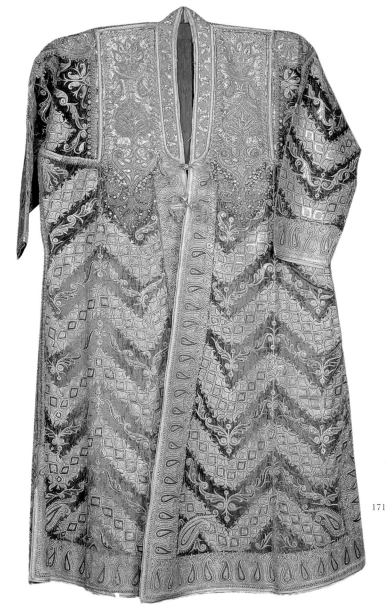

171

in a more urban form and is occasionally included in the collections of some contemporary designers.

Achkan and Shervani

The achkan is a full-sleeved tunic with a high round neck. This garment has a length, which falls about 3-5 cm. above the knee. It has a full front opening in the centre and is fastened with buttons and buttonholes. It is worn among all communities in combination with a *churidar*, especially on formal occasions. The front panels–the bodice and skirt–are cut from a single length and are flared at the side-seams. The armholes of the achkan are slightly curved, in contrast to the straight armholes of garments like the angarkha and jama. The sleeves are tapered with a fitted effect, ending at the wrist. The neck is finished with a small stand-up collar, known as the Nehru or Chinese collar. Slits are made near the side of the hem and on the cuff of the sleeve. It is lined on the inside, giving it a clean finish.

Another garment of similar construction is the shervani. This is worn in certain parts of the region and that, too, mostly at weddings. The shervani differs from the achkan in its length and flare. It is longer and falls 3-5 cm below the knee and has a wider flare.

Throughout the nineteenth century the achkan and shervani gradually replaced the angarkha, jama and choga as the main outer-garment worn by men in the royal courts. The evolution of these close-fitting jackets and coats came through the gradual assimilation of British clothing styles into Indian attire. Indigenous textiles and their integral decorative elements were still favoured over imported fabrics and certain stylistic elements of the angarkha, jama and choga were also retained. Later, the silhouette became more westernised. Unlike the earlier outer-garments worn by men, these fitted long coats with closed-neck acquired a more tailored-look. Instead of attaching the square cut sleeves at right angles to the main body of the fabric, as in the puthia, the armholes were curved and the sleeves structured to fit. The achkan became fashionable in most courts at the turn of the last century. It was tighter fitting around the wrists, chest and waist, tapering out at the hips to flare around the knees. As a result, the achkan was more streamlined than its predecessors. Purely for purposes of ornamentation, embroidered borders were often added around the collar, front edges and hems. It is still the most popular item of formal clothing in India today and commonly worn at weddings.

Jodhpur or Bandgala Coat

The Jodhpur-coat or *bandgala*, probably, originated in Jodhpur but is worn all over North India today. It is a short-coat resembling the English blazer and was popular with royalty in the late nineteenth century. The garment is short and closely fitted to the body. It is finished at the neck with a Nehru collar and has a centre front opening and full sleeves.

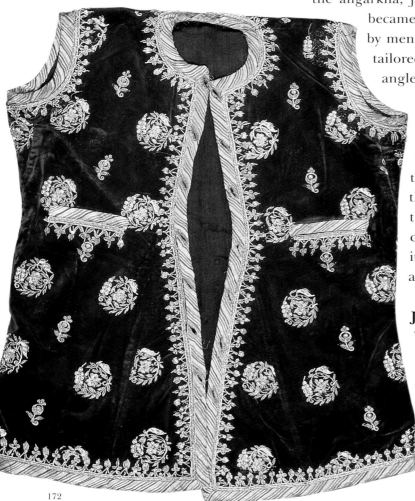

172. **Sadri.** *Jodhpur (c. 1920).* Velvet waistcoat with *zardozi* work.

173. Maharaj Kumar Bhagwat Singh Mewar. *Jodhpur (c.1940).* He dresses for his wedding in an **angarkha, pyjama,** turban and **jutis** on his feet. The turban is adorned with a **sarpech** and around his neck is a **motimala.**

172

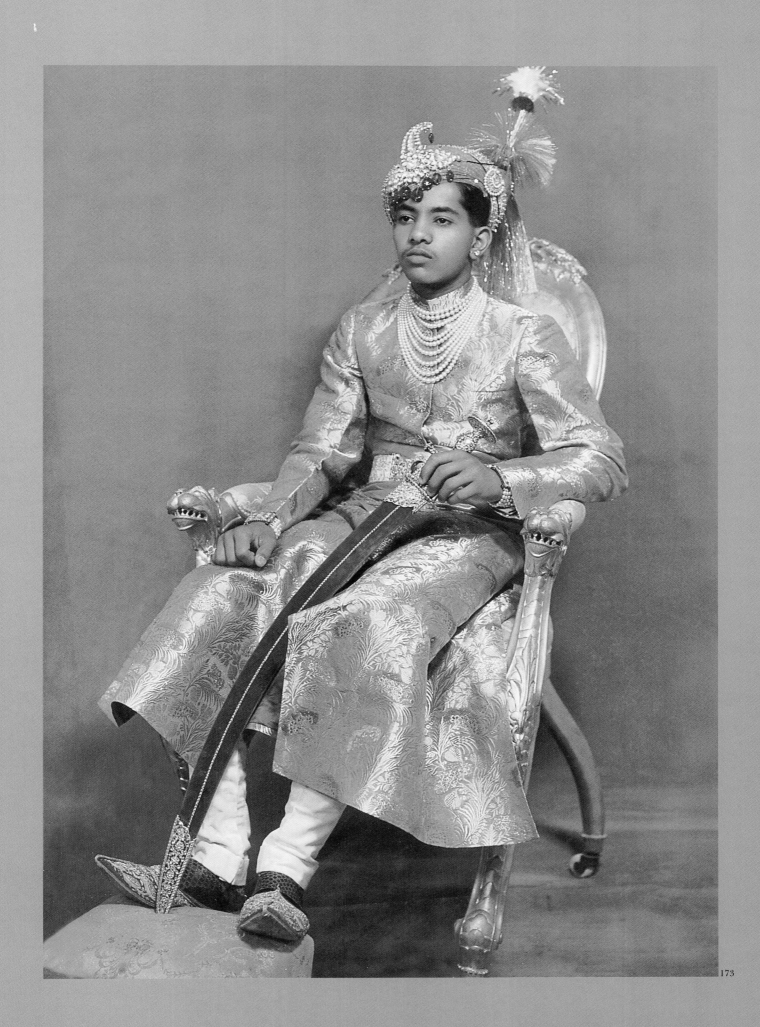

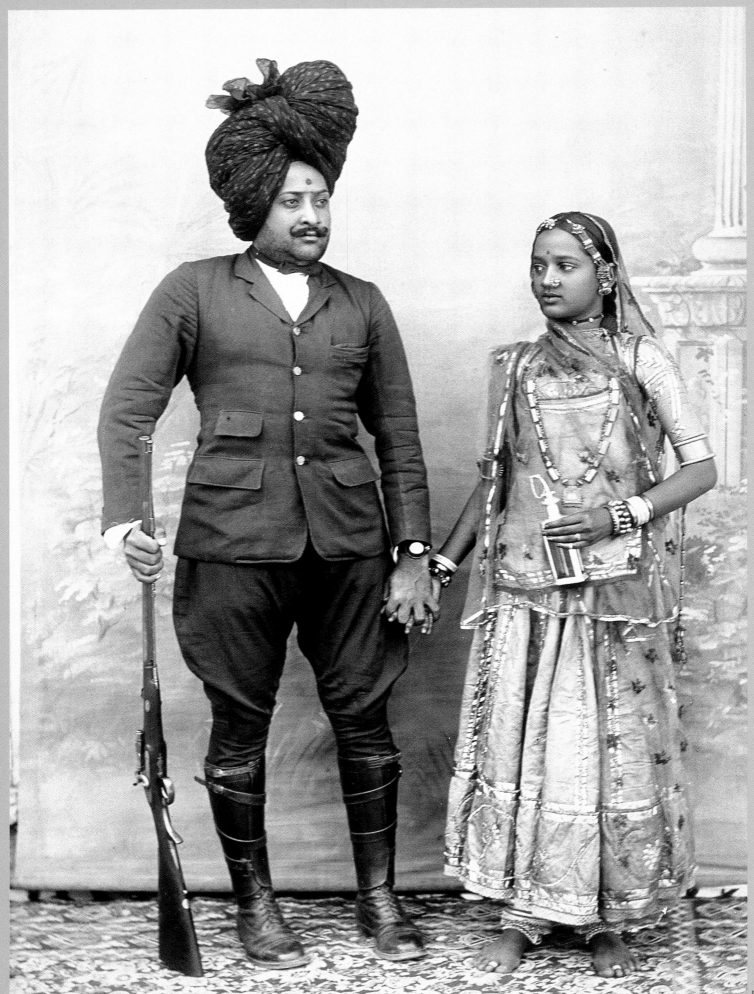

174

Lower Garments

There are two categories of lower-garments worn by the men of Rajasthan, unstitched and stitched. The unstitched garment is called the dhoti, while the pyjama, in all its styles and the Jodhpur-breeches are categorized under stitched garments.

Dhoti

The word dhoti or *dhotan* is generally traced to the Sanskrit word *'dhauta'*. It is one of the earliest known draped garments in India and continues to be worn even today. One of the reasons for the dhoti's enduring popularity is its loose trouser-like form, which is convenient and extremely well-suited to the tropical Indian climate.

The dhoti falls from the waist and partially or fully covers the legs by the pleating, folding and knotting of an unstitched length of cloth. The fabric for a dhoti is woven as a single rectangular piece and worn without any cutting or stitching. Its size varies from two to five meters in length and one to one and a half meters in width. It is usually white and made of cotton.

There is evidence that dhotis were worn from the Vedic period onwards, if not earlier. Men and women of this period, wore three garments–the loincloth or nivi, which had a long unwoven fringe, a garment or vasa and an over garment or adhivasa. There are numerous detailed representations from all the dynasties that reigned between the first and the fourth century A.D., indicating that the dhoti continued to be worn and that innovations were introduced, from time to time. For instance, the dhoti could be tied to the waist with a waistcloth that had a bow shaped knot with a patka hanging down the front.

By the tenth century, the dhoti had been in existence for a fairly long period and several regional and local particularities had crept into its modes of draping.

The garment continued to be worn throughout the medieval period. The Moorish traveller, Al-Biruni, who came to India in the eleventh century and left us a treasure trove of details of contemporary life and civilization of the time, made several observations on the dress of north-Indian men. He says:

"They use turbans for trousers; those who want little dress are content to dress in a rag of two fingers' breadth, which they did bind over their loin, with two cords; but those who like much dress wear trousers lined with as much cotton as would suffice to make a number of counterpanes and saddle rugs."

This statement has led many to surmise that Al-Biruni mistook the dhoti worn in the *kacca* (meaning 'pleats drawn up between the legs') style for what he called *"turbans for trousers"*. Kacca refers to the upper ends of the pleats being folded in at the navel and the lower end being drawn up between the legs and tucked in at the centre back. During this time, the dhoti was held in place by a belt around the waist. The belt was embellished either with embroidery or some other form of ornamentation. It, sometimes, had an exquisite clasp that came to rest on the elaborately folded front pleats.

In this period, the dhoti underwent tremendous modifications in style, length of fabric and even its wearers. Yet, it continued to hold sway as the most popular of all the clothes available to Indian men. B.N. Goswamy calls it a truly native Indian dress.

The dhoti is still draped at the waist, with elaborate pleating in the front and back. The differences in draping modes arise from social status, the occupation of the wearer and of course, individual taste. These numerous styles are

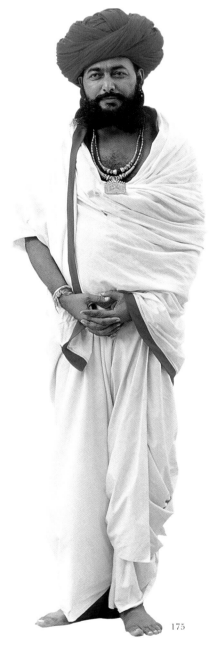

175

174. **Man and woman in traditional ensemble.** *Jodhpur (c. 1910).* The man wears ***Jodhpur breeches*** with an English blazer and tie-dyed ***safa.*** The woman is in full ***poshak*** with traditional jewellery.

175. **Priest in an unstitched ensemble.** *Marwar Junction.* He wears a turban. His ***chadar*** and ***dhoti*** are draped around the body. Unstitched clothing is a mark of high status and is considered pure among Hindus.

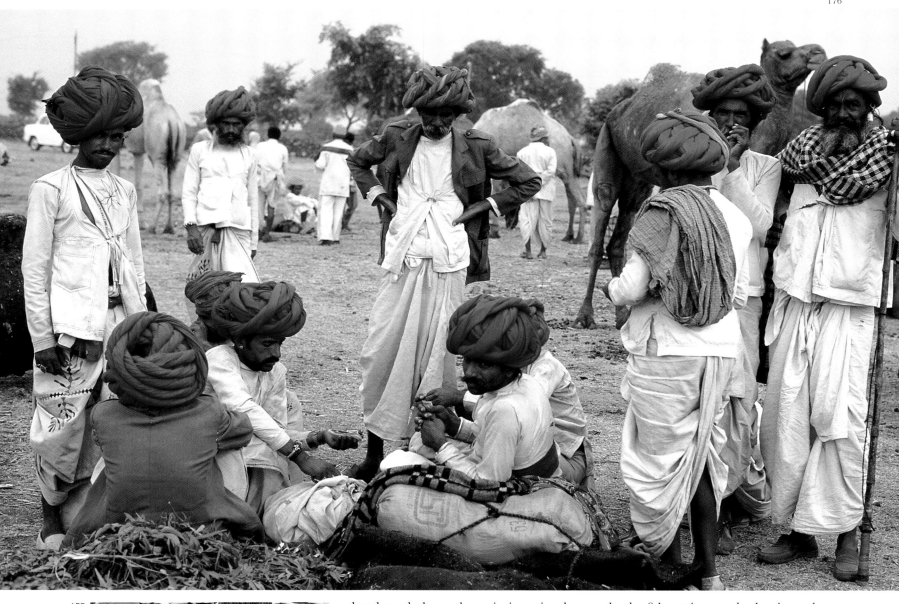

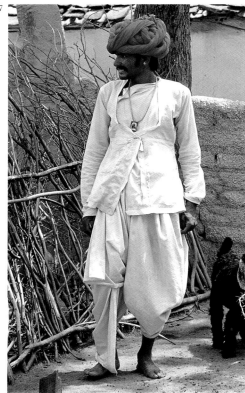

developed through variations in the method of knotting and pleating, the length of the dhoti and the texture of the cloth. Men with sedentary occupation generally wear a long and extravagantly pleated dhoti. Those whose work involves more arduous physical labour wear a shorter style.

Some of the more prevalent styles of arranging the dhoti are enumerated below. It is fascinating to note how a piece of unstitched fabric can be draped in innumerable ways. The dhoti is always draped from the back, brought forward around the waist and secured around the abdomen.

Stitched Lower Garments

The *pyjama* is a popular garment in India and often deemed a Central Asian import, because its literal meaning is derived from a compound of two Persian words, *pae* and *jama*, the first meaning 'legs or feet', and the second, 'covering', thus signifying 'leg clothing'. There is sufficient evidence from early sculptures and paintings, that 'a pair of loose drawers or trousers, tied around the waist', was known at least from the beginning of the Christian era in India, even though it was not widely worn. The Harshacharita mentions three different kinds of pyjamas: the *Svasthan*, which later became the *suthan*, the *pinga*, perhaps, an early form of the *salvar* and the *satula*. However, it is not easy to determine exactly how these garments originated and why they possessed such

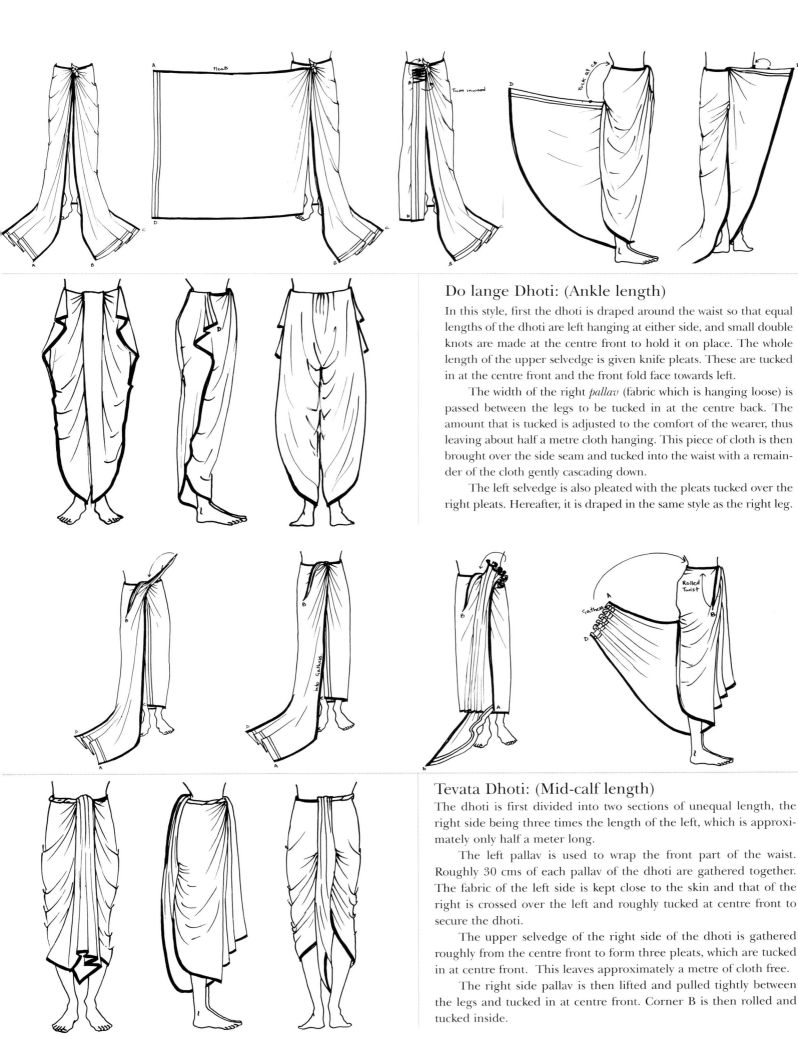

Do lange Dhoti: (Ankle length)

In this style, first the dhoti is draped around the waist so that equal lengths of the dhoti are left hanging at either side, and small double knots are made at the centre front to hold it on place. The whole length of the upper selvedge is given knife pleats. These are tucked in at the centre front and the front fold face towards left.

The width of the right *pallav* (fabric which is hanging loose) is passed between the legs to be tucked in at the centre back. The amount that is tucked is adjusted to the comfort of the wearer, thus leaving about half a metre cloth hanging. This piece of cloth is then brought over the side seam and tucked into the waist with a remainder of the cloth gently cascading down.

The left selvedge is also pleated with the pleats tucked over the right pleats. Hereafter, it is draped in the same style as the right leg.

Tevata Dhoti: (Mid-calf length)

The dhoti is first divided into two sections of unequal length, the right side being three times the length of the left, which is approximately only half a meter long.

The left pallav is used to wrap the front part of the waist. Roughly 30 cms of each pallav of the dhoti are gathered together. The fabric of the left side is kept close to the skin and that of the right is crossed over the left and roughly tucked at centre front to secure the dhoti.

The upper selvedge of the right side of the dhoti is gathered roughly from the centre front to form three pleats, which are tucked in at centre front. This leaves approximately a metre of cloth free.

The right side pallav is then lifted and pulled tightly between the legs and tucked in at centre front. Corner B is then rolled and tucked inside.

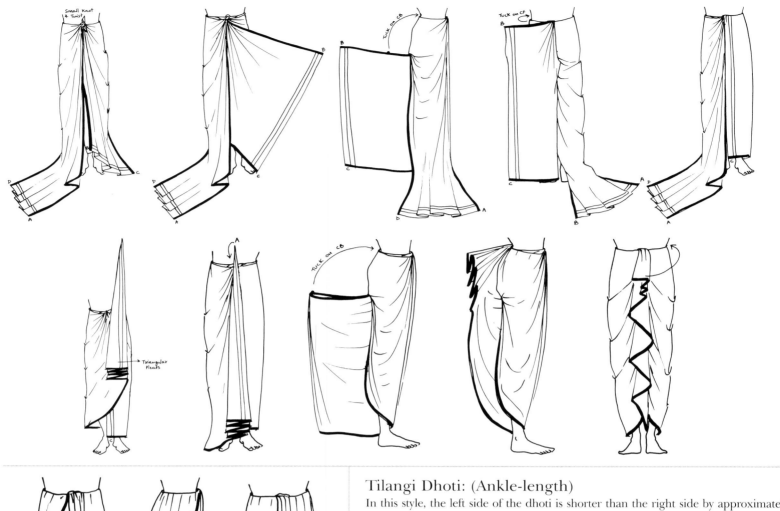

Tilangi Dhoti: (Ankle-length)

In this style, the left side of the dhoti is shorter than the right side by approximately two lengths.

First, a small knot is given and then ends are twisted and tucked at the centre front.

Then the upper selvedge of the left-hand side is held mid way at its length.

It is then taken between the legs and tucked in firmly at centre back.

Corner B is picked up and brought forward round the waist and tucked in almost near the centre front.

Corner A is picked up and folded to form three triangular pleats.

The narrower side of the triangular pleats are tucked 1 foot deep in at the centre front.

The untucked upper selvedge is then drawn between the legs and tucked at centre back.

This leaves the broader end of the triangular pleats still hanging. They are pulled tightly between the legs and tucked in at the mid point at centre back.

Then, the remaining part of this fabric is brought to the front from the right side and tucked near the centre front.

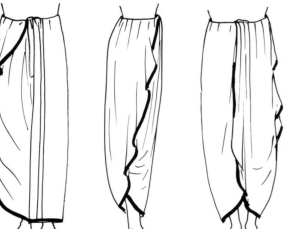

176.(Previous page). **Men at the Pushkar fair.** *Gol safa,* **puthia** and **dhoti** is worn is worn by a group of men. Similar style of dress is an indication of ethnic affinity and identity.

177. (Previous page). **Rabari man in traditional dress.** *Marwar Junction.* He wears the **gol safa,** **puthia** and **tevata.** A **phul** or medallion is worn around the neck.

178. (Next page). Back view of a **dhoti,** draped lower garment. *Jaisalmer.*

a strong family resemblance. In general, the words suthan and salvar signify, at least, in the popular imagination, the wide, baggy garments that are also not especially tight around the lower legs or ankles. The pyjama has tended to vary a great deal, with regard to shape, especially when girth, length, fit and fabric are considered. However, as a general article of apparel, it has been in use in India for a long time and still continues to be worn. Pyjamas were initially the dress of the elite and seen mostly on formal and ceremonial occasions. For example, in Rajasthan, there are pictorial depictions of women wearing pyjamas under their ghaghras. The sheer convenience and the mobility it afforded led to its adoption for specific use, such as by soldiers. In Rajasthan, many paintings show Rajput soldiers outfitted in pyjamas. However, today both men and women wear this garment throughout the country.

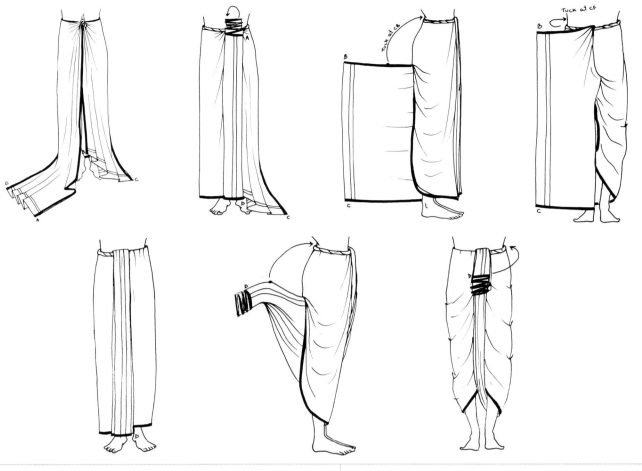

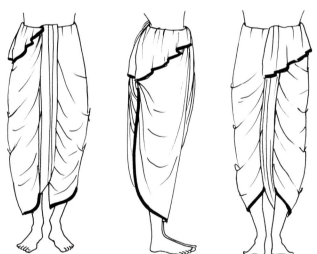

Dolangi Dhoti: (Ankle-length)

The fabric is first divided into two lengths. As in the Tilangi style, left side of the dhoti is shorter than the right side by approximately two lengths.

First, a small knot is given and the ends are twisted and tucked at the centre front. Knife pleats are made from corner A of the right pallav and are tucked at the centre front facing outwards.

Left pallav is gathered at mid width, (between Corners B and C), passed between legs and tucked at centre back. The remaining fabric is brought across the left hip and tucked near centre front.

Similarly, the right upper selvedge is given knife pleats that are turned outwards and tucked at centre front. These pleats are then picked up, drawn tightly between the legs and tucked at their mid length at centre back.

Remaining fabric is then tucked along the waist.

The common stitched lower garments worn by Rajasthani men are the *siddha pyjama*, *churidar pyjama* and the Jodhpur breeches.

The siddha pyjama is the most common pyjama cut. This garment is cut like the trouser, but is wide at the waist, while its legs taper down to a narrower hem at the bottom.

The upper portion of the churidar pyjama is similar in construction to the siddha pyjama. The portion from the waist to just above the knees is broad. The garment tapers downwards from the crotch, along the inside leg and is cut in a straight line from the lower leg. It concludes in a series of gathers that resemble bangles (*chudi*) at the ankles. To create these folds, the legs are cut longer than would normally be required and the lower portion meant for the area between the knees and the ankle is narrow and tight, which, when worn,

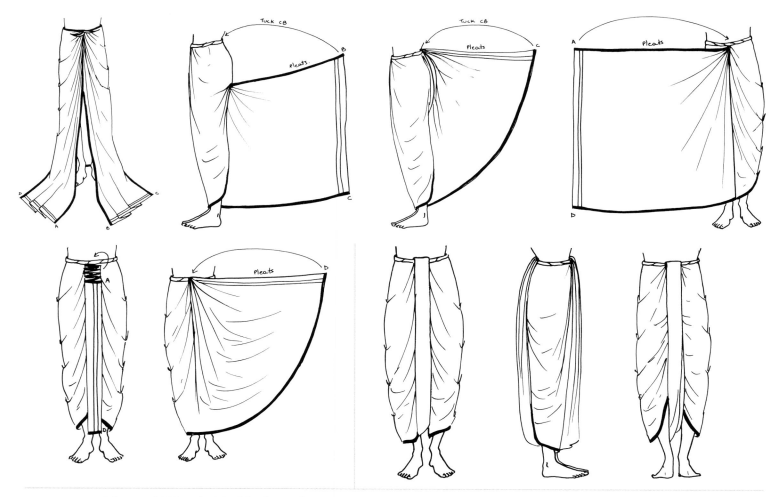

Marvari Dhoti: (Ankle-length)

This dhoti is again a centralized one and double knots are tied at the centre front using 30 cms. of the selvedge at both sides that are twisted inwards.

The left upper selvedge is passed between the legs. Care is taken to ensure that the material does not ride up as the length of the dhoti is till the toes.

From upper selvedge corner B, pleats are made first along the length and tucked at centre back and then the width is also pleated and tucked here.

Upper selvedge is pleated from corner A and tucked at centre front.

Then corner D is lifted and pleated. The pleats are then tucked at centre front.

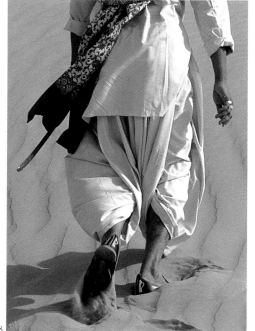

forms folds and fits tightly around the ankles. Although it appears to cling to the body, it provides the wearer enough ease as it is cut on a true bias, in the direction of maximum stretch. The churidar pyjama is generally worn with a kurta, angarkha or achkan.

The Jodhpur breeches, known universally as 'Jodhpurs', were developed in India in the late nineteenth century. The name comes from Jodhpur, the capital of the erstwhile kingdom of Marvar, where they were initially worn. This garment is a combination of the pyjama and military breeches. It was particularly popular in western Rajasthan and was patronised by the aristocracy. Jodhpurs fit snugly at the knee and fall with ease at the ankle. However, there are no folds along its length. Since the garment is used for strenuous activities like horse-riding, it is reinforced with sections of fabric at the knee and the inner ankle. In addition the bias-cut gives the garment extra durability (it stretches and prevents the fabric from tearing.) It resembles the loose-fit of pyjamas above the knees.

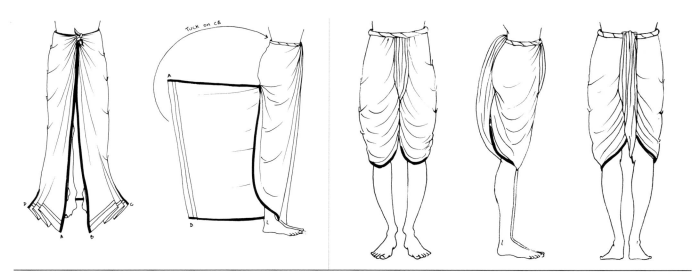

Short Dhoti: (Knee-length or just below knees.)

This dhoti is centralised. The upper selvedge near centre front is gathered, twisted over each other, rolled down and tucked in. The right upper selvedge is taken between legs and tucked at its mid width at centre back. The remaining selvedge is pleated and tucked in at centre back. However, this still leaves some of the fabric hanging free around the hip region, which is roughly gathered and tucked in at centre back itself.

Left selvedge is given knife pleats and tucked at centre front. Then corner C is lifted, and roughly pleated such that the length of the dhoti is raised till the knees. It is then taken across the right side of the waist to the back and brought forward to the left, passed under the folds and neatly tucked in the front.

These are some variations within the short dhotis. The process of tying is similar. First, a knot is tied at centre front. Then the remaining fabric is given either of the following treatments: Both the pallav are passed between the legs and tucked in at the centre back. All the excess fabric is tucked in at the centre back itself, so that it forms a bulging bundle of cloth, which can act like a cushion when one sits. The right side pallav of the dhoti is passed between the legs and tucked at centre back covering one leg. The left pallav is pleated and the pleated ends are tucked at centre front.

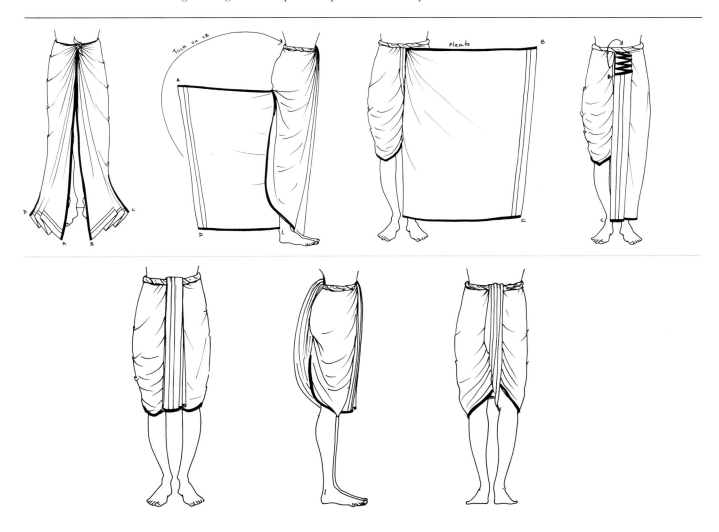

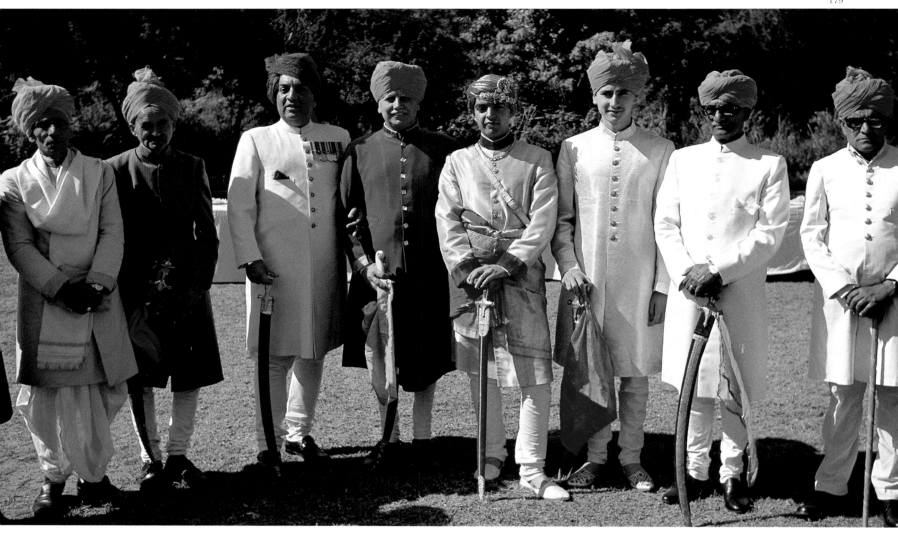

Cummerbund or Patka

The *cummerbund* or *patka* is a waistband made from a long, narrow, strip of cloth. Cummerbund literally means 'article that ties around the waist' and defines the function of the garment. The patka, on the other hand, is derived from the Sanskrit word *patta* and describes its more physical aspect, the closest meaning to this word being 'strip'.

The ornamental fabric is placed around the waist and the long length wrapped several times around. It is then knotted, with its two ends falling gracefully down the front or on the left side. The article seems to be more decorative than functional in nature and found favour with royalty and nobility. A lavish yet elegant accessory, the cummerbund is ornamented on the main body. Its borders and the ends of the width are the most heavily decorated. The sumptuous garment is finely woven, often with gold and silver threads either in the patterning or worked into its body to add to its extravagant beauty.

Fine block printing techniques and beautiful embroideries embellish the cummerbund. Cotton, silk and, sometimes, wool was also used to make this accessory, which was worn by most of the Rajasthani royalty.

Surprisingly where most garments are still used in some form or the other, the cummerbund as an item of clothing has almost completely disappeared and is now more often found in historical records. It is well represented in Mughal paintings and even the sculptures of ancient India. Beautiful examples grace the museums, although the cummerbund can sometimes be confused with the turban. The elaborate ornamentation on the end-pieces gives

179. Colourful turbans are used as headgear by a group of Rajput men dressed in traditional attire of **shervani** and **churidar.**
180-183, 185-188. The turban is twisted and folded around the head in different ways creating a range of styles. Fabrics such as **mothra, leheriya, chunri** and single dyed cotton are used to wrap turbans
184. Farmer in gol **safa.**

the cummerbund its identity. It is seldom worn today and though it may, sometimes, appear in ceremonial accoutrements, it is not as heavily ornamented as earlier examples.

Turbans

The turban is certainly the most eye-catching feature of the Indian man's ensemble. Evidence of its existence is found in some of the earliest literary sources. It finds mention in the Vedas, where men are said to have draped an unstitched garment, *usnisa*, elegantly around their shoulders or on their heads. From the earliest times a hierarchy was established, that specified what type of headgear a person could wear. Although primarily a man's accessory, both literary and archaeological evidence indicates that women also wore headgear. For example, in Vedic literature, there is a reference to Indrani, wife of Indra, the king of the gods of the Hindu pantheon, wearing an usnisa.

Some of the oldest sculptures in Sanchi and Bharhut, which date to the first and second centuries A.D., testify to the existence of turbans. They are visible in paintings and find mention in folk songs, proverbs and literature. There exist extensive court records from the later periods, especially from the princely states of Rajasthan, which provide details of their length, material and even actual cost.

In Rajasthan, the turban has many names, such as *pagadi, safa, pag, potia, mandil* or *shamla* and its significance for a man could be equated to the value of an odhna to a woman. The style of tying the turban, the colour, design, material, measurements, embellishments and accessories are dictated by many factors. To the initiated, they convey at a glance, the identity of the wearer. His occupation, community, region, economic and social status are proclaimed by the style of his turban.

The turban is usually made of a fine muslin like fabric, which, when folded, is light, yet voluminous and airy at the same time. Cotton is the most preferred fabric, since it has all the desired qualities. It is easily available, abundant, inexpensive and provides excellent protection from the heat. However, silk may be used occasionally and that too, mainly by the affluent.

The turban is a cloth of varying length and width, usually rectangular or square. The length of a typical turban is 8-9 meters, extending up to 18 meters in some cases. The width also varies, from 15 cm. to 90 cm. The square kind, known as the *rumal* may be from 1 to 3 meters across. This is a useful size as it is wide enough to be worn on the shoulders or over the head. Often a piece of fabric is draped on the shoulder, and serves a dual purpose of turban and shoulder scarf. The turban is twisted or folded and turned or wound around the head in different ways, creating a range of styles.

The two most commonly worn headgear in Rajasthan are the pagadi and the safa. The pagadi or pag is made from narrow width fabric about 15 cm. wide, but it is very long, measuring 6-7 meters. The safa, on the other hand is created with a comparatively broader fabric, approximately 75-90 cm. wide and 6-9 meters long. The safa is fashioned by twisting pleats on the right side, generally seven to nine in number, which rise up to form the *muth*. The left side of the safa is characterized by the placement of up to nine plain pleats. The short bit of fabric that fans out at the top is

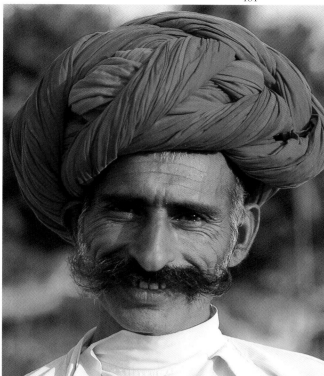
184

185

186

187

188

183

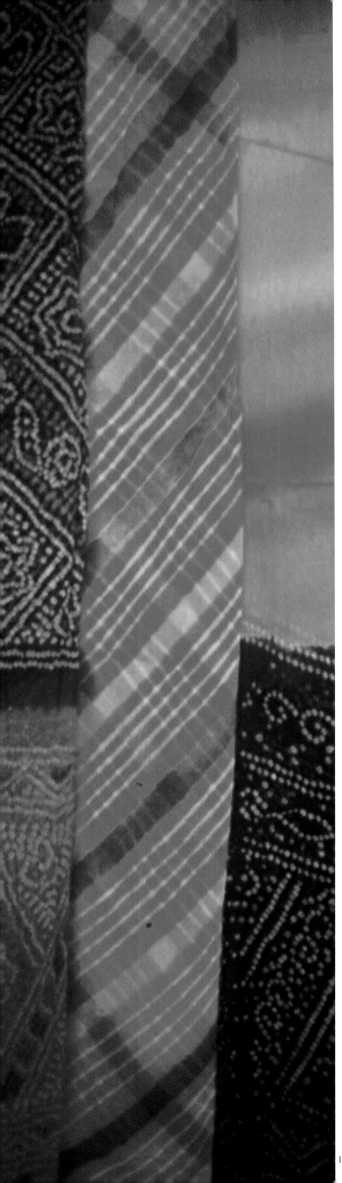

called a *turra*. The safa is distinctive for its long trailing end called the *poonch* or tail, the length of which varies not only from community to community but in accordance with the ensemble. This is seen among the royal families of Rajasthan, where, with a Jodhpur coat, the tail ends at the waist but reaches below the knees when worn with a long coat or achkan.

There are a large number of regional variations as well. The Udaipuri pag is flat, while the Jaipur pagadi is angular. The shape and size shows tremendous variety depending on the occupation of the wearer and the climatic conditions of the geographic region in which he resides. Desert turbans, like the gol safa, are big and loose. The safa is held such that it can be folded or gathered width-wise in one hand, and then tightly wrapped around the head. Such turbans provide excellent protection to farmers and shepherds who spend long hours in the sun. A tail left hanging from these turbans would be an encumbrance. Thus, a long tail is suspended from the turbans of only those who lead more sedentary lives.

Several innovations were introduced from time to time. Within the royal families, the initiative for change was often taken by experts who were especially hired by the royal family to tie turbans for all the male members of the house. Sometimes, innovation could also come from the sovereign himself. For instance, Maharaja Jaswant Singh I of Jodhpur introduced the *Jaswant Shahi Pag* in the year 1678. The Mughal influence is apparent, which is not surprising considering that this was at the zenith of the Mughal rule. This style continued to be popular till the early nineteenth century. The fashions introduced by the royal houses did not, however, remain confined to select groups and often filtered down to the masses as well. In Bikaner, the king, Rao Bikaji, bestowed a mothra pagadi made of seven colours on his people. Every community could use it and the pagadi was appropriate for every occasion, whether celebration or bereavement. Similarly, in Jodhpur, Maharaja Gaj Singh II created the panchranga or five-coloured turban, which is now known by the name of *Gaji Shahi* turban. It has a colourful combination of five colours.

Turbans were decorated according to the wearer's means. They were dyed either in one colour or with the resist technique. Tie-and- dye produced designs such as leheriya, mothra, and chunri patterns. Special designs like the panchranga (five-coloured), gandadar (diagonal zigzag patterns), rajashahi (used by kings) were crafted for different occasions and usually for royalty. Sometimes, the turbans were block-printed.

In Rajasthan, the turban is a symbol of a man's honour. Legends, proverbs, songs, stories and traditions highlight its value. For instance, a turban is never placed on the floor, for that would lower the prestige of the wearer. Similarly, it is a grave insult to step over a turban or take off another man's turban. The turban has several positive connotations. This can be seen in the tradition of publicly honouring an individual with a turban or a stole. Turbans are also presented at the time of weddings, as a mark of respect to close relatives and the bridegroom and his family. A turban is so closely identified with the wearer and his standing in the community that it was, and, in some cases, it still is, accepted as collateral on a loan. The understanding is that as the borrower's reputation is at stake, repayment is guaranteed. Conversely, the act of laying one's turban at the feet of another symbolizes submission and, therefore, is an expression of submission. In feudal times this was a valid and common practice. The vanquished ruler was required to signify his total surrender to the victor by placing

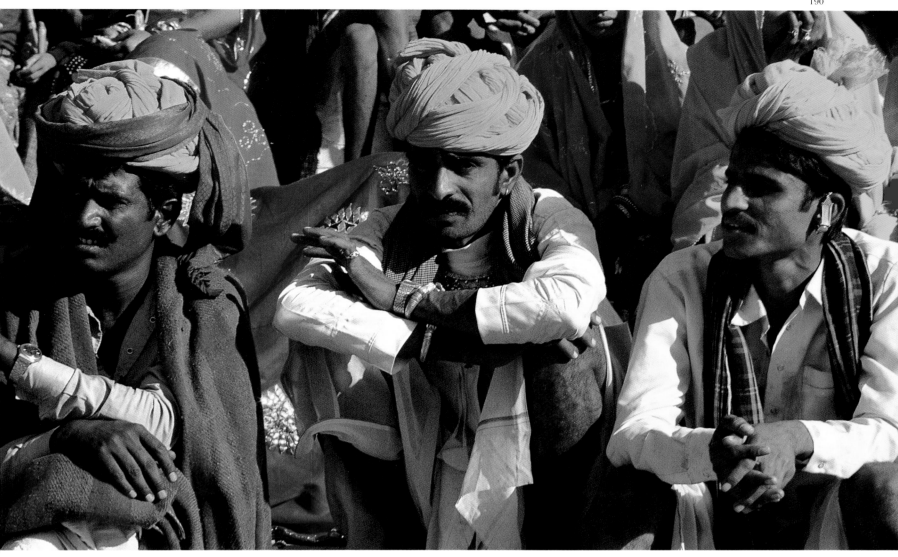

his turban—and with it his honour—at the feet of the conqueror.

The turban could be used to communicate other messages as well. A warrior's turban carried back from the front, to be handed over to the warrior's wife signalled that her husband had been killed in battle. Other symbols included tying a pagadi displaying nine folds in all, which meant that the wearer was associated with the royal durbar or court.

Turbans are an integral component of most ceremonies. They help forge relationships between families. An exchange of turbans signifies a long relationship, friendship and brotherhood and or even the end of a feud. On the twelfth day after the death of the head of the family, the *Rasam Pagari*, or the 'ritual of the turban' is observed. The father's turban is formally passed on to the eldest son, handing over the reigns as it were to the new head of the family. This investiture is a ceremonial event attended by the whole clan. It is also a symbol of responsibility. A father may give it to his grown-up, eldest son, indicating that he wishes to retire from worldly affairs.

The turban possesses denominational characteristics, as well. The community to which he belongs dictates the designs of the turban. For example, a *kesariya* or saffron safa is the mark of the Baniya community, the Osval and the Maheshvari. Priests prefer red turbans, and interestingly, so do the wandering shepherds, the Rabari. The Bishnoi wear a white safa. Between some tribal and agricultural communities, block-printed turbans are preferred. The Pushkarna Brahmin use a kesariya and red pag tied together during their

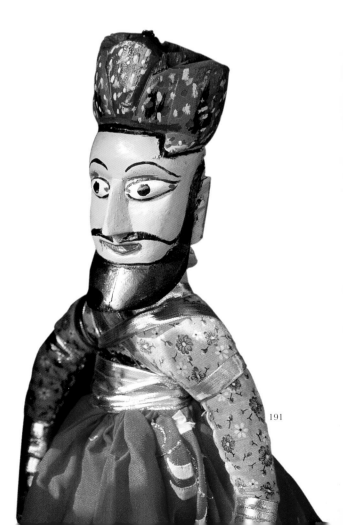

weddings in a special style, called the *khirkiya pag*. The higher the social status, the more beautiful and intricate is the turban and its design. The finest bandhani and leheriya were reserved for royalty and special dyers were employed to create them.

Turbans bring colour, to the otherwise, spartan clothing of the Rajasthani men. The brightness and colour of the turban is chosen according to the seasons and festivals. In summer, saffron turbans are worn. Green makes an appearance during the monsoon and bright red is sported in winter. During the Teej festival, the trend is towards leheriya or striped multicoloured turbans. On the occasion of Dusshera, the turbans have floral designs, worked in gold thread. White or yellow turbans are very popular on the festival of Holi. Men of most communities don a red chunri safa for family weddings. Rajasthani men generally prefer bright colours, although khaki or white turbans may mark solemn occasions like funerals.

The turban, especially in the countryside also has immense practical utility. It protects the wearer from the harsh sun and doubles as a pillow, or a bed sheet. It can become a rope; a bundle of cloth, and a cushion for a load carried on the head, a measuring tape, and a water strainer a storage place and may also be used in lieu of a helmet.

So striking is the turban's appearance that it has come to be recognised universally as the mark of the Indian man. Flamboyant, functional or emblematic, truly, this is one of India's finest innovations in dress.

JUTI

The footwear worn in Rajasthan is unique to this region. *Juti, mojari* or *pagarkhi* are leather shoes worn by both men and women of all communities. These are mostly tight fitting and triangular at the front end though, in some rare cases, they may even be rounded. The people of the Mochi community have practised the traditional craft of making the juti for centuries and continue to do so even today. Other communities like the Regar and Bhambhi, prepare the leather, from which the juti is made.

The juti may be plain, but the more ornamental footwear is decorated with heavy ari-embroidery and, sometimes, little pom-poms as well. The ari-embroidery worked in chain stitch, is a common style of ornamentation. The tool used in this work is also called an *ari*. Brightly coloured threads of wool, silk and, sometimes, zari are used for this stitch, creating colourful and vibrant footwear.

The quality and colour of leather employed is also quite varied. The footwear style, raw material and ornamentation may be unique, depending on the profession. For those engaged in outdoor work such as agriculture, jutis are made of tough leather with little decoration. Those who stay primarily indoors, women, for instance, use footwear made of soft light-coloured leather, richly embroidered in bright colours, with elaborate trimmings.

The juti is still worn in rural Rajasthan though, in urbanised areas, it has gone the way of other traditional garments in the changeover to western attire. The juti, however, dominates as the most popular footwear and has a charm and grace of its own, much like the other traditional attire.

189. (Previous page). **Turban cloths in full length.** Bandhani, leheriya and mothra are tie-dye techniques employed to ornament these turban fabrics. The fabric is rectangular with dimensions varying from 8 meters to 18 meters in length and 15cm to 90cm. in width.

190. (Previous page). **Group of farmers at a fair.** *Jaisalmer.*

191. (Previous page). **String puppet in traditional mens'dress.** *Udaipur.*

192. **Juti.** *Jaisalmer.* Footwear embroidered in ***mochi-bharat*** style.

192

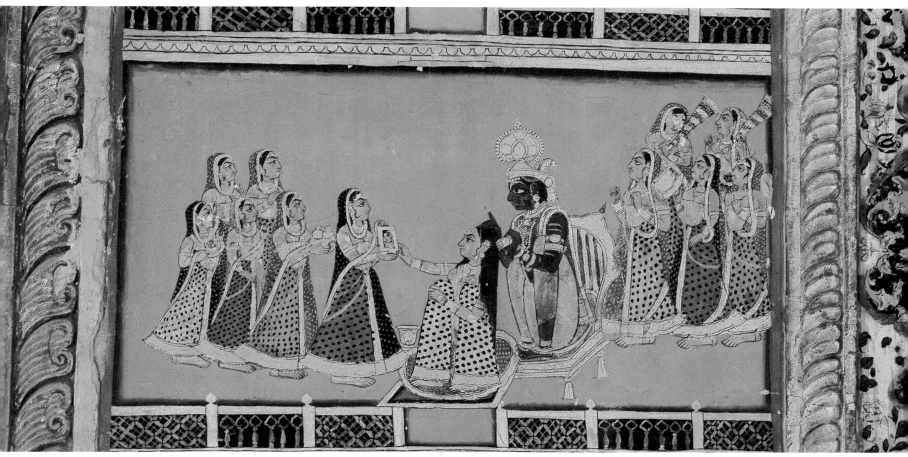

HAIRSTYLES

Apart from a colourful ensemble and stunning jewellery, the women of Rajasthan also wear elaborate hairstyles. Much like her costume, the way a woman does her hair also denotes her marital status and ethnic origin.

Women, usually, have long hair, except when they are very young. Short hair is preferred on young girls, as it is hygienic and easy to manage, especially, in the dry, dusty environment of Rajasthan. As girls reach the age of ten or twelve their hair is allowed to grow.

Hair is perceived as an important aspect of a woman's beauty and personality, so it is well-cared. It is regularly oiled and washed to keep it clean. Animal fat and other natural substances are used as cleansers for the hair. It is most commonly worn in tight plaits and various ornaments are either braided into or tied on these plaits.

Each community has its own unique way of styling and adorning the hair, which is embellished with jewellery, decorative threads, braids or charms. Interestingly, some communities use natural adhesives to sculpt their hair into certain styles. The plaits and ornaments are all braided together after their application. These adhesives are made from extracts of plants like the *babul* tree and *seda*. The glue is made from a mixture of herbs. The creation of these semi-permanent hairstyles could be necessitated both by style as well as the scarcity of water in this region.

The importance of hair can be appreciated not only from the ornamentation and care that go into the maintenance, but also the custom of never allowing a woman's hair to be cut once she reaches adolescence. After that it is cut only when she is widowed. Cropping the hair for any other reason is considered extremely inauspicious. The women also never leave their hair loose, as this is a sign of bereavement in the family.

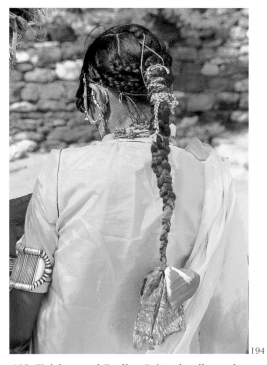
194

193. **Krishna and Radha.** Painted wall panel. *Jaisalmer Palace (12th century).* Krishna is making Radhas hair as she looks in the mirror.
194. **Meghval woman.** *Phaloudi.* Back view of head showing elaborately braided hair.

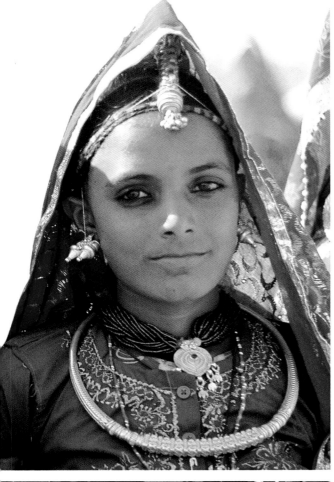

195

196

Hairstyles for men are much simpler. They usually wear their hair short. This is both convenient and easy to maintain. Their work in the fields or in their workshops, coupled with the hot climate, demands it. In some communities, men shave off the hair over their temples. This is an attempt to keep the area often left exposed the by headgear clean and cool. Facial hair is integral to the male identity. It could be said that in certain communities a man is incomplete without a moustache. It is a sign of masculinity and is sported by almost all communities, barring a few. The moustache is usually worn long and is rarely shaved off, except in the case of a bereavement. Men take great care of their moustaches, with regular trims and waxing to maintain the shape or style. A man is proud of his moustaches and sports it with great aplomb.

MEHENDI

Henna or *mehendi*, as it is called, is probably one of the most auspicious forms of ornamentation in the everyday life of India. It is derived from the leaves of the henna plant and is considered a symbol of good luck. It was earlier worn frequently, but with changing lifestyles it has now come to mark festivals and marriages and is an important part of all rituals and religious ceremonies. In Rajasthani communities, daily life is incomplete without mehendi. Women use the paste to decorate their hands, feet and, sometimes, other body parts as well. Mehendi creates intricate and complicated designs and its application is an art-form. The designs are replete with symbolism and bring good luck to the wearer. Some popular motifs are the tender mango or *keri*, the moon, peacock, flowers, leaves and geometric forms. These are brought together in countless permutations to create exquisite designs on the hands and feet.

Men also use mehendi on their hands, although its application may be limited and varies from one community to another. Their motifs are much simpler and less ornamental.

TATTOOS

Tattoos are another popular form of body decoration. They are largely used to ornament body parts such as the hands, arms and waist. In some rare exceptions like the Rabari, tattoos may also adorn the face.

Usually names and a few other symbols are tattooed on the body. The tattooist's repertoire is not very large and these symbols are usually inspired from nature, like flowers and leaves or animal forms such as peacocks, scorpions and others.

TRADITIONAL MEASURES

The measurement system in use today is only a recent invention. In India, the human hand was the most effective tool for measurement and its various lines served as a standard. The fingers were used for shorter measures. Often cotton string was marked, using a hand as its basic standard to make a measuring tape.

Angul: The smallest measure was the finger or *angul*. The angul could also vary depending on the number of fingers used. When three fingers were placed together the length was one angul or a *giri*.

Chua: The circumference of four fingers of the right hand was another measure called the *chua*.

Baint: The *baint* is one span, from the tip of the thumb to the tip of the little

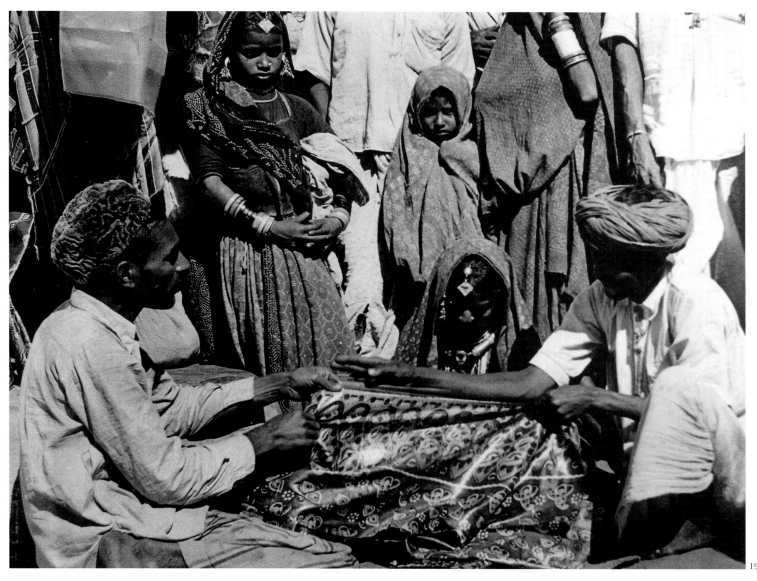

197

finger with each outstretched. Two baint make a *badi* and two badi equals the measurement of a round chest. The width of the fabric is called the *pat* and is the equivalent of three baint.

Kur: The space between the stretched thumb and forefinger makes a measure called the *kur*.

Muth: The *muth* is a closed fist including the thumb and is equivalent to half a baint.

Haath: The *haath* is the length of the hand from the tip of the middle finger to the elbow bone and is a long measure. It is also the length of 28 angul taken together. The sum of two haath makes a *var*, while three haath make a *put*, which also interestingly equals the height of the individual, and five haath make a *tukdi*.

Var: A var may also be calculated directly from the body, as it is the distance from the middle finger to the front neck bone when the arm is outstretched. This is also equivalent to the unit of the *gaj* in the formal Indian measurement system and in the metric system it measures 90 cm.

Several such permutations and combinations are used to arrive at markers for an accurate system, which is used traditionally. This system worked well in traditional societies and also represented a high degree of adaptability, depending on the person who used it.

195. **Gujar woman.** *Ajmer.* A small cylindrical piece is attached to the hair, which raises the **odhna**. She wears a **bor** on her forehead and **hansli** and **phul** around her neck.

196. **Tattoo designs on the hands of a tribal woman.** *Udaipur.*

197. **Traditional measurement at a village market.** The hand is used to measure cloth, the distance between the tip of the finger and the elbow is called a *'haath'*.

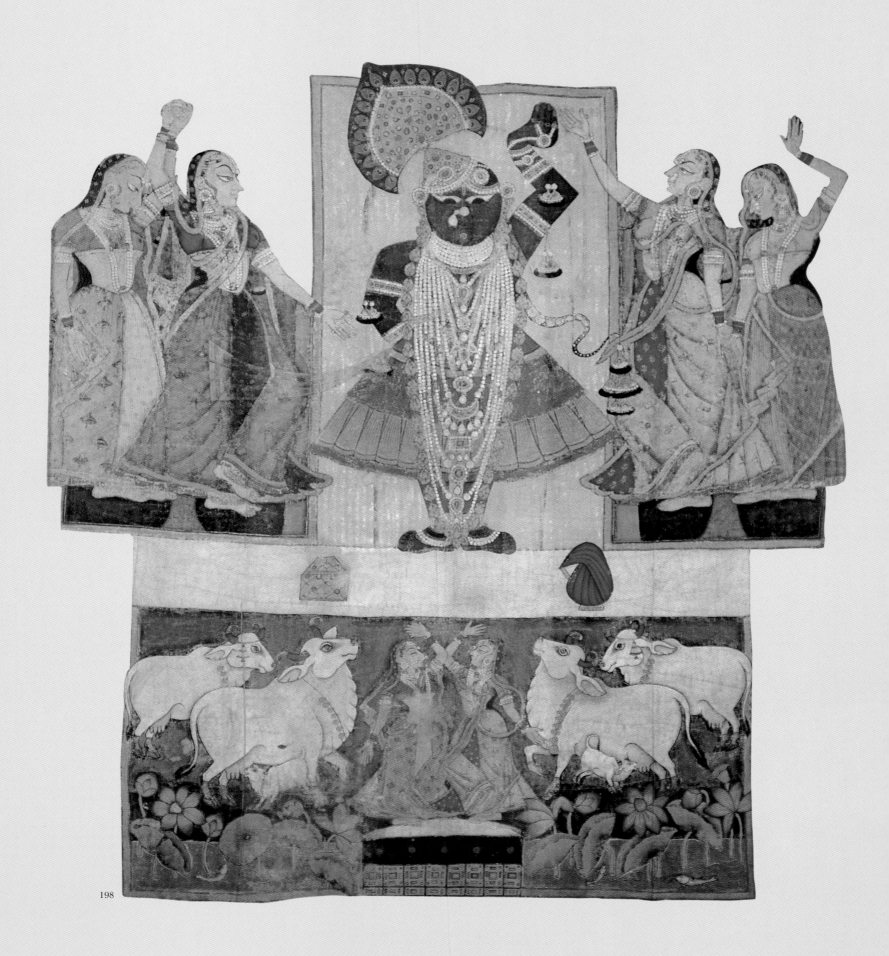

198

Jewellery and Ornamentation

"No aspect of life was too insignificant or humble to lay claim to beauty or acquire sanctity as symbols of good omen…"

-- *Kamaladevi Chattopadhyay*

199

Even in the earliest records of costume in India, jewellery is seen as a vital accessory to everyday attire. Jewellery in India, much like costume, is the manifestation of a refined design sensibility and skill, evolved by a civilization over the millennia. The vast and diverse range that exists today is an indication of the creativity and aesthetic consciousness of the Indian craftsperson, as also the inherent desire for personal adornment.

Unlike the western notion of jewellery, a piece of Indian jewellery is never simply decorative. There is invariably a symbolic value attached - the desire to also enhance the human spirit. Popular magic, theological or metaphysical beliefs are expressed through the metaphor of jewellery. The shape especially symbolizes esoteric life concepts and is often believed to exude growth and energy. For instance, geometric shapes like the circle represent the heavenly bodies like the sun and the moon, which, in turn, represent the cyclical motions in the Cosmos. The use of plant and animal forms express the power of nature. Hence, a seed represents the propensity for potential growth, while fertility is symbolized by animal representations such as the fish. Consequently jewellery forms a part of the ongoing circle of life.

The link between ornaments and religion is strong. Specific pieces of jewellery and even the material, of which they are made, proclaim the religious affinities of a group. As for example the pendants depict the gods and goddesses. The pious Hindu associates gold with Lakshmi, the goddess of wealth and others perceive it as symbolic of the sun. Like the sun, gold too is held to be immortal and sacred. Similarly, the cool, white shimmer of silver is considered representative of the moon. Ornaments made of specific gems and metals are believed to play a protective role by warding off any evil that threatens the wearer and attracting good fortune instead.

Continuity and the co-existence of India's urban civilization and tribal cultures have imparted a distinct cultural identity to traditional ornaments. This is especially true in Rajasthan, where master-craftsmen in the urban centres enjoyed royal patronage and so were able to develop their skills and imagination to create exquisite pieces of jewellery. On the other hand, Rajasthan's tribal and rural communities remain rooted in their traditions. Today, jewellery frames the context of its wearer's social standing, economic status and even political power or inclination. Much as they have always done, ornaments in Rajasthan also serve the purpose of differentiating one socio-ethnic group from the other.

198. *(Previous page):* **Srinathji.** *Nathdwara. National Museum (A.D.1800).* Krishna celebrating the festival of Sharad Purnima.

199. **A young woman in full regalia, displaying the symbols of her marital status.** *Jodhpur (c. 1950).* A **bor** ornaments the centre of her forehead and the **shishphul**, **jhela** and **mathapatti** frame her face. The earrings are **jhumka**. Around her neck are ornaments including **kanthi**. A **bajuband** is visible on her upper arm. On her arms she wears, from elbow to wrist, **gajra**, **sankel**, **moti chudi** and **hathphul**. Her blouse is made of velvet and the **odhna** is worked in **zardozi** embroidery.

200. **Bajuband.** *National Museum (Harappa civilization).* Red fabric with metal studs. This ornament is tied on the upper arm.

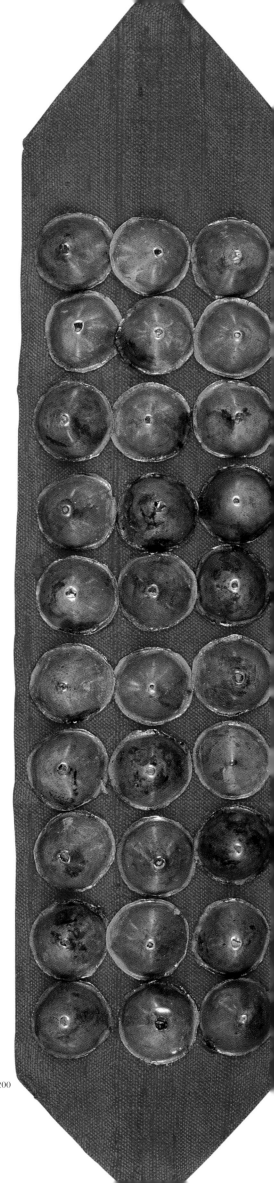

200

Apart from its symbolic value, jewellery is also an important investment because of its easy liquidity. This is especially true in this region with its hostile desert environment, its continuous internecine warfare and history of turbulent political upheaval. Feudalism, invasions and instability made it essential to hoard movable assets for security. These assets were in the form of ornaments made of gold, which has always been recognized as the universal medium of exchange and an important and reliable means of savings. This was especially relevant for women who in a feudal, patriarchal society have traditionally had little or no opportunity for financial independence. Their personal ornaments, usually obtained at the time of marriage, are a means of safeguarding their future.

Precious ornaments were also a measure of survival for displaced dynasties and a means for new pretenders to the throne to buy legitimacy. Rulers, in an attempt to legalize their reign, often traced their origins to Vedic heroes and even to deities like *Surya*, the sun god and *Chandra*, the moon goddess. They were creatively assisted in this endeavour, by the priestly classes, to appease whom religious institutions were generously endowed with gold, the most sought-after metal in the world.

From the Mughal period, however, the use of gold came under severe scrutiny. Several laws were enacted, which clearly restricted the use of the metal. Royalty alone could display gold ornaments anywhere on their person, whereas the rest of the social elites were allowed to wear gold only from the waist up. All other sections of society were permitted the use of gold in strict moderation, for example, only in nose rings. Otherwise, it was believed that the sanctity of this precious metal would be corrupted. Thus society was divided by the wearing of gold.

Almost two centuries of colonization could not change the Indian tradition of jewellery as daily wear. While its use as ornamentation may not be so routinely visible in urban India, it is still an essential part of the everyday attire of the rural Indian. Rajasthan, like so many other parts of India, has a rich living tradition of jewellery. It has its ornaments, motifs and designs, which are intrinsic to its people and are worn even today.

The Soni community are traditionally the jewellers of Rajasthan. They use a host of materials, both organic and inorganic, from which they fashion beautiful jewellery. Although ornaments in Rajasthan are crafted from a wide variety of metals, gold and silver are the most popular. Apart from their aesthetic appeal, religion and mythology grant them their privileged status.

Silver has always been the unrivalled favourite in Rajasthan, as it is found in great abundance in the region and, therefore, more affordable than gold, which is beyond the reach of ordinary people. So great is the attachment to silver that once it is worn, it is almost never taken off. For example, the village-jeweller who solders a silver kada as an anklet, will be called back to remove it only when its wearer has passed on. The silver mined in Rajasthan is of a very high purity, which also makes it a reliable form of currency. However, the drawback with silver is its weight, which renders it enormously cumbersome and, hence, places restrictions on its mobility. Gemstones like diamonds, pearls, rubies, sapphires and emeralds are also widely used for making jewellery, as are non-minerals such as *lac*, grass, feathers and cowrie shells.

Lac, aptly termed 'the common man's gold' is

*201. **Navratan Haar**. National Museum (19th century).* Necklace made of nine precious gems: ruby, pearl, coral, emerald, topaz, sapphire, zircon, diamond and cat's eye, representing the nine planets and their reigning deities. The arrangement of their settings is laid down in ancient texts. Each stone in the ***navratna*** is believed to influence a different aspect of its wearer's destiny, the central ruby being the most powerful.

*202. **Sa-ghosha-kataka**. Jaipur (c.1920).* Rigid, hollow anklets. Silver set with diamonds, hinged at one end, and fastened with a screw. Small metal balls inside the anklets tinkle as the wearer walks.

202

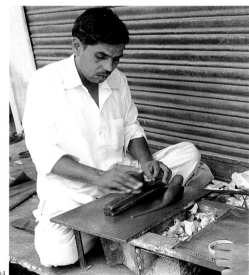

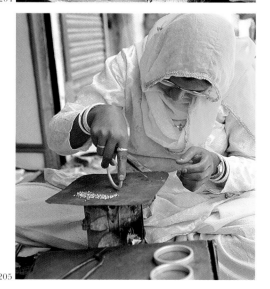

well loved in Rajasthan. It is also considered extremely auspicious by certain communities like the Bishnoi. The Bishnois are nature-worshippers and lac, a natural substance, is a mark of their religious beliefs and so considered auspicious. Today this belief has spread among other communities, and lac bangles are hugely popular for special occasions like family weddings, *Teej* and other festivals. Ivory, associated with Ganesha, the Hindu god of prosperity, was extensively used for beads, wedding bangles, brooches, rings, ear tops, and pendants. However, it is now banned and is no longer used to make ornaments.

Lac Bangles are made through an interesting process, with natural materials.

First, coarse lac is melted down and strained through a muslin cloth. The residue obtained is called *chapadi*. The next stage involves the preparation of the *guni* and *batti*. Guni is the lac stick. It is prepared by heating together coarsely pounded lac, *beroza* powder and crushed soapstone. These are then rolled on to a wooden stick.

To make the batti or colour cake, the chapadi is first softened by heating and coloured powder is added. This mixture is kneaded, heated a little and cut into small cakes. Immersion in water then cools these cakes and a wooden stick is attached. Once the guni and batti are prepared, the batti is heated and rolled onto the surface of the guni. Several coatings are made so that the guni gets a generous amount of colour. This coloured guni is then heated and pressed into an unbroken column with a tool, locally known as the *hatta*. This column is cut to get bangles of the required size.

Lac bangles are usually worn in sets of odd numbers on each hand. They display tremendous variety in style and design. The most common design is the leheriya, a wavy or zigzag pattern. Some bangles may also be studded with little mirrors, bright stones, beads or gold and silver powder. Popular varieties are *hinglu ka chuda, nagon ka chuda, leheriya ka chuda and taron ka chuda*. Lac bangle-making is a family-based cottage industry. The men are responsible for

cleaning and dyeing the lac, while the women are involved in the decoration of the final product. Today, although many traditional crafts seem to be losing their earlier markets, lac and the bangles made from it still enjoy the patronage of the public and the industry has seen growth and continuous support even in the present day.

Grass, straw and feathers are other materials commonly used for ornamentation by the tribal people. Garasia women braid grass chains into their hair and wear wheat stalk tassels called *choti jhumka*. They also make bracelets from rice stalks. Cowrie shells are used to embellish women's hairpieces and also in trappings for animals. In Rajasthan, coconut shell bangles are called *kasla* and are worn mostly by Bhil women.

THE CRAFT OF JEWELLERY MAKING

There is an endless array of raw materials available to inspire the Indian jeweller's craft and there is a corresponding profusion of techniques at hand for jewellery making. Of the innumerable processes employed by the master craftsmen of India, there are some that are almost synonymous with Rajasthan.

Filigree

This highly labour-intensive jewellery making technique utilizes only the highest quality gold or silver wire. Apart from the delicate beauty of this kind of jewellery, it is especially attractive because elaborate articles can be created from even a very small quantity of metal. This keeps the price of filigree objects low.

206

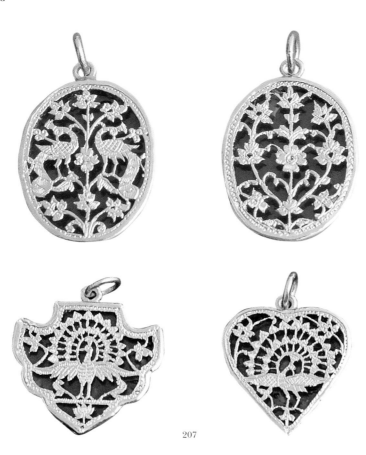

207

203. **Lac bangles stacked up for display in a side-street shop.** *Jaipur.* Tiny pieces of glass are used to create the patterns on the bangles.

204. **Coloured *lac* is turned into bangles.** *Kishangarh.* **Lac** becomes pliable when it is heated and can be moulded into virtually any shape.

205. **Woman presses decorative bits of coloured glass into the *lac*.** *Kishangarh.* The bangles are heated over a coal fire to soften them.

206 & 207. ***Theva* work pendants.** *Chittorgarh (c. 1940).* Gold-plated silver on glass, depicting floral and peacock motifs. A combination of *minakari* and *theva* skills have been used to create these designs.

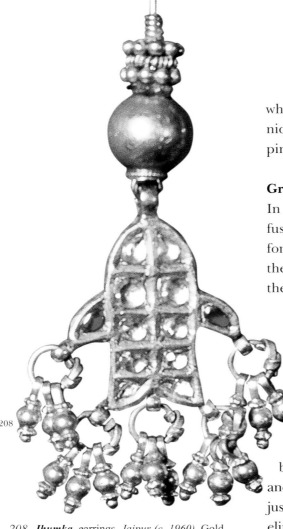

208

The jewellers of Rajasthan fashion spectacular ornaments in filigree, which have been used to decorate practically every part of the body. The technique has been used to create a variety of ornaments like diadems, tiaras, hairpins, necklaces, earrings and even brooches, clasps and buttons.

Granulation

In this technique, minute solid gold or silver balls, with varying diameters are fused on the surface of a base metal to make a pattern. The process used is a form of fusion-welding. These balls or granules can all be of uniform size or they may vary within the same ornament. These balls are usually worked on the ornament in geometric patterns.

Kundan

Kundan is the process of setting gemstones by embedding them in strips of pure, soft gold. It completely eliminates the need to create frames or bezels to clasp each gemstone. Hence, stones of any shape or size can be used in any setting. The gold jewellery unit prepared to hold a gemstone is generally of hollow construction, with individual parts soldered together.

The process is complete and begins with high purity gold wire being beaten into thin, flat strips. These strips are then cut to the required length and led around the stone with a stylus. The high purity of this gold ensures that just the application of pressure can weld the gold in any shape around the stone, eliminating the need for heating.

As far as the Kundan surrounding the stone is concerned, it is either left plain or designs can be created on it to heighten the play of light on the stone. Sometimes, the reverse side is ornamented with enamel work or *minakari*.

Minakari or Enamelling

Minakari is enamel work, which originated under the patronage of Mirza Raja Man Singh (1590-1614), the ruler of Jaipur. A chemical process employing a variety of chemicals, for example - metallic oxides, creates *Mina* or enamel. These metallic oxides are used as colourants. For example, cobalt oxides for blue, copper oxides for green and gold chloride for red.

Minakari combines the skill of several specialist craftsmen like the goldsmith, the engraver, and the enamel worker. First, the goldsmith creates a

*208. **Jhumka**, earrings. Jaipur (c. 1960). Gold with kundan settings. The gems are embedded in strips of pure, soft gold, eliminating the need for frames or bezels to clasp each stone.*

*209. **Sarpatti**, turban-ornament. Jaipur (c. 1930). Crafted in gold with rubies and emeralds, set in the kundan technique. The piece is fringed with uncut emeralds.*

*210. **Haar**. National Museum (19th century). Necklace in gold*

*211. **Chand**, **turban-ornament**. Udaipur. Gold set with precious stones. It is worked in the kundan technique.*

*212. **Ear Ornament**. National Museum (19th century). Fish design, edged with pearls. The reverse side seen here is ornamented in enameling technique.*

*213. **Gajra**, wrist ornament. Udaipur. Gold worked in the granulation technique. The bracelet is hinged at the centre and is fastened with a screw clasp.*

*214. **Bajanti**, **choker**. Jodhpur. Granulation on gold. It is backed with cotton fabric and has adjustable thread ties.*

*215. **Sankel**, flexible gold wrist ornament with fish-head terminals. Jodhpur. The bangle is enamelled in the **minakari** technique.*

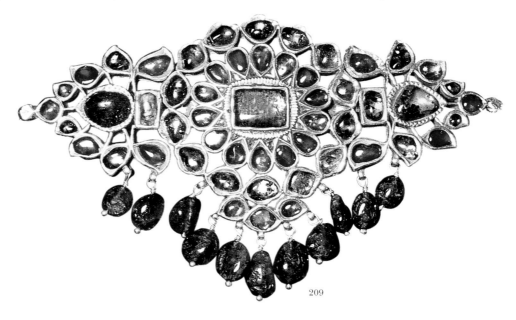

209

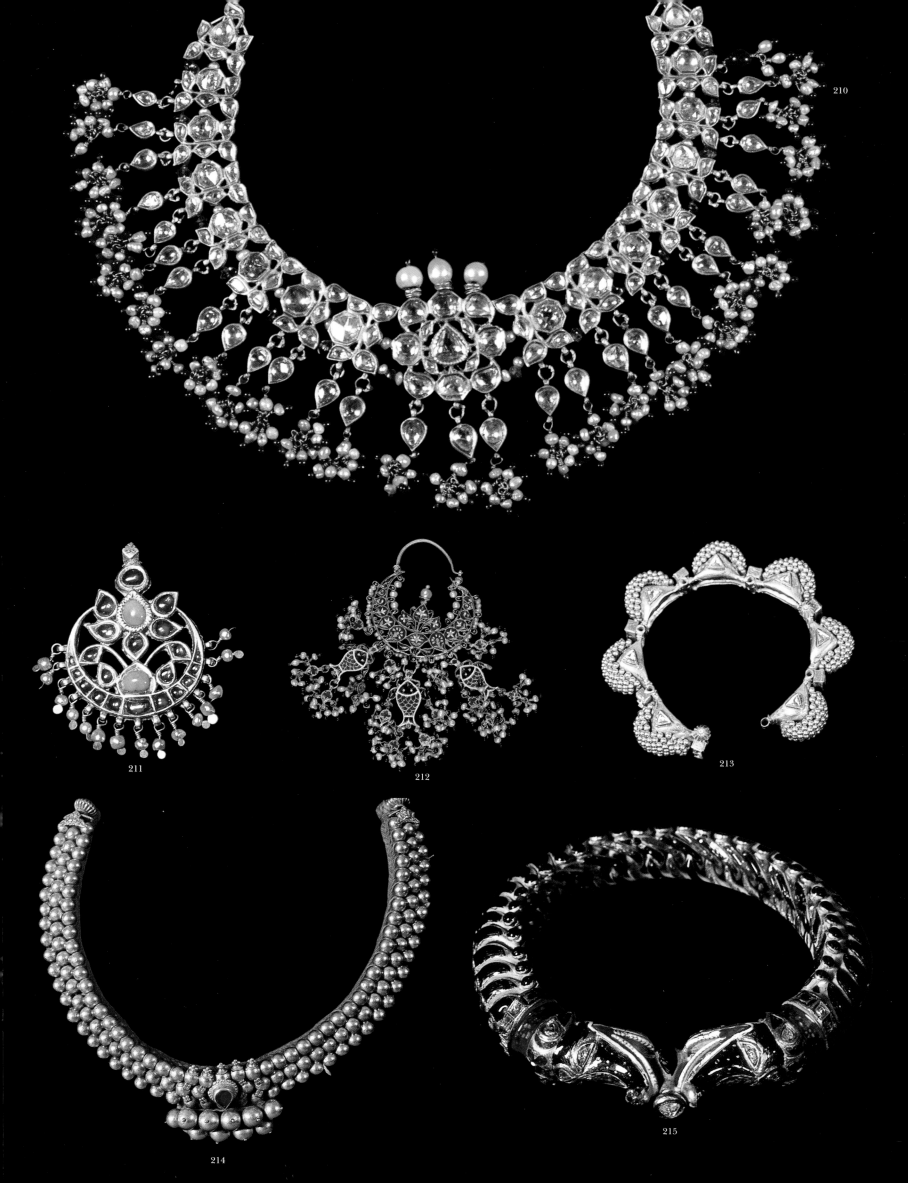

210

211

212

213

214

215

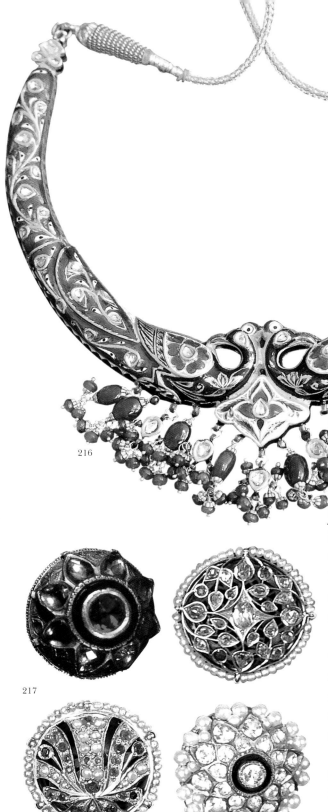

basic item of jewellery. The designer then draws a pattern on the surface of this article. The engraver strips off the metallic coating from the sections within this pattern that are to be enamelled. He scores the surface fairly deep to allow the enamel to seep in. The enamel worker takes over from here. He applies the colours, starting with those, such as white, which have the highest degree of fire resistance and ending with a colour like red, which has the lowest resistance. In the final stage, the article is fired in a kiln.

Popular motifs in Jaipur enamelling are birds, flowers and human figures. Sometimes, the two beautiful techniques of Minakari and Kundan combine to create stunning pieces of jewellery. Minakari may also be used in combination with theva, in the process creating a rare combination of colour and design.

Theva

Theva is considered one of the finest, most delicate and sophisticated jewellery making crafts in India. Pratapgarh, a princely state of Rajasthan is credited as being the birthplace of theva. It was probably introduced in the latter half of the eighteenth century, possibly during the reign of Maharawat Samant Singh. Theva craftsmen, known as the Raj Sonis, zealously guard the secret of the technique; its tools and usage, thus ensuring that theva remained within the domain of a select group.

A delicate filigree design is created by fusing a thin gold foil sheet of 24-carat purity onto the visible surface of a sheet of glass. The glass may either be red, blue or green, suggestive of precious stones like rubies, sapphires or emeralds. Once the gold foil is mounted onto glass, the whole unit is then mounted once again on a separate foil, usually silver, and then set into a piece of jewellery or an article like a spice box.

Each individual piece of theva takes a geometric shape and could be round, oval, square or rectangular. The designs created are mostly traditional floral motifs, mythological characters, hunting scenes or episodes of settled domestic life.

ADORNING THE PERSON-JEWELLERY FOR WOMEN

This section identifies and studies ornaments that are commonly worn by women in Rajasthan. An attempt has been made to present traditional pieces of jewellery according to their placement on the person, adorning the woman's figure as it were, from head to toe.

The Forehead and Crown

Rajasthan has a long tradition of ornaments for the forehead. These, like the *bor*, can be placed right in the middle of the forehead, or as is the *sirmaang*, be worn only in the parting of the hair, or be in the shape of a headband like the *mathapatti*.

216. **Hansli, rigid torque.** *Jodhpur. Minakari* or enamel work on gold with precious stones in **kundan** settings. The necklace takes the form of two peacocks.

217. **Bor, spherical forehead ornaments.** *Udaipur (c. 1900).* Examples of the wide variety of styles, materials and techniques used to fashion this universal symbol of marriage.

218. **Bhil women.** *Banswara.* Displaying the **bor** crafted in silver. The ornament is worn at the top of the forehead.

219. **Tribal woman.** *Jaisalmer.* She wears a silver **jhela** over her left ear.

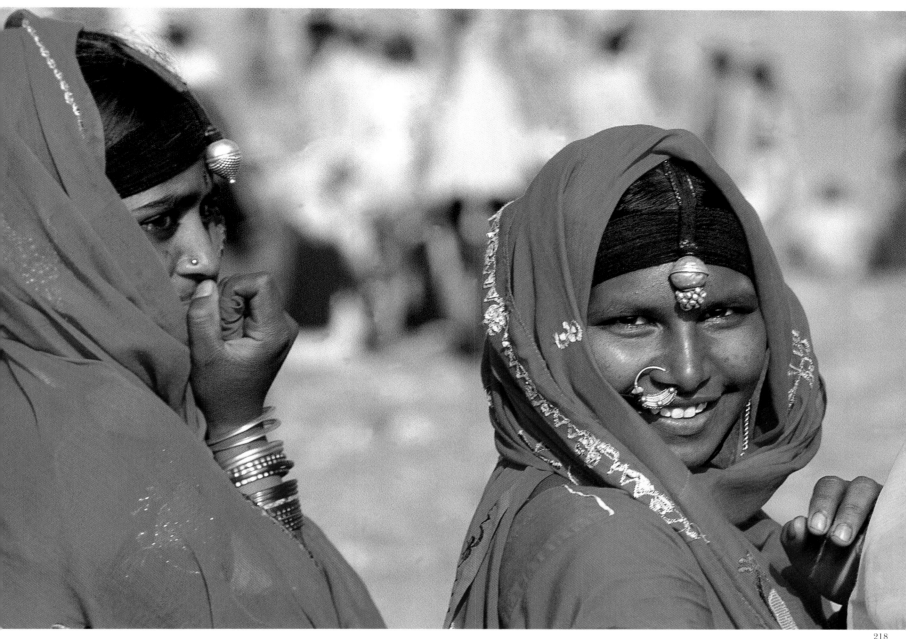

Bor Or Rakhdi

The *bor or rakhdi*, also known as a *ghundi or borla,* is worn in the centre of the forehead, at the hairline. It is made of either gold or silver. Its shape is generally spherical but it can sometimes have a flat top. Designs are usually crafted on the surface through the process of granulation. On its sides and back these are provisions for attaching other ornaments. The bor, is sometimes, made in a combination of lac and gold. A small tube is attached to the front of the sphere. Sometimes colourful beads are threaded on the curved face of the ornament. A fine chain called the *tidibalka* is worn below the bor forming a semi-circular frame for it.

The *bor* is a symbol of marriage and is worn only after the wedding rituals are over. It is presented to the bride by her husband's family and is worn everyday for as long as she remains married.

The *bor* sees great variation across communities. While in the Rajput, Maheshvari and Osval communities it is made of gold, for others, it is made of silver. The Meghval wear a *bor* made of beads, or sometimes, a little silver globe. Bhil women also wear a silver *bor*, which usually has a *jabia* or chain attached and is held in place by cotton strings tied to the hair at the back of

220

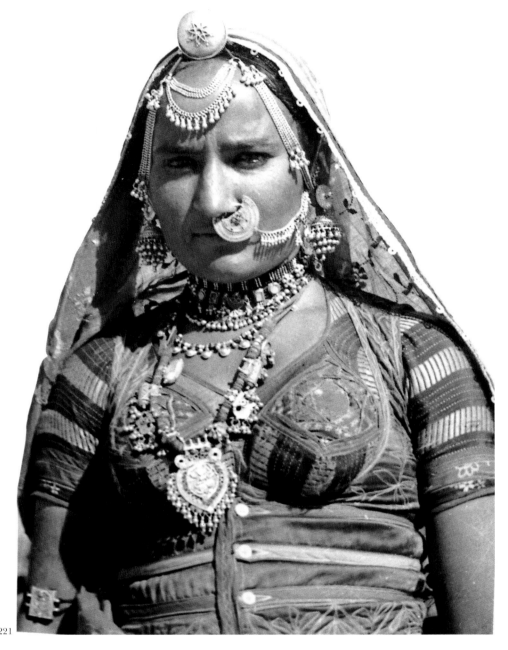

221

the head. Some bor have metal chains called *dora*, joined to either side which run behind the ears and are fastened behind the head.

Jhela

The *jhela* is a series of chains, which support the weight of ear ornaments called *jhumka*. Two jhelas are worn on the head and they pass through the central rod of each earring, meeting the bor at the centre of the forehead. The ornament frames the face around the hair. *Sankli*, *damini* and *moro* are other names used to describe the bor, which is used by most communities in Rajasthan.

Pan

The *pan* is worn behind the *dora*, and lies flat on the head. It has strings that go behind the ears and tie at the base of the head. It derives its name from its form, which is very like the heart-shaped betel leaf. *Pan* is made of small heart-shaped cutouts, inter-linked with chains.

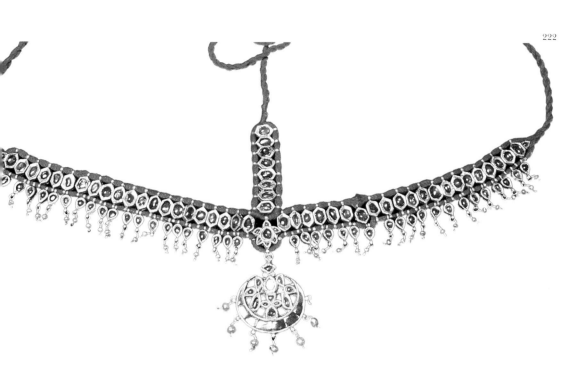

Mathapatti

The *mathapatti* is a headband, which is usually crafted in gold. It is a popular ornament and worn by women across communities. It starts at one ear and ends at the other, resting on the hairline. It can have a *tika* or *sirmaang* attached, making it an elaborate head ornament. Often earrings called *karn-phul* are fixed on either side. This combination of the mathapatti, tika and karnphul is called the *phul-jhumka-bind-suda*.

Seldi

The *seldi* is used at the end of a braid and is a popular hair ornament. It is made of gold or silver and is about 5-10 cm. long. It has a conical shape, with tiny bells dangling from its base.

Shishphul

The *shishphul* quite literally means a 'head flower'. This ornament is usually made of gold and has three flat floral pendants joined by chains, with smaller pendants in the centre. The ornament is worn next to the *pan* and runs parallel to it.

Sirmaang

The sirmaang is worn in the parting of the hair or *maang*, from where it gets its name. It is usually a single chain set with precious stones.

*220. **Jhela, head and ear ornament.** Jaisalmer (c.1940).* Gold with **kundan** settings.

221. **Bishnoi woman.** *Barmer (c.1950).* Her forehead is adorned with the **bor, tidibalka** and **jhela.** She wears a **kanthi, gugri** and **phul** around her neck, and **jhumka** hang from her ears. A chain, attached to her ears, supports the gold nose-ring, or **bhavariya.** An amulet can be seen on her upper arm. She is dressed in a **kurti** and **kanchli,** her head and face are partly covered by an **odhna**

*222. **Mathapatti** with **sirmaang** and **tika.*** *Udaipur.* Head ornament in gold, set with rubies in the **kundan** technique. Red cotton ties that join the pieces are braided into the hair to keep them in place.

*223. **Tika,** Jaipur.* Forehead ornament. Gold and precious stones worked in the **kundan** technique. The ornament is suspended on a pearl chain.

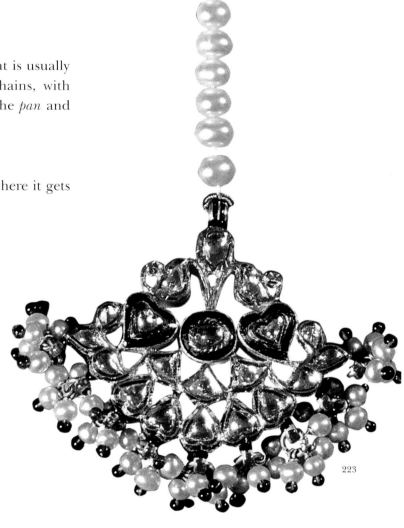

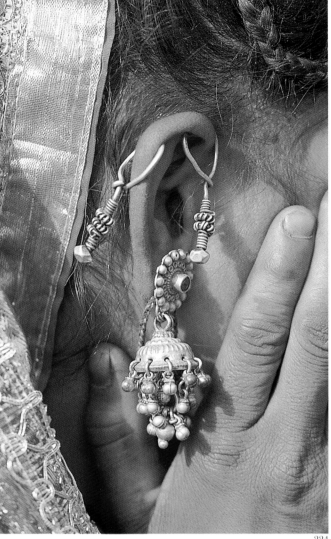

224

Tika

A *tika* can be a circular or heart shaped pendant with a small chain affixed at the back. It has a clasp on its end, which hooks it to the hair. The *tika* is also known as a *tolda*. It is worn suspended in the centre of the forehead.

Titah

Titah is a head ornament for women of royal aristocratic birth. Men usually wore the *sarpech* and women were very rarely allowed to wear them. A sarpech is named titah when a woman wears it. Wearing the *titah* was a privilege, exclusive for royalty and the aristocracy.

The Ears

Ear ornaments are a charming enhancement to a woman's appearance. However, a somewhat less-known fact is that their function goes beyond mere adornment. Ear-ornaments also provide their wearer with the benefits of acupressure. The variety in design, shape and skill that go into their making is considerable. The most popular earring is in the shape of a five-petalled flower, set with pearls and precious stones.

Bedla

The *bedla* is either circular or long and is worn on the upper region of the ear. Two or three are worn together by married women. Bedla are small hooked wires, with heart shaped ends. Variations of the bedla are also known as *lair, oganiya, jhutna* and *jubi*.

Jhumka; Jhumar or Jhumri

The *jhumka, jhumar* or *jhumri* are among the most popular ear ornaments in Rajasthan. They are bell-shaped earrings, made in gold or silver. The jhumka is a hollow hemisphere about 2.5 cm. in diameter, with bells of graded length strung in concentric circles on the outside as well as the inside. The innermost circle has the fewest but the longest bells. Rajput and Mahajan women wear gold *jhumka*, which weigh up to fifty grams. Among other communities, these ornaments are crafted in silver. One common type of *jhumka* is in *jadau*, which is set with precious stones.

Karnphul

Earrings come in an immense range of designs. Some are inspired by nature, like the popular *karnphul* design. The *karnphul* are fashioned like a five-petalled flower. They are often studded with precious and semi-precious stones. Another ear ornament that borrows from nature is the *lathan*, shaped like a bunch of grapes.

Kudka

The *kudka* is made of brass and worn mainly by Meghval and Sindhi Musalman women. This earring has two semi-spherical parts of different sizes, which are linked. The centre of each piece is often set with a stone.

226

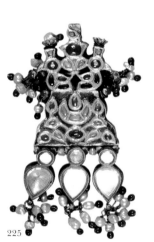 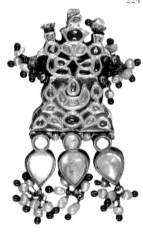

225

224. Jhumka and bedla. Ajmer. Ear ornaments made of silver.

225. Jhumka. National museum(19th century). Ear-ornament. *Kundan* inlay on gold.

226. Jhumka, Udaipur. Ear ornament. *Kundan* work made colourful by the choice and placement of gems – rubies, emeralds and pearls.

227. Jhumka, jhela and *oganiya. Jaisalmer.* Ear ornaments in silver.

228 & 229. *Jhela* with *jhumka* and *bala. Jaisalmer.* Ear ornaments. Enamel work on silver.

230 & 231. Jhumka. Jodhpur. Earrings, gold set with precious stones pearls. *Kundan* technique.

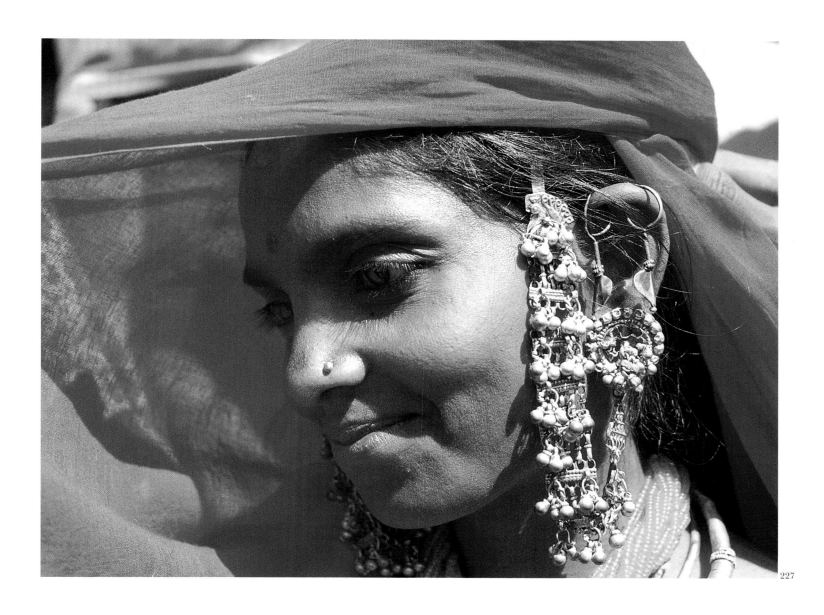

227

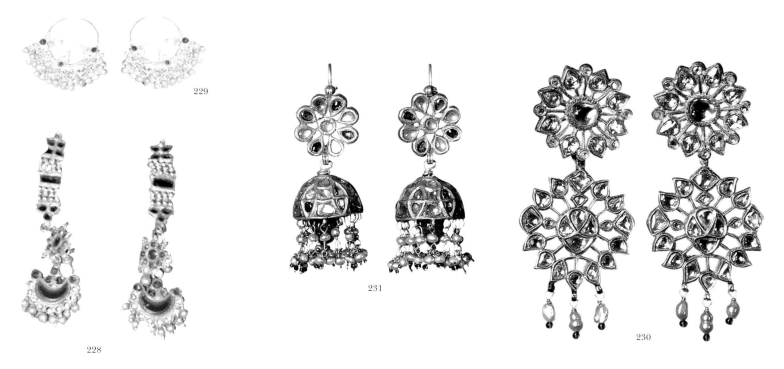

229

228

231

230

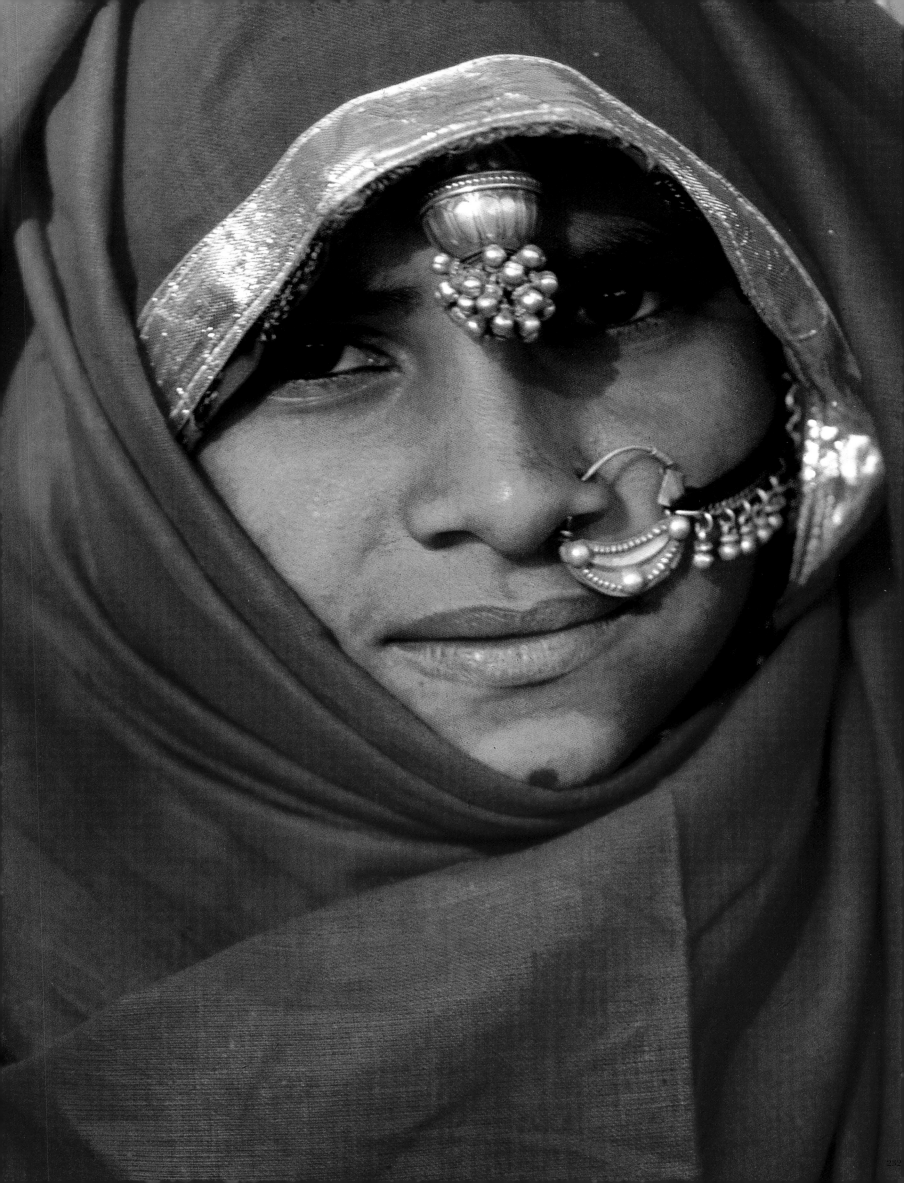

Kundal

Kundal are large circlets, set with precious stones on their visible surface and usually enamelled on the reverse side.

Murki; Jhalar; Bala; Panda

These are different ear ornaments and are worn mostly by Muslims in Rajasthan. They are circular hoops embedded with green and red stones. These rings are worn on various parts of the ear. The *panda* is worn in the centre of the ear. The three pieces on the top are called *jhalar*. A *bala*, is sometimes worn in the central fold of the ear and the *murki*, worn by both men and women, is on mid-section.

Svargsilli or Nasbi

The central fold of the ear is known as the *nasbi* and the ornament worn on this part is named after it. This is a small gold ring worn in the centre of one ear. It is put on at the time of marriage and never removed. There is a popular belief among the people here is that those who wear this ornament secure a place for themselves in heaven.

Toti-Durgala

This ornament consists of a flat curved piece of silver or gold, shaped like a parrot. It has a central projection with a red or green stone set on it. Its rim has small triangular protrusions, resembling a flower in bloom. A thick rod at its back passes through the hole in the ear lobe, dilated to accommodate its size. Both married and unmarried women across all communities wear the *toti-durgala* with some variations.

The Nose

The most symbolic and visible ornament to identify a community adorns the nose. There are three categories of nose ornaments, studs, rings and septum rings. This ornament is considered sacred, so almost all communities use nose ornaments made from gold, even though all of their other jewellery may be in silver.

It is worn by a woman at the time of her wedding and is a symbol of her marital status. It is associated with a woman's honour and *nathni utarna*, meaning removing a nose ring, signifies her disgrace. The nose ring, worn most commonly in Rajasthan represents the sun and the moon. The large circle represents the sun, and under the nose is the crescent moon. The upper portion is studded with red stones and the underside has white ones.

Buli

Rings or small flat designs are worn as nose-studs. The nosepieces are known by different names among different communities. The *buli*, for example, is a ring that passes through the septum.

Kanta

The *kanta* is a flat plate with a diameter of 0.5 cm. to 1 cm. The visible side is embedded with stones. A spring-like wire on the back is passed through the hole in the side of the nose to hold the *kanta* in place. Women of the Jat, Jogi, Meghval, Osval and Rajput communities wear it.

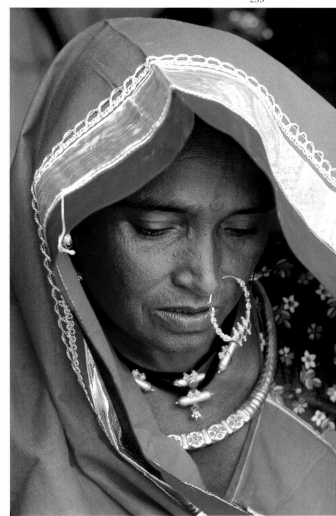

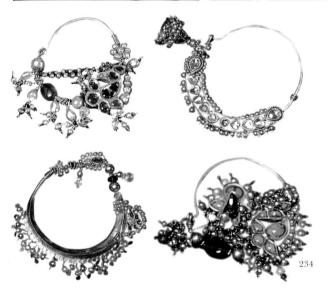

234

232. **Bhil woman.** *Dungarpur.* The **nathdi** in her left nostril is supported by a silver chain attached to her hair. A **bor** ornaments her forehead.

233. **Jat woman displays a gold nose-ring.** *Kishangarh.* The **madaliya** on a black string around her neck has alleged powers of warding off the evil eye. She also wears a rigid silver **hansli**.

234. **Nath.** *Udaipur.* Nose-rings. Variations in gold, set with precious stones and fringed with tiny pearls. Gold is the preferred metal for nose-rings.

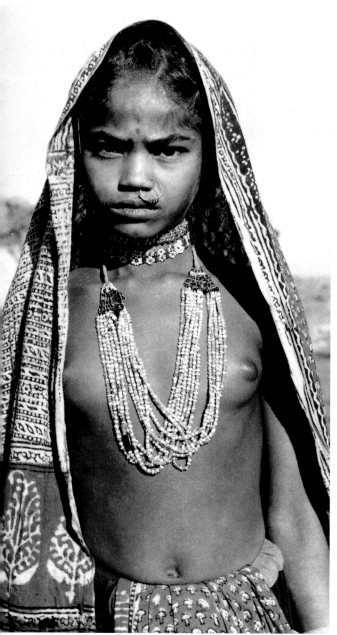

235. **Tribal girl adorned with jewellery.** *Udaipur (c.1960).* A **kanthi** and long bead necklace on her bare torso emphasize the high value placed on jewellery. She wears an **odhna** over her **ghaghra,** but her upper garments are conspicuous by their absence.

236. **Badla.** *Jaisalmer.* Rigid silver choker decorated with coiled wire. The **badla** has a hooked clasp on the front.

237. **Galapatti.** *Bikaner (19th century).* Close-fitting necklace. Gold with **kundan** setting of precious stones on its visible surface and enamelling on the reverse side. The adjustable ties are in cotton and gold thread.

238. **Chandanhaar.** *Jaisalmer.* Long necklace of gold and silver filigree chains linked with plaques at regular intervals. The central pendant, **madaliya** also serves the function of an amulet.

239. **Hansli.** *Bikaner. (19th century).* Rigid choker. Gold and precious stones in **kundan** work. Its reverse side is covered with enamelling. The necklace is fringed with pearls.

Laung or Kol

The *laung* or *kol* is a commonly worn nosepiece. The top has small leaves made in gold and in the centre is a red stone. A wire at the back fixes it on the nose.

Nath

Rabari women wear a nose-ornament, called the *nath*, which is made of a thick metal wire, 2-3 cm. in diameter. To lessen the pressure of the *nath* on the nose, the ornament is often tied to the hair behind the ear with a chain or thread. Women of the Maheshvari and Muslim communities also wear the *nath*. Another, similar ornament is the *nathdi*, a silver-ring worn by Bhil women in the centre of the left nostril.

The Neck

Apart from the ears, the neck is often the most heavily ornamented area of a woman's body. Usually several neck-ornaments are worn on the neck at once, sometimes, numbering upto ten different pieces.

Even within the same community, neck-jewellery may reveal an enormous variety. For example, within the Bhil community alone, women wear necklaces made of silver buttons, which are interlinked with chains hung with pendants. They also wear necklaces made of beads, preferably, of blue and green, showing remarkable diversity in design, length and style.

Badla

This is a circular, cylindrical, hollow, round circlet piece, which tapers towards at one end. The back is narrow and the diameter increases towards the front. The hooked opening is in the front with a hinge on one side. The tube core is wrapped in spiral fashion with different gauges of wire. It is generally made in silver, except in certain communities like the Rajput, who use a gold version of the ornament. Only Hindu women wear the *badla* after marriage. Rajput, Jat, Bishnoi, Suthar, Nai, Bhil, Meghval, Kalbi, Rabari, and Hindu Jogi are some of the groups who use the *badla*. This striking ornament rests about four inches below the collarbone.

Galapatti or Gulaband

The **galapatti** or *gulaband*, is an ornament, literally a 'neckband', made by stringing together small pieces of kundan or minakari to form a necklace. The necklace, when worn, covers the neck like a collar. The lower edge has a fringe of small miniature units of identical design, which adds to its beauty.

Haar

Haar is a standard term for any long necklace and could also suggest a garland. These necklaces may be of varying length and demonstrate a tremendous variety of styles and forms. The *patri haar* is made of long chains joined together by metal pendants and a large central pendant. The *ath pahlu* haar is made of octagonal-

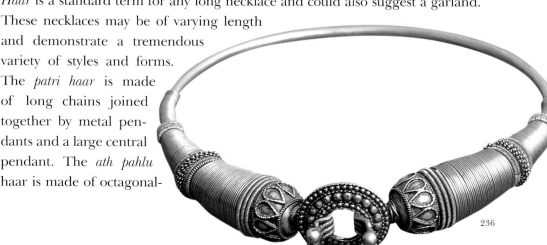

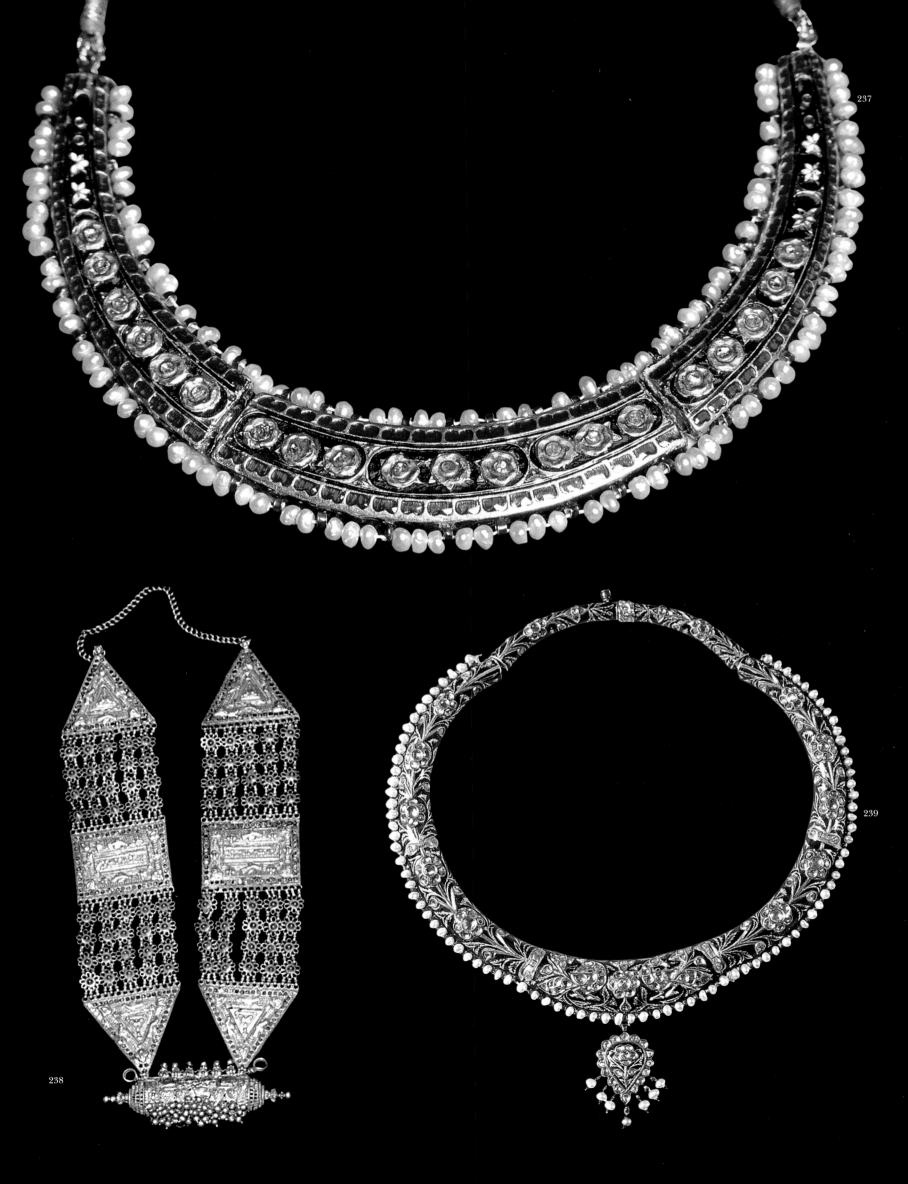

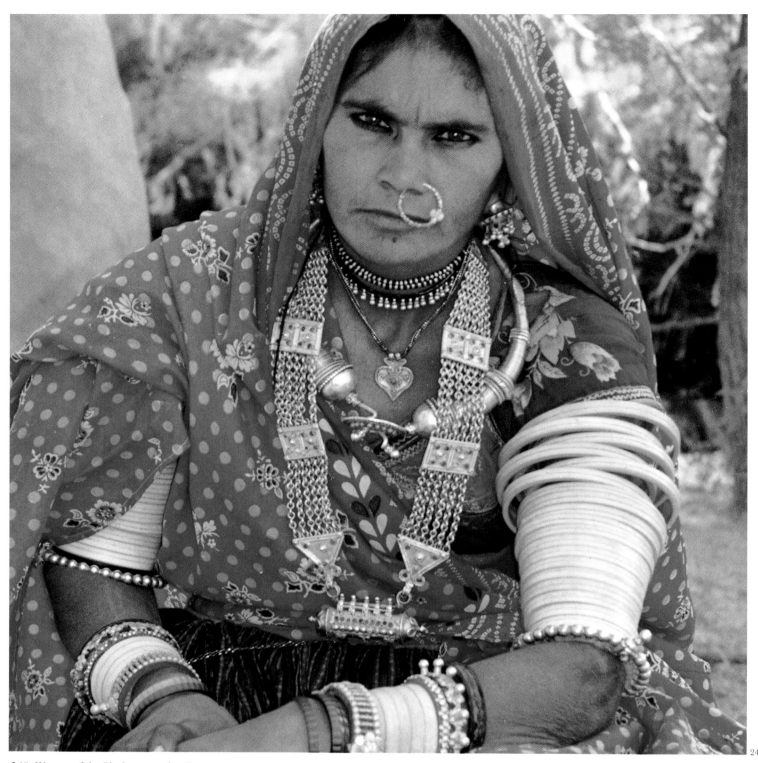

240

240. Woman of the Sirvi community. *Barmer region.* The ear ornaments are called **toti.** Her nostril bears a **nath**, and around the neck are **gugra, phul, sanger** and **badla.** The upper arms are covered in **chuda** and **katariya,** and her lower arms have **chamakchudi, chuda, duni** and multi-coloured plastic bangles. Her garments comprise a **chunri, kanchli** and **ghaghra.**

241. **Mina girl.** *Banswara.* She wears the **bor** on her forehead and a **nath** in her nose. Her ears are adorned with the **jhela, toti** and **durgala.** Around her neck are a **hansli** and long chains.

242. **Phul,** religious neck-ornament. *Jaisalmer (c.1860).* Silver pendant on cotton tie-dyed thread.

shaped units, which are mounted at the back with theva plaques or enamel on the reverse. The *lara haar* comprises three, five, seven or nine strands of pearls, beads or chains, each with a small central pendant. The number of pearls or chain strands may be three, five, seven or nine. These are known as the *paanchlada haar,* and the *saatlada haar,* meaning five and seven strands, respectively. The *rupaya haar* is also long and this necklace is made of rupee-coins or medallions that represent coins. A pendant is suspended from the centre.

The *chandanhaar* is a long neck ornament, similar in design to a *sanger,* but with more intricate work. It is made in gold, and silver with gold polish. The central medallion is like a big madaliya or square plaque, but with a large number of *ghughra* attached. There are filigree chains crafted in floral designs. The plaques joining the chains are triangular at

the two ends and rectangular in the middle. These plaques have designs in relief, carved on them.

Hamel

The *hamel* is a long necklace, which has a solid silver rectangular piece at the centre. It is worked with geometric designs and studded with red and green stones. It also has an interesting protrusion and small extensions on top, through which a silver chain is passed. This is attached to a series of chains interspersed with various rectangular and triangular plates. Mainly Jat women wear the *hamel*.

Hansli

The ornament derives its name from the word *hans* which means 'neck'. Its shape is circular and it is widest in the centre, tapering towards the ends. The whole ornament is made of forged silver and some additional linear designs, are sometimes, engraved on its surface. The *hansli* can be solid, hollow, flat or three-dimensional.

This is a popular neck-ornament worn across sexes and ages, by men, women and young girls. However, the men's *hansli* are fringed with little bells.

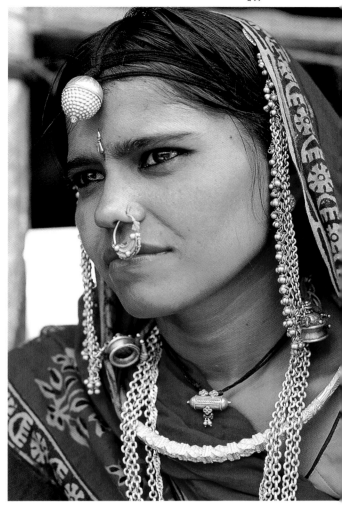

Kanthi

The *kanthi*, as the name signifies, is worn close to the throat or *kanth*, the Sanskrit word for the larynx. Small gold or silver units are threaded together with rows of black beads. The centrepiece is a half moon, flanked by two floral units, which are, in turn, adjoined by rectangular pieces. Each of these five central pieces is set with red or green stones and has three bells attached to each piece. Floral motifs, two or three in number, are present on each side. The units are always in an odd number, since Hindus believe that odd numbers are auspicious. Gold *kanthi* is worn among Rajput, Maheshvari and Osval women, while other communities use silver. The Meghval wear a particularly long *kanthi* with pendants that reach down till the navel.

Katsari

This is an elaborate choker that ends on the upper part of the chest. It is made of a series of units, usually identical, strung on cord.

Limbori

This necklace is handcrafted and worn, exclusively, by Bhil women. It is made of silver wire links and black wooden beads, which resemble the seeds of the neem tree, hence, the name *limbori*.

Madaliya

A *madaliya* is essentially a charm box, which is usually cylindrical but can, sometimes, be square. The *madaliya*'s exclusive function is of an amulet container. It is believed to be endowed with divine magical and protective powers. The hollow cylinder has pointed designs, on either side. Its base could have small protrusions with loops for suspension. This ornament can be in silver or gold and is generally threaded on black cord. It is worn either around the neck or on the arm. The *madaliya* is often filled with charms to enhance the protective and healing powers it is said to possess.

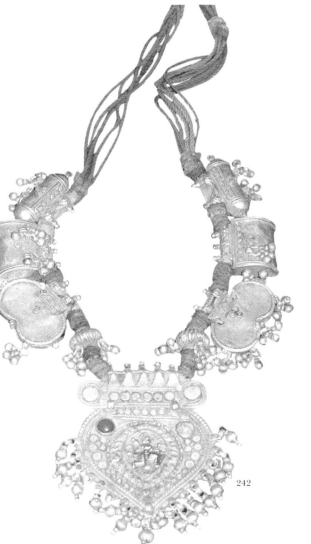

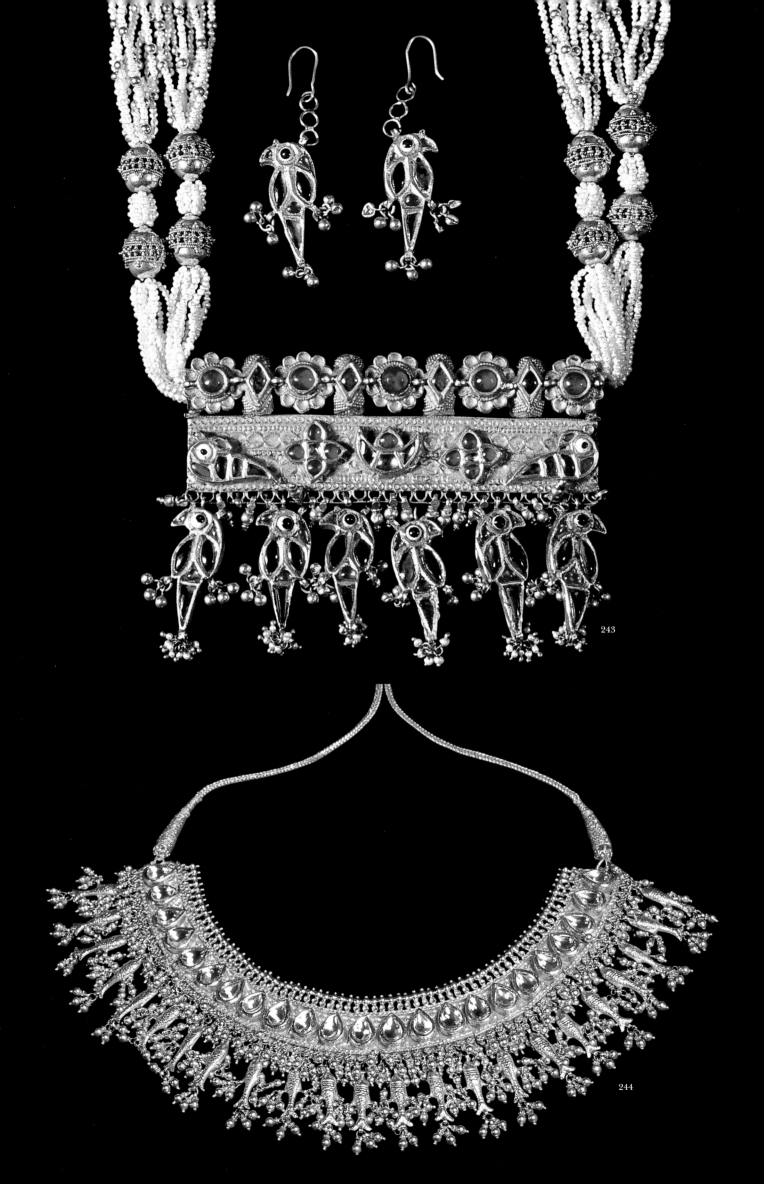

243

244

Phul

The *phul* is a medal with an image of the local deity engraved on it. It is worn by all ethnic groups and is popular with both sexes. It can be rectangular, circular, or heart-shaped, with the design worked in relief. It is usually strung on a *mauli* (untwisted tie-dyed cotton thread). The medallion is known by various names, *thala,* meaning small temple, *chauki* or temple and *phul,* the word for blossom, among others. The plaque has one or more holes at its apex, through which the cord is passed. The deity, it portrays, varies with communities, the Bishnois carry an impression of Ramdeoji or Hanumanji, the Rabaris who are camel breeders, display a camel.

The cord often has silver coins or metallic discs strung along its length so that the *phul* can be worn as a long ornament, which falls to the breast. The phul serves the function of an amulet with mystic significance and is believed to ward off evil. It could also play the role of a rosary, as touching it brings contact with the wearer's deity.

Sanger

This is a long necklace that falls below the bustline. It consists of a central pendant, which is shaped like a cylindrical *madaliya,* but is 8-10 cm. wide, with a thin rectangular plate, attached to its base. Little bells dangle from a profusely ornamented wool or cotton thread. Glass beads, silver pieces and *madaliya* cover the full length of the cord. Sometimes, silver chains, with triangular and square plaques, are used to suspend the pendant

Timaniya

The term *timaniya* means three jewels, *ti* for three and *mania* for gem or jewel. This is a flat rectangular piece of gold, mounted on a cloth worked with various designs. The top of the rectangle has four carved floral designs and each is separated by a rhomboid piece. The centre of each rhombus is embedded with colourful stones. The surface has numerous designs like lines, crescents, peacocks and circles. The bottom has *ghughra* or bells, some of which are in clusters, usually of three. The size, shape and curvature also vary among groups. It is held at the neck, by a rope of beaded strings, the colours of which are specific to each community. The Rajputs use yellow and green, the Bishnois use blue and a combination of red and yellow is worn by the Mahajans. The ornament is worn about 10 cm. below the collarbone.

The *timaniya* is a symbol of marriage and is worn by Hindu-women at the time of the *phera*. As long the woman's husband is alive, she continues to wear the ornament. As with nose-pieces, different communities use different names for the variations: the Mahajans call it muth, to the Rajputs it is *aad* or *nimboli*, the Bishnois call it *tegad* or *tegdi*, the Rabaris, *gungri* and the Jats, the *tevata*.

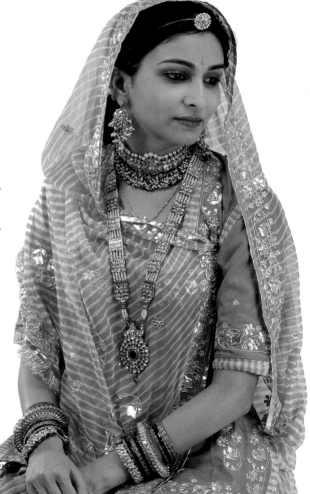

243. **Timania**. *Jodhpur*. Three-gem necklace of emeralds, rubies and pearls. The frontal plate of this very ornate necklace is flat. A web of smaller units suspended from its base end in parrot-designs worked in the **kundan** technique. It is held in place by multiple strands of pearls.

244. **Tussi** **in gold kundan**. *Udaipur*. The auspicious fish design is visible on its fringe. It is held in place by an adjustable gold thread.

245. **Aad vali nimboli.** *Jaisalmer*. Curved gold plate with coloured beads and stones.

The arm, wrist and hand

Jewellery plays such a vital role in the Rajasthani woman's life that every visible part of her is assigned some special ornament. One example of this is the short-sleeved *kanchli*, possibly designed to highlight the wearer's elaborate bangles, which start at the upper arm and go all the way down to the wrists, while also modestly covering the bare arm.

Upper Arm

Anat

The *anat* is a circular armband in gold. The two ends of the ornament are not joined and are shaped in the traditional form of lion head.

Bajuband or Bhujband

The *bajuband* in gold or silver is worn on the upper arm, just above the elbow. It is a flexible, circular armlet and made of interlocking metal units, threaded on a black or multicoloured *dori* or cord, to form a semi-circular band or plate. A long *lum*, ornamented thread with mirrors, beads, pom-poms and other baubles, hangs from the ends of this ornament. It is, sometimes, long enough to touch the end of the *ghaghra* and is called a *talia*. The wearers of the bajuband are considered wealthy, as it is a symbol of prosperity.

Chauki

This is a relatively modern ornament and consists of flat rectangular or other geometric forms, which are threaded together.

Chuda

All married Hindu women wear the *chuda* in Rajasthan. A woman puts on the *chuda* at the time of her marriage, offering prayers for her husband's safety from calamities and the preservation of her marital status. This consecration of the *chuda* may be related to the fact that it was originally made of ivory. In Hindu mythology an elephant is the incarnation of Lord Ganesha - the god of prosperity and happiness.

The *chuda* is made of different materials like ivory and silver. It has an *utar-chadav*, literally meaning to increase and decrease. The size of each consecutive bangle in the set is graded to form a perfect conical shape. The uppermost region of the arm has the largest ring and the bangles taper down towards the wrist. The uppermost ring is generally black.

The width of the bangle varies depending on the community. Some Rajputs wear very fine bangles with a red-printed design. This is called *chandanbai-ka-chuda*, which comprises two sets of bangles - *khanch*, which are worn on the upper arms and called *muthia* for the lower arms.

Maheshvari and Osval women wear a plain white ivory *chuda* and for the Maheshvari, it is their most important symbol of marriage. The Jat, Bishnoi, Musalman and Jogi traditionally use a variant of the *chuda* called *chud*, which is made of silver. This is a rigid armlet, which is conically tapered and has engraved designs on it. It has a hinged clasp that is fastened with a pin. The

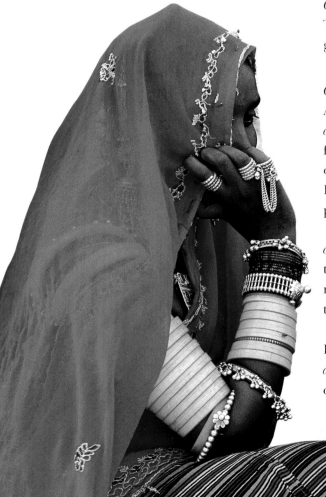

246. *(Previous page); Young Rajput woman.* Ajmer. Her **poshak** is silk, with **gota patti** embroidery, which is repeated on the pink **odhna** and white **lehenga.** She wears a small **bor** on her forehead. There are **machi suliya** in her ears, and a **kanta** adorns her nose. Around her neck are a **galapatti** and **patri haar,** worn in combination with the **kanthi, badla** and **sanger.** Her wrists are covered in glass bangles, with **chamak chudi** and **gajra.**

247. **Arm and hand ornaments.** *Jodhpur.* From shoulder to wrist: **chuda, katariya, duni,** silver bangle with small bells, **bitis** or rings are seen on the fingers.

248. **Chauki.** *Ajmer.* Upper arm bracelet. Gold and precious stones worked in the **kundan** technique. It is fastened with a hook and loop.

249. **Bajuband.** *Jodhpur.* This armband is made of interlocking gold strips backed with dyed cotton. It is fastened on the arm by an adjustable string ending in multi-coloured tassels.

250. **Chauki.** *Jodhpur.* Upper-arm ornament with precious stones, set in **kundan** style. The armlet is fastened with a hook.

251. **Bajuband.** *Jodhpur.* Armband of silver interlocked units. A black cotton loop and button made of cotton thread secures the ornament.

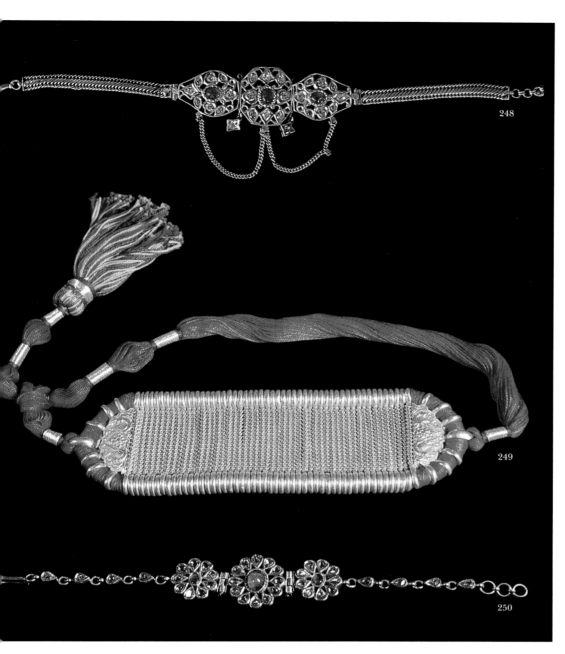

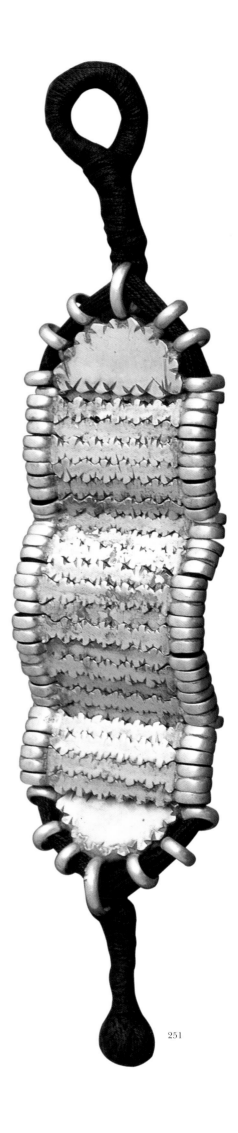

Bishnois wear the chud only on the lower arm. The Musalmans also use a chud on both the upper and lower arms which are longer than those worn by other communities. Some chud have rings attached, with stonework in red and green on alternate rings. The number of rings worn in the chuda is always an *eki* or odd number.

With rising prices and non availability of ivory, plastic is now commonly used as an alternative to ivory. Lac chuda numbering between seven and eleven are also supplemented by silver bangles.

Kangan Pola

A *kanganpola* is a circular hollow ring worn above the elbow. It has a protruding clasp with floral designs on the clasp. Women of the Sindhi Musalman community wear this.

Katariya

This bangle is worn below the *chuda*. It is distinguished by a ring and has protruding spheres around the edges.

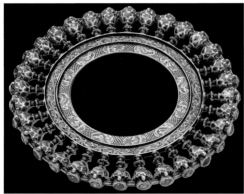

Madaliya

Usually, three or five madaliyas are threaded together in pairs and this ornament is generally worn just below the chuda. The commonest shape of a madaliya is a hollow cylinder with pointed shapes, on either side.

Mangli

The mangli is a semicircular ornament worn above the elbow. It is made of solid silver and the open edges have various designs on them.

Phundi

The *phundi* hangs from the upper arm. Several chains, on which are attached small variously shaped bells or *ghughra*, tinkle musically every time the wearer moves her arm. This ornament is worn especially by women in Rajasthan.

Tadde or Tidda

The *tadde or tidda* is a circular ornament crafted from solid gold cylinders. The cylinders are wrapped in a circular form with designs worked on the bangle.

Lower Arm & Wrist

Ornaments for the lower arms are crafted from of a range of materials. Each community has its own favourite styles, which give it a distinct identity.

Bahiyan

Mostly Bhil widows wear this bangle. It is about 7 cm. wide and made of either silver or nickel.

255

Bangri

The *bangri* is worn on the lower arms between two pieces of *gokhru*, and several versions are worn. A common style is one resembling a katariya in design, although the black plastic ring is absent in these. A metal ring with floral engravings forms the centrepiece. Another popular type is a broad band with a raised pattern 1cm. spikes, sometimes there are circular projecting knobs, placed very close together on its face.

Perhaps the most common design however, is the simple bangle. Its edges are raised and the central portion has a thin film of gold, silver or other metal known as a patri. This type of bangle is also known as *patri ki chudi*.

Bedola

The *bedola* is a wrist ornament. It is semi-circular in shape and made of solid silver. A striated design is worked on the ring and the open ends are rounded.

Dodia

This silver bangle has four raised structures on its outer face, which rise up about 2 cm. above the ring and

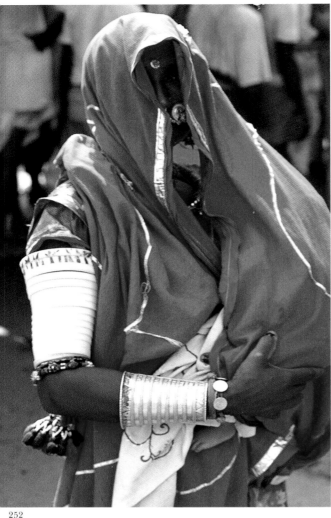

252

253

252. **Rabari woman.** *Pokhran.* Her upper arm is covered in plastic **chuda.** A **madaliya,** or amulet, is tied just above her elbow with coloured woollen yarn and pompoms. The lower arm is covered with silver **chud** and a coin bracelet.

254

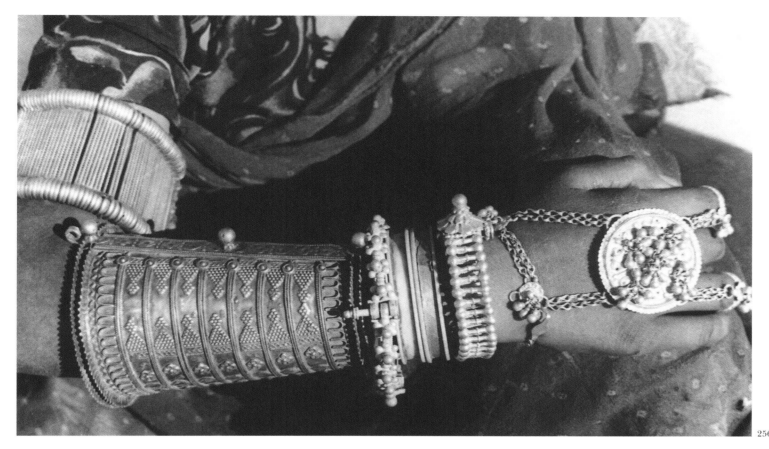

are engraved with a dotted design. The Rabaris, Jats, and Meghvals commonly wear the *dodia*.

Duni

A *duni* is a hinged bracelet worn by a number of communities. It consists of two rings held together on the inner surface. It has small balls all along both rims and its ends are held together with a pin.

Gajra

The *gajra* is a flexible ornament made of small rectangular plates joined together. Each plate has a raised semi-circular design in tiny gold or pearl beads on its front side. These plates are linked and a screw pin is used to hold the clasp. Sometimes, a silver bangle in a similar design is also worn.

Gokhru

The *gokhru* is either a gold or silver bangle. The outer edge of the *gokhru* has raised protrusions, which end in a design of circular balls. Another variation of this is called chamakchudi.

Kadi or Kada

This is a ring of solid metal, worn on the wrist. The *kadi* is wider at one end and tapers towards the opening. It is only removed after the wearer's death. The kadi is usually made of gold, silver or gilt. As with men, women wear kada on the ankles, as well. The kada can also be a golden bangle with an elephant or a lion's head on the terminals.

Moti ki Nogri

These are thin bangles, edged with pearls. The Mina women wear silver *nogri*.

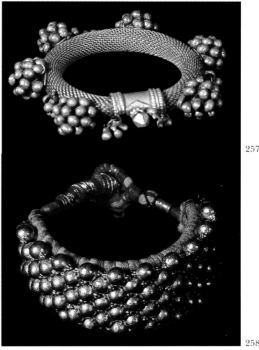

*253. **Gokhru**. National Museum.(19th century).* Wrist ornament in gold with ornamentation done using the enameling technique.

*254. **Gokhru**. Ajmer.* Wrist ornament in gold.

*255. **Madaliya**. Jaisalmer.* These amulets are worn as ornaments on the upper arms. The adjustable ties are made of black cotton cord, ending in tassels.

*256. **Arm ornaments**. Barmer (c. 1950).* From top to bottom: Silver ***bajuband, chud, chamakchudi, patri chudi, duni, hathphul***.

*257. **Gajra**. Jaisalmer.* Wrist ornament in silver.

*258. **Pahunchi**. Udaipur (c. 1950).* The gold bracelet is set on a cloth backing. It is fastened with cloth ties ending in a loop and button.

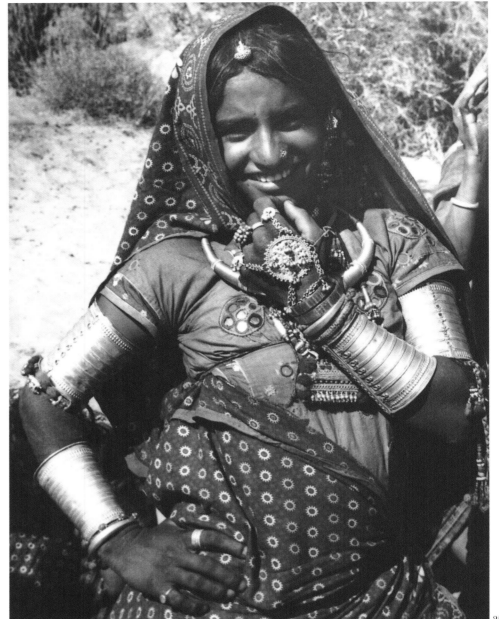

259. **Jat woman.** *Barmer (c. 1960).* She wears silver ***jhumka*** in her ears. There are silver ***chud*** on her upper and lower arms. A ***madaliya*** is visible just above her elbow. Her wrists and hands are adorned with ***hathphul*** and she has multiple rings on her fingers. Her garments are the traditional embroidered ***kanchli*** and ***chunri***.

260. **Key chain.** *Udaipur.* Waist-ornament in silver. Ear-cleaning implements hanging from the key chain are both functional and decorative.

261. **Kanakti.** *Ajmer.* Waistband fashioned from gold chains.

262. **Satka.** *Ajmer.* Key chain. Gold with ***kundan*** work. A hook attaches the key chain to the skirt-waistband.

263. **Kanakti.** *Barmer.* Waistband fashioned from silver chains.

264. **Kanakti.** *Barmer.* Girdle. The central piece is an ornamental clasp worked in ***minakari***.

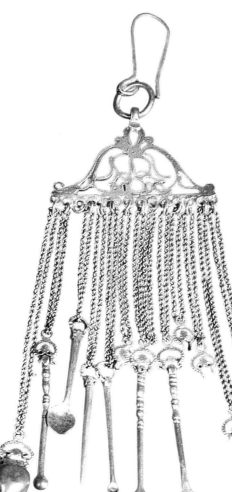

260

Pahunchi

Pahunchi literally translates to 'wrist' and is also the name for a bracelet made of hollow gold or silver balls filled with lac. Each ball is roughly the size of a maize grain. The balls are strung together on a piece of black silk or cotton in 3-4 parallel rows. A loop and a cotton ball serves as the fastening unit.

Sankel

The *sankel* is used both as a wrist ornament as well as an anklet. The former is made in gold whereas the latter is in silver. It has a flexible design and is made of interlinked solid pieces with a screw for an opening.

Hands

A variety of accessories ornaments the fingers. The *arsi* is a silver thumb ring, which is worn in other parts of the country, as well. It is usually worn on the thumb of the right hand and has a heart-shaped mirror on the surface which women use just as they would use any other mirror. The *damna* is a set of two interlinked rings and adorns the two central fingers of the hand. The *mudrika* is a metal ring, set with gems.

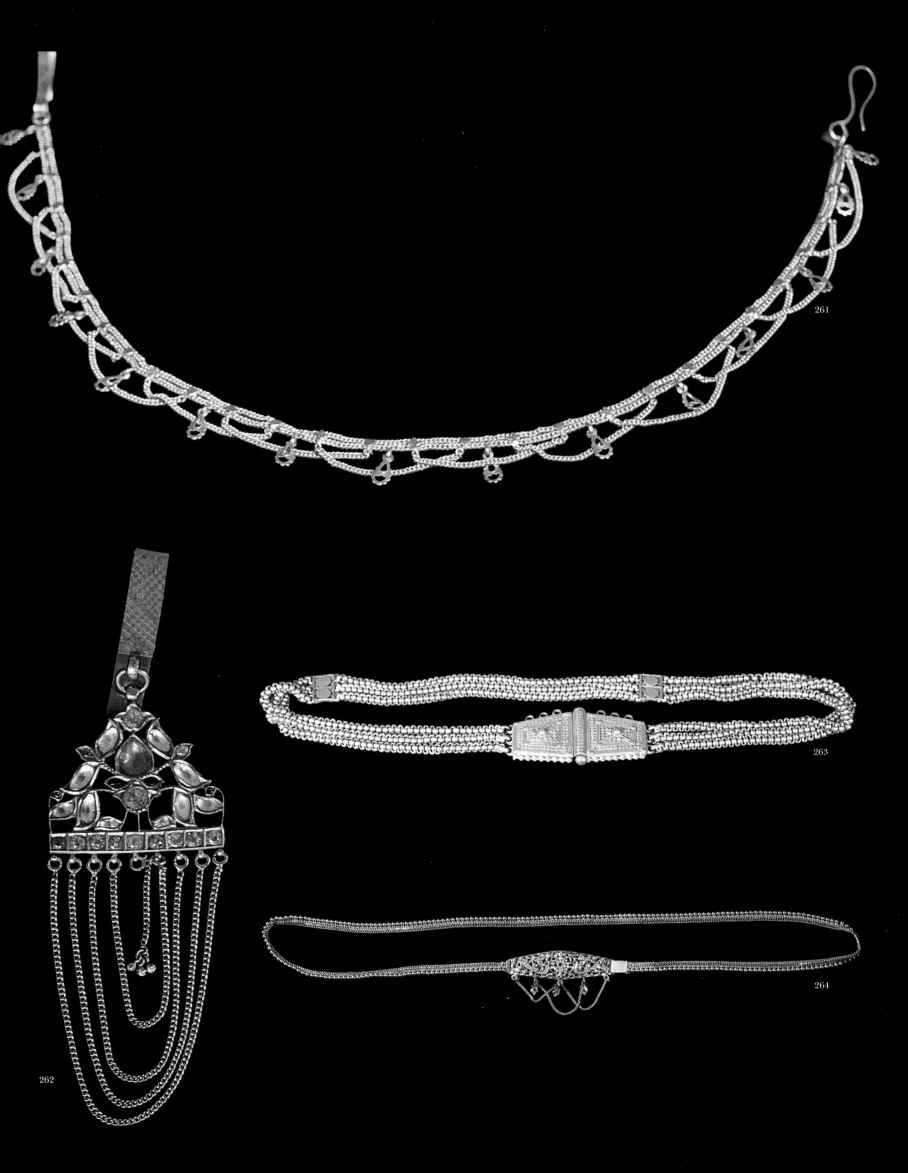

261

263

262

264

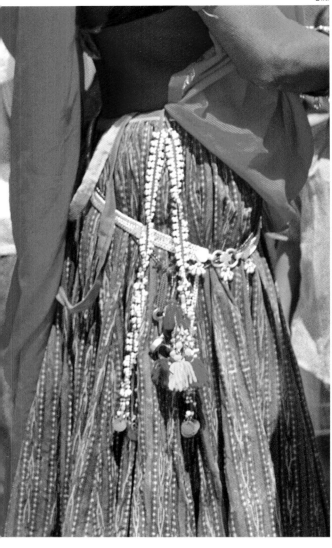

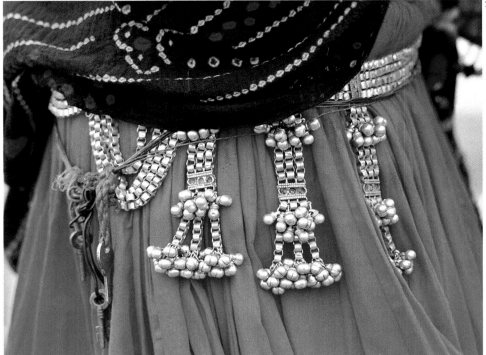

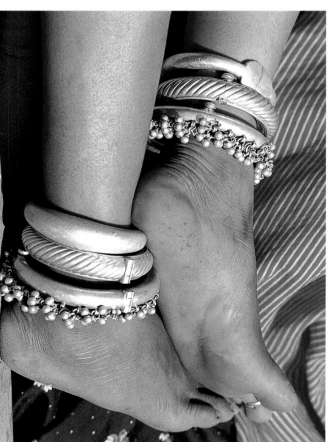

Hathphul

This literally means 'a flower for the hand'. It covers the back of the hand and although it has several variations, its commonest form has an ornamented spherical plate at its centre. One end is attached to a bracelet, which is clasped on the wrist. Two fine chains run from top of the sphere to link two ornate rings, on the first and fourth fingers of the hand. Interestingly, no single motif is repeated on the rings and the design is different on each finger.

The Waist

The waist seems to demarcate the usage of gold and silver among different communities. The distance between the kanchli and odhna exposes an expanse of waist and the exquisite ornaments that grace the waistline enhance the wearer's charm. Much effort, therefore goes into creating waist-ornaments as striking as those worn on other parts of the body.

Kanakti; Kamarband; Kandora

This is a heavy girdle worn around the waist by almost all communities. It is generally made of silver. However, royalty and aristocrats were permitted to wear gold below the waist and their *kamarband* were often wrought in gold.

The *kamarband* is worn in various designs, with intertwining filigree or chains. Usually, some small silver trinkets like a mango, a small *kupli* or kohl box, a little spoon-shaped metal implement to clean the ears, or key rings dangle from one end. Sindhi Muslim women generally do not use any waist-ornament and some groups like the Jogi and Rabari also tie cotton or wool around their waist. Several types of key chains made in gold and silver are also hooked to the waist and are both functional and decorative.

The Ankles and Feet

The ankles and feet, like all other parts of the body are extensively decorated. A large variety of rings, usually known as *angushtha* are worn on the feet. One type, especially popular in Rajasthan, is made of hemispherical forms joined

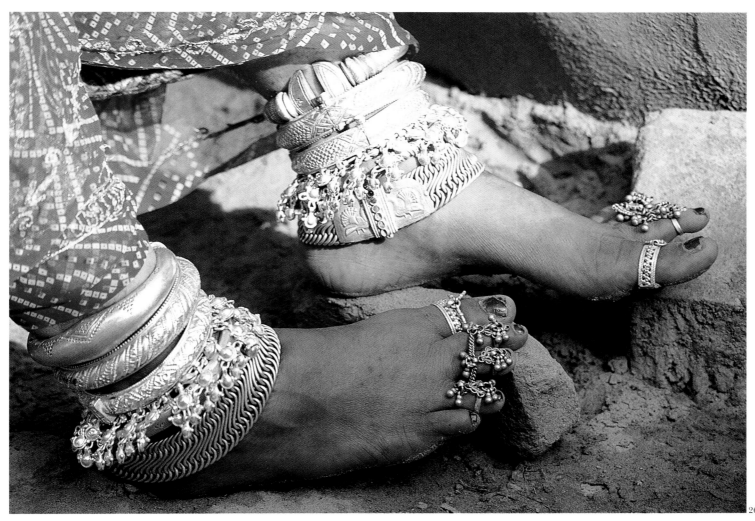

268

with globular bells. There are also rings for the big toe and others, known as double toe rings that cover the entire toe. However, most people prefer the single toe rings. They come in a variety of designs and the edges can even be hexagonal or octagonal.

All these ornaments are worn at the same time and provide the advantages of decoration, musical accompaniment and acupressure while proclaiming the marital status of a woman.

Avla

The *avla* is a hollow, evenly circular ring. It has striated designs just like the myrobalan fruit, or cherry plum, locally known as *avla*. Its name is derived from this design-feature on its surface.

Bichiya

In Rajasthan, as in other parts of India, bichiyas are symbolic of the woman's marital status. These are slipped on the woman's toes at the time of marriage and continue to be worn, as long her husband is alive. In addition, they serve as acupressure rings. The big toe has a plain rounded ring at the base, known as an *anguthia*. The other toes have flexible strips of metal open at one end, which are either curved or flat with small spherical balls attached. At times, the three central toes are adorned with a joined bichiya, which, sometimes, have figures like a peacock or a fish, worked on it.

265. *Kanakti. Udaipur.* Waistband in silver. The ornamental tape is a drawstring for a *ghagra.*

266. **Waistband.** *Barmer.* This heavy girdle is crafted in silver.

267. *Jod. Pushkar.* Three leg ornaments worn as a set. They are the *kada*, *nang* and *payal.*

268. **Ankle ornaments.** *Sanchor.* From top to bottom: *kada, avla, tanka, nevari, haathe.* The *anguthias* are worn on the thumb. The toe rings are called *phulris.*

269. *Sanger. Barmer.* Flexible chain anklet in silver. It is fastened with a screw clasp.

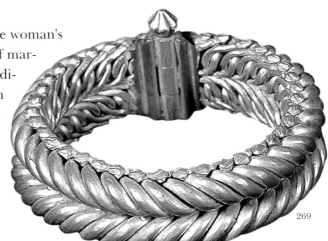

269

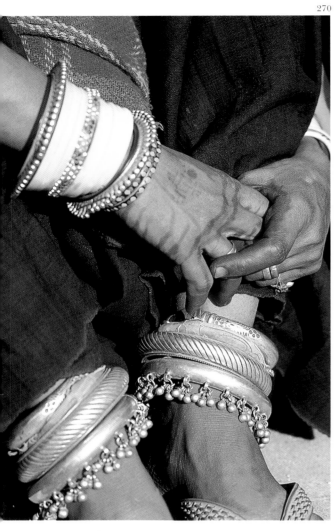

Haathe-Sathe

This is the precursor to the modern *paijeb* and is worn on the lowest part of the leg. It is crafted by interweaving small chains to form a flat, flexible net-like structure. Its width is about 2-3 cm.

Hirmani or Hirmain

This is a single solid wire worn on one foot. It is worn in some communities like the Meghval and the Jat.

Jod

When three leg ornaments, the kada, *nang* and *payal*, are worn as a set, they are known as a *jod*. A large number of communities wear the *jod*. The nang is similar in design to an avla and the payal is made of small-interlinked chains, much like the *haathe* but with ghughra attached.

Kadi

The kadi is made of solid metal and worn by all communities in Rajasthan. It is narrow on one side and widens towards the other. The ring, however, is not continuous, but marked by a break. A semicircular plate adorns this opening. The kadi is worn for life and is fixed and removed by the *sunar* or the gold-smith. Among the Meghvals, Jats, Jogis and Rabaris, the kadi is made of gilt, whereas the Rajputs wore gold with jadau work. It is traditionally gifted to a woman by her husband's family and its significance can be appreciated in the Marvari adage that the daughter-in-law of the family demands a pair of kadi even though there is no food in the house.

Nevari

The *nevari* resembles the kadi in design but the broader end has patterns engraved on it. The most popular designs are raised dots or geometric patterns.

*270. **Jod.** Jodhpur. Silver **kada, nang** and **tanka**.*
*271. **Turban ornament.** National Museum (19th century). The crescent moon shape is set in the **navratan** design.*

Pate

This flat piece of metal is worn on the centre of the foot. It is also known as a *chika* or *patriya* and lies a little behind the toes. The ornament is worn among most Hindu communities

Rimjhol

This is an evenly formed ring and is an ornament, which tinkles with movement. Suspended at its base are a large number of *ghunghru* which could be as many as eighty-four. It is also known as a *tanka*.

ORNAMENTS FOR MEN

Although male jewellery has seen a decline, over time, traditional gold and silver ornaments are still worn by rural men.

The Head

Turbans reached new heights of popularity under the Mughal dynasty. It was also during this time that special turban ornaments became popular. These were the *kalgi, sarpech, sarpatti and turra*.

Kalgi

The *kalgi* was a feather plume inspired by the feathered crests of the magnificent

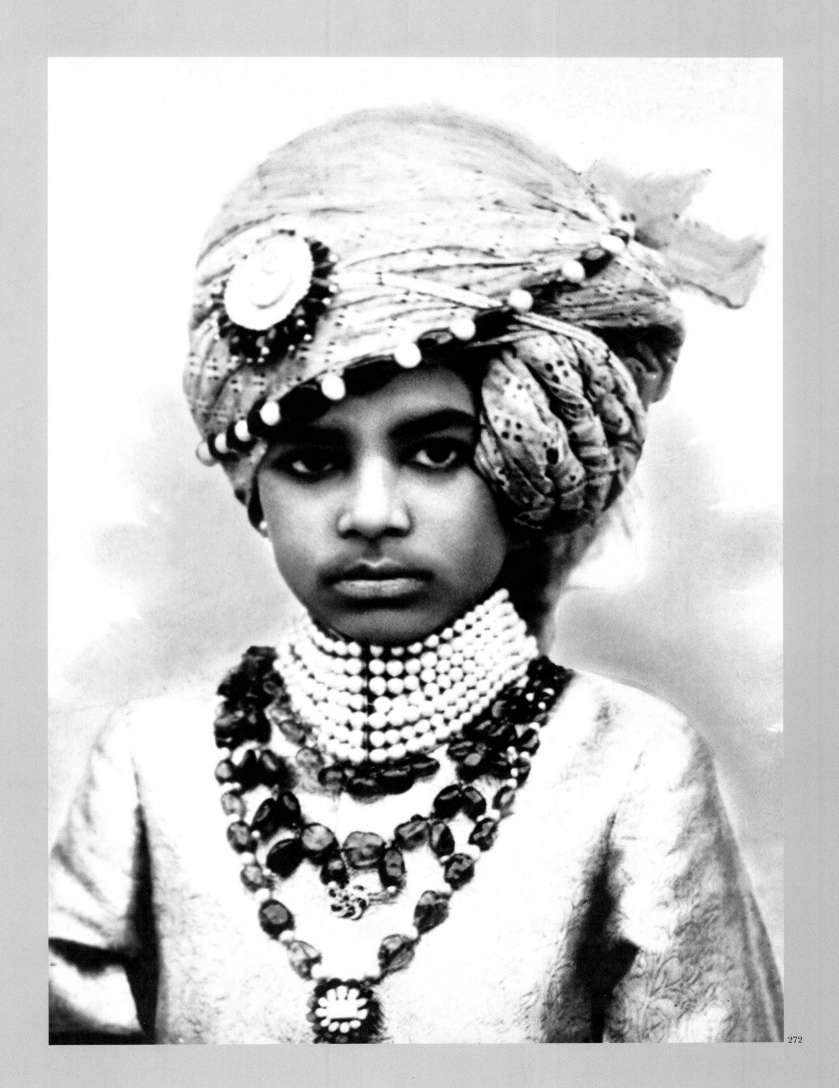

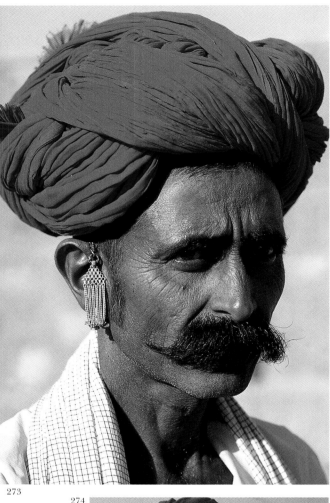

birds, native to their region. The most distinguished Mughal kalgi-design had three black heron feathers and only members of royalty could wear this kalgi. Sometimes, metal-sheets were substituted for feathers. The sheets were beaten into fine strips and, then, carefully crafted in the shape of feathers.

Sarpatti

The sarpatti is a turban ornament that first came into vogue around the late eighteenth century. It is essentially a synthesis of the sarpech and armband and consisted of hinged units, their numbers ranging from three to seven, with a kalgi attached to the central unit. Sometimes, a single gemstone pendant was suspended from the sarpatti. In another style, the entire ornament had several gems set like a fringe at the lower rim of each unit.

Sarpech

The sarpech is a compound of two words, namely *sar* literally, 'head' and *pech*, which means 'screw'. As an ornament, although it was flat, it was shaped like a single vertical feather, with a curved tip. Crafted from metal, it was set with gems on the obverse side. Sometimes, even the reverse was elaborately enamelled or decorated with precious stones. It was worn by tucking its gold stem, usually called the quill, into the folds of the turban.

Turra

The turra is an ornament, often shaped like a fan, used on the turban.

The Neck
Baleora

This is a gold necklace, commonly worn by influential Hindus until the early twentieth century. It consisted of seven chains that were further adorned with seven clasp units (usually five of these were floral units), which were set with gemstones. A screw was built into the back clasp to fasten the entire piece. The necklace had an elaborate central pendant called a *dhukd-huki* or *jugni*, set with gemstones. Another common neck-ornament is the gop and *jugavali*. This is a circular torque with a pendant known as the jugavali.

Hansli

Men, women and children wear the hansli. It derives its name from the collarbone on which it rests. The basic form of the hansli is a rigid circular silver torque with a hollow or solid construction. The men's hansli is distinguished from those worn by women and children by the presence of bells or ghughra. Rigid gold torques, with gemstones and enamel work were also worn in some communities.

Motimala; Manakmala; Panch-Lada-Haar with Moti

This is an elaborate necklace made of pearls, emeralds or rubies. It usually has five or seven strings of varying or similar length.

The Ears

The ears are pierced at a very early age. Ear-piercing

272. (Previous page): **Maharajadhiraj Maharaja Sumer Singh.** *Kishangarh (1939).* On his succession as ruler of Kishangarh. A *chandrama sarpech* with *kundan* settings of emeralds adorns his *safa*. On his neck is a pearl *kanthabharan,* an emerald *tildi,* a *saat-lada-haar* of pearls and emeralds with pendants depicting *Urvashi* and *Dugdugi.* His jacket is a formal *achkan.*

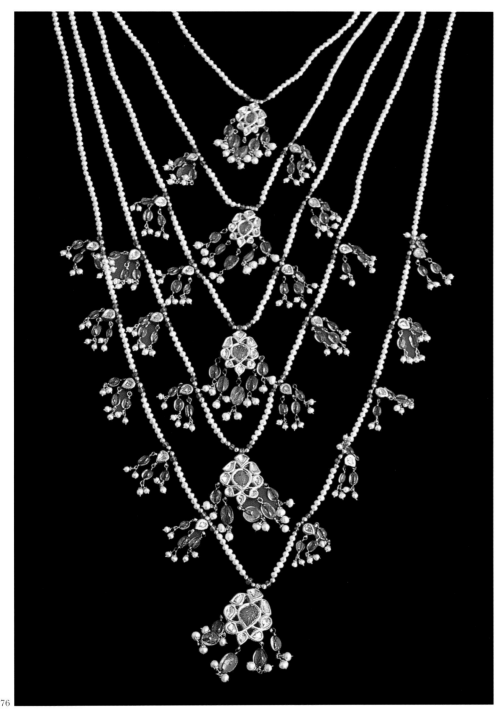

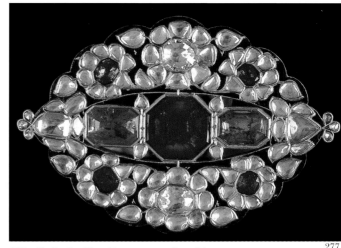

277

273. **Jhela.** *Pushkar.* Ear ornament in gold.

274. **Phul.** *Pushkar.* Medallion in gold, suspended on gold thread cord.

275. **Sarpech.** *Bikaner. (19th century).* Turban ornament with rubies, diamonds and emeralds set in the *kundan* technique.

276. **Paanchlada haar.** *Udaipur.* The necklace gets its name from the five strands of pearls.

277. **Khag.** *National Museum(19th century).* Shoulder ornament set with rubies, sapphires and diamonds.

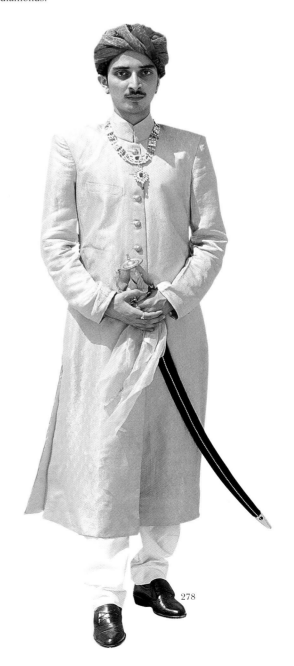

276

is considered auspicious and an elaborate ceremony generally marks the occasion.

Bala

Balas are gold wire hoops, usually strung with precious stones, like pearls or rubies.

Jhela and Murki

These small ear-rings are worn on the earlobes and are often shaped like six-petalled flowers.

The Shoulder

Khag or Kandhe-Ka-Gahna

This was made of gold, its obverse side set with gemstones and enamelled on the reverse. Although its earliest records in India date back to the twelfth cen-

278

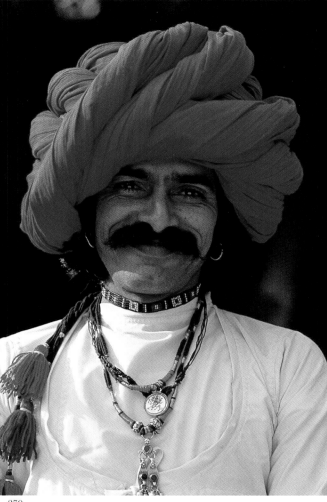

279

280

tury, this ornament has seen several innovations introduced to its design. It was worn either on one or both shoulders.

The Arms and Hands
Bajuband
The bajuband is an armlet. It was usually made of floral motifs and these designs were set in precious stones.

Beenti
These are rings worn on the fingers.

Kada
Kada are bracelets made of either gold or silver. It is a common piece of jewellery and worn by almost all communities. Ornaments of the same name are also worn around the ankles.

The Waist
Belt Buckles are lavishly ornamented in Rajasthan. They are made of both gold and silver and the inner side may often be enamelled.

The Ankles and Feet
Gajjalu
The *gajjalu* are cast brass ankle bells that are sewn on to a strip of leather and worn by male-dancers when they perform. This is a theatrical costume-jewellery worn only by performers and not for everyday wear.

Kada
These are ankle bracelets made of silver or gold. Paijeb or ankle bracelets made of interlinked chains were also used in the past.

Tazim
The *tazim* is crafted in gold or silver. It is a hereditary chain anklet that was a sign of special recognition and honour granted by a ruler. It was worn on the right ankle, though sometimes, when granted in pairs, they were worn on both ankles. The recipients of this ornament were called *tazimi sardar* and were entitled to several privileges, which included a position at the court, exemption from certain taxes and duties and immunity from criminal processes. At present, villagers wear tazimi on their right ankle at the time of their marriage.

Amulets and Talismans
Amulets are protective pieces of jewellery and belived to bestow good luck to the wearer and are found in most traditional societies on the Subcontinent. In Rajasthan, the choice of amulets is more often dependent on the wearer's community or clan and its patron-deity, rather than on individual choice. Amulets may be worn either as necklaces or bracelets. Amulets come in a wide variety of shapes.

The *sher-nakh-jantr* is a silver amulet that curves like a tiger's claw. Metal plaque amulets usually bear a relief-worked image of a Hindu deity, accompanied by his *vahana* or vehicle. Alternatively, the god or the goddess may be symbolically represented, as for example, *vishnupada* as the footprints of Vishnu are known, or Shiva's trishul.

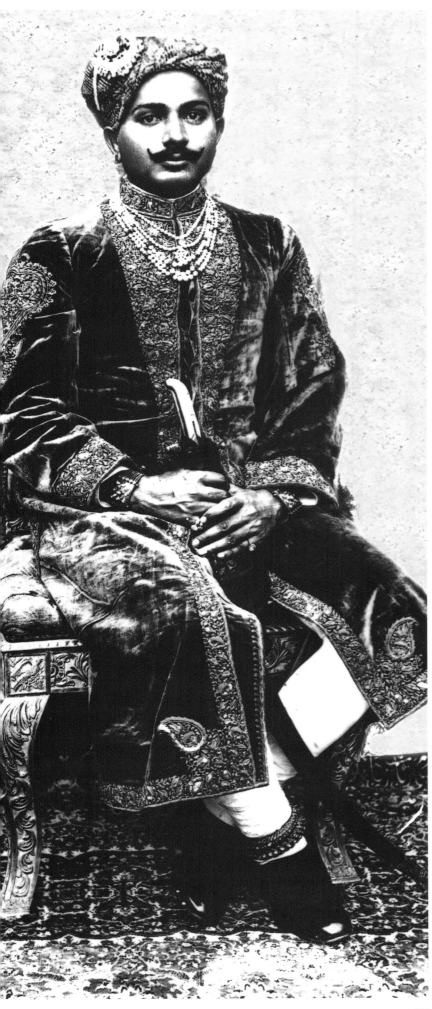

Amulets may also depict folklore heroes. An example of this is found in Ramdeoji, possibly the best-known local hero, highly regarded and deified in temples, dedicated to him.

Amulets often have geometrical shapes. Squares, rectangles and pentagons are symbolic of a house, six-sided amulets are known as patri and are representative of a temple, and circular amulets called mandala are believed to ward off evil spirits.

Jewellery made from coins, that are no longer in circulation, also falls under the category of talismanic jewellery, although they might, at first sight, appear to have purely ornamental value. Coins could be easily conceived of as amulets, partly because metals are considered sacred by the local people and because of the stamped images on them.

Besides these, there are several forms of amulet-holders as well. These are three-dimensional containers containing special objects such as paper with magic words or special beads or ashes.

Ornaments are thus interwoven into the fabric of everyday life in Rajasthan. Crafted from a wide variety of raw materials, they serve a multitude of purposes and their designs range from the simple to the highly elaborate. They accentuate the striking appearance of the Rajasthani people, giving Rajasthan its awesome splendour and celebration.

278. (Previous page): **Rajput man.** *Jaisalmer.* He wears a ***panna-haar*** with a pendant around his neck. His costume is the ***angarkha*** and ***pyjama*** with a ***leheriya safa.*** The sword and cloth tie proclaim his royal status.

279. **Farmer.** *Ajmer.* He wears the ***kundal*** in his ears and a ***kanthi*** around his neck. The silver pendants are strung on an adjustable tie-cord of dyed cotton wool decorated with gold thread.

280. ***Gajjalu.*** *Jodhpur.* Brass ankle-bells worn by male-dancers.

281. **Rajput Prince.** *Jaisalmer (c.1890).* He wears numerous pearl necklaces, a ***pahunchi*** on his wrist and ***tazimi*** on his ankle. There is a sword at his waist. His costume includes a velvet ***shervani*** worked in ***zardozi*** embroidery over Jodhpur breeches and a turban.

281

282

Diversity in style

"Each ethnic group maintained separate characteristics of dress and ornaments, which became symbols of recognition and identification and served to establish common ancestry."

-- *Pupul Jayakar*

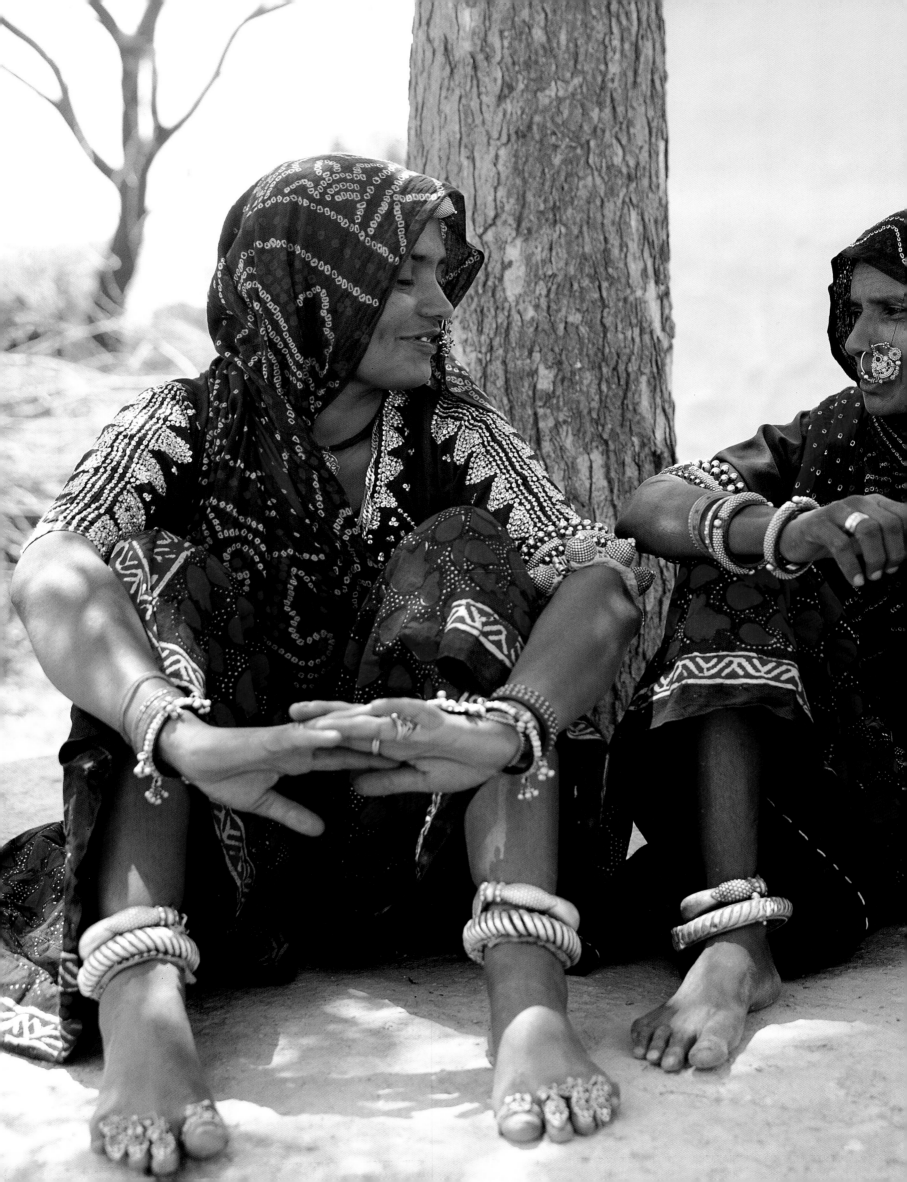

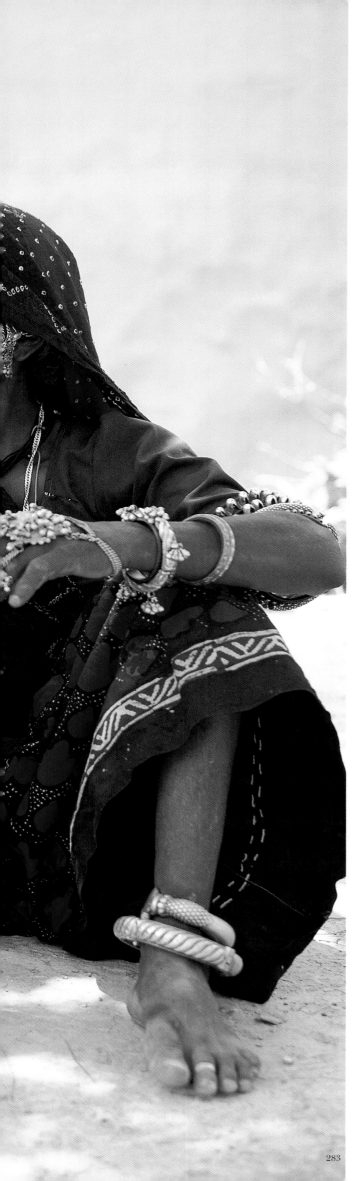

The people of Rajasthan are, by far, the most fascinating aspect of the region. Each community here is distinct in custom, dwelling, occupation and dress. They cover a gamut of lifestyles, from aristocratic to tribal, settled to nomadic and include farmers, camel-herders, shepherds, craftsmen and traders. These communities represent a homogeneity in socio-economic and aesthetic interrelationships. Regardless of their place in the social hierarchy, they clearly demonstrate the two-way flow of tradition, from the local folk ethos to the aristocratic and vice versa - leading to a continuum of identifiable aesthetic criterion. Costume then becomes a statement of identity and, hence, is very rigid in traditional communities. With the advent of modernization, however, change is inevitable. Although garments, jewellery and other techniques of adornment may be broadly similar, each community has, over time, developed an individual and separate version of its costume. Evident in their attire and jewellery is the history of an aristocratic tradition, the influence of its vernacular ethos and a pervading aura of mythology and religion.

BHIL

The name 'Bhil' is derived from the Dravidian word *'bhilawar'*, meaning archer. The members of this community are believed to be the oldest inhabitants of Southern Rajasthan, which comprises the districts of Dungarpur and Banswara. The Bhils are traditionally hunters and gatherers and live a rudimentary lifestyle.

The Bhil-woman wears an upper garment called the *kapada*, a *ghaghra* and an *odhna*. The *kapada* is a short-sleeved cotton blouse, which is held by cloth ties at the back around the neck and the waist. The *ghaghra* is ankle-length and is ingeniously turned into a pair of trousers, while working in the fields. A string attached at the centre back of the hem is passed between the legs through a loop in the centre front hem and is then tucked in at the back waist, to look somewhat like a man's dhoti. In the past when the Bhils were primarily hunters, the Bhil-women wore a shorter knee length skirt to facilitate movement through the undergrowth. The fabric used has a resist-dyed print called *nandana*, often greenish-blue, dark-blue or black. To the same end, an ornament called the *pejania* was worn on the hands, arms and legs offering protection from thorns and animals. The women cover their torso and head with an odhna or *lugda*, made of hand-spun fabric that may be block-printed, resist-dyed or screen-printed.

The typical Bhil bride wears a yellow ghaghra called a *piliya*, the colour of turmeric, which is a symbol of purity. The ghaghra is worn by married Bhil-women in printed designs like *gulbadan bhat*, the *halarighand bhat*, the *ghandbhat* and also the *minakari* and *dilpasand*.

282. (Previous page): **Rasleela**. *National Museum (19th century).* Krishna and Gopis are depicted on a **pichvai,** an embroidered altar cloth.

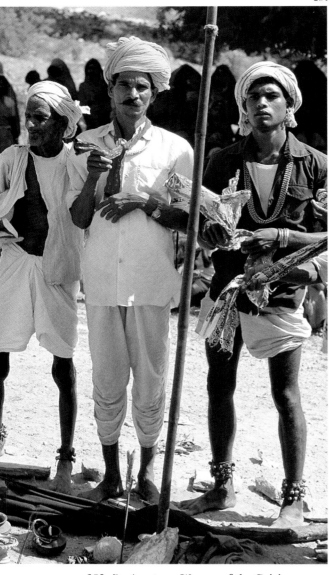

Bhil women wear the bor and jhela on their forehead. Their ear-ornaments include the *dhimmna* and *oganiya*. The hansli, haar and *tagli*, are neck-ornaments. The muthia are a set of bangles worn on the forearms and comprise the kasla and the *kasakada*. Kaslas are bangles made of coconut shells embellished with silver bands and the latter are plain bands of brass or lacquer worn around the wrist. Finger rings called *beenti* and *bidi* are made of brass or copper. Married women wear brass anklets called pejania. Toe rings are called bichiya and are made of silver, brass or white metal.

Tattoos are very popular and have acquired a certain social and religious significance. The most common patterns are birds, flowers and scorpions. The usual areas tattooed are the forearms, wrists, forehead, chin, calves and feet.

The women wear an intricate and complicated hairstyle. Their hair is combed forward, to hang on the forehead and is pleated into an ornamental network that falls over the eyebrows. Another style is a centre parting with small plaits on either side of the forehead. These are intertwined with thick red-and-black cords called *lasa* and are joined to the main braid at the back of the head.

The costume of a Bhil man comprises a turban or *feto*, an *angi*, tunic and a lower garment called *potario*. The turban is made of a white handspun, handwoven fabric. It is 5.5 meters long and 0.5 meters wide and is draped snugly around the head. The tunic is made of coarse, handspun, unbleached cotton. It is a full-sleeved, hip-length garment and has an asymmetrical front with a yoke. It is fastened with cloth ties at the shoulder and centre front. It has slits on the sides, with a bias edging. The lower garment is knotted around the waist and the entire length is drawn between the legs and tucked in at the back. Bhil men also keep a *pacheri* or shawl on their person.

Very young Bhil boys wear loincloths and then switch over to a dhoti at the age of 10. They usually do not wear upper garments or headgear until they marry. At the time of marriage, the groom wears an *ango*, a shin length tunic, which follows the cut of a Rajput angarkhi. This is worn with a turban and a dhoti.

Bhil men are fond of ornaments. They wear murki in their ears, silver bracelets called *bhoriya* and a necklace called hansli, anklets or kada and silver belts around the waist called *kandora*.

The men's tattoos are unique. They do not prick in the design, but rather brand their forearms with three to nine circular motifs called *damla*. There is a religious significance to this procedure, in that tattoos are believed to help the soul enter the gates of heaven.

The hair is loosely plaited and fastened with a wooden comb or allowed to fall in unkempt tresses. Some men shave their hair clean from the hairline at the centre of the forehead leaving only a lock on the crown of their head. This is called a *choti* and the hairstyle is called *vat-padna*.

BISHNOI

The Bishnois inhabit the area around Barmer and trace their ancestry to a saint and ascetic named Jambhaji, regarded by them as an incarnation of Lord Vishnu, whom they worship. An interesting rationale for this name is that the sect follows twenty-nine doctrines and 'Bishnoi' in the local dialect translates to twenty-nine. Their primary occupations are cultivation and animal husbandry. The Bishnois are strict vegetarians and also ardent protectors of trees and wildlife. Their environs are always the greenest and

283. Previous page: **Women of the Gairi community.** *Akola.* They are in traditional dress. The **odhna**, draped over the head and upper body, is a tie-dyed **chunri**. The calf length **ghaghra** is printed in **koyali bhat** pattern. Their jewellery includes the **nath** on the nostril, and silver earrings. On the backs of their hands, both women wear **hathphul**, which are attached by chains to finger rings called **duni**; on their wrists are ornate **gajra** and **bangri**. The woman on the left wears a **dodia** just above her left elbow; and her companion wears **chamakchudi** on both wrists. On their ankles are **kadi** and **avla** and the **bichudi** or toe rings, which indicate that they are married women.

284. **Bhil men.** *Udaipur.* They sport turbans called **feto.** The **angi** or tunic is worn over a lower garment known as a **potario**; and each carries a **pacheri** or shawl. Their fondness for jewellery is apparent in the brass anklets and long silver chains around their necks.

285. **Bhil women.** *Ajmer.* Their lower garment is the black cotton hand stitched **saadi**, worn with a blouse and draped **odhna**. The woman on the left wears a plain red **odhna**; her companion in the centre has on a red and yellow **pila odhna**; while the one to the right is in a deep red **chunri**. All three **odhna** are edged with **magazi**. On their feet are traditional leather **juti**; and they wear silver bangles on their arms, **hansli** around the neck, **kada** on the ankles, and the **nath** on the nose.

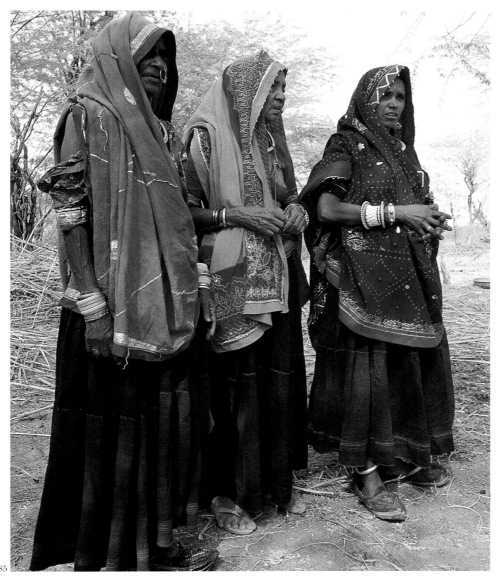

286. **Bishnoi couple.** *Dhorimina*. The woman's *kurti* has a wide neckline, revealing most of the *kanchli* under it. Her tie-dyed *odhna* is worn over a *ghaghra.* She has a gold *tegad* around her neck, and a gold nose ring. The man in a *kurta-dhoti*, with a shoulder cloth and *safa* is dressed typically in white from head to toe.

felling of trees and hunting are strictly prohibited.

The puthia, *pada* or *pothdi* and odhna make up the entire ensemble of unmarried girls. The puthia is white with full sleeves and ends about 12 cm. below the waist. The piping on the puthia is red and 1.5 cm. in width. Two cloth-buttons called *guthia* fasten the garment. The lower garment is called a pada. It is made from a blend of cotton and wool or in pure wool. The fabric is woven in black and white checks and the skirt is generally referred to as a dhabla. The length of the dhabla is 15 cm. above the ankle, and the width of the material varies from 3 to 6 meters depending on the wearer's age.

Bishnoi odhnis display a variety of prints, like the *rati-chunri*, a red printed chunri, the *sundri pakodi* in cotton and the *ludi*, which is black. The ludi is a woollen shawl made from sheep wool and is often embroidered.

A married woman wears a kanchli with a kurti, a dhabla or ghaghra as her lower garment and an odhna, which she drapes over her body. Bishnoi-women wear a short kanchli with a deep neckline revealing the upper part of their breasts. The neckline is generally decorated with a small frill and small bells are attached just below the tuki, drawing attention to the garment and to the décolletage. Sleeves are worn longer than in other

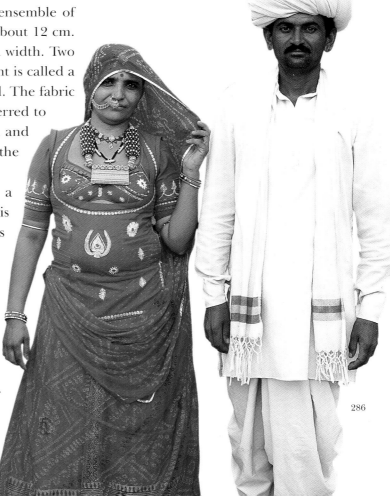

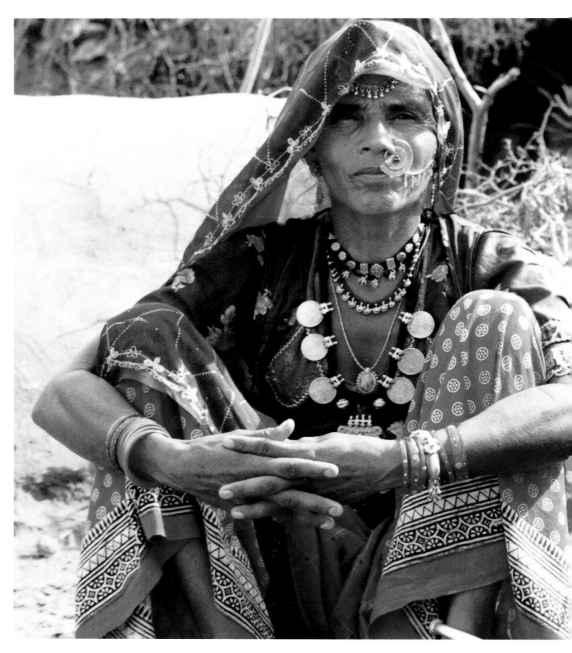

communities and are tight at the hem. Often two to three pleats are made at the hem of the sleeve and are trimmed with piping.

A kurti, also with a deep neckline, is, sometimes, worn over the kanchli. Its length is about 0.5 meters and it has long side slits through which the midriff and upper portion of the ghaghra are revealed. The lower garment is a lehanga called ghaghariyo and can be in satin, cotton or wool.

For the marriage ceremony a kanchli made of *mashru* is preferred. The wedding lehanga is generally pink or red. It is 10 cm. above the ground and has a 3 cm. wide piping and a yellow *rekh*. A red *chhint* fabric in cotton, with white circles and black borders called *jaleb chaap* is most commonly used for this lehanga. The border designs at the two ends are brought to the front to form a vertical design down the centre of the ghaghra. Sometimes, the ghaghra is given a permanent pleat-effect with the use of a natural glue, called *morla*.

The Bishnoi women wear a great variety of odhni. Generally, during the marriage ceremony, the *pir ki chunri*, gifted by the bride's mother, is worn. This is a draped garment, printed in *laung bhat*. A *kajli odhni* or *chapal chunri* in bandhej are also used for the marriage ceremony. The chunri is 2.5 meters wide and 3 meters long. Another odhni is the *kangrechi odhni*,

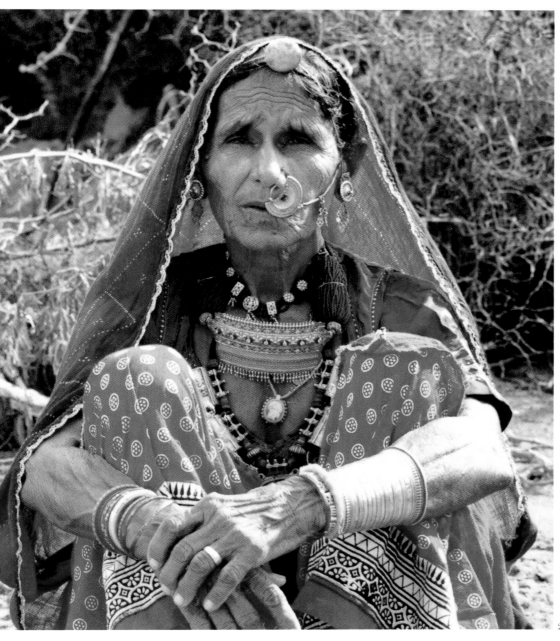

which has bandhej work on fine mulmul. The damini, an embroidered red *odhna* is also popular. The edging of an odhna is finished with double piping, generally blue and yellow.

Rickrack and gota are used for ornamentation on the body of the odhna. The odhna is draped so as to expose most of the kanchli. One end is tucked on the left side, with its length taken over the head to the right side of the body. Of the two parts one is left hanging loose and the other is brought up covering the waist and tucked under the kanchli on the left side. The older women commonly wear a dhabla, lehanga, petivali kanchli and a *pakodi chunri*. Women use the ludi and *lunkar* as shawls.

A widow's dress is similar in styling but lacks ornamentation and the colours used among them are either plain black for older women and red and black for younger widows.

The Bishnoi man's attire comprises the *chola*, the dhoti and the pagadi. The chola is worn as an upper garment and is usually made of white cotton. It reaches down to the mid-thigh and has full-length sleeves. An interesting detail is its shirt collar, probably assimilated from Colonial India. It also has wide cuffs on its sleeves.

287. **Bishnoi women.** *Pokhran.* The **kanchli** and **kurti** are worn as upper garments. The lower garment is the **lehanga** in **jaleb chaap** print. The woman on the right wears a **kangrechi odhna**, or veil. Their jewellery shows that they are married. Their foreheads display the **bor**. **Kanthi**, **tegad** and **phul** adorn the neck. They wear **jhumka** in their ears and **bhanvariya** as nose rings. A **chauki** is visible on the upper arm of the woman on the left and the lower arm of the woman at her side is covered by **chud**. On their ankles, the **kadi** can be seen.

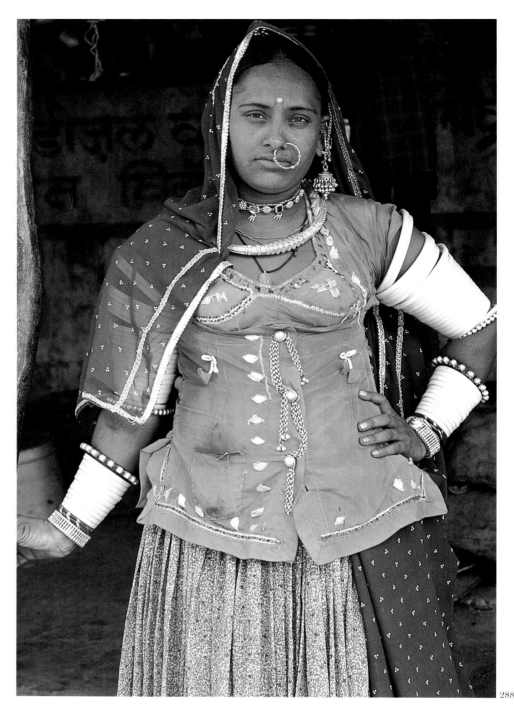

A dhoti is worn as the lower garment and measures about 5 meters. It is made of white cotton fabric and is worn at ankle-length.

The headgear of the Bishnoi men is known as the *potiya*. It is white and worn at all times. The fabric used is cotton and it measures roughly 8-10 meters in length. The men are fond of jewellery and wear murki in their ears.

GADULIYA LOHAR

Gaduliya Lohar literally means 'blacksmith in a vehicle'. The Gaduliya Lohars claim Rajput ancestry and are essentially metal workers. They profess superiority to all other nomadic groups. Historically, they were assigned the job of making weapons for the warrior Rajputs.

The ensemble of a Lohar woman consists of a kanchli, kurti, ghaghra and odhna. The kanchli is cut on the same lines as the one worn by a Rajput woman. It is fastened at the back, around the neck and the waist with cloth cords. The upper portion of the kanchli is profusely ornamented with tinsel,

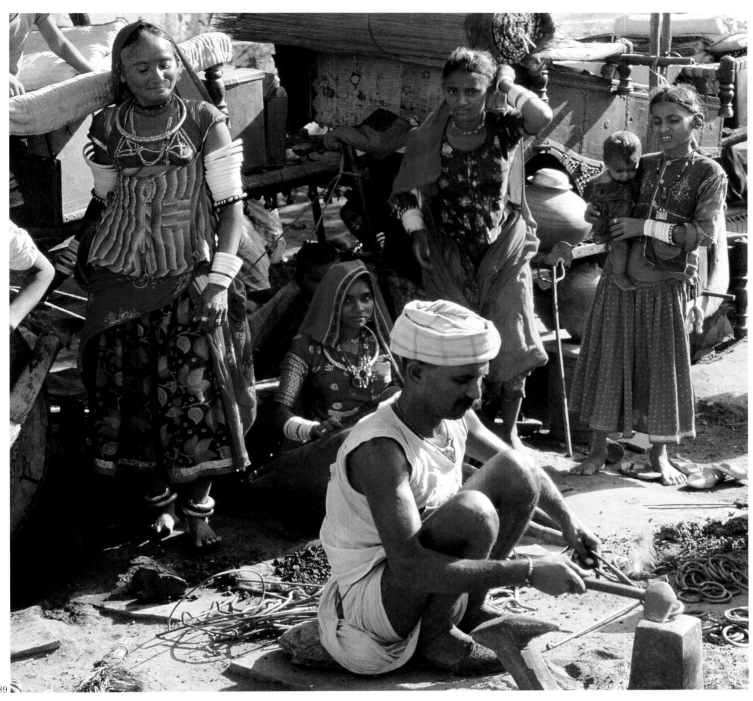

289

sequins, mirrors and silk threads. The kurti is a close fitting, sleeveless bodice reaching a little below the waistline. The neckline is finished with piping, which extends down the centre front opening to form a placket and is fastened with silver buttons. The neckline is usually quite deep and tattoos on the central part of the chest are visible. The cut of the kurti exposes the entire kanchli and a portion of the midriff.

The shin-length ghaghra is made up of 10-15 meters of cloth with 60-80 kalis. These are gathered and held together at the waist by a drawstring belt in a contrasting colour. The hem of the ghaghra is edged with narrow piping called the guna and a magazi, which is usually 3-4 cm. in width. The colours of the guna and piping contrast with the main fabric, which is usually a blue block-printed *pharad*.

Single and married women wear bright colours, while widows wear deep blue, green or black. An interesting custom is observed among the widows of this community. The central front portion of the kalidar

288. **Gadulia Lohar woman.** *Udaipur*. Her upper garments are the *kanchli* and *kurti*, decorated with silver *gota* appliqué. The *kurti* is fastened with elaborate detachable silver buttons. Synthetic fabrics have crept into her traditional costume by way of the mill-made printed materials of her *ghaghra* and *odhna*. The *jhumka* in her ears are supported by long chains called *jhela* that attach to her hair. A *nath* can be seen in her left nostril; and she wears the *kanthi* and *hansli* around her neck. Her bare upper arms are covered by plastic *chuda* that are kept from sliding down the elbow by a *katariya*; while on her lower arm are the *chuda* and *gokhru*.

289. **Gadulia Lohar settlement.** *Chittorgarh*. This nomadic tribe are ironsmiths by tradition. The man, seen here firing iron on a coal furnace, wears clothes well suited to his work– his upper garment is a *bandi*, worn over a *dhoti*. A *potia* is tied around his head; and he wears a *kada* on his wrist. In the background are married women and girls in traditional dress.

ghaghra is picked up, taken between the legs and tucked in at the back waist. This probably signifies the absence of sexual activity in her present life-stage.

The odhna is 3.5 meters long and 1.5 meters wide. It is draped in a style similar to that of a Rajput woman. The odhna covers the head and its borders are appliqued with tiny silver gota flowers. The odhna is either plain or patterned in floral designs.

Married women wear a borla on their forehead and ivory bangles cover the upper arms and wrists. A nose ring called *bhanvaria*, a *bichudi* or toe ring and silver anklets called *kadula* are worn as symbols of her marital status. These ornaments are not removed until the death of her husband, after which they are destroyed. The women also wear a *tabiz*, a pendant believed to ward off the evil eye and a necklace called the kanthi. Their neck jewellery is made from old silver coins, much like gypsies in other parts of the world.

Tattoos are popular and believed to ward off misfortune. The names of lovers and life partners are tattooed on their bodies. The eyes are rimmed with black and palms are decorated with *mehendi*. The teeth are decorated with gold nails fixed on their upper incisors.

Gaduliya Lohar women part their hair in the centre and have two thin plaits running along either side of the forehead, in addition to one at the back. All three are then braided together down the entire length of the hair and are fastened with the help of a *chutila*, which is made of strings and beaded tassels.

The attire of the Lohar men consists of an angarkhi, dhoti and turban.

The angarkhi is made from white, unbleached, coarse, cotton reza. It is of hip-length and much the same as other angarkhi, is tied on the right-hand side. The full-length sleeves are plain, ending in short wristbands cut on the bias, which may or may not have slits in them.

The turban is usually tied in the gol safa style. Turbans for daily wear are red or yellow and are white for elderly men. On festive occasions, vivid turbans in a variety of colours may be worn. The lower garment, dhoti, is about 3-5 meters in length. The fabric is white cotton and it is usually worn in the tilangi dhoti style.

The men wear gold murki and other ear-rings like the jhela. On weddings, they wear a gold or silver locket on a black thread tied round their neck, which they call a phul. Silver bangles called kada are worn on the wrists and, on special occasions, they also wear a hip girdle in silver called a *kanakti*. A thick silver anklet called kadi is worn on their right leg.

The men dress their hair in a unique fashion. The older men shave off almost all their hair except for a lock or two, just over the temples. These little tufts of hair are allowed to grow into long, bushy whiskers that are visible even under their safa. This probably saves time on regular hair care. They also wear long, luxuriant moustaches that almost touch their sideburns. A small, handy comb made from bullock horn is kept in the pocket, which they use very often, to style their thick whiskers and moustaches. Their footwear is usually the *juti*.

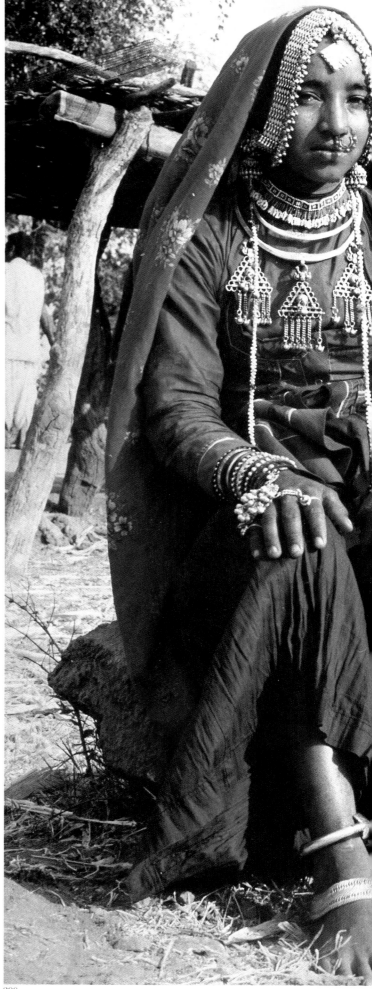
290

GARASIA

According to local lore, the Garasia are descendents of the Chauhan Rajputs. About six centuries ago, after a crushing defeat in battle they escaped to the hills and mingled with local tribals. It is believed that they settled around Mount Abu and Rotra region of Udaipur.

The Garasia dress is very colourful and attractive, both in design and embellishment. The clothing of Garasia women has a predominance of strong shades of red, blue and green. A long sleeved jacket called jhulki, which has a front opening, is used as the upper garment. Beneath the jhulki, a *polaku* is worn. The jhulki has two pockets on either side. The jhulki is also indicative of marital or romantic attachments of the wearer as, the name of the wearer's husband or lover is embroidered in gota or coloured thread on either side of the jhulki. Women wear *chhano* or ghaghra as their lower garment. Young unmarried girls use a long skirt, which is made of 1-2 meters of cloth. The odhna is used to cover the head and upper body and is in a particular style called *harlu* or *haluru*. The Garasia widow wears a chhano, a black odhni.

To enhance the looks, lips are painted with a red pigment, as a sort of substitute for the modern lipstick. The soles, fingers and nails are painted red as well. Garasia also use mehendi extensively for decorating various body parts.

A Garasia woman usually wears a great deal of jewellery made of bronze, stones and shells. They wear *vithali*, which are silver rings in the nose and the ears. Another personal ornament is the *borayoo*, worn at the centre of the forehead, below which a jabla is suspended. They also wear oganiya and *damani* -- which are ear ornaments. Their neck ornaments are colourful and include the *bhamrio*, *kanikoya patiyu* or *pulyu*, which are made of glass or silver beads.

They also wear hansli, *hains*, and *hariyoo*, white bangles turned from shellac.

A unique and decorative silver ornament is the *haathpan*, worn so as to cover the back of the hand with floral designs. Ornaments adorning the feet are the *pavla* or *karla*, which are silver anklets along with toe rings, known as *polari* or anguthia.

Facial and body tattooing is popular. The most preferred motifs are dots, peacocks, scorpions, parrots, svastika and the names of lovers and life partners.

Garasia women wear their hair in different styles and take great care of their tresses. The hair is usually worn long and washed once a week with fuller's earth or lukewarm buttermilk. They also regularly massage mustard or sesame oil into their hair. Other indigenous hair care products include the residue obtained after boiling neem leaves and the bark of the aritha tree. Women part their hair in the middle and braid it into plaits, one on either side or one down the centre of the back. The plaits on the sides of the head are tucked into the central braid. Sometimes the hair is knotted at the top of the head and a mesh of decorative threads is hung loosely from it. This thread also embellishes the area around the temples and hangs in front of the ears.

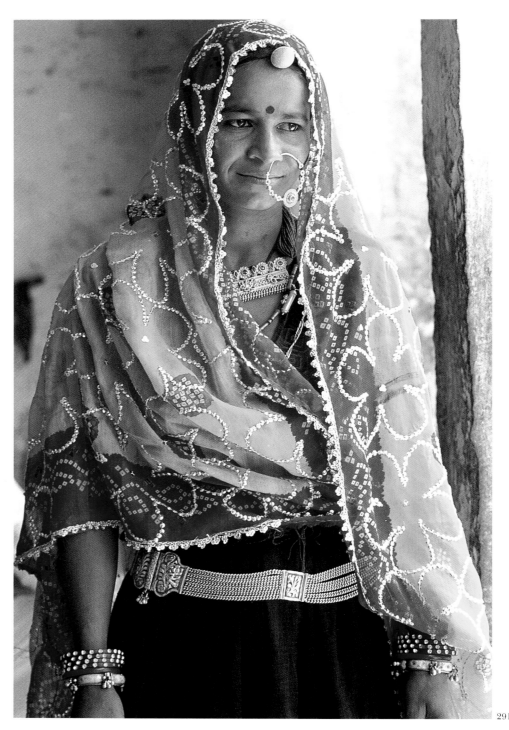

290. *(Previous page):* **Garasia girl.** *Udaipur.* She wears a ***puthia*** over an indigo dyed crinkled cotton ***ghaghra***, which is gathered at the waist. Her ***odhna*** is made of block printed cotton fabric. She wears a great deal of silver jewellery. A large ***tika*** is suspended from the centre of the ***jhela*** that frames her forehead and supports the ***jhumka*** in her ears. Around her neck are a ***moti kanthi*** and silver ***hansli***. A ***nath*** adorns her nose; and she wears silver ornaments on her wrists. She wears the ***hathphul***, with a ring on each finger; and on her ankles are ***kadi*** and ***haathe***.

291. **Gujar woman.** *Kishangarh.* A ***pila odhna*** with silver ***gota*** work is draped over a cotton ***saadi***, an unstitched lower garment. She wears a ***bor*** on her forehead, and a large ***nath*** on her nose is supported by a chain attached to her hair. The ***aad*** and ***madaliya*** are visible round her neck. Her silver girdle is called a ***kanakti*** and she has silver bracelets on her wrists.

292. **Gujar man.** *Kishangarh.* His upper garment is a cross between a western style man's shirt and the traditional ***kurta***. The ***safa*** is of multi-coloured ***bandhani*** fabric. The ***phul*** around his neck, engraved with the image of a deity, is suspended on an elaborately tasselled cord; and there are ***murki*** in his ears.

291

The dress of the Garasia men is similar to that of other communities. Headgear is particularly important and the men generally wear turbans called *potiyu* or pagadi, the colour of which depends on their age and status. For example, a young man would wear a red turban, whereas older men wear a white turban. All men wear a white half-sleeved kurta called jhulki, as the upper garment and the dhoti as their lower garment.

Jewellery worn by Garasia men includes the jhela or *jharmaruyu* in gold or silver. These are worn in the ears. A *mataliyo* or kada, which is a solid silver bangle, adorns the wrist. *Bire* is an ankle ornament, while *terayo* is a pendant that is worn on a long thread and hangs on the chest. They also wear a kandora, which is a silver ornament worn around the waist. *Mandaliyo* is a silver or copper armlet. The kurta is fastened with buttons called *hakali*.

Hairstyles in this community point to social and economic class, current position and other status indicators. The village leader maintains a beard and

moustache, considered symbols of masculinity. Priests grow beards and moustaches and wear their hair long. Women, girls and boys apply vermilion to the parting of their hair, so in this case it is not a sign of marriage. Children's hair is dressed in a peculiar manner. The boys' hairstyles include *latto*, which means not carefully groomed; *kataria*, finely cut and dressed; *boroo-bhondu* clean cut; *kebaroo*, where a band of hair is left around the scalp; *patta-kataria*, combed on either side of the scalp with a lock of hair left loose; and *tosi*, where a lock of hair intended as an offering to the family goddess is left tucked in the front.

GUJAR

The Gujars are a community whose main occupation is cattle breeding, though, of late a few have also turned to agriculture. They rigidly adhere to their time-honoured costume and are a study in the preservation of tradition.

Gujar women wear a characteristic saadi, which resembles a *ghaghra*. It is a long rectangular strip of coarse cotton cloth worn around the waist. The black saadi is stitched along the length of the fabric, pleated at the waist and secured by an ornamental tie or rope. It is worn with a kanchli and *lugri*. The unmarried girls wear a puthia, ghaghra and odhna. Married women wear a ghaghra, a kanchli with gota trimmings and a colourful odhna. The Kumhar and the Gujar wear a ghaghra, in a nalchi bhat, as this block-printed fabric is called. It is predominantly black with a red and white design on it. The skirt has a *palla* design on the belt and leheriya on its hem. The phetiya is also used as a lower garment. It is plain black in colour, of ankle-length and hand-stitched at the waist.

The kanchli has a deep neck and ends just below the breasts. Its sleeves are elbow length and it is made of lightweight cotton, popularly in red, green or blue floral prints. The kanchli is also decorated with thin piping and mirror work. A special odhna worn by the Gujar women is the lugda, made of printed red cotton fabric. It is about 3.75 meters by 2.5 meters in size and is decorated with gota flowers, especially around the head. Gujar widows wear prints that are markedly different from those worn by married women and unmarried girls. The women usually cover a part of their face. Tattoos are also a popular form of decoration.

The women are fond of jewellery, which is mostly in silver. They wear a bor with a jhela on the forehead; *kungali* and a gold amulet called *ramnami* on the neck; jhumar in the ears and a kanakti on the waist. Their arms are covered with ornamental *gugra*, *pahunci* and kada, while the kada, *jhanjhar,* avla and *chade* are worn on the feet.

The upper garment for men is the angarkhi or bagalbandi, which has, ties on the right side and is usually of hip-length, though longer, knee-length angarkha are donned on special occasions like marriages. The Gujar angarkhi has more flare than other working class men's angarkhi. It is characterized by the absence of piping at the hem and side seams and has an embroidered putia design. This is a floral design in running stitch on the back bodice and on the sleeves at the upper arm level. At the back, a thin muslin fabric on the underside of the bodice, reinforces the pattern, giving it a quilted effect. On special occasions, the men wear a knee length jama called the baga, which

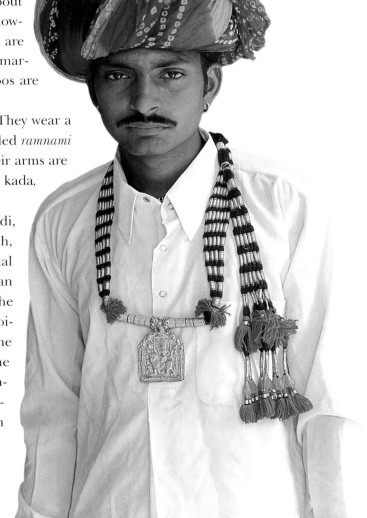

292

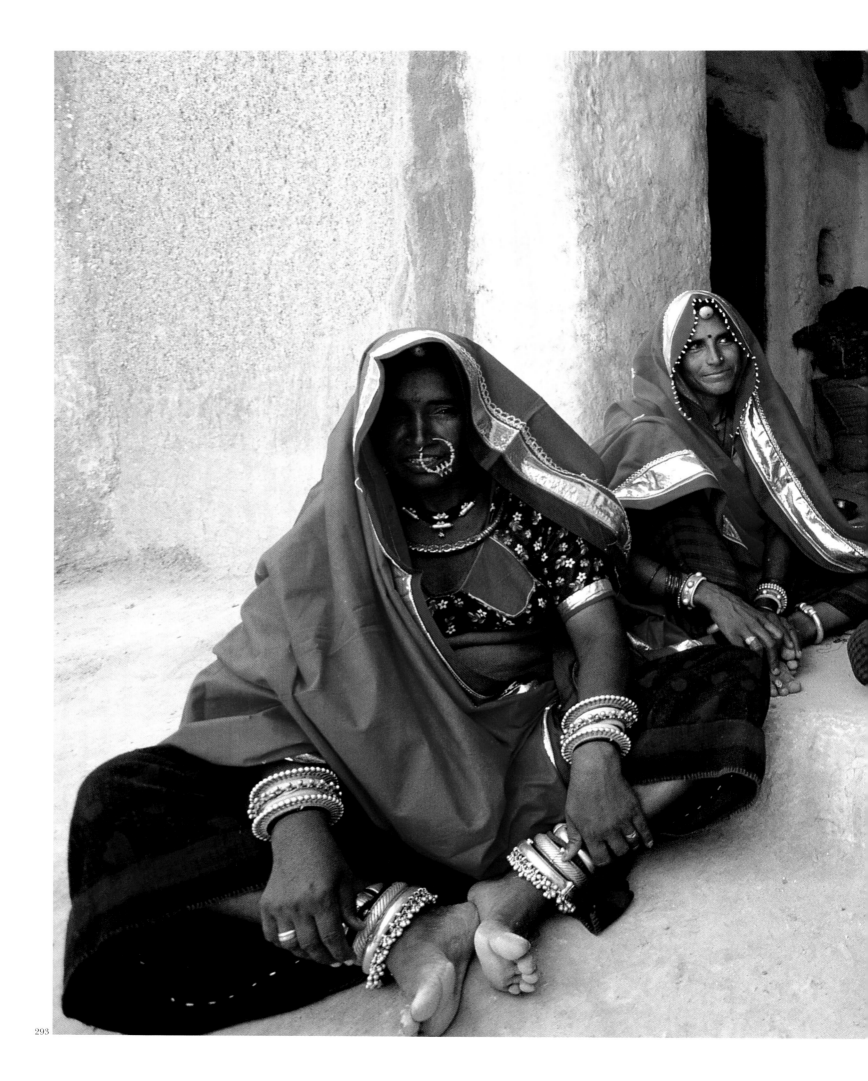

293

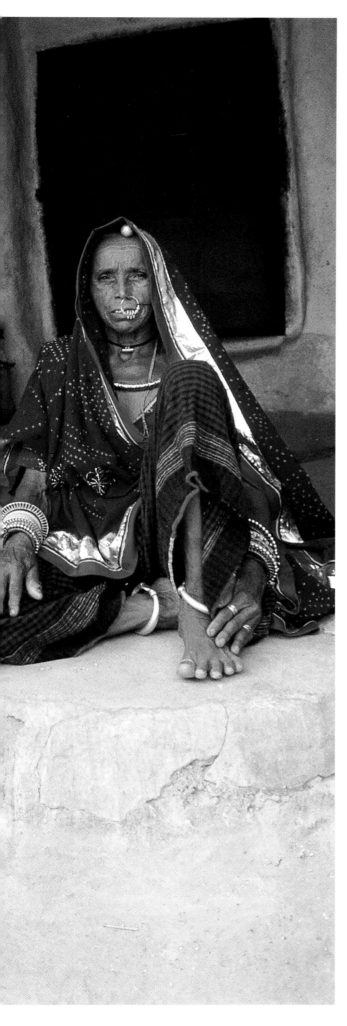

is made of red cotton fabric and decorated with gota work on the seams, the front yoke, back bodice and sleeves.

The men's dhoti ends just below the knees and is about 5 meters in length and 1.25 meters wide. It is white and worn in the *dolangi* style. The men, at times, also wear an angocha, which is a small blue or green checkered handkerchief size cloth. It is thrown over the right shoulder and used as a handkerchief or as a spread to sit on. In winter, the Gujar wrap a blanket round their shoulders like a shawl.

The men wear a gol safa made of cotton as the headgear. The safa fabric is either red or white and, on festive occasions, the turban is elaborately ornamented with gold.

The men are also fond of jewellery and wear gold murki, jhela or kundal in their ears. On their wrist they wear a kada and a kadi on one foot. Phul, a gold or silver pendant on black thread and colourful woollen tassels are also worn around the neck on occasions. For everyday wear they use a heavy silver choker, called a hansli.

A moustache is de rigueur for all men and is usually worn long. The hair is short and the elderly men often sport beards.

JAT

The Jats are farmers and cattle breeders. They are said to have sprung from the *jata* or lock of Shiva's hair, from whence they derive their name. They are followers of Hinduism and worship Tejaji, a local deity.

The basic garments worn by Jat women are the puthia or kanchli, ghaghra and odhna. Though there is very little difference in the fabrics used, the colours and variations in the styling of garments distinguish between unmarried girls, married women and widows.

The puthia of young unmarried girls is made of white pichodi or sometimes a red floral printed fabric. Its length is 10-12 cm. below the waist with three quarter or elbow length sleeves. There is a single button on the centre front and another one on the right shoulder. The lower garment for daily use is a white khaadi pothdi, which is constructed like a pair of shorts and tied with a tape at the waist.

On special occasions the older girls wear a block printed ghaghra in a *katari bhat* design. It falls to a little below calf length and uses 1-2 meters of fabric. A 5 cm. wide facing is attached on the inside at the hem level. Mainly older girls use the odhna - made either of *khata bhat* print or red tul.

On her wedding day, the bride wears a heavily embroidered puthia, which, after the ceremony, is replaced by a kanchli or angia. The kanchli ends just under the breasts and the neck is deep and wide, cut in a three-cornered sweetheart neckline. Older women wear a higher, closed neckline. Each piece of the kanchli is demarcated by a yellow rekh and the edges of the short sleeves and peti are bound with a 1.5 cm. wide piping in red colour.

Almost 80-100 kalis are used in the construction of a kalidar ghaghra made of *katari bhat* in cotton. The hem ends 5 cm. above the ankle and has two edgings, a fine yellow one along with a 1.5 cm. wide red piping. Sometimes a red got is used as finishing. The waist is finished with a 3 cm. wide belt, which is edged with fine yellow piping. A red *chunri*, heavily ornamented with silver gota at the edges and on the main body, is worn at

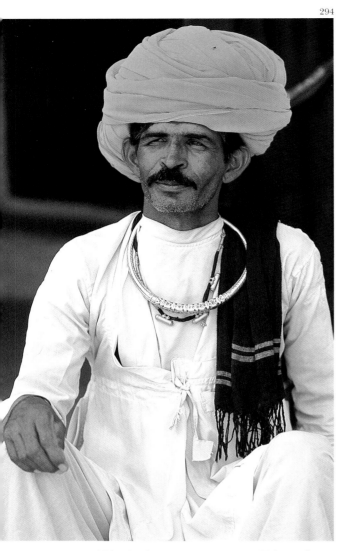

293. (Previous page): **Jat women.** *Kishangarh.* They wear the **kanchli** over a black checked **saadi**, or lower garment. Their **odhna** have a double edging of blue cotton and silver **gota**. As married women, they all wear **bor** on the forehead and a nose ornament called **nath**. They wear silver **kada** on their wrists and ankles. The woman in the foreground has an amulet container, or **madaliya**, around her neck, silver bracelets and **jod** around her ankles.

294. **Jat man.** *Ajmer.* His upper garment is a white **puthia**, which is worn over a **dhoti**, draped in the **tilangi** style. The shawl over his left shoulder is woollen; and around his neck are a silver **hansli** and **madaliya** on a black cotton cord.

295. **Jogi family travelling between temporary camps.** *Jaisalmer.* The woman's upper garments are a **chola** and **kanchli**. Her lower garment is called a **palla ghaghra**. A yellow muslin **odhna** is draped over the whole ensemble. Her neck is adorned with coin necklaces. The hammock suspended from the pole on her head is a portable cradle in which she carries her baby.

the time of marriage. After the ceremony the kanchli and ghaghra continue to be used for daily wear.

At the onset of winter a woollen dhabla is put on as a lower garment. The fabric is woven from pure sheep's wool or a blend of cotton and wool. It is usually in black and white checks, obtained from natural black or white wool. Sometimes it is dyed with natural or chemical dyes. The lower edge is embroidered with brightly coloured wool. Generally seven colours, green, yellow, red, orange, white, black and turquoise are used to produce a *kangasia* design. Kaccho bharat and suf bharat are the main stitches used. The dhabla is worn at all stages of a woman's life and is a fine example of an unstitched garment moulded to the shape of the body. Another popular design used for making ghaghras are black and red or red and white checks in pure cotton. This is known as *jati-ka-sada* and is preferred for the summer months.

The different printed odhnas worn are *kanta bhat, makhana bhat, katari bhat, tiptipari bhat* and *jati-ka-odhna*. They are draped in two ways. In one style, two or three pleats are made at one end and tucked into the left side of the ghaghra. The odhna covers the head and one end goes over the right shoulder. The other end emerges from under the arm over the front of the body and tucks into the left side of the waist. In the other style, one end is tucked in near the centre of the waist. The odhna covers the head and is brought round from under the arm. The ghaghra is almost completely covered by the odhna.

A widow's garb is conventionally without ornamentation. It consists of a long full-sleeved kanchli in tobacco colour or a red kanchli with green piping. The dhabla and plain ghaghra and odhna in a tobacco colour are also worn.

The women usually wear a circular nose-ornament called kanta. The timaniya and badla are neck-ornaments. The hamel is a long necklace, which has a central rectangular piece made of solid silver. The Jats traditionally use a variant of the chuda called a chud, which is made of silver. The dodia are circular rings, worn on the wrist and have four raised structures about an inch high, which are engraved in a dotted design. The kadi is made of solid metal and worn by all communities. The hirmani - or hirmain - is a single solid wire worn on one foot.

Jat men can easily be identified by their saffron, white and pink gol safas. The cloth used is about 10 meters in length. The white and saffron headgear are by far the most popular. On festive occasions, the turbans are ornamented.

The angarkhi worn by them ends 5-10 cm. below the waist. As they work in the fields, the length of the garment is kept short for easy movement. The construction is the same as that of a right tied angarkhi, except that there is no piping on the sides. The angarkhi also has an embroidered putia design, which is present only on the back bodice and is absent on the sleeves. The bodice is fitted till the waist, from where it flares out. A welt pocket on the left panel is present along with slit pockets in both the side seams. Even on special occasions, Jats do not wear coloured angarkhi.

The Jat men usually wear a mid-calf-length dhoti as the lower garment, which is about 0.5 meters in length. This is usually worn in either a tilangi or a dolangi style. The fabric is thick and the dhoti fits close to the body.

The men wear jhela and murki in their ears, kada on their hands, a kadi on their right foot and a madaliya on their neck. A curious custom among the men is to bore their upper front teeth and insert small gold plugs into the cavities as ornamentation. They are especially fond of wearing earrings and charms.

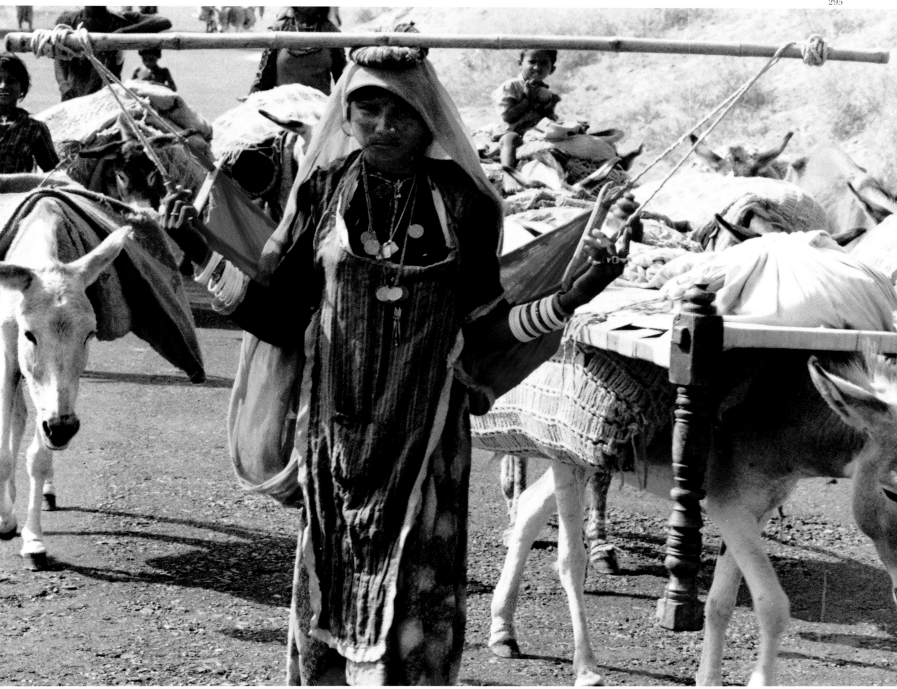

JOGI

The Jogis are traditionally an ascetic sect, who worship Lord Shiva, and are followers of Gorukhnath, a saint, who, they believe, is immortal. The people of this tribe slit their ears and wear red clothes as a sign of renunciation. The Jogis have two main subdivisions. These are Kanphata Jogi and Kalbelia Jogi. The latter are nomadic and mainly snake-charmers.

The young Jogi girl wears a chola as her upper garment. This is usually made of red printed fabric, although other prints in blue, orange or yellow are also popular. It has a small round neck, which is, sometimes, finished with a Chinese collar or left plain.

The lower garment is a skirt made of *katari chhint*, often in the same fabric as the upper garment. It is long, sometimes, trailing the ground. Five or six meters of fabric are used to make the skirt and both styles, of kalidar and pat ghaghra are worn. In a *katari bhat* printed-ghaghra, two rows of piping in red and blue, bind the hem. The red piping is narrow, whereas the broader edge

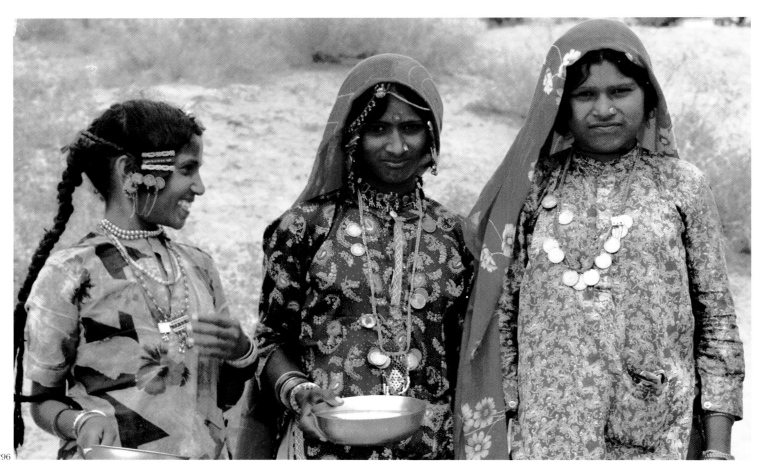

296

297

is in blue. Red-printed skirts have piping that matches the colour of the ghaghra and fine piping in blue or pink is used to bind the hem. Traditionally, unmarried girls wear a bandhani odhna in yellow and orange, which is 1.5 meters wide and 2.5 meters long.

Married women wear a kanchli in combination with a chola or kurti. The latter is of knee length and forms a typical triangular shape at the bottom. Red, pink or yellow floral cotton prints are the most commonly used fabrics for these garments. The neckline of the kanchli is high and touches the base of the neck with tight fitting plain sleeves of three-quarter length. The chola is sleeveless, with a deep neckline. The garment is finished using 4 cm. wide piping and, sometimes, an edging of gota follows the piping.

The ghaghra is often in the same colour as the kanchli and is usually in two popular prints, of either *katari chhint* or *minakari*. The skirt is known as a *ghaghar pat ghaghra* and is long, touching the floor, with a broad edging in the same colour. Often a rickrack in yellow, known as mankhi may be top stitched and provides a contrast.

The odhna is of a thick, red handmade fabric, called tul, and about four meters long. It is about two meters wide and the joint at the centre is finished with a run and fell-seam. Its surface is ornamented with gota work in gold and silver. The odhna is draped with one end tucked inside the waist of the ghaghra on the left side after the width is pleated. The other width covers the head and the edge of the length is similarly tucked in on the right side.

The garments of the Jogi widow, whether it be the kanchli, kurti or ghaghra are all in a similar fabric, which is either a dull red or chhint in a faded red. The construction is similar to the garments worn by married women. They also use a dull black odhna devoid of any brightness or colour.

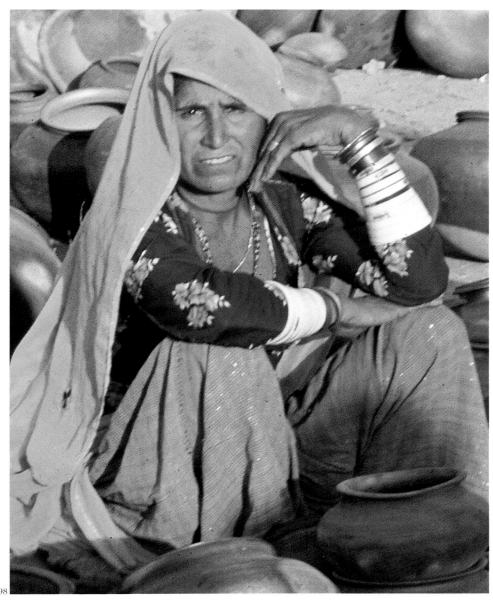
298

296. **Jogi women at the fair**. *Jaisalmer*. The woman in the centre of the group is married, as seen by her clothing and jewellery. She is flanked by two unmarried girls. Her upper garment is the **chola**. The draped garment is a tie-dyed **odhna**. The hair, styled to fall across the forehead, is held in place by beautifully crafted ornaments. In the centre of her forehead, framed by **jhela**, hangs a **bor**. Her neck is adorned with a **kanthi** and pendants worked in **moti bharat**.

297. **Jogi man**. *Jodhpur* He wears a **kurta** with silver buttons over a cotton **dhoti** and a multi-coloured **safa** dyed in the **bandhani** technique. There are **murki** and **jhela** in his ears, and embroidered **juti** on his feet. He plays an ancient Rajasthani musical instrument called **pungi**.

298. **Kumhar woman**, *Bhilwara*. She is wearing a **kurti** and **kanchli**, with a woven **saadi** as her lower garment, and an **odhna**. Her arms are covered by **chuda**.

Jewellery is extensive and an integral part of the married women's attire. The women wear a variant of the chuda in silver, called a chud, on their arms. They wear an elaborate nose ornament called the kanta and large neck ornament called the badla.

On their waist, a heavy band called the cummerbund or kandora is used. The kadi or ankle ornament made of solid metal is also worn.

Jogi men wear long white cotton chola, as their upper garment. The *tehmat* is the lower garment and is usually white. The tevata dhoti is also worn on occasions though it is less popular than the tehmat. They wear a phetiya on their head for everyday wear. The pagadi is worn in the gol safa style. It is approximately 20 meters in length and about one meter wide. Popular colours for the pagadi are red, yellow and green.

The attire of the Jogi men is characterized by a single colour, which is most often white, although sometimes the entire ensemble may be in a dull red.

KUMHAR

Kumhar is the community name for the village potter, an essential member of rural society, who supplies all the earthen vessels required for cooking and storage. The Kumhar can be divided into a number of exogamous divisions. Both Hindu and Muslim Kumhars live in the region.

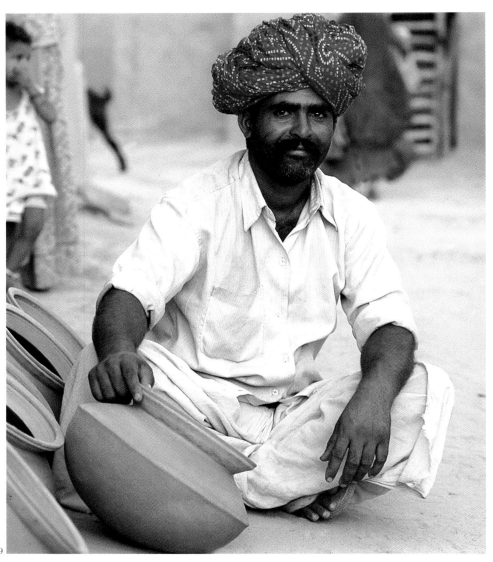

299

Kumhar women dress much like the Gujar women. They wear a black and red-checkered saadi of thick woven fabric draped around the waist. It is made by joining two lengths of a narrow width fabric, which are left unfinished at the seam and the hem.

Their kanchli is similar to the Maheshvari kanchli. It ends just below the bust, with a bare back and short sleeves just above the biceps. It has a large sweetheart neckline, which exposes the upper part of the breasts and is made of thin, transparent voile fabric.

All women usually wear the *angutha* chaap odhna. This odhna has a dull red base and is printed all over with a design of white block printed rectangles. They also wear yellow, red and black chunri, which is sometimes embroidered. Its central portion is often ornamented with silver bells.

The women are partial to brass jewellery and usually wear no silver. At least, one bangle on the wrist must be made of brass. They also wear a brass kada on the ankle.

The costume of the Kumhar men is quite similar to that of men from other working class communities. The upper garment, called the bandi, has half sleeves and a round neck, with buttons on the centre front. Since the Kumhar works squatting on the ground, his upper garments are short. On special occasions silver buttons adorn the bandi. At times, the Kumhar men also wear an angarkhi. This garment is quite similar the Jat angarkhi, except that its sleeves are of elbow length. The lower garment of the Kumhar men

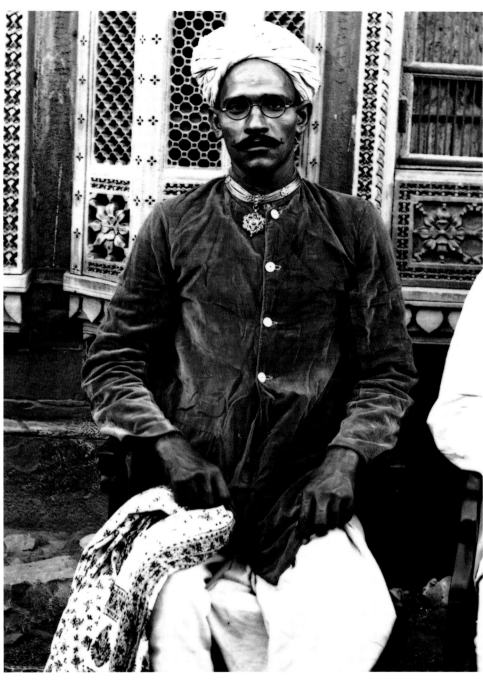

299. **Kumhar man**. *Pokhran*. His ***kurta***, ***dhoti*** and ***bandhani*** turban are made from cotton fabric.

300. **Man from the merchant community**. *Bikaner (late 19^th century)*. He wears a short tunic and a ***dhoti*** as the lower garment. His ***safa*** and shoulder cloth are of block printed cotton. Around his neck can be seen a ***baleora*** with a pendant.

301. *Next page:* **Maheshvari woman**. *Bhilwara*. The blouse, and the ***pat ghaghra*** she wears as her lower garment are made of silk with ***gota*** appliqué. The ***odhna*** is fine cotton muslin with floral ***gota*** motifs. On her head is a ***bor*** with a ***pan*** and ***dora***. Neck ornaments include a ***tussi*** and ***haar***. She wears gold bracelets and ***hathphul*** on her hands. A ***nath*** adorns her nose.

300

is a calf length dhoti worn in the tilangi style. Their headgear is a white gol safa. They also wear a deep red safa, or a printed turban called *jaipuria* on some occasions.

The men are fond of jewellery and wear murki in their ears, silver amulets around the neck and a kadi on the right ankle. They do not wear kada on their wrists, as it would probably hinder their work.

MAHESHVARI

The Maheshvaris trace their origins to the Rajputs and they are part of the larger group of commercial traders known as the Mahajans, literally meaning great men. They are so called, also because they are worshipers of Lord Mahesh or Mahadeo. This community is divided into 72 clans and they abstain from liquor, meat and garlic.

Maheshvari women traditionally remain within the confines of their homes. Their garments are elaborate and vary greatly, depending on the occasion.

Unmarried girls usually wear the puthia or the *kabja* made of soft cotton,

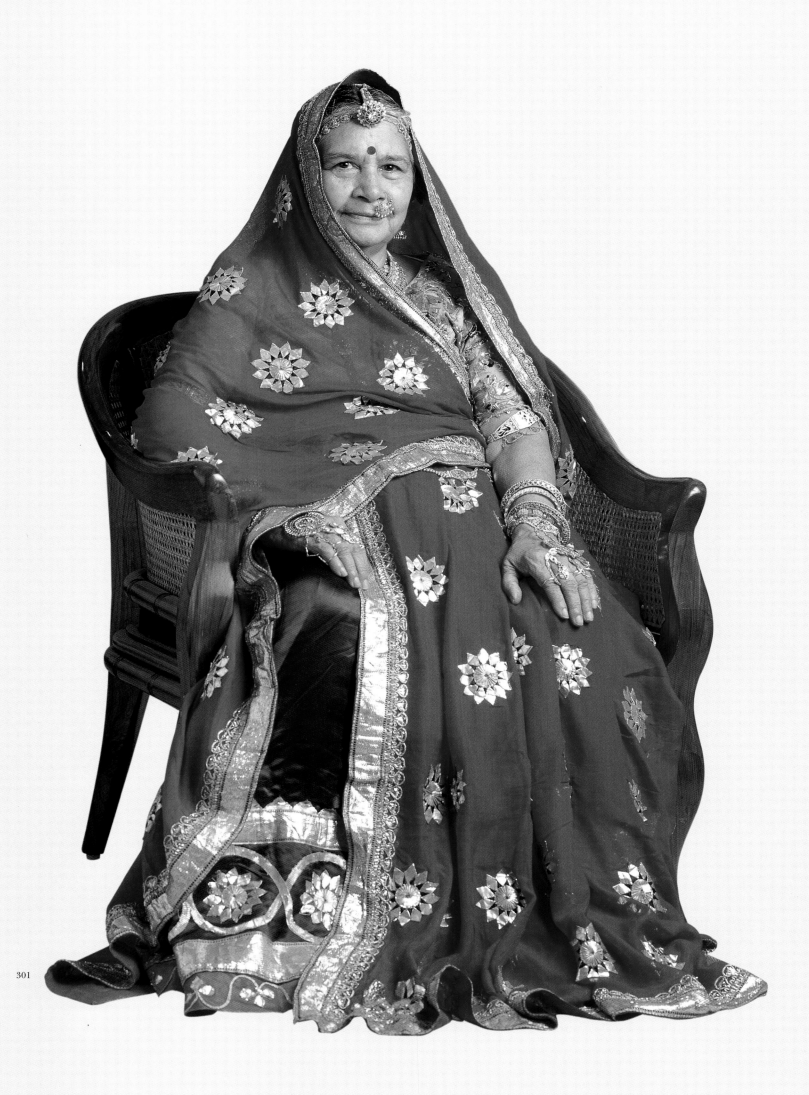

301

as an upper garment. Sometimes, a *khadi kamiz* is also worn, which is designed like a man's shirt. The fabrics used to make this garment are white reza or pichodi, red poplin or small chhint in a medium weight. Prints in red, green, light blue and bright yellow are also popular.

The different garments used for the lower part of the body are shorts or the ghaghra. On special occasions older girls wear a ghaghra. Cotton in large prints of dark green, blue and pink and plain voile are used to make the ghaghra.

The kalidar ghaghra falls just above the ankles and uses four to five meters of fabric with a total of 20-25 kalis of equal size. The size of each kali is about 3 cm. broad at the top and 6 to 10 cm. wide at the hem. A double piping ornaments the hemline. The broader piping is in red or green and the finer rekh is in yellow. The belt is narrow and has a fine demarcating yellow piping. There is also a side slit at the waist, which is edged with a fine yellow strip cut on a bias.

As the girl grows older, an odhna is introduced into her ensemble. At the age of around 10-12 years a *bachkani* odhna is used. It is made up of brightly coloured poplin, pichodi, tul or fine voile. Red is the most popular colour and yellow is generally avoided. It is 2.5 meters long and 1.25 meters wide and may use both printed and plain fabric. Its edges are left raw and ornamented with gota work. Gota is appliquéd not only on to the edges but used to make floral designs on the main body as well.

In contrast to bright colours and fabrics, a woman's bridal dress is simple, almost austere. During the wedding ceremony, the upper part of the woman's body is wrapped in a white sari, called a kavaljoliya, and no stitched garment is used. The kalidar ghaghra is in tul without any ornamentation. The odhna draped on the body is called a *kasumal* chunri. This is tie-dyed, with yellow dots on a red base with green edges. It is also known as a *hara-palla* odhna and is a gift from the bride's maternal uncle.

On the second day of her marriage the bride is dressed elaborately in a kanchli, ghaghra and odhna, which is gifted to her by the groom's family. A phavri, which is a red odhna with white tinsel printing, completes the ensemble.

The *ghaghra*, called *bajti-ka-ghaghra* is made of satin and has as many as 80 kalis. The total fabric used is as much as 20 meters. The hem is finished with two biases, a 3 cm. piping in green and a fine yellow bias with gota stitched all around borders. The three elements of dress kanchli, ghaghra and odhna are generally in different colours.

The daily attire of a married woman is bright and colourful. Everyday skirts are made of thin satin or fine printed-cotton. The ghaghra is known as *kala-kajaliya*, which is made with a minimum of fifty two kalis and is finished with red and yellow edgings using as much as 9 meters of fabric.

The most popularly worn odhna are the phaguniya, leheriya, mothra, bandhani and *ladu bhat* or plain voile in red, pink or parrot green. These are all in a light fabric and are 4 meters long and 1.5 meters wide. The kesariya and kasumal odhna, ornamented with gota, are also quite popular. The odhna is tucked in near the centre of the ghaghra and taken around the back, over the right shoulder totally covering the chest. One end is brought around the front and fixed towards the right side of the body at the back. The head is covered and most women cover their faces. Special occasions like festivals or the birth of a child are marked by a change in the odhna.

The most essential piece of jewellery for married women is an ivory chuda, put on the hands during the marriage ritual. Married women wear a gold bor on

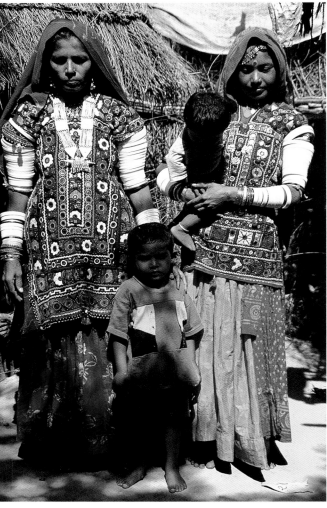

their foreheads. The women also wear a charming gold necklace called kanthi.

A widow's dress is characterized by its plain colour. The kanchli is full-sleeved, while the kalidar ghaghra is often replaced by the less attractive phetiya, made of rectangular panels and the odhna is an unornamented length of fabric.

The Maheshvari man's costume is characteristic of the affluent male attire in the region. These days, however, traditional costume is almost disappearing and urban alternatives in dress are more prevalent.

The men's angarkhi is front-open and tied on the right side. It is a knee-length garment, made of soft cotton khaadi. Underneath the angarkhi, a sleeveless bandi made of soft cotton voile is worn.

The lower garment is the *khuli-laang-ki-dhoti*, which reaches down to the ankles. It is made of soft, white and almost transparent cotton.

Headgear is called pagadi, pag or mandil. It is 18 to 20 meters long and 25 cm. wide. The cotton fabric used may be in a single colour or it may be printed with several colours. It may, sometimes, even have gold and silver-thread work done on it.

The men usually wear their hair short. Although very little jewellery is worn on the person, their ornaments are made of gold. A chain on the neck, or a ring is sometimes worn. Maheshvari men may or may not wear gold ear-rings but the ear-piercing ceremony is mandatory for a male child.

Footwear for men and women is the fine quality camel-leather juti, decorated with colourful embroidery.

MEGHVAL

The Meghvals are also known as Bhambi, which, in the local dialect, literally means 'drummer'. Even today people of this community play the *bhamb* or drum. There are various mythological tales about the origin of the Meghvals. The Meghval were originally associated with tanning and the manufacture of leather articles. The men of the Meghval community are expert weavers, just as the women excel at embroidery.

The unmarried girls wear a puthia. It is usually made of red fabric for the newborn child and changes to white on the first Holi, after ceremonial rites are performed. The puthia is embroidered in various styles, like kharak, suf bharat or *humrichi* and silver gota is also used as edging. Young girls usually wear shorts and begin to wear the ghaghra only much later. The ghaghra is made of cotton, in colours like green, blue and pink. Also popular are hand-printed fabrics like the *ghand bhat*. Young girls wear a red, yellow or green odhna, which is about 4 meters in length and it increases in size as age advances. Popular prints are the *dhanak, chunri, reta, champabhat* and *kasumba*, among others.

It is tradition to wear a red puthia at the time of marriage. This is referred to as the angarkha or *jhabba* and worn with a *minakari* print ghaghra. Subsequent to the ceremony the bride changes into a kanchli. Her head is covered with a band-hani chunri having yellow and white designs on a red base colour.

Clothes may show tremendous variety within the community. A case in point is the kanchli, the upper garment worn by all married women of the Meghval community. Those who live near the border and have been influenced by the Sindhi-Muslim way of dressing, wear long kanchlis, which reach down to their hips. Those Meghval women who live in other parts of the region wear a smaller kanchli. The sleeves of the kanchli are short, but the

302. **Meghval women.** *Barmer.* Their **kanchla** are heavily embroidered. The woman on the left wears a cotton **bandhej odhna**; the **odhna** on the right is block printed. Their jewellery indicates their married status. The forehead is ornamented with **bor**, suspended from the **jhela**. Their arms are covered in **chuda**. The long silver necklace is called a **sanger**, and on their ears are **kudka**.

303. **Meghval men.** *Phaloudi.* They are wearing the **dhoti** with a shirt and **safa**. The man in the foreground is weaving a **pattu** on a pit loom.

304. **Meghval woman.** *Phaloudi.* Her **kurti**, **kanchla** and yellow **odhna** are made from polyester. A **bor** hangs from her forehead. Her intricately braided hair is kept in place by a silver hair-clip, and she has a **kanta** in her nose. Around her neck are a **timaniya**, made in the **moti bharat** technique, with multiple rows of beads, and a long bead necklace with a silver medallion. She wears **bajuband** on her arms.

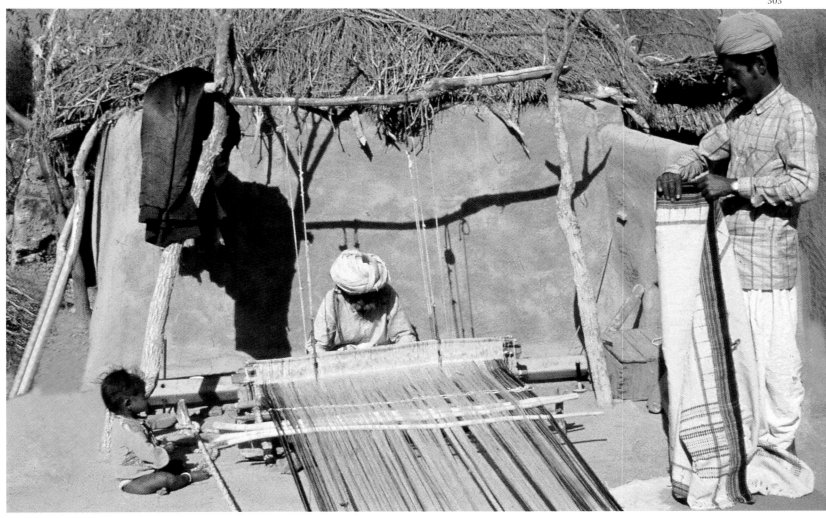

arms are not left bare. Bracelets called chuda are worn from the wrist all the way up to the shoulder. The kanchli seen here is especially striking because of its heavy embroidery, in a variety of colours such as red, blue, pink, yellow and green. The women wear a kalidar ghaghra, with broad piping. The ghaghra is in bright colours like red and pink. In a *saldar ghaghra*, a single thread is tacked along the width of the ghaghra, then drawn, into gathers over which a belt is attached to finish the waist. Winters see the Meghval women wear a variety of wraps, like the reta, which is an embroidered shawl. A widow usually wears the puthia or jhabba as the upper garment. The jhabba is the most preferred and is worn with a ghaghra as a lower garment. The odhna may vary depending on age for example, a young widow wears a black odhna with an orange print, while older widows wear a plain tobacco coloured odhna.

The Meghval women wear head ornaments called bor, made of beads or silver, brass ear ornaments called kudka, elaborate necklaces called chandanhaar and a nose ornament known as kanta. The kanta has a diameter of usually 1.5cm to 2 cm. The visible side has stones embedded in it. On the invisible side, there is a spring-like wire. The kanta is fixed with a wire that is passed through the hole in the nose. Other varieties of necklaces include the timaniya made of *chid* or small glass beads and the badla, which is generally made of silver. The dodia is a circular silver bangle, worn on the wrist. The hirmain, a solid metal ring, is worn on the ankle all through life.

The most striking characteristic of the men's dress is that it is white from head to toe. Traditional male attire consists of the puthia, dhoti

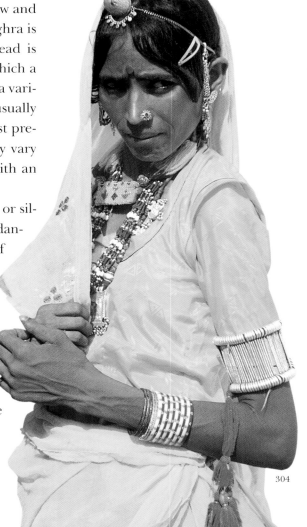

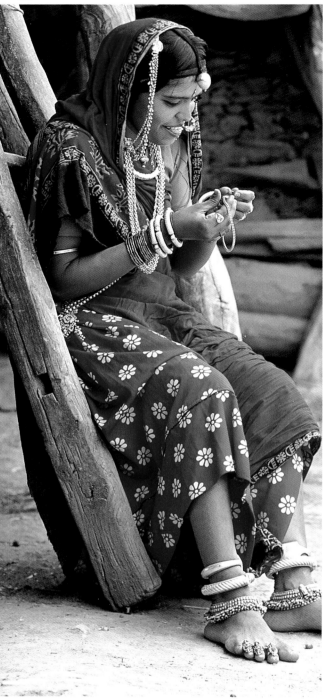

and safa. The puthia, worn as the upper garment, is white. The dhoti, also white, is worn long, usually till the ankles. Sometimes, a bandi is the only covering on the upper body.

The safa is usually worn in white or yellow. The men also carry the *gamcha*, a striped piece of cloth, thrown casually over one shoulder or round the neck.

Increasingly now, the men are abandoning their traditional costume for the more pragmatic and popular kurta pyjama. In some places the upper garment is either the chola or the kurta.

Footwear for men is always the juti, which is made of thick leather, embellished with copper studs along the edges. Men usually wear their hair cropped short and rarely grow beards.

MINA

The Minas tell the story of their origin through numerous myths and legends in oral history. Although the derivation of the word is obscure, it has been suggested that *mina* means fish. Mina mythology, traces their origin to Matsay or Minavatar, the tenth incarnation of Vishnu, a principal Hindu God. The Mina is numerically the largest tribe in Rajasthan. They once ruled over the former states of Jaipur and Alwar and are essentially an agricultural community.

The dress of a Mina woman comprises an odhna, ghaghra, kanchli and kurti. Unmarried Mina girls wear a sari called lugda. This red or yellow odhna is large and square roughly measuring 1.5 to 2.5 meters. The *dabkiwali ludi* is a special odhna worn by Mina women and is always coloured red and green. A woman can be easily distinguished by her ankle-length ghaghra, which is usually made of deep red cloth with blue designs. The ghaghra, which is heavily gathered at the waist, is also known as a palla ghaghra. The sleeves of the kanchli or the kurti are usually elbow-length, though the kanchli is rarely used these days.

The Mina woman's most prominent ornament is the borla, a symbol of her marital status. Women also wear a hansli round the neck, a nath in the nose, timaniya in the ears, *poonchi*, bangri, gajra and bangles on the forearms and bajuband on the upper arms. All married women invariably wear chuda made of lac. They also wear kadi and paijeb on their feet. Silver is used for head and neck ornaments, while ornaments for the feet are crafted from brass. Mina women generally do not wear gold.

Irrespective of marital status, a Mina woman does not wear her hair loose. It is usually parted in the middle of the forehead, which, is set off with a borla, which in the case of married women, is studded with imitation stones. Unmarried girls wear their hair in a single braid, which ends in a knot. They part their hair in the middle and make several thin plaits on the side. These are then interwoven into a single braid, which is held in position by a long red or black cotton cloth.

Tattoos are also popular with the Mina. Mina women display tattoos on their hands and faces. The most common designs are dots, flowers or their own names. They wear kohl in their eyes and black dots on the face as a form of body ornamentation.

The dress of the Mina man consists of a dhoti, kurta or a bandi and a turban, although the younger generation has adopted the shirt, with pyjamas or

305. **Mina woman.** *Banswara.* She wears a blouse over her block printed ***palla ghaghra***. Her ***odhna*** is also block printed. The jewellery is typically profuse. At the centre of her forehead hangs a ***bor***. She has long chains and a rigid ***hansli*** around her neck. There are ***bangri*** and ***gajra*** on her wrists and a ***kadi*** is visible on her upper arm. She has a ***nath*** in her nose; and ***jod*** on her ankles, comprising ***kadi***, ***nevari*** and ***payal***. There are ***bichiya*** on her feet. Her hair is braided in the traditional style of the community.

306. **Mina woman.** *Banswara.* She wears a blouse over a ***palla ghaghra*** with the customary block printed ***odhna***. On her forehead is a ***borla***. There is a ***hansli*** and long silver chains round her neck. She wears a nose pin and silver bracelets on her wrists.

307. **Mina bridegroom.** *Banswara.* He wears a ***kurta*** over a ***dolangi*** style ***dhoti***. The colourful garland identifies him as the bridegroom. A turban ornament called a ***turra*** decorates his ***safa***. On his feet are densely embroidered traditional ***juti***. He carries a ceremonial sword.

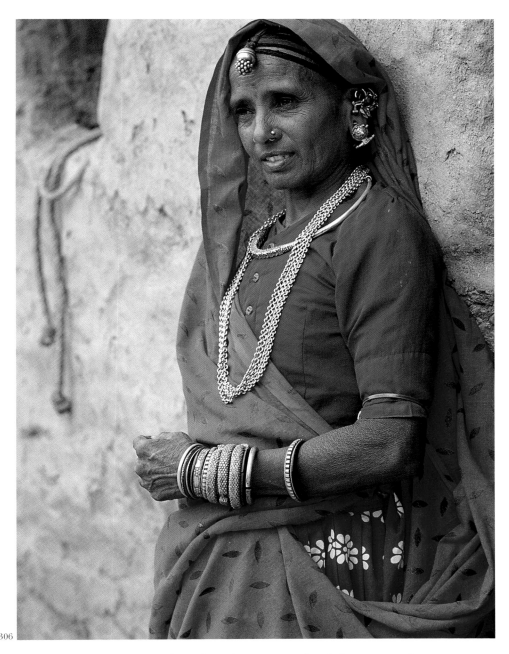

306

trousers. During winter, the Mina men wear a shawl that covers the upper part of their body. Their usual headdress is the potia, which is wrapped around with decorative tape.

Marriage brings a change to the spartan everyday dress of the Mina man. A long red upper garment is worn at the time of marriage. It is calf-length and straight, with long slits on the side and full sleeves. It has green piping on the ends of the sleeves, hem, slits, neck and front. It is also appliqued with gota and has a front-opening. They normally wear the dhoti as the lower garment, which falls just below the ankles. It is worn tight and is draped like the dolangi or tilangi dhoti.

Red-printed headgear with gota work is also worn. A shawl, which is worn around the neck, is also in colours of red and green. Other accessories at the time of marriage include a large sword and a kada on the wrist.

Mina men do not wear much jewellery. The most common ornaments are ear-rings called murki. The men wear their hair short and usually, sport beards and small moustaches. Tattooing is popular with the men as well and they usually have their forearms tattooed with their names, floral motifs, figures and deities.

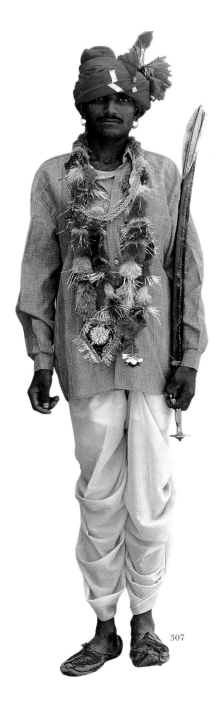

307

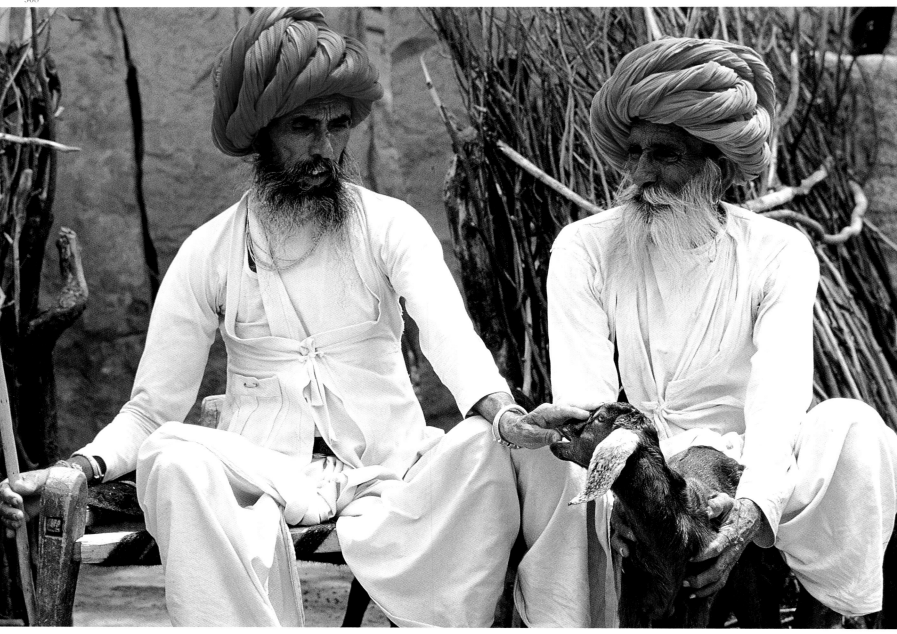

309

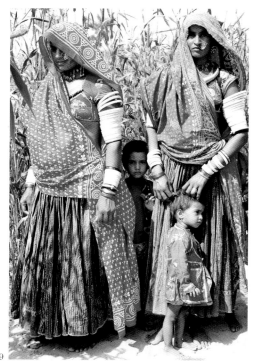

RABARI OR RAIKA

The Rabaris have traditionally been the camel-breeders of Rajasthan. Their creation-myth tells of Mahadeva, an incarnation of Shiva, who created the first camel for the amusement of his consort, Parvati. Subsequently, he created the first Rabari to take care of the animal. A more credible explanation may stem from the immense knowledge of the desert that the Rabaris possess. The name could be a variation of 'rehbari' or a person who shows the path. The community is nomadic and moves from place to place in search of pastures for their camels, sheep and goats.

The Rabaris have continued to wear their traditional garments. Being a nomadic community every effort is made to maintain their community identity. Hence, the changes in costume over the past several decades seen in other groups have been slow or almost absent here.

The attire of an unmarried girl consists of a puthia, a pothdi or ghaghra and, sometimes, an odhna. The puthia can be made with several kinds of fabric like white pichodi, plain coloured poplin and block-printed fabric with small to medium floral prints. The puthia is generally in red, pink, blue or green. Mashru or *meru*, a blend of silk and cotton, is also used. Mashru is

distinctive in its design as it has stripes in red, yellow and brown. The length of the puthia varies between a few cm. below the waist to almost down to the knee and the sleeves vary between three-fourths length to full sleeves. The popular combination of colours for piping is red on a white fabric, pink on green and blue, green on pink, or red on green. Silver gota is appliqued around the piping and, sometimes, motifs like a trishul or svastika are placed on the back.

The lower garment for the very young is a pair of white shorts, which are almost covered by the puthia. The older girls wear a *katari bhat ghaghra* which is made of 20-40 kalis and falls to about 10 cm. above the anklet.

Plain red material, *kasumba bhat* and chunri are some of the fabrics used for the odhna. The base-colour, in all cases, is red and a variety of prints are popular. Younger girls wear an odhna, which is approximately 3 meters long and 1 meter wide.

At the time of marriage, girls often wear a puthia made in plain red mashru. This is trimmed with green and yellow piping as also with gota. Older girls wear an angia, which is made in meru or mashru, mostly in shades of green and red. The angia is tied just under the breast and has a wide, deep neckline and short sleeves. It is heavily decorated with rickrack. Tuki and sleeves are in bright green, pink or blue and covered with many lines of rick-rack and gota flowers. The garment is very short with a deep neckline and short sleeves and exposes a large part of the stomach. The kanchli is tied very tight at the waist, leading to a further rise in the blouse.

The lower garment is a kalidar ghaghra in a *katari chhint* print. The kali can number as many as 100 and the length of the ghaghra is 12 cm. above the ankle. The hemline is finished with a red got. Sometimes, there is also a red and fine yellow piping. The ghaghra is tied very low on the waist, exposing an expanse of midriff between the upper and lower garment.

The odhna is generally a chunri, although a *kasumba bhat* odhna is also worn, occasionally. There is no ornamentation except a single broad edging of gota at the hem.

For daily wear, ghaghra with different prints like *gunda bhat, methi bhat* or *bavli-ro-phetiya* are used. The skirt is known as a phetiya and is constructed like a pat ghaghra using 6 meters of fabric with no piping at the hem. It is gathered at the waist and a belt is attached to finish the edge.

The Rabari widow's attire is remarkably different in colour, styling and embellishment. She wears a tobacco-coloured kanchli with full sleeves, a high neck and longer length than the one used by married women. Widows in this community drape a plain tobacco-coloured odhna, known as a *lalar* odhna.

The women wear a phul as a neck ornament. It is tied with a tie-dyed red and yellow untwisted thread. They also wear chuda on their arms, which is put on at the time of marriage.

The men's upper garment is the white puthia, a unique feature of which is the occasional red-coloured piping at the seam, usually absent in the puthia of other communities. The puthia is tied on the right side. It is long, almost to mid-thigh length and has little or no flare. The Rabaris are one of the few communities where the men continue to use the traditional attire of the puthia and the dhoti even today. At the time of marriage a red

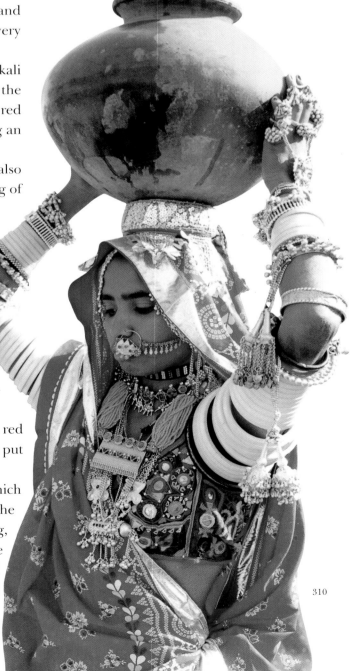

308. **Rabari men**. *Pali*. They wear the **puthia** as their upper garment. The **dhoti** is tied in the **tevata** style; and their turbans are red cotton **gol safa**.

309. **Rabari women**. *Sirohi*. They wear **kanchli** over **kalidar ghaghra**, block printed in the **katari chhint** design. A printed **chunri** is draped over the ensemble. The child is dressed in a printed **puthia**.

310. **Rabari woman**. *Nagaur*. A block printed **chunri** is draped over her embroidered **kanchli**. There is a **jhela** on her forehead, and she has a **nath** with a chain on her nose. Her neck is adorned with the **kanthi**, gold **muth** and a long **sanger**. Her upper arms are covered in **chuda**, ending with a **katariya** from which hang silver ornaments. Below the elbow can be seen the **duni**, **chamakchudi**, **muthia** and **hathphul**.

310

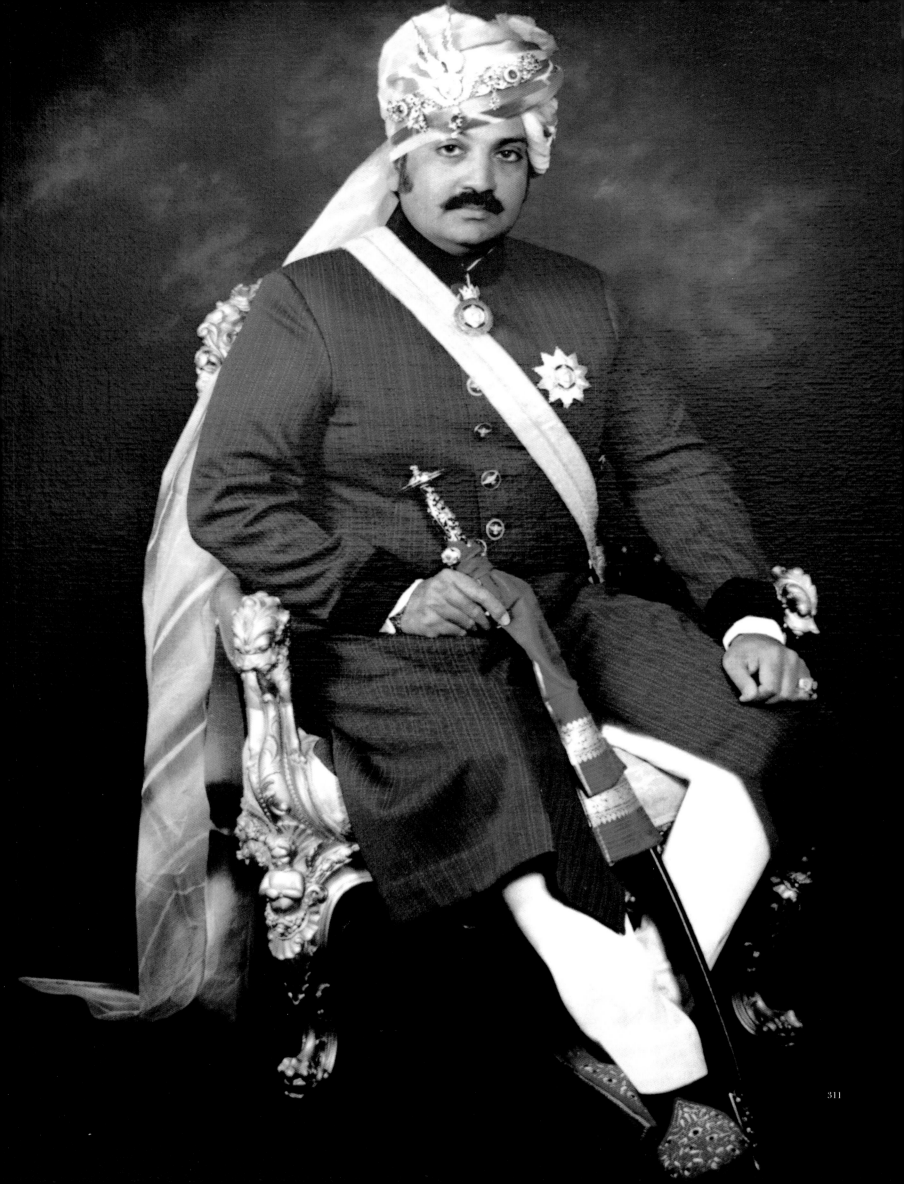

311

puthia decorated with gota is used. The nature of their occupation dictates that the men s clothing is both minimal and functional.

The dhoti of the Rabari man is draped to mid-calf length. The dhoti fabric is reza and it is worn in the tevata style. In winter, a blanket is draped for warmth. Headgear is a yellow or white turban. On festive occasions, they wear red turbans embellished with gota work. Headgear is in the gol safa style. It is the older men who usually wear the white turbans. The more popular colour for the turban is the traditional red. The men wear the murki in their ears and also the jhela.

RAJPUT

The word Rajput is derived from the word Rajaputra meaning sons of the king. The Rajputs formed the warrior aristocracy of Rajasthan. As leaders of a primarily feudal society, they played the role of protectors. Affluent and powerful, they wear garments made of fine fabric, with elaborate designs and a high degree of ornamentation.

Unmarried Rajput girls usually wear an upper garment called puthia. It is made up of cotton fabric in colours of yellow, pink and white and may be either plain or printed. Young girls wear a loose pyjama called *suthanki*. This is in plain or printed cotton and the preferred colours are pink, red or yellow.

The upper garment of a married woman can be a kanchli, angia and kurti. These are usually made of satin or fine cotton in red, magenta, green or yellow. The kanchli is heavily ornamented with gota in floral designs. The kurti is a short sleeveless tunic with a deep neckline, which is worn over the kanchli and reaches a little below the waist. At the time of marriage, an angia is worn. The fabric and design of the angia is almost the same as for the kanchli. Widows and unmarried women of the Rajput community wear a *polka,* which is a half-sleeved bodice that ends at the waist. It has a full centre-front opening which is fastened with buttons. A Rajput widow s dress is a dull tobacco or faded black and is donned one year after the husband s death.

The Rajput woman s ghaghra is a voluminous gored skirt of fine satin, silk or organza. The extent of gold or silver embroidery on the ghaghra and its length are a measure of the wearer s affluence. Rajput women wear three styles of ghaghra -- Kalidar, *charpatti* and kalipatti. Ghaghras for daily wear are in plain bright colours of yellow, parrot green or magenta.

An odhna is worn after a girl attains the age of 10-12 years, or on special occasions and serves as a veil. The Rajput odhna is woven in brocade. It is worked in silk thread on a bright base, like pink or violet. The odhna is elegantly draped over the costume. It is first pleated and tucked into the left side of the ghaghra. The other end is then taken around the back to cover the head, drawn over the right shoulder and tucked in at the left breast. The edge is allowed to fall free and is called a *khulla-palla.* Each special occasion, festival and change in the season has a different odhna. The most common for daily wear is a *khamka bhat* odhna. It is red, with yellow dots and a dark palla. Other popular designs include the lotus flower or pomcha, chunri with dots forming floral patterns and the striped leheriya. A zari dupatta in bright pink organza is worn at the time of marriage. Rajput women also wear a white odhna, called thirma.

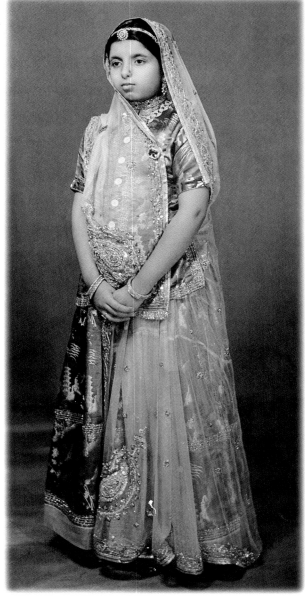

312

311. **Maharaja Gaj Singh of Jodhpur.** He wears a ***shervani***, Jodhpur breeches and a ***leheriya safa*** with embroidered ***jutis.*** His turban is ornamented with a ***sarpech*** and ***kilangi***. His sword denotes his royal lineage, the silk tie signifying that it is carried in peace.

312. **Portrait of a young princess.** *Bikaner (early 20ᵗʰ century).* She wears rich fabrics, heavily embroidered, in accordance with her aristocratic status. Her blouse is tailored in satin; the ***ghaghra***, also in satin ends in broad ***magazi***. The chiffon ***odhna*** is covered in ***zardozi*** work. The ***bor*** on her forehead and ***chudi*** on her wrists indicates that she is married.

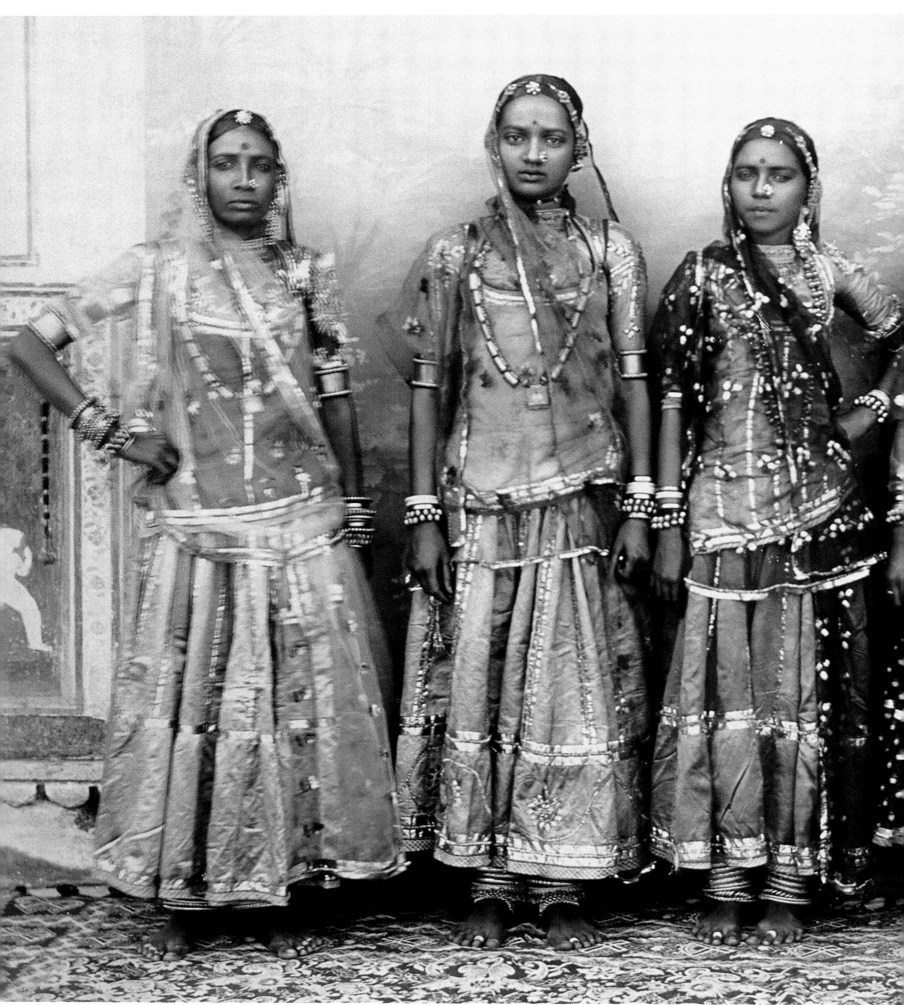

313

The jewellery worn by Rajput women is as exquisite as their garments. Rakhdi is a head ornament; *machi-suliya* is worn on the ears. Their necklaces are the tevata, the *pattia* and the aad.

The rakhdi, nath and the chuda are symbolic of a woman's married status. Ornaments for the feet include the jod, rimjhol and the *pagpan*.

The Rajput men, who were essentially warriors and farmers, always present a distinctly masculine appearance. The moustache is an important sign of masculinity and virility and is, therefore, maintained with a great deal of care. A special accessory called *jadia* or *moonchpatti* is used for its grooming. This is a strip of cloth that is tied to the moustache to ensure that it remains upright.

The Rajputs were artisocrats and their dress is quite elaborate Court-dress for men consists of a pagadi, angarkhi, churidar pyjama and a belt called the cummerbund. The turban, 7 meters long and 10 cm. wide, is wrapped snugly around the head. The colours of the headgear indicate the region and royal court to which the wearer is affiliated. Festivals and celebrations demand a particular style and shade of turban. The angarkhi is a long upper garment, worn over a sleeveless close fitting vest. It has an asymmetrical front with a yoke and is open, down its length at the centre-front and is fastened with cloth ties at the shoulder and at the centre-front waist. Other upper garments worn by royalty include the jama and the shervani. Lower garments include the salvar, a pair of shaped-trousers and the churidar-pyjama, which is a fitted pair of trousers. There are also the Jodhpurs, riding breeches familiar to equestrians the world over, which are very popular with the Rajputs. The dhoti is also worn, though styles differ from region to region. The tevata style is most commonly worn in theThar desert region, while the other regions use the tilangi style.

An interesting variation used by some older men is a semi-structured dhoti in which both the edges are stitched together. The dhoti is knotted in the middle, then pleated at the front and tucked in at the waist. One end is inserted in the back, giving it an unusual semi-structured style. The Jodhpur-coat worn with Jodhpurs is a popular and typical combination worn by the Rajput men. The most common traditional dress nowadays is the shervani worn with the churidar-pyjama and the turban.

The footwear of both men and women are very similar. Called mojari or juti, it is made of leather with dense embroidery on the surface.

SINDHI-MUSALMAN

The Sindhi-Musalmans constitute a large segment of Rajasthan's Muslim community. They are chiefly cultivators and herdsmen and belong to the Sunni sect of Musalmans. They are an industrious people with a tall physique and come from a hardy stock.

The women of this community wear very different garments from others in the region. The ghaghra or lower garment is long, full and unstitched. The chola or upper garment is loose, with a high neckline and sleeves that cover most of the arm. The odhna is large and thick and is draped to conceal the body.

An unmarried girl wears a cotton-printed chola as her upper garment. It usually has a large floral pattern in blue, green and red. The upper garments have many variations. The first is long, like a man's kurta, with short sleeves, a front kurta placket and a shirt collar. The sides have slits from the waist to the knees, and there is piping on the edging, known as *haar*. The chola is 10 cm. above the knees, with plain elbow-length sleeves. It is edged with piping

313. (Previous page): **Dancing Girls**. *Jodhpur (19th century).* They are dressed in traditional ensemble of ***kurti-kanchli***, ***kalipatti ghaghra*** and ***odhna***. The dress is embellished with ***gota*** and the girls are adorned in jewellery. There is a profusion of leg ornaments.

314. **Sindhi Musalman women**. *Jaisalmer.* The women wear long ***bandhej chola*** as their upper garment. A semi-stitched length of fabric called ***pada*** is draped as a lower garment. The ***odhna***, is draped over the ensemble, and like the rest of the costume, is in thick cotton with red and black ***bandhej***.

315. **Sindhi Musalman Man**. *Jaisalmer.* His upper garment is a ***chola***, and he wears a skull cap, with a ***chadar*** or wrap. The block printed wrap is called a ***malir*** when it is coloured red, and used for a special occasion.

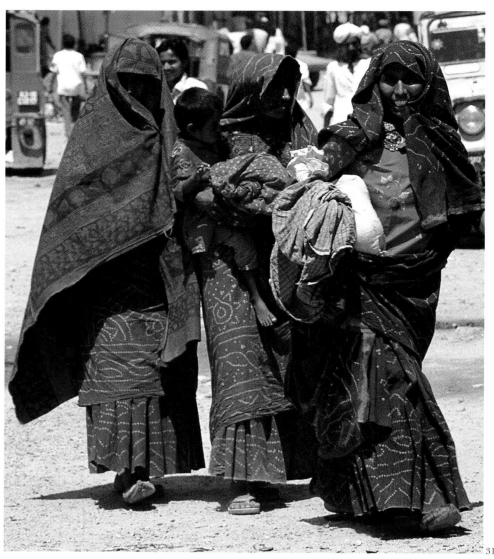

314

about 1 cm. wide and is decorated in the centre with a profusion of rickrack. The hems are finished with piping and the garment's construction is similar to a man's kurta. Sometimes, a puthia-like construction is seen. However, unlike the common puthia design, it has no overlap and a centre-front opening is present.

The lower garment is an ankle-length skirt known as the ligra. It is made of a red bandhej fabric with white dots and is similar in construction to the garment worn by married women. The odhna is known as a *baila* and is also in red bandhej worked on heavy material. The length is about 1 meter and the width is a little more than 50 cm. The odhna covers the head and the rest of the fabric falls down the wearer's back.

At the time of marriage, a kanchli of red bandhej with orange and white dots is preferred. This kanchli is embroidered with black and ornamented with gold and silver mukka and pakka work, inset with mirrors. It has long slits, which begin at the waist and these are finished with a topstitched bias in contrasting colours. The kanchli is ornamented with quilting, rickrack, gold thread, wool and beads. The women stitch their own ghaghra, known as pada. Two widths with a total of nine meters long, are joined together to make up the length of the dress, which touches the feet and is unfinished at the hemline. The top is handstitched and gathers are drawn to give it fullness at the waist. This is held by an ornamental tape, called *anghat*, which is made of braided cotton decorated at the ends with beautiful pompoms, multicoloured beads and mirrors.

The odhna changes colour with the seasons. In winter it is usually a black bandhej, while red bandhej marks the onset of summer. The fabric is called *pori* and the garment, a chunri.

Some other styles of odhna worn by Sindhi-Musalman women are *ghandbhat*, *gulbadan* and *minakari*. The odhna, which is 4 to 8 meters long, is made by joining together two widths of the fabric along the length, using a run and fell seam. This seam is ornamented and also ensures durability. For everyday wear, the young women prefer a black bandhej odhna with red and white dots, whereas the older women use a dull-red odhna with a chandan-haar design in the centre.

The Sindhi-Musalman widow is fully attired in black. The kanchli is black and sometimes has suf-style black embroidery. The ghaghra and odhna are similar in construction to those worn by married women, but these are also in black though sometimes, blue or dull maroon drapes may be used.

Some of the Musalman-women's ornaments are slightly different from the jewellery worn by other communities. Their ear-ornaments, like the kudka, the murki, jhalar, bala and panda are circular in shape and are worn in various portions of the ear, often at the same time. The traditional neck-ornament is the long chandanhaar, which falls below the bust. This is usually made in gold, silver and gold polish on silver. They also wear kanganpola, a circular hollow ring, worn above the elbow. It has a protruding clasp and a floral design near the opening.

The attire of the Sindhi-Musalman men shows a little variation from that of the other communities. The men wear a long chola as their upper garment. It sometimes, extends below the knees, much like a long shirt with full sleeves. In recent times, the young men have taken to wearing shirts and, on occasions, a coat, as well.

The commonly worn lower garment is the tehmat, which is of ankle-length, unlike the usual dhoti. The tehmat is usually white and is a long strip of fabric, about 4 meters in length. It is wrapped around the body with 2-3 knife pleats in the centre. The tehmat can, sometimes, be in an ajrak print. The tevata dhoti is also used as the lower garment. This could either be in plain white or in ajrak fabric. Depending on the region, a short piece of material, either plain white or an ajrak print, is carried on the shoulder and, sometimes, tied round the head.

Jewellery for the men consists of ear-rings and amulets, which are tied around the neck and arms with black-thread. Prayer is an essential daily ritual. While praying, the men wear a typical white skullcap, which is ornamented with gold and silver threads.

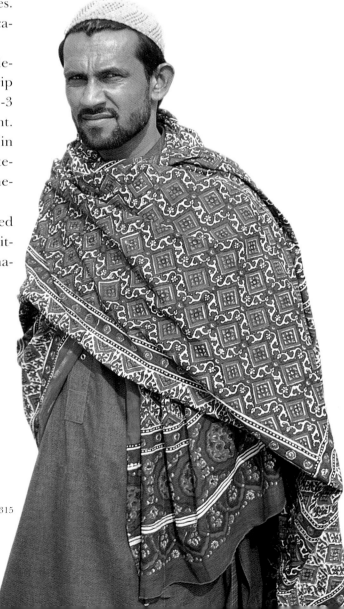

315

Garment Analysis

In this section, some stitched garments described in the text are analysed for their cut and construction. The selection includes contributions from people who are currently wearing the clothes, or have worn them in the recent past; as well as samples from the Mehrangarh Fort Museum, Jodhpur and Prachina Museum, Bikaner, which were examined for this study. Besides this, the help of tailors living in the villages was also enlisted and after discussions, special prototypes of individual pieces were developed.

All the garments presented here were analysed for pattern and construction details, on the basis of which final layouts were prepared. Unless otherwise specified, the patterns are drawn on a scale of 1:15. Seam allowances are not marked on the diagrams. A double-sided arrow denotes the straight grain on the fabric and shows the direction of the warp.

A wide range of stylistic variation exists within each category of garment. A few of these are represented as patterns, as for example in the jama - where the skirt can be gathered, flared or panelled. In such cases, one diagram is presented in this section, while the variations are mentioned in the text. Similarly where variations occur in the same garment used by different ethnic groups, in the kanchli for instance, the variations are highlighted only when there is a significant difference in cut or design.

Traditionally, these garments were sewn by hand in a basic running stitch. The seams used widely are the plain seam, flat fell seam and French seam.

Most of the garments have piping or facings sewn along their edges. These are always cut on the bias and vary in width from 1 cm. to 4cm. Patterns of these edgings are not included in the drawings.

To simplify understanding of the final garment, pattern pieces are laid out as they are stitched together. On smaller garments like the kanchli, numbered notches on the drawings indicate the points to be matched while joining the sections. Each garment is also presented as a flat scale drawing of the front and back view. The sketches are a two-dimensional view of a flat garment and the pattern placement provides an aerial perspective such that the garment is spread open and the inner surface is visible to the viewer.

All the pieces used in the garment are shown as separate pattern drawings.

Puthia

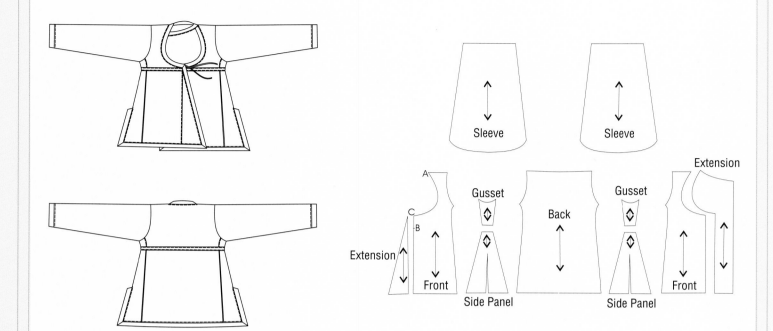

Childs' double-breasted garment with the upper flap crossing over the right side
and tied with a cord under the left armpit.

Scale 1:15

Puthia

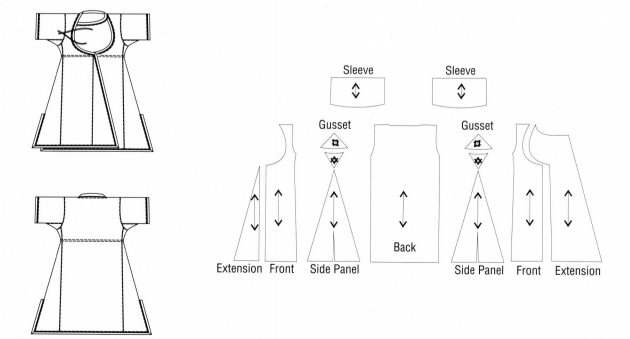

Double-breasted upper-garment worn by young girls.

Scale 1:20

Puthia

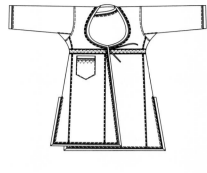

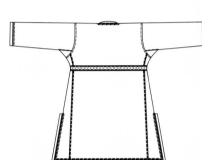

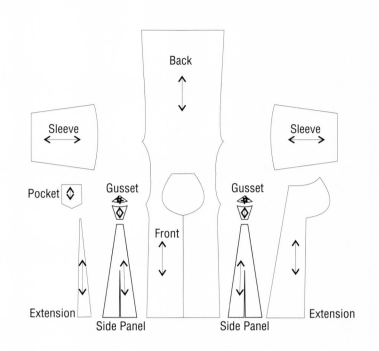

Double-breasted upper-garment for an adult woman.

Scale 1:20

Chola

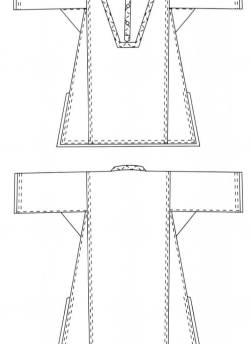

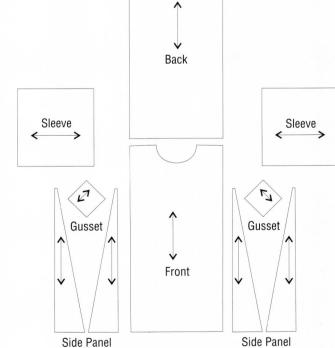

Upper-garment worn by young Muslim girls.

Scale 1:15

Choli

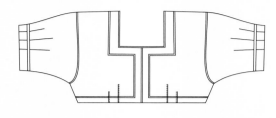

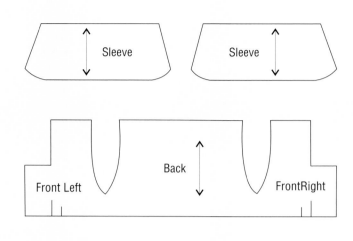

Upper-garment worn by married women.

Scale 1:10

Kanchli

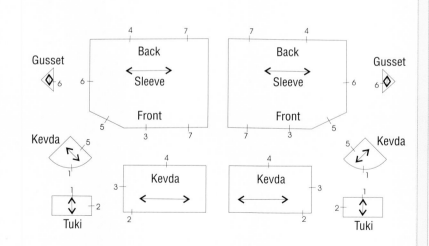

Upper-garment worn by married Maheshvari women

Scale 1:10

Kanchli

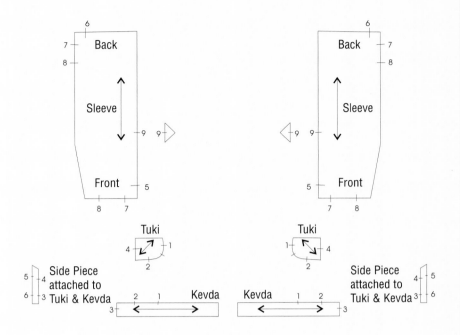

Upper-garment worn by married Rabari women.

Scale 1:10

Kanchli

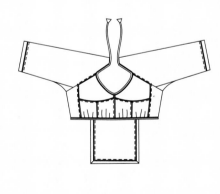

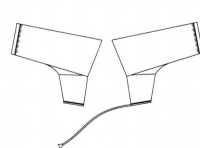

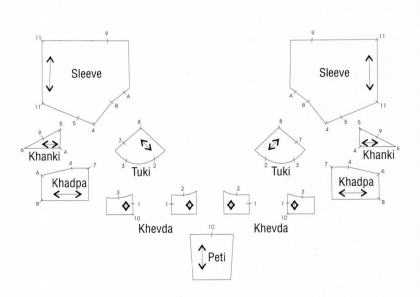

Upper-garment worn by married Bishnoi women.

Scale 1:15

Kanchli

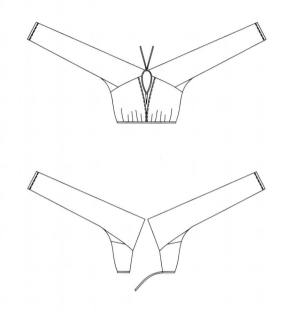

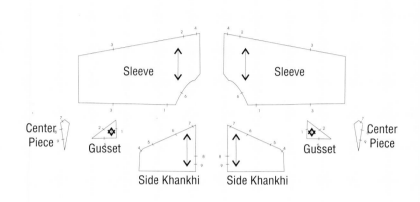

Upper-garment worn by widows of different communities, like Rajput.

Scale 1:20

Kanchli

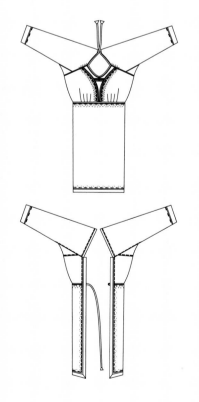

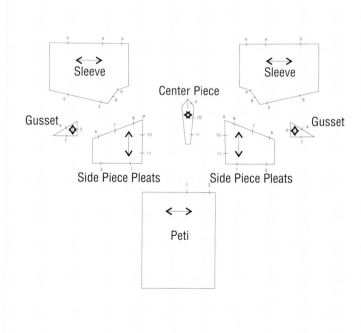

Upper-garment with long panel worn by married Jogi women.

Scale 1:20

Kurti

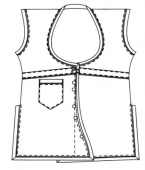

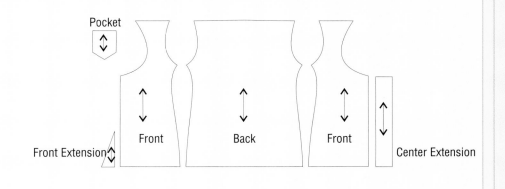

Pocket

Front Extension

Front

Back

Front

Center Extension

Sleeveless overgarment worn along with a kanchli by Bishnoi women.

Scale 1:15

Kurti

Pocket

Front

Back

Sleeveless overgarment worn along with a kanchli by Rajput women.

Scale 1:15

Chola

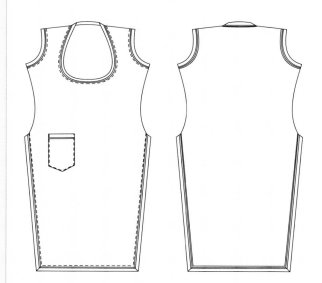
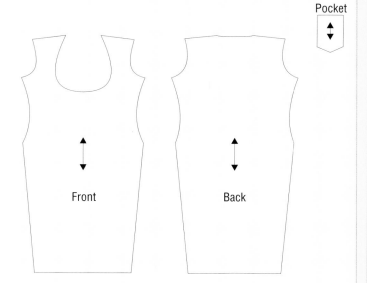

Pocket

Front

Back

Long, sleeveless overgarment worn along with a kanchli by Jogi women.

Scale 1:15

Kalidar Ghaghra

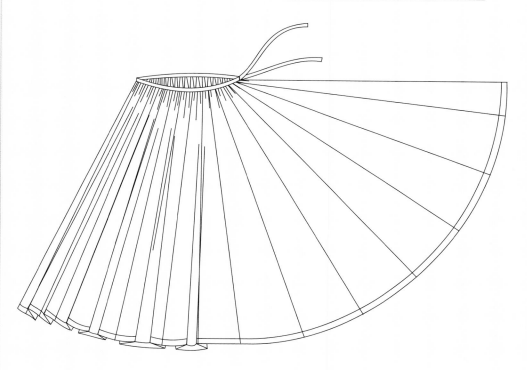

Kali

Panelled long skirt worn commonly by women in Rajasthan.

Scale 1:15

Kali Pat Ghaghra

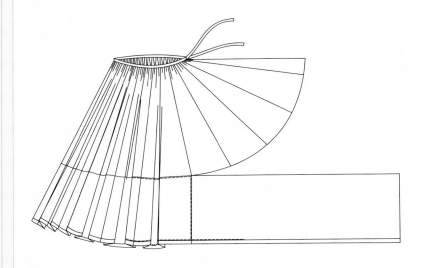

Kali

Lower Panel

Long skirt with panels on the upper half and straight panel on the lower half.

Scale 1:20

Bandi

Front

Sleeve

Back

Back

Back

Pocket

Sleeve

Close fitting, sleeveless inner garment, generally cut on bias and worn by men.

Scale 1:15

Angarkha

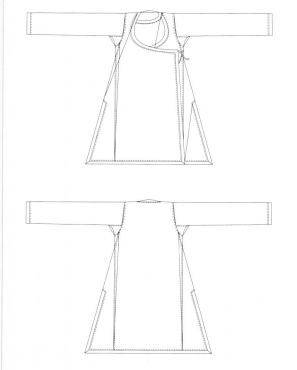

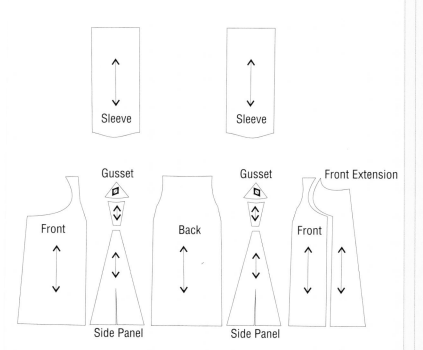

Double-breasted, long-sleeved, upper-garment worn by men.

Scale 1:20

Puthia

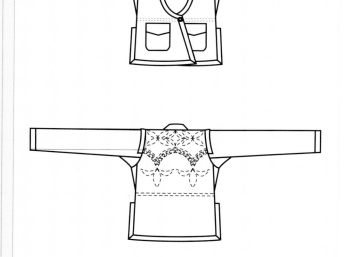

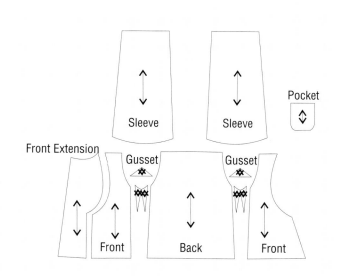

Long sleeved, double-breasted upper-garment worn by Gaduliya Lohar men.

Scale 1:15

Puthia

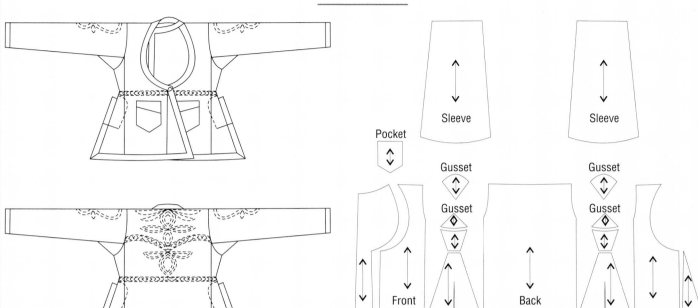

Long-sleeved double-breasted upper-garment worn by Gujar men.

Scale 1:15

Jodhpur Coat

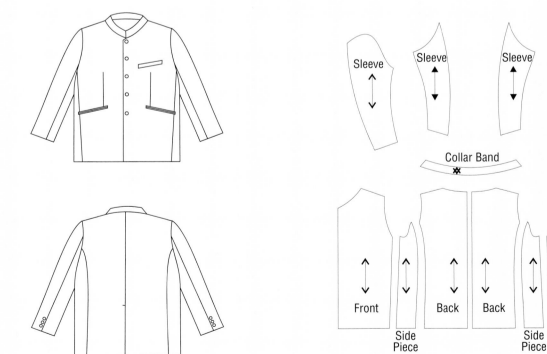

Fitted short upper-garment worn by men.

Scale 1:20

Jama

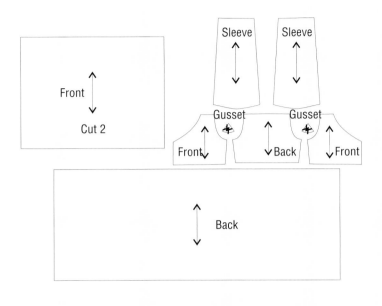

Double-breasted upper-garment with side fastening, fitted at the waist with a gathered skirt.

Scale 1:30

Choga

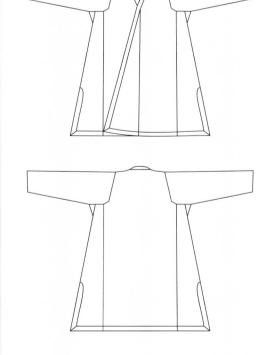

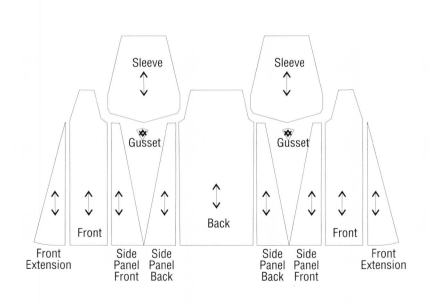

Long, flowing overgarment worn by men.

Scale 1:30

Shervani

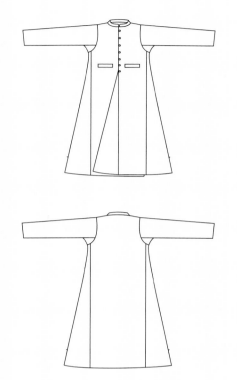

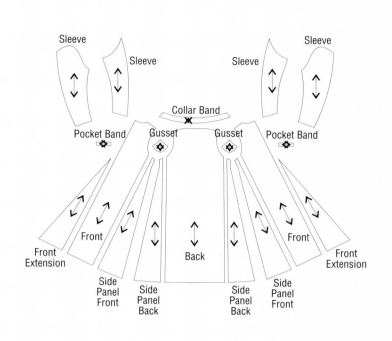

Sleeve

Sleeve

Sleeve

Sleeve

Collar Band

Pocket Band

Gusset

Gusset

Pocket Band

Front

Front

Front
Extension

Back

Front
Extension

Side
Panel
Front

Side
Panel
Back

Side
Panel
Back

Side
Panel
Front

Fitted upper-garment worn by men.

Scale 1:30

Jodhpur Breeches

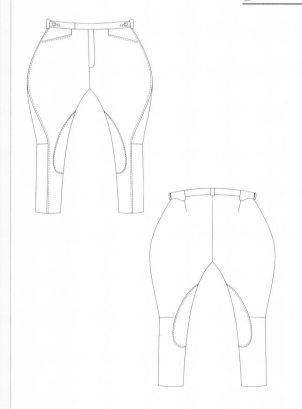

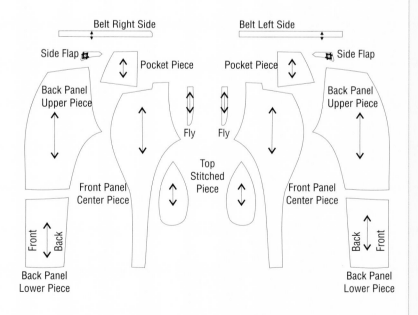

Belt Right Side

Belt Left Side

Side Flap

Pocket Piece

Pocket Piece

Side Flap

Back Panel
Upper Piece

Fly

Fly

Back Panel
Upper Piece

Front Panel
Center Piece

Top
Stitched
Piece

Front Panel
Center Piece

Front

Back

Back

Front

Back Panel
Lower Piece

Back Panel
Lower Piece

Stitched lower-garment used as riding breeches.

Scale 1:20

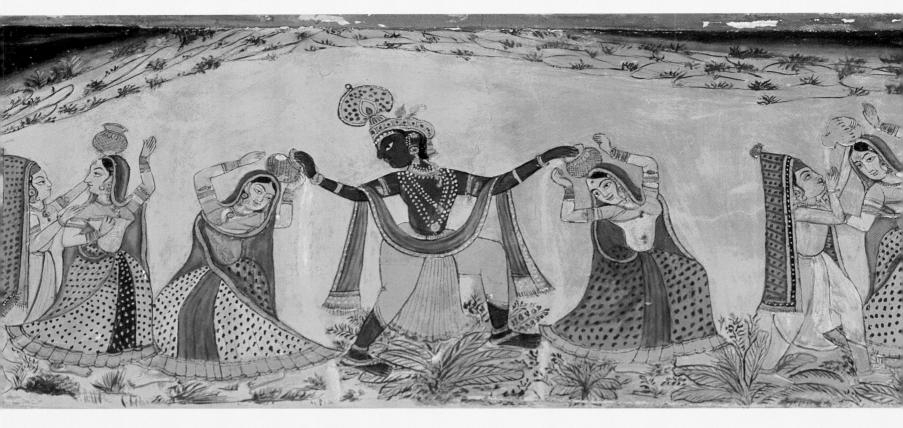

ℊlossary & Index

GLOSSARY

ACHKAN: man's long fitted, full-sleeved tunic, usually with a high round neck and buttoned down the front

ADHIVASA: unstitched shawl-like over-garment draped on the upper body

AJRAK: block printing technique, characterized by the use of indigo, with geometric patterns, usually stamped on both sides

AMBARA: woman's lower garment

AMSUKA: woman's lower garment

ANAT: circular gold ornament, worn on the upper arm

ANGA: any part of the human body; also upper body garment worn by both men and women

ANGARKHA: long-sleeved, full skirted upper garment of varying length generally open at the chest and tied on the front with an inner flap or parda, worn mostly by men

ANGARKHI: shorter version of the angarkha; in some regions referring to the same garment

ANGAVASTRA: unstitched garment draped over the shoulders and thrown across the chest

ANGHAT: ornamental tape, used as a tie cord.

ANGI: tunic, worn on the upper body

ANGIA: short, close-fitting upper garment with elbow-length sleeves

ANGO: calf-length tunic

ANGOCHA: short-length of cloth used as a stole by men

ANGUL: traditional measuring unit of one finger length

ANGUSHTHA: circular metal rings worn on the feet

ANGUTHA: thumb

ANGUTHIA: metal toe-rings worn by women

ANTARIYA: (archaic) type of loin-cloth worn by both men and women

ARI: small hook, like a cobbler's awl, used to create chain-stitch patterns in embroidery

ARSI: large silver thumb ring set with a mirror

ASSIKALI: common term for lower garment constructed from eighty triangular cloth panels

ATAMSUKH: loose garment worn over the shoulders while walking, also often draped as a shawl when seated

ATH: the number eight

ATHMASIYA: width measure for gota or metallic tape appliqued on garments

AVAGUNTHANA: woman's veil or scarf

AVLA: metal toe-ring

AZRAK: special blue dye used in ajrak printing

BACHKANI: odhna worn by young girls

BADI: traditional measurement of a two-hand span or baint; two badi is taken as the circumference of the chest

BADLA: flat gold or silver wire with a thread base used for embroidery.

BAGA: upper garment with tight bodice, high waist and flared skirt similar to the jama

BAGALBAND: short tunic or jacket worn close to the body and fastened under the armpits (see also jama)

BAGATRI: see jama

BAINT: traditional measurement of one hand span, from the tip of the thumb and the tip of the little finger

BAJUBAND: armlet of silver or gold with interlocking bands, sometimes, studded with precious stones

BALA: gold or silver hoop ear-rings

BANDGALA: man's formal long coat with Chinese collar and front-opening

BANDHANARI: women who tie designs during the tie-and-dye process

BANDHANI: technique of resist-dyeing practised extensively in Rajasthan

BANDHEJ: design produced on fabric using the bandhani technique, also name for the technique

BANDI: man's short upper-garment made of very soft cotton voile

BANDIA: upper-garment worn by unmarried women

BANGRI: bangle, often with floral engraving, worn on the forearm

BATTI: colour cake used in printing.

BEDLA: small curved wire ornament

with heart-shaped ends, worn on the upper ear

BEDOLA: semicircular wristband made from silver

BEENTI: vernacular term for ring

BEGAR: alum mixed in gum-paste, used for printing

BHAIRNIVASINI: skirt

BHANVARIA: nose-ring

BHORIYA: silver bracelets.

BICHIYA: *also bichudi;* metal toe-rings worn by women as a symbol of marriage

BIDHAN: wheat flour thickener for printing paste

BIDI: finger rings

BODAL: fine mica dust or cheap granulated metal powder used in tinsel printing

BOKANI: embroidered length of fabric worn as a sash or headband by the bridegroom during the wedding ceremony

BOR: spherical metal ornament worn by women in the centre of the forehead as symbol of marriage

BORLA: head-ornament, similar to bor

BULI: nose-ring worn on the septum

CHADAR: blanket or shawl

CHADE: foot-ornament

CHAKDAR: garment similar in style to the jama, with an asymmetrical hemline

CHAMKI: tinsel-printing

CHANDANHAAR: long, elaborate necklace with large central pendant

CHANDATAKA: type of petticoat

CHAPADI: ingredient in the preparation of colour cakes

CHAPAI-LIKHAI: process involving wooden blocks and fugitive dyes for tie-and-dye printing

CHAPKAN: man's long-sleeved upper garment fitted at the waist

CHARKHA: spinning wheel

CHARPATTI: four-panelled ghaghra

CHAUKI: Marvari term for medallion, usually silver and sometimes gold, worn by both men and women of all ages

CHHANO: type of ghaghra

CHHINT: literally, 'speckled', denoting type of print popular with women,especially for ghaghras

CHIKA: metal ornament for the upper-foot

CHIPRI: bamboo net used in block-printing

CHOGA: man's upper-garment similar to an open coat usually long-sleeved, used for ceremonial wear

CHOLA: man's upper-garment with high neckline and full sleeves

CHOLI: woman's tight-fitting blouse (*see also kanchli*)

CHOLKI: upper-garment for unmarried woman

CHOTI: term for lock of hair, in communities where long hair is braided and bound

CHUA: circumference of four fingers of the right hand, traditionally used to measure fabric

CHUD: *variation of chuda;* single large bangle, generally in silver

CHUDA: symbol of marriage, number of bangles of varying size worn by the woman on the day of her marriage and not removed until she dies or is widowed

CHUDI: bangle

CHUNA: lime paste

CHUNRI: red bridal odhna, either dyed or printed, usually heavily embellished

CHURIDAR: tight-fitting trousers with bangle-like folds below the knee worn by both men and women

CHUTILA: silk braid often plaited into hair

COWRIE: small shell of marine gastropod, historically used as low-value currency

DABKA: tightly coiled fine metallic wire, used for embroidery

DABU: method of resist-printing; also mud used in resist-printing

DAMINI: embroidered draped garment; also head- ornament

DANKA: embroidery employing different kinds of stitches around a small metal square

DATTA: wooden block carved in bold relief

DHABLA: unstitched length of narrow width fabric, worn by women of the Jat, Bishnoi, Gujar and Kumhar communities

DHAUTA: dhoti

DHIMMNA: ear-ornament

DHOLA-MARU: legendary lovers from Rajasthani folklore

DHOTAN: man's lower garment

DHOTI: man's draped lower garment

DHUKDHUKI: necklace with elaborate central pendant set with gemstones

DODIA: circular wristband

DOLANGI: style of tying dhoti

DOLIDAR: type of resist used in block-printing

DORA: head-ornament

DORI: thread

DUNI: bracelet made of two bands, joined on the inside

DUPATTA: type of odhna

DURBAR: royal court

DURRIES: woven floor covering, made and used extensively in Rajasthan

EKI: odd number

FARJI: jacket, sleeveless or with short-sleeves, worn as an over-garment

FATU: lightly quilted sleeveless jacket resembling a vest

FETO: turban

FITKARI: alum, used as a mordant in printing

GACH: alum resist or mordant, used in printing

GADDI: coarse woollen cloth

GAJ: equivalent of unit in formal Indian measurement system of approximately 90 cm

GAJJALU: cast-brass ankle bells on a leather strip, worn by male dancers

GAJRA: flexible ornament worn on the forearm, made of small rectangular plates joined together

GALAPATTI: neck-ornament

GAUND: local word for glue

GAWARBALI DABU: sticky substance produced from plant sources used for resist-printing

GER: group dance using long wooden sticks as props

GERU: local term for red fugitive dye

GHAGHARKI: lower garment or skirt

GHAGHRA: generic term for skirt, usually gathered and widely flared, fastened with a drawstring that passes through a short, narrow belt at the waist

GHAGRI: short-gathered skirt with a drawstring

GHER: volume and fullness of the ghaghra

GHERDAR: flare and volume mostly of the ghaghra, or, in some cases, the jama

GHUGHRA: small bells which are used on clothes and in jewellery

GHUGHRAVAAT: elaborate ghaghra decorated with small bells at the hem

GHUMERDAR: expression used to describe the beauty of a ghaghra as it flows around a woman's body

GHUNDI: head-ornament (*see bor*)

GHUNGHRU: small musical bells worn in foot-ornaments

GHUTANNA: man's short, tight pyjama, which ends just below the knees; garment related to the pyjama

GIJAI: circular thin stiff wire used for embroidery

GIRI: traditional measure corresponding to three fingers placed together

GOKHRU: silver or gold bangle worn on the forearm

GOL: round shape

GOP: neck-ornament, shaped like a circular torque

GOTA: narrow ribbon or strip woven with gold or silver thread used for appliqué work

GUGRA: ornament worn on the arm

GULABAND: see galapatti

GUNA: thin piping on the ghaghra

GUNI: lac-stick used for bangles

HAAR: long necklace or land; also edging on a garment

HAATH: traditional fabric measure corresponding to length of the arm from tip of middle finger to the elbow joint

HAATHE: circular ring foot ornament

HALDI: turmeric

HAMEL: long necklace v tangular piece made of solid silver

HANS: origin of the word hansli, meaning neck

HANSLI: rigid circular torque for neck

HARA: green

HARDA: chemical agent used in dyeing

HATTA: tool used for making lac-bangles

HIRMAIN: solid wire worn on one foot

HIRMANI: circular ring worn on the ankles

IZAR: type of pyjama

JABIA: head-ornament worn as an attachment to the bor

JADAU: bell-shaped ear-ornament also known as the jhumka, made of gold and studded with precious stones

JAJAM: floor covering

JAMA: outer upper-garment for men with tight-fitting bodice and flared skirt, with tie-cords under either armpit; popular in the Mughal and Rajputs courts

JAMDANI: weaving technique traditionally practised in Dhaka; used to produce fine cotton muslin with a floral pattern.

JATA: hair of lord Shiva, a Hindu deity; also a generic term for long unkempt hair

JHALAR: large and elaborate earrings

JHANJHAR: foot-ornament

JHELA: chain, which supports an ear-ornament.

JHULKI: long-sleeved jacket worn by Garasia women

JHUMKA: bell-shaped ear-ornaments

JHUMRI: bell-shaped ear-ornaments

JHUTNA: variation of *bedla*; an ear-ornament.

JOD: three ornaments worn in conjunction with each other, around the ankle

JUBI: *see bedla*

JUGAVALI: pendant on a necklace

JUGNI: elaborate pendant for a necklace

JUTI: leather footwear worn by men and women

KABJA: loose type of upper-garment

KACCA: dye that is not permanent

KACCHO: embroidery using an interlacing stitch

KADA; KADI: ring in solid metal worn on the wrist or ankle; it is wider at one end

KALA: black

KALABATTU: silver gilt-thread used in embroidery

KALGI: head-ornament worn on turban, made of feather plumes and precious stones

KALI: gored panel; a triangular piece of cloth used in making garments (like a godet)

KALIDAR: several gored pieces or kalis, type of skirt

KALIPATTI: type of ghaghra

KAMARI: upper-garment which reaches till the waist, like a short Angarkhi

KAMBAL: blanket, generally in wool

KAMDANI: light, delicate zardozi work embroidery

KAMIZ: the khadi kamiz resembling a man's shirt in design

KANAKTI: waist-ornament

KANCHLA: upper-garment worn by woman

KANCHLI: stitched upper-garment for women with short sleeves

KANCUKA/ KANCULIKA: upper-garment for women most often mentioned in Sanskrit literature

KANDORA: heavy waistband worn by women

KANGANPOLA: circular hollow ring worn above the elbow by women

KANTA: nose-ornament

KANTH: neck

KANTHI: neck-ornament

KAPADA: upper-garment

KARCHOB: embroidery frame

KARCHOBI: dense metal embroidery done on material using a frame

KARIYANU: printing in which a resist-aste of lime is applied to fabric

KARNPHUL: ear-ornament, shaped lik a flower

KASA: tie cords or strings used for tightening

KASAB: gold or silver wire

KASAKADA: plain bangles made of brass or lacquer, worn on the wrist

KASHIDA: embroidery

KASLA: coconut shell bangles

KATARIYA: bangle

KAVALJOLIYA: white sari worn by the bride during a Mahesvari wedding

KAYABANDHAN: girdle

KEBAROO: type of hair style

KESARIYA: saffron

KESULA: flowers which produce natural dyes

KHAADI: hand-spun, hand-woven cotton fabric

KHADDI: pit loom for weaving fabrics

KHADI: tinsel print

KHAMBHIRI: embroidery stitch

KHANCH: bangles worn on the upper-arm

KHANKHI: gusset

KHAR: river residue used to make emulsion for desizing fabric

KHARAK: type of embroidery

KHAT: checks, produced while weaving the Kota doria sari

KHILAT: ceremonial robes of honour

KHIRKIYA: type of draped headgear, usually in saffron or red

KINARI: edging, often given to ghaghra as well as other garments

KORPATTI: *see danka*

KOTA DORIA: woven textile produced in the Indian city of Kota

KRISHNALEELA: stories of Lord Krishna, a Hindu deity

KUDKA: brass ear-ring made of two semi-spherical pieces

KUNDAL: large circular rings, in which the main surface is set with precious stones and the reverse is usually enamelled

KUNDAN: technique of setting gemstones in gold

KUPLI: small boxes used for storing Kohl

KUR: traditional measure corresponding to space between the thumb and forefinger

KURPASA: *see kanchli*

KURPASAKA: *see kanchli*

KURTA: knee-length loose fitting upper garment worn by men and women

KURTI: woman's short upper-garment worn over the kanchli

LAC: resinous substance secreted on trees by indigenous scale insect (*Tachardia lacca*), used in jewellery-making

LANKA: waist

LAPPE: *see gota work*

LARA HAAR: pearl necklace with an odd number of strings

LASA: cords in red and black tied on to braided hair

LATHAN: ear-ornaments shaped like a bunch of grapes

LATTO: type of hairstyle

LAUNG: ornamental nose pin

LEHANGA;GHAGHRA: stitched lower-garment for women

LEHAR: ocean wave

LEHERIYA: process of tying and dyeing to produce a wave- like design on fabrics

LIGRA: ankle-length skirt worn by women

LIKHAI: printing using fugitive design - serves as reference for tying motifs

LIMBORI: necklace worn exclusively by the Bhil women and also handcrafted by them

LUDI: embroidered woollen shawl

LUGDA: draped garment

LUGRI: draped garment

LUM: long ornamented string with mirrors, beads, pom-poms

LUNGI: lower draped garment for men, worn like a sarong and knotted at the waist

MAANG: parting in the hair

MADALIYA: armlet

MAGAZI: piping

MANDANA: Rajasthani floor painting

MANDIL: headgear

MANGLI: semicircular ornament worn above the elbow

MASURIYA: woven fabric

MATHANIA: fine muslin, woven fabric made in Matahnia, near Jodhpur

MATHAPATTI: head-ornament

MAULI: sacred cotton thread, tie-dyed in red and white or sometimes, red and yellow

MEHENDI: coloured body ornamentation; applied by tracing patterns, mainly on the hands and feet, with a paste of dried henna leaves

MINA: stage in Ajrak printing; to produce jewellery

MINAKARI: polychrome enamel work

MINAVATAR: the fish: one of the ten incarnations of Lord Vishnu

MIRZAI: quilted jacket or coat, used as an upper-garment or over-garment

MITTI: mud

MOCHI: cobbler; also a kind of embroidery stitch

MOJARI: *same as pagarkhi;* traditional hand-made leather shoes worn by both men and women of all communities in Rajasthan

MORO: head-ornament

MOTHRA: checkered tie and dye design formed when two diagonal stripes intersect

MOTI: beads

MUDRIKA: finger-ring

MUKHAPATA: draped garment; a kind of odhna

MUKKA; MUKKE: embroidery style

MULMUL: fine cotton-muslin

MURKI: ear-ornament

MUSTADI: court-scribes

MUTH: traditional fabric measure corresponding to the circumference of a closed fist including the thumb; equivalent to half a baint

MUTHIA: bangles worn on the lower-arm

NANG: silver ring worn on ankle

NASBI: ornament worn on central portion of ear

NASHPHAL: yellow dye made from pomegranate rind and turmeric

NATH; NATHDI; NATHNI : terms for nose-ring

NATHANI UTARNA: removing the nose-ring; a nose-ring is the symbol of a woman's honour and the term as such indicates dishonour for a woman

NEEL: blue fugitive colour

NEELGAR: dyers who specialize in indigo-dyeing

NEEM: tree (*azadiracta indica*)

NEVARI: wrist-ornament resembling the kadi in design but with patterns engraved on the broader end

NIMBOLI: bitter sweet fruit of the neem tree

NIRANGIKA: *see odhna*

NIRINGI: *see odhna*

NIVI: loin-cloth

NOGRI: thin bangles worn by women

NOLIA: brass nail worn over the finger for tying designs

NUA: *see nolia*

ODHNA; ODHNI: woman's veil, usually worn in conjunction with a ghaghra; draped garment which covers the head

OGANIYA: ear-ornaments *(see bedla)*

PAANCHLADA: necklace made of five strings

PACHERI: shawl

PADA GHAGHRA: type of gathered skirt

PAGADI; PAG: turban or headgear; in Rajasthan, pag is another name for headgear

PAGARKHI: *same as mojari;* traditional hand-made leather shoes worn by both men and women of all communities in Rajasthan

PAHUNCI: bracelet worn by women

PAIJEB: anklet worn on the lowest part of the leg

PAKKA: style of embroidery.

PAKKO: style of embroidery

PALLA: one fabric width

PALLAV: width of the dhoti fabric, which is passed between the legs to be tucked in at the centre back

PANCHRANGA: five-coloured

PARDA: veil

PASSAM: untwisted silk-thread used for embroidery

PAT: traditional measure, taken as width of the fabric; the equivalent of three baint.

PATKA: waistband made of a narrow long piece of cloth, the ends of which remain hanging

PATRI: armlet

PATRI KA HAAR: necklace with long metal chains connected to a central pendant

PATRIYA: anklet

PATTI: narrow strip of fabric

PATTU: traditional shawl from western Rajasthan made from sheep wool

PAYAL: ankle-ornament

PECH: screw

PEJANIA: ornament worn on the hands and anklets

PETI: small rectangular piece of fabric stitched at the centre of the hem of the kanchli to cover the midriff; resultant garment is a petivali kanchli

PHAGUNIYA: type of draped tie-dye odhna in white and red, popular in spring

PHAMRI; PHAVRI: special red chunri with silver or gold tinsel printing; an essential part of the Rajasthani bride's trousseau

PHERA: circles around the sacred fire in the traditional Hindu wedding

PHERVAJ: edging in red fabric attached under the ghaghra

PHETIYA: lower garment of ankle-length, and hand stitched at the waist

PHUL JHUMKA BIND SUDA: head and ear-ornament

PHULKARI: traditional embroidery from Punjab, flower work done with floss silk on coarse cotton cloth in darning stitch

PICHODI: same as reza

PICHVAI: painted or embroidered textile also used as altar cloth for the Hindu deity, Krishna

PILA: yellow odhna with red central motif and borders

PILIYA: odhna worn by mother of a newborn

PINGA: stitched lower-garment

POMCHA: lotus flower; also an odhna created from the bandhej technique

POONCH: long trailing end of turban

POONCHI: hand-ornaments for women

POSHAK: entire ensemble of a woman consisting of kurti, kanchli, ghaghra and odhna

POTARIO: draped lower-garment used by men

POTHDI: stitched lower-garment, like shorts, used by young girls

POTIA: headgear for men

POTNA: process of smearing pomegranate dye on the fabric

PUT: traditional measurement of three haath; also equals the height of the individual

PUTHIA: double-breasted, waist-length upper-garment, worn by both men and women

PUTIA: embroidered floral design on an angarkhi.

PYJAMA: stitched lower-garment resembling trousers, worn by both men and women

RAJAPUTRA: son of a king

RAKHDI: head-ornament

RAKSHA: protection

RALLI: quilted in white material, the top layer is of new fabric and embroidered with a colourful running stitch

RAMNAMI: amulet with symbol of Ramdeoji, a local deity, worn around the neck

RANGREZ: dyer

RASAM PAGRI: ritual of the turban

REKH: very fine piping used as edgings of garments

RETA: type of shawl, usually red in colour

REZA: white hand-spun, hand-woven, thick cloth with a rough texture

ROGAN: viscous paste used for printing

RUMAL: large square handkerchief carried on the shoulder and also used as a turban

RUPAYA: term for the Indian currency: Rupee

SAADI: long rectangular fabric draped like a skirt

SAATLADA: long necklace of seven strings

SADA: type of draped garment worn as a skirt

SADRI: sleeveless jacket

SAFA: type of headgear or turban

SAFEDA: fine white powder

SAJ: printing trays used for block-printing

SALMA: coiled, springy metallic wire used in Zardozi embroidery

SALVAR: stitched baggy full-length lower-garment, similar to the pyjama, tapered at the ankle and worn by both men and women

SANCHA: special brass block with a hollow mould used for tinsel printing

SANGER: long necklace that falls below the bust, with a large central pendant

SANKEL: ornament worn both on ankle and waist

SANKLI: ornament worn around the head to frame the face

SAR: head

SARDAR: leader of a tribe or community

SARESH: resin used for making a printing paste

SARPATTI: gold headband worn by men and, sometimes, by women as well

SARPECH: turban-ornament

SATULA: stitched lower-garment

SELDI: hair-ornament braided in the hair

SEVA: stitch given on a skirt to allow alteration in length

SHAHI: royal

SHAMLA: headgear

SHER-NAKH-JANTR: silver armlets-shaped like tiger claws

SHERVANI: coat-like garment of knee-length, with front-openings and button fastenings

SHISHPHUL: head-ornament shaped like a flower

SIDDHA PYJAMA: garment which is straight in its definition with no moulding to the body

SINDHI TAROPA: embroidery worked in interlacing stitch

SIRMAANG: ornament worn in the parting of the hair

SUF: kind of embroidery, done in plied cotton thread or, in some cases, with silk floss, worked from the reverse side of the fabric in surface satin stitch

SUNAR: goldsmith

SURYA: the Sun God in Hindu mythology

SUTHAN: stitched lower-garment

SUTHANKI: lower garment similar to the pyjama, made of a white and blue checked fabric; sometimes satin in plain colours is also used

SVASTHAN: stitched lower-garment

SYAHI: viscous paste of gum and iron filings used for printing

TABIZ: pendant worn by women and children, believed to ward off the evil eye

TADDE: circular ornament made of solid gold cylinders; the cylinders are wrapped in a circular form and designs are made on the resulting armlet

TAGLI: neck-ornament

TAKAUCHIYA: court-dress characterized by flare in the garment; *(See Chakdar Jama)*

TALIA: long drawstring for ghaghra, the ends ornamented with mirrors, beads, pompons, etc.

TAMDA: copper vessel used for dyeing alizarin

TANKA: foot-ornament

TANTU; TANTIK: thread; embroidery style worked by counting the warp and weft threads

TAZIM; TAZIMI: ornaments bestowed on nobles by royalty

TEGAD: neck-ornament

TEGDI: neck-ornament

TEHMAT: lower-garment of ankle-length, usually white or in ajrak fabric about 4 meters in length, wrapped around the body with 2-3 knife pleats in the centre

TELKHAR: emulsion used for pre-treatment of cotton for printing or dyeing

TEVATA: type of draped lower-garment for men (dhoti); also neck-ornament

THALA: chauki, phul, etc., meaning a small temple; used as a neck-ornament

THALPHOSH: cover for a plate; generally dowry cloth

THEVA: craft of delicate filigree work on coloured stones used for making jewellery

THIRMA: white draped garment covering the ensemble of a woman

TIDDA: ornament worn on the upper arm

TIKA: head-ornament; suspended from the head on centre of forehead

TILANGI: style of draping a dhoti

TILLA: simple, flat metal wire, used for embroidery

TIMANIA: necklace studded with three stones

TIPAI: dabbing of certain areas after tying with colour.

TITAH: head-ornament worn by royal or noble women; the name for a sarpech worn by women

TOLDA: *see tika*

TORAN: pennant doorway hangings

TRITIK: stitched tie dye technique

TUKDI: traditional measurement of five haath

TUKDI: traditional measurement of five haath

TUKI: pattern piece of kanchli; triangular section of cloth at breast

TUL: thick hand woven fabric in red colour

TURRA: styled length of fabric that fans out at the top of a turban

UPAVASA: over-garment

USNISA: draped fabric around the shoulders or on the head

UTAR-CHADAV: literally, an increase and decrease in shape, refers to shape of a chuda

UTTARIYA: unstitched upper-garment made of very fine material and worn like a veil; also referred to as the odhni

VAHANA: vehicle, usually associated with a Hindu deity

VAR: traditional measurement; sum of two haath; also calculated directly from the body, as distance of from middle finger to the front neck bone when the arm is outstretched

VASA: collective name for cloth and clothing of the Vedic period

WARAK: very thin metal foil

YAVANIKA: see odhna

ZAR: Persian word for gold

ZARDOZI: silver and gold metal embroidery

ZENANA: women's section of a palace

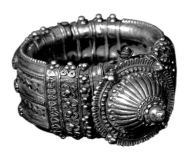

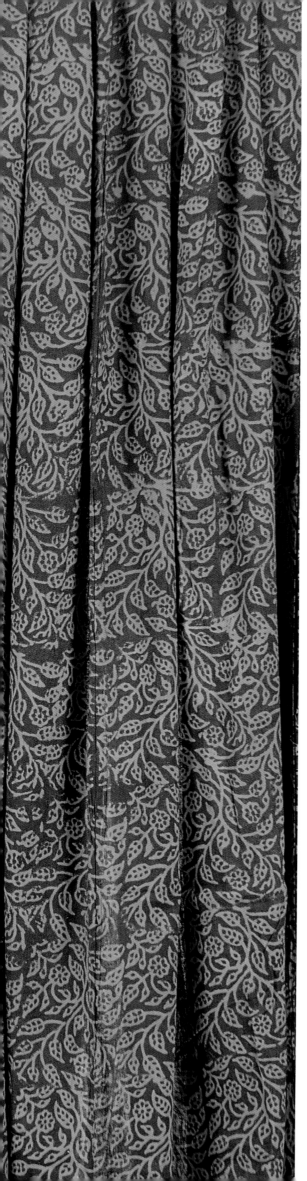

ℬibliography

Agrawala, V.S. *The Heritage of Indian Art.* Ministry of Information and Broadcasting, New Delhi: 1964

--------"References to Textiles in Bana's Harshacharita", *Journal of Indian Textile History*. Calico Museum. Ahmedabad: 1959

Ahuja, D.R. *Folklore of Rajasthan.* National Book Trust, New Delhi: 1980

Alkazi, R. *Ancient Indian Costume.* Art Heritage, New Delhi: 1983

Askari, Nasreen, and Crill, Rosemary. *Colours of the Indus, Costume and Textiles of Pakistan,* Exhibition Catalogue. Victoria and Albert Museum, London: 1997

Bhandari, Vandana. *Women's Costume in Rajasthan.* Unpublished PhD. thesis. University of Delhi: 1995

-------- **and Kashyap, Ruby.** *Celebrating Dreams - Weddings in India.* Prakash Books and NIFT Publication Division. New Delhi: 1999

Bhowmick, P.M., et al. *Traditional Garments of Udaipur, Banswara and Dungarpur.* National Institute of Design. Ahmedabad: 1992

Bhushan, Jamila Brij. *Indian Jewellery, Ornaments and Decorative Designs.* D.B. Taraporevala and Sons Pvt. Ltd. Bombay: 1964

--------*Masterpieces of Indian Jewellery.* D. B. Taraporevala and Sons Pvt. Ltd.Bombay: 1983

--------*The Costume and Textiles of India.* D. B. Taraporevala and Sons Pvt. Ltd. Bombay: 1958

Bilgrami, Noorjehan. *Sindh jo Ajrak - Cloth from the banks of the River Indus.* White Orchid Books. Bangkok: 1998

Brunel, F. *Jewellery of India : Five Thousand Years of Tradition.* National Book Trust. New Delhi: 1972

Buhler, A., and Eberhard, F., et al. *Indian Tie-dyed Fabrics.* Calico Museum. Ahmedabad: 1980

Chandra, Moti. "Costumes and Textiles in the Sultanate Period". *Journal of Indian Textile History.* Vol. VI. Ahmedabad: 1961

--------*Costumes, Textiles, Cosmetics and Coiffure in Ancient and Mediaeval India.* Oriental Publishers. Delhi: 1973

--------*Pracheen Bhartiya Vesh Bhusha.* Bharti Bhandar. Allahabad: Sm. 2002

Chattopadhyaya, K. *Handicrafts of India.* Indian Council for Cultural Relations. New Delhi: 1975

Chaturvedi, T.N. (ed.), *Rajasthan Vaibhav.* Bhartiya Sanskriti Sanghrakshan and Sankradhan Parishad. New Delhi: 1983

Coomaraswamy, A.K. *Arts and Crafts of India and Ceylon.* T.N. Foulis. London: 1913

--------*Catalouge of the Indian Collection in the Museum of Fine Arts*: Harvard University Press, Boston: 1926

--------*Rajput Painting.* Oxford University Press. London: 1916

--------*India's Craft Tradition.* Munshiram Manoharlal. New Delhi: 1980

Crill, R. and Murphy, V. *Tie-dyed Textiles of India.* Mapin Publishing Pvt. Ltd. Ahmedabad: 1991

Dar, S. N. *Costume of India and Pakistan.* Munshiram Manoharlal. Bombay : 1969

Dhamija, J. (ed.), *Living traditions of India - Crafts of Gujarat.* Mapin International, Inc. New York : 1985

--------**and Jain, J.** *Handwoven Fabrics of India.* Mapin Publishing Pvt. Ltd. Ahmedabad: 1989

Dongerkery, K. *Jewellery and Personal Adornment in India.* Vikas Publications. Delhi: 1971

Doshi, S. *The Impulse to Adorn.* Marg Publications. Bombay: 1982

Elson, C.V. *Dowries from Kutch: A Womens' Folk Art Tradition in India.* Museum of Cultural History. Los Angeles: 1979

Fisher, N. (ed.), *Mud, Mirror and Thread: Folk traditions of Rural India.* Mapin Publishing Pvt. Ltd. Ahmedabad : 1993

Ghurye, G.S. *Indian Costume.* Popular Book Depot. Bombay: 1951

Gillow, J. and Barnard, N. *Traditional Textiles of India.* Thames and Hudson Ltd. London: 1991

-------- **and Sentance, Bryan.** *World Textiles - A Visual Guide to Traditional Techniques.* Thames and Hudson Ltd. London: 1999

Goswamy, B.N. *Indian Costumes in the Collection of the Calico Museum of Textiles.* Volume V. Historic Textiles of India Calico Museum of Textiles. Ahmedabad: 1993.

Gupta, C.S. (ed.), Census of India. 1961 *Village Survey Monograph.* Rajasthan, 1965

Gupta, Neerja, and Bhandari, Vandana. *Traditional Men's Costume of Some Castes in Beawar (Rajasthan).* Unpublished Masters thesis. Department of Textiles and Clothing, Lady Irwin College. New Delhi: 1992

Hendley, T.H. *Indian Jewellery.* Low Price Publications. Delhi: 1991

Irwin, John. Bibliography of Indian Textiles, Part 2 " Travellers Records,1300-1700", *Journal of* -------- *Indian Textile History,* Vol. II. Ahmedabad: 1956

-------- **and Hall, Margaret.** *Indian Embroideries.* Ahmedabad: 1973.

Indian Painted and Printed Fabrics. Ahmedabad: 1971

Israel, S. and Sinclair, T. *Insight Guides - Rajasthan.* APA Publications. Singapore: 1989

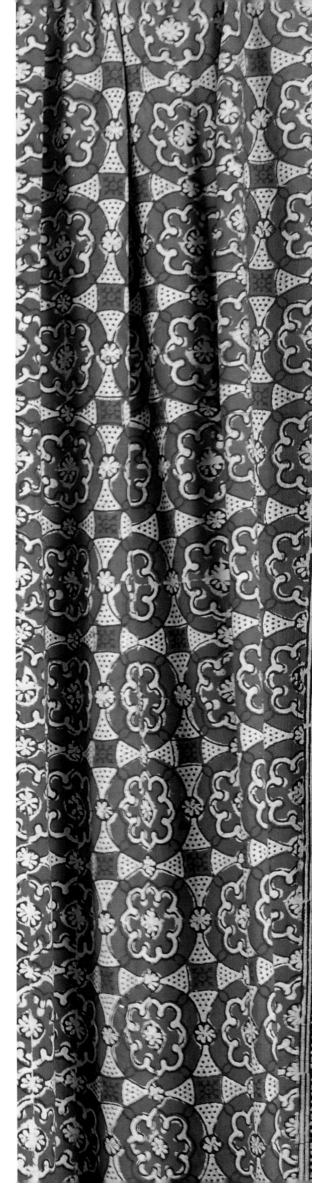

Jain, Dr. J. *"Craftsmen - Skill of the Hands"*. The India Magazine, Bombay: Dec. 1986.

-------- **and Agarwala, A.** *National Handicrafts and Handloom Museum.* Mapin Publishers Pvt. Ltd. Ahmedabad: 1989

Jayakar, P. *"Indian Fabrics in Indian Life"* *Textiles and Ornaments of India.* (ed.), Wheeler, Monroe. Museum of Modern Art. New York: 1956

Kothari, Gulab. *Colourful Textiles of Rajasthan.* Jaipur Printers Pvt. Ltd. Jaipur: 1995

Krishna Pooja, Varandin Sonia, Chauhan Bhavana, Rathor Nikhil, Som Samrat. *The Weft of Gold, Warp of Silver and Weavers of the Sand, Kota - The Green Side of Rajasthan.* Craft Documentation. Textile Design and Development department. National Institute of Fashion Technology. Dec. 1995

Lal, H. and Russel, R.V. *The Tribes and Castes of the Central Provinces of India - Vol. I -- IV.* Cosmo Publications. Delhi: 1916

Malani, Hema, and Bhandari, Vandana. *Embroideries of Meghwals and Sindhi Musalmans of Barmer (Rajasthan).* Unpublished Masters thesis. Department of Textiles and Clothing, Lady Irwin College. New Delhi: 1993

Mardumshumari, Rajwar. Census Report of Raj Marwar. Census Press Rajasthan. Jodhpur: 1815

Marg. Rajasthan. Vol. XVIII, No. 1: Dec. 1964

-------- *"Some Notes on Indian Jewellery"*. Vol. 1, No. 1: October 1976

Mathur, Pushpa Rani. *Costumes of the Rulers of Mewar.* Abhinav Publications. New Delhi: 1994.

Mathur, U. B. *Folkways in Rajasthan.* The Folklorists. Jaipur: 1986.

Meharda, B. L. *History and Culture of Girasias.* Adi Prakashan. Jaipur: 1985.

Mohanty, B. C. and J. P. Mohanty. *Block Printing and Dyeing of Bagru (Rajasthan).* The Calico Museum of Textiles. Ahmedabad: 1983

-------- **et al.** *Natural Dyeing Processes of India.* The Calico Museum of Textiles. Ahmedabad: 1981

Muchrikar, N. V. *Hand Printed Textiles of Rajasthan - A Study.* National Craft Institute for Hand Printed Textiles. Jaipur: 1986

Nagar, Mahender Singh. *Rajasthan ki Pag Pagriyan.* Maharaja Mansingh Pustak Prakash Shodh Kendra. Jodhpur: 1994

Nath, A., and Wacziarg, F. *Arts and Crafts of Rajasthan.* Mapin Publishing Pvt. Ltd. Ahmedabad: 1987.

Neeraj, J., and Sharma, B.L. *Rajasthan Ki Sanskritik Parampara.* Rajasthan Hindi Granth Akademy. Jaipur: 1989

Paine, Shiela. *Embroidered Textiles, Traditional patterns from Five Continents with a Guide to Worldwide Identification.* Thames and Hudson. London: 1990

Pal, H.B. Handicrafts of Rajasthan. Ministry of Information and Broadcasting. New Delhi: 1984.

Patnaik, N. *A Desert Kingdom -* The Rajputs of Bikaner. Weidenfeld and Nicolson Ltd. London: 1990

-------- *A Second Paradise - Indian Courtly Life.* 1590 - 1947. Rupa Books. Calcutta: 1985

Perkin, H.J. "Social History", in H.P.R. Finberg (ed.), *Approaches to History: A Symposium,* London: 1962

Sharma, D. *Rajasthan Through the Ages Vol. I - III.* Rajasthan State Archives. Bikaner: 1966

Singh, C. et al. *The Costumes of Royal India.* Festival of India in Japan. New Delhi: 1988

Singh, Chandramani. *Textiles and Costumes from the Maharaja Sawai Man Singh II Museum.* Maharaja Sawai Man Singh II Museum Trust City Palace. Jaipur: 1979

Singh, H. *The Castes of Marwar.* Books Treasure. Jodhpur: 1894

Stronge, S. (ed), *A Golden Treasury - Jewellery from the Indian Subcontinent.* Mapin Publishing Pvt. Ltd. London: 1988

-------- (ed.), *The Jewels of India.* Marg Publications. Bombay: 1995

Tilke, M. *Costume, Patterns and Designs.* Magna Books. West Germany: 1990

Tod, J. and W. Crooke. *Annals and Antiquities of Rajasthan Vol.1-III.* Low Price Publications. New Delhi: 1829

Untracht, Oppi. *Jewellery - Concepts and Technology.* Doubleday. New York: 1982

-------- Traditional Jewellery of India. Thames and Hudson. London 1997

Vardrajan, Lotika. *Traditions of Textile Printing in Kutch, Ajrak and Related Techniques:* New Order Book Company. 1983

Watson, J. Forbes. *The Textile Manufacturers and the Costumes of the People of India.* India office. Publisher London: 1866

-------- *The People of India,* A Series of Photographic Illustrations of "The Races and Tribes of Hindustan". 8 Vol. W.H. Allen and Co. (Publishers to the India office). London: 1875

-------- **and J. W. Kaye.** (ed.), *The People of India.* Vol. 1 - VII. B. R. Publishing Corporation. Delhi: 1868

Weir, S. *Palestinian Costume.* British Museum Publications Ltd. London: 1990

Acknowledgements

This book is primarily based on field research carried out as part of my doctoral work. During the course of this study, conducted at intervals, over a long span of 15 years, I was fortunate to receive help and encouragement from many individuals and organizations, whose invaluable contributions I wish to acknowledge here.

First, I would like to thank Dr. Satinder Bajaj Director, Lady Irwin Colllege and Dr. Jyotindra Jain eminent scholar and Professor who jointly guided my doctoral work. Dr. Jain has been a source of continued and steadfast support and guided me throughout with his valuable advice.

The people who opened their homes to me and offered their generous hospitality during my fieldwork and photography, are too numerous list here, but my thanks go out to each one of them. I am particularly indebted to Sh. Sohan Lal Tapadia and Sh. Marudhar Mridul who welcomed me on my many visits to Rajasthan; and to Sh. Komal Kothari who helped me gain a deeper insight into the many facets of Rajasthan. His knowledge of the Rajasthani people was vast and I am privileged that he shared some of it with me.

I also gratefully acknowledge the help of all these organizations and individuals including, Siddhi Kumari Ji of Prachina, Bikaner; The Maharaja Ganga Singh Ji Trust, The Lallgarh Palace, Bikaner; Mahender Singh Ji and Karni Singh Ji at the Mehrangarh Fort Jodhpur, Kr. Narender Singh at City Palace, Jaipur and The Department of Archaelogy, Government of Rajasthan, Tribal research Institute, Udaipur and Lok Kala Mandal, Udaipur and in Delhi, The National Museum and National Handicraft and Handloom Museum. They deserve a special mention as they enabled me to study and photograph their priceless collections. Brijraj Singh and Rajeshwari Ji of Jaisalmer allowed me access to their photographs and personal collections. Brijraj Singh and Meenakshi Devi of Kishangarh gave me the use of pictures from their collection and discussed them in detail with me. I would like to thank Jaya Jaitley for permission to use the Crafts maps of Rajasthan.

I would also like to express my appreciation for the assistance given to me by Minda Jewellers in Udaipur, Sudhir Kasliwal in Jaipur; Mahender Nagar at Jodhpur, Khempal Rathi, Kesrimal Kesri, Bhurchand Jain, in Barmer and Nand Kishore Sharma in Jaisalmer.

Special thanks are due to Amitabh Bhattacharya for accompanying me on my travels and undertaking all the photography for my PhD; and to artisans, like Badshah Miyan Ahmed and Hanuman Dharopia, in Jaipur and Suresh Ji in Akola and Devilal Ji in Udaipur helped me to understand textile techniques. I thank Roshan Singh for working tirelessly and helping me to develop the computer drawings for the Garment patterns.

Many researchers and local residents helped me to contact different ethnic groups and organized interviews, which were a source of valuable information. Others escorted me to villages, fairs and places I could never have reached on my own. I thank them for their time, company and selfless help. The people of Rajasthan whom I visited and interviewed were generous and hospitable, the wisdom of the village folk, their warmth will always remain a treasured experience.

To my friends and colleagues who supported me through the years and encouraged me to persevere with the project, I shall be forever grateful.

A large part of my family is spread out over Rajasthan and they helped by offering their hospitality and providing important contacts and information. They made the research more enjoyable and gave me an opportunity to stay connected with my extended family.

There are many others, in Rajasthan and elsewhere, who helped in some way or other with this book. Without their inputs, this massive project could not have been completed. Although they are not mentioned here individually, my gratitude to them is no less.

My heartfelt thanks also go to Ashwani Sabharwal who believed in me long before this book was completed.

Last but not least, thanks are due to my parents who instilled in me a spirit of inquiry and gave the freedom to pursue my goals. My husband Sundeep and my children Tanya and Kartik have lived with this book everyday and I thank them for their patience, encouragement and support towards this work.

Photo Credits

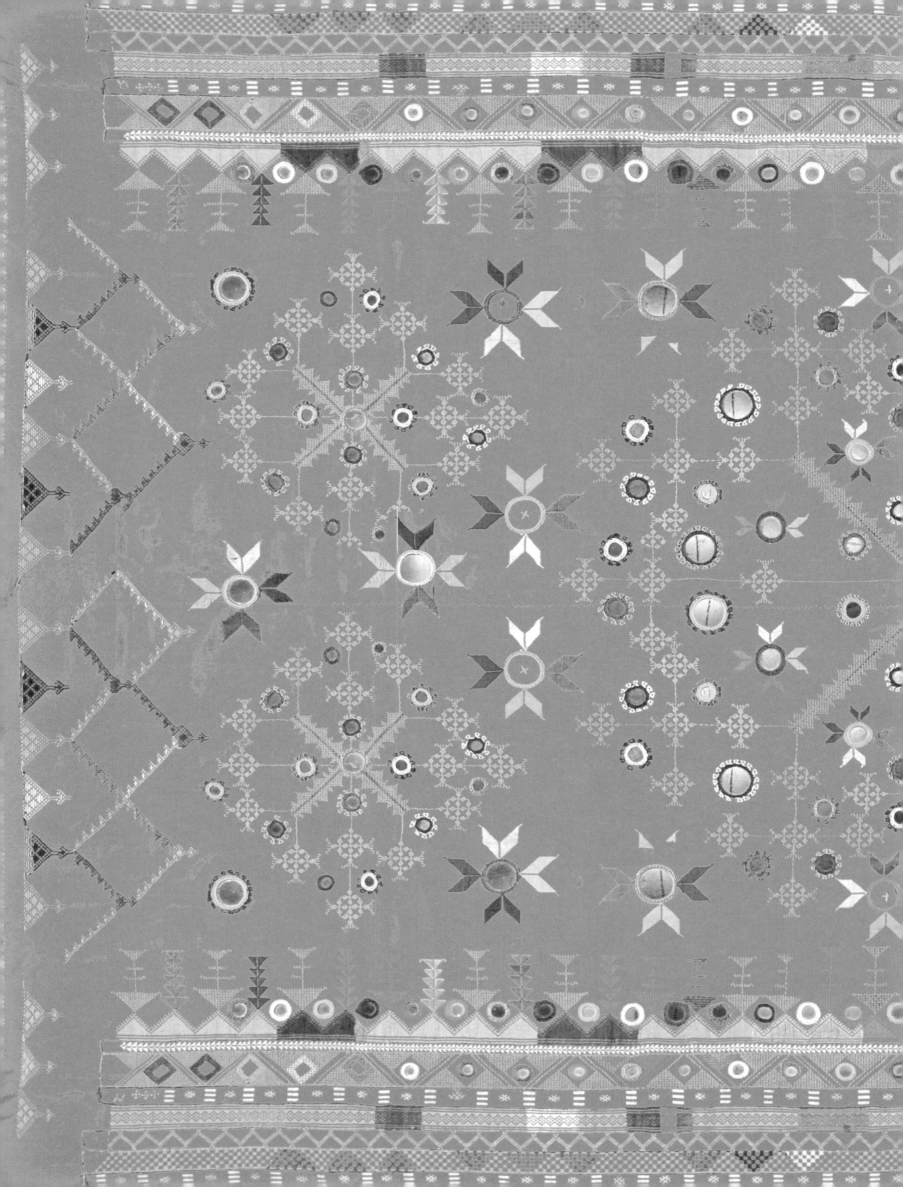